Experimental Filmmaking and the Motion Picture Camera

Experimental Filmmaking and the Motion Picture Camera is an introductory guide to experimental filmmaking, surveying the practical methods of experimental film production as well as the history, theory, and aesthetics of experimental approaches.

Author Joel Schlemowitz explains the basic mechanism of the camera before going on to discuss slow and fast motion filming, single-frame time lapse, the long take, camera movement, workings of the lens, and the use of in-camera effects such as double exposure. A comprehensive guide to using the 16mm Bolex camera is provided. Strategies for making films edited in-camera are covered. A range of equipment beyond the basic non-sync camera is surveyed. The movie diary and film portrait are examined, along with the work of a range of experimental filmmakers including Stan Brakhage, Rudy Burckhardt, Paul Clipson, Christopher Harris, Peter Hutton, Takahiko Iimura, Marie Losier, Rose Lowder, Jonas Mekas, Marie Menken, Margaret Rorison, Guy Sherwin, and Tomonari Nishikawa.

This is the ideal book for students interested in experimental and alternative modes of filmmaking. It provides invaluable insight into the history, methods, and concepts inherent to experimental uses of the camera, while providing students with a solid foundation of techniques and practices to foster their development as filmmakers.

Supplemental material, including links to films cited in the book, can be found at www. experimentalfilmmaking.com.

Joel Schlemowitz is an experimental filmmaker who works with 16mm film, shadowplay, magic lanterns, and stereographic media. He teaches experimental filmmaking at The New School, New York. His first feature film, *78rpm*, is an experimental documentary about the gramophone, and his short works have been shown at numerous film festivals, including the New York Film Festival, Tribeca Film Festival, and Ann Arbor Film Festival. For more information visit www.joelschlemowitz.com.

Experimental Filmmaking and the Motion Picture Camera

An Introductory Guide for Artists and Filmmakers

Joel Schlemowitz

Routledge
Taylor & Francis Group

LONDON AND NEW YORK

First published 2019
by Routledge
2 Park Square, Milton Park, Abingdon, Oxon OX14 4RN

and by Routledge
52 Vanderbilt Avenue, New York, NY 10017

Routledge is an imprint of the Taylor & Francis Group, an informa business

British Library Cataloguing-in-Publication Data
A catalogue record for this book is available from the British Library

Library of Congress Cataloging-in-Publication Data
Names: Schlemowitz, Joel, author.
Title: Experimental filmmaking and the motion picture camera : an
 introductory guide for artists and filmmakers / Joel Schlemowitz.
Description: London ; New York : Routledge, 2019.
Identifiers: LCCN 2018056683 | ISBN 9781138586581 (hardback : alk. paper) |
 ISBN 9781138586598 (paperback : alk. paper) | ISBN 9780429504488 (e-book)
Subjects: LCSH: Experimental films—Production and direction. |
 Experimental films—History and criticism.
Classification: LCC PN1995.9.E96 S325 2019 | DDC 791.43/611—dc23
LC record available at https://lccn.loc.gov/2018056683

ISBN: 978-1-138-58658-1 (hbk)
ISBN: 978-1-138-58659-8 (pbk)
ISBN: 978-0-429-50448-8 (ebk)

Typeset in Bembo
by Apex CoVantage, LLC

Visit www.experimentalfilmmaking.com

Contents

Figures

Charts

Acknowledgments

I would like to thank the following people who played some role in helping to make this book possible: Dawn Elliott for her support and patience during the writing of this book. MM Serra and The Film-Makers' Cooperative for the scholarly residency where I viewed many films cited herein, and for the scanning of still images from films in the collection. Mike Olshan for his invaluable assistance in copyediting the draft manuscript. The peer review readers for providing useful feedback. The readers who looked at smaller portions of the manuscript: Keith Sanborn, Kathryn Ramey, and Jeff Kreines. Bradley Eros and Jed Rapfogel, among others, with whom I bounced ideas around in the early stages of writing this book. Joanna Ebenstein for her encouragement at the outset of this project. Pip Chodorov for providing access to early material from the Frameworks Listerv. The many filmmakers who provided work for me to view, including Guy Sherwin, Christopher Harris, and others. The editors and staff at Focal Press.

For the images in this book, I greatly appreciate the help from Michael Stewart at The New School, Zach Poff at Cooper Union, and Steve Cossman at Mono No Aware for allowing me to photograph cameras and other equipment, as well as the filmmakers who provided images, including Albert Alcoz, Zoe Beloff, Norwood Cheek, the Paul Clipson Family, Peter Cramer, Mary Engel, Paolo Gioli, Christopher Harris, the Harvard Library's Film Conservation Center, Curt Heiner, Jim Hubbard, Martina Kudláček, Jeanne Liotta, Marie Losier, LUX, Tomonari Nishikawa, Julie Orlik, Jenny Perlin, Margaret Rorison, Lynne Sachs, Jeff Scher, Jérôme Schlomoff, MM Serra, Guy Sherwin, Brendan and Jeremy Smyth, and Mike Stoltz, among others. Thanks too to Antonella Bonfanti and Seth Mitter at Canyon Cinema for help in tracking down images.

Introduction

The purpose of this book is to provide a text for an introductory experimental filmmaking course. It is designed to fill a void with its emphasis on experimental approaches. Books on production techniques for introductory filmmaking courses are of a more generalist nature. Existing literature on experimental cinema tends to be non-technical, focusing on film history and theory. The exception to this deficit is Kathryn Ramey's *Experimental Filmmaking: Break the Machine*, a superb and comprehensive book on experimental film technique. However, its coverage of cameraless filmmaking, hand-processing, optical printing, and expanded cinema is premised on the assumption that the fundamentals of film production (how to load a camera, an understanding of exposure, lenses, and basic shooting techniques) are covered elsewhere in the filmmaking curriculum. This book covers these fundamentals from the experimenter's vantage, drawing upon my experience teaching an introductory experimental production course at The New School: "The Innovative Camera: Experiments in 16mm Filmmaking."

The organization of material for this book is tailored to this framework. Chapters have been arranged to track the progress during a 12 to 15-week semester in which students first learn how the equipment works and shoot their own short projects.

Chapter 1: The first chapter introduces the fundamental functions of the camera and the range of experimental capacities associated with the mechanism itself.

Chapter 2: Time and exposure are the principal subjects of this chapter, including film speed, shutter speed, frame rate, and aperture settings.

Chapter 3: The lens is the subject of this chapter. At this point in the semester, having gained an understanding of the camera, exposure, and lenses, students will experience working on in-class shoots relating to optical experiments, single-frame sequences, and filming time exposures with the Bolex.

Chapter 4: In-camera effects, such as double exposure, are detailed in this chapter. Students will shoot in-class experiments with double-exposure and matte shots by this point in the term.

Chapter 5: By now, the time has arrived for students to go out and shoot on their own, so a comprehensive guide to the Bolex camera is the subject of the fifth chapter.

Chapter 6: This chapter provides guidance regarding the making of a three-minute single camera-roll film, edited in the camera. Creating experimental camera-roll films forms the basis of the experimental production course for which this book was written.

Chapter 7: The seventh chapter surveys a range of equipment beyond the basic non-sync camera. It is here to introduce students to the technological history of the camera and provide a base of knowledge from which to embark on further experimentation.

Chapter 8: The final chapter looks at the work of artists who have made the camera an intrinsic tool in their process by means of the film diary, the film portrait, and using the camera's photographic glimpses as a form of preservation of the tangible present for some unknowable future. While reading these last two chapters, students are working on finishing their projects as the term comes to an end.

The distinction between this book and the general-purpose filmmaking guide is not just the practical application of alternative techniques but also the range of examples of film-makers who have made the camera a critical aspect of their working method. The films of Christopher Harris, Rose Lower, Marie Menken, and Guy Sherwin, among others, are provided as examples. This book is not, nor is it meant to be, a comprehensive survey of experimental filmmakers, owing to its principal focus on the camera. Production courses tend not to show very much work, leaving this to the purview of film studies courses. But experimental film production courses are more obliged to address students' lack of exposure to this work. The descriptions of films throughout the book are provided to assist the teacher, as well as the student, in finding work for screening in the classroom. Short films are the primary examples given. Online links to view many of the films described in this book can be found via *Experimental Filmmaking and the Motion Picture Camera*'s web supplement: www.experimentalfilmmaking.com

The objective for providing these examples also stems from a desire to not divide technical matters from aesthetic concerns. The concept for a project should not be conceived in isolation from the inherent qualities of the medium, because an ill-fitting pairing of concept and consequence may result. The filmmaker Sam Wells expressed this concern in a posting on the Frameworks Listserv[1] in 1999:

> FRAMEWORKS Experimental Film Discussion List
> Mon, 25 Jan 1999 17:54:08
> Subject: [FRAMEWORKS] Reverse/Negative: a comment..
>
> . . . I suppose there are two ways to consider the use of any photographic material. Either, you ask if _it_ can serve _you_ and therefore let you engage your subject with a minimum of fussy mediation. . . . Or, you approach the product not _only_ on the level of [its] servitude but as a kind of servant to its particular qualities, which . . . lead you into an engagement with what it – and its use can reveal to you – which is often more abstract. . . .
> Real world experience obviously falls between these two categories.
>
> –Sam Wells

It is therefore not just a matter of learning to use the techniques, equipment, and basic properties of the media but also what one can learn from them while working with these tools. The examples provided have been comingled with the technical content of this book to demonstrate the many ways in which this learning takes place. The diverse nature of the films reflects the innumerable directions such a conversation between the artist and the medium may take.

[handwritten margin note: Concepts should be developed with a (fitting) medium in mind]

The primary medium for *Experimental Filmmaking and the Motion Picture Camera* is 16mm film. As with Ramey's *Experimental Filmmaking: Break the Machine*, the relevance of a text on analog film in an increasingly digital production environment is a response to young filmmakers' desire to experience working with "real film." Even if working with 16mm remains as a transitory occurrence, or is practiced as an avocation rather than as a professional occupation, the discipline and concentration of working in film will carry over into approaching other media. There is a particular combination of care and creativity gained from what film reveals to the filmmaker.

Working with 16mm film, one shoots not just with one's eye but also with one's hands. The hands hold the camera, manipulate the controls, turn the rings on the lenses, and push the button to release the spring. Shooting film (especially with a camera like the Bolex), one can be physically aware of the momentum of the film through the camera, the release of the camera's spring tension, the machine subtly trembling one's hands. The film camera's subtle shuddering energy can affect one, as if transferring some of the spring's energy to the act of filmmaking – what the experimental filmmaker Marie Menken referred to as "the twitters of the machine."[2]

The prevalent idea of filmmaking is to see the function of the camera as a component coequal with all other facets of the process. It is the tool of cinematography, along with a movie's other ingredients, including screenwriting, directing, acting, set design, costumes, lighting, special effects, editing, sound design, and music. This dovetails with the notion of cinema as an aesthetic amalgamation, incorporating aspects of all the other arts in its production. Russian director and film theorist Sergei Eisenstein proclaimed, "... the cinema is that genuine and ultimate synthesis of all artistic manifestations that fell to pieces after the peak of Greek culture, which Diderot sought vainly in opera, Wagner in music-drama, Scriabin in his color-concerti, and so on and on."[3]

If we momentarily adopt this analogy of the cinema as grandly orchestrated endeavor – with the movie director in the role of the conductor, baton in hand – the filmmaker who journeys out with just a camera is more like the solo musician, creating the film without the need for a concert hall filled with production gear. The moving-image instrument invites virtuosity comparable to its musical kin: the aplomb and precision of Fritz Kriesler or the inextinguishable creative energy of Zeena Parkins. In 1960, Jonas Mekas wrote about what he termed "film troubadours" in his column in the *Village Voice*: "Every day I meet young men and women who sneak into town from Boston, Baltimore, even Toronto, with reels of film under their coats – as if they were carrying pieces of paper scribbled with poems.... They are the real film troubadours."[4] The solo filmmaker with a movie camera is very much the film troubadour, it would seem.

Pragmatically speaking, for filmmakers who place the camera at the crux of the creative undertaking, this pared-down process might be a question of economy: Just a camera, a light meter, a film roll, that's all that's needed. This approach allows the beginning filmmaker to commence working on projects with just the acquisition of the most basic implements of the craft, with the camera acting as the entryway through which creativity can be fulfilled in a complete fashion and on a personal scale.

Notes

1 http://www.hi-beam.net/cgi-bin/fwredirect.pl?dir=fw10&listfile=author.html&file=0361.html&da te=25+Jan+1999&subject=Reverse/Negative:+a+comment.

2 Mandell, Leslie (assisted by Paul Sitney), "Interview with Marie Menken," *Wagner Literary Magazine* no. 4., Gerard Malanga and Paul Katz ed. Staten Island, NY: Wagner College, 1963–64, p. 48.
3 Eisenstein, Sergei, "Achievement" (1939), in Jay Leyda ed. and trans. *Film Form Essays in Film Theory and Film Sense*. Cleveland and New York: Meridian Books, 1968, p. 181.
4 Mekas, Jonas, "On Film Troubadours" (1960), *Movie Journal: The Rise of the New American Cinema 1959–1971*. New York: Collier Books, 1972, p. 20.

1 Dream-vision of the pulldown claw and the hidden workings of the camera

This chapter covers how the motion picture camera was created, how it works, and filmmakers who make use of its fundamental aspects.

Three inventions, created in the nineteenth century, are unlikely kinsfolk. The common bond between these devices is a sequence of movement and stillness, repeating in quick succession. This trio of the mechanical age comprises the sewing machine, the motion picture camera, and the machine gun.[1] Perhaps the typewriter, with its spring-driven carriage advancing the paper between strokes of the key, may be considered yet another cousin of these inventions. Each of these was less an entirely new idea than a clockwork-drive version of its manual precursor: The sewing machine brought machine-age production to the handcraft of the seamstress; the mechanically reloading Gatling gun brought death on the battlefield to a scale of industrial mass production; the motion picture brought the dreamy shadowplay and painted glass-slide phantasms of the magic lantern show into the photographic age.

Inventor Louis Lumière acknowledged the genealogical pedigree of the one device begetting the other; the camera's "pulldown claw," resembling the "presser foot" of the sewing machine, coming to him as a mental image during a night of insomnia while fretting over the invention's development.[2] The terminology may be a bit inexact as far as this comparison is formulated; the presser foot of the sewing machine acting to halt the fabric so the needle may pass through serves a function like the motion picture camera's pressure plate. It is a component called the "feed dog," which seems to bear a greater resemblance to the critical component of the Lumière camera. On a sewing machine, the feed dog is a pair of thin saw-toothed plates coming up through slots in the bed of the machine. The teeth of the feed dog move the fabric to the location of the next stitch and withdraw as the needle penetrates the fabric once again. A rotating cam produces this series of movements. In Lumière's insomnia-induced solution, the mechanism of the camera is comprised of a pulldown claw (feed dog) grasping onto the film to move it to the location of the next exposure. The film is held still and steady by the pressure plate (presser foot) during exposure. The shutter opens, ushering in the lens-light (needle) to stitch an exposure onto the film's emulsion.

In its rapid, death-dealing chain of actions, the ammunition-laden machine gun belt advances a cartridge, coming to a halt in the firing chamber, where the firing pin engages with the bullet's primer. Just as the motion picture camera takes in light through the barrel of the lens, the firearm expels its projectile outbound through its barrel. In either case, the action is "to shoot."[3]

shoot film, not people

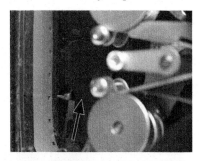

Many inventors played a role in the birth of cinema, in a patchwork of developments: Eadweard Muybridge's Zoopraxisope, created in 1879, took the optical toys of the nineteenth century and added the photographic camera to create a looping series of sequential photographs. Inspired by Muybridge's device, Thomas Edison directed his employee William Kennedy Dickson to build a moving image companion to his audio-reproducing phonograph. This eventually became the Kinetoscope camera and its accompanying peep-show viewer, both patented in 1891 after years of experimentation.

In 1895, the German magic lanternist Max Skladanowsky adapted the use of dual glass slide projections of "dissolving views" to the task of moving photographic images, fashioned into two alternating loops, punched with perforations and grommets, and then projected on the screen in a device that seems more like some unruly Steampunk hallucination than a practical cinematic apparatus.[4] There was also the work of Louis Le Prince, whose unexplained disappearance on a train from Dijon to Paris in 1890 produced more of an unsettling mystery than a sustained place among the innovators of the motion picture camera. "Perhaps the question or priority, like the Loch Ness Monster, is best left alone,"[5] writes John Frazer on this jumble of rival claims.

But it was the brothers Lumière who saw opportunity where Edison had imagined unprofitability; the moving image projected to an audience on a screen, rather than the single-viewer Edison Kinetoscope peep-machine. The Lumières first presented this to the public in 1895.

The machine created by the brothers Lumière was not just a camera; it was a printer and projector as well – a whole system of production in one modular device. As historian and filmmaker Erik Barnouw described it:

> The *cinématographe* could be carried as easily as a small suitcase. Handcranked, it was not

Figure 1.1 I: The pulldown claw of a non-reflex Bolex H16 camera with the pressure plate removed to better see the sequence of actions of the claw. The arrows indicate the movement of the claw as it advances the film between exposures, and then retracts, moving back into position during the exposure of the film.

dependent on electricity. The world out-
doors – which offered no lighting prob-
lems, at least during the day – became
its habitat. It was an ideal instrument for
catching life on the run – "sur le vif," as
Lumière put it.

A remarkable fact about this small box –
a trim hardwood item of much elegance –
was that it could, with easy adjustments, be
changed into a projector, and also into a
printing machine. This meant that an *opé-
rateur* with this equipment was a complete
working unit: he could be sent to a foreign
capital, give showings, shoot new films by
day, develop them in a hotel room, and show
them the same night. In a sudden global
eruption, Lumière operators were soon
doing precisely this throughout the world.[6]

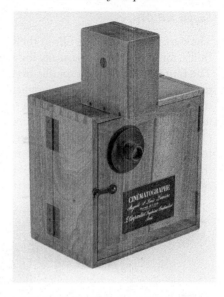

Figure 1.2 The Lumière's cinématographe
35mm hand-crank motion pic-
ture camera. In the words of Erik
Barnouw: "The cinématographe
could be carried as easily as a
small suitcase." Courtesy of the
George Eastman Museum.

What also makes the Lumière apparatus so
remarkable is how little the core elements
of the motion picture camera have changed
since the design of the *cinématographe* (except,
of course, the separation of camera, contact
printer, and projector functions into specialized
machines). Once loaded with film, and the door of the camera is closed, the internal
workings become concealed from view. Yet, if we might be shrunken down to Lilliputian
scale and slip inside the metal enclosure, what would we witness therein? What aspects
of the camera's core functions and particularities might be fodder for experimentation?
Becoming acquainted with the motion picture machine also includes an understanding
of how to avoid common mistakes; deciding how to choose between different cameras to
achieve a particular outcome; and gaining a sense of the range of possibilities (from a more
pragmatic standpoint) when making use of equipment readily on hand.

We will tour the camera, following the path of the ribbon of film, pausing now and
then to address these other questions along the way. We will occasionally highlight the
work of filmmakers who have made special use of some element of the mechanism.

The camera

The body of the camera itself is a light–tight box, the tightly fitting camera door contain-
ing a baffle around the edge to keep light from seeping in through the seam and fogging
the film. Sometimes fogging of the film can happen due to some small crevice in the door.
Typically, this will be seen on screen at the beginning or the end of a shot as a smudge of
light upon the surface of the film, or as a red glow along the side of the image. To prevent
light leaks from causing fogging, it is common practice to put gaffer tape around the cam-
era door as an additional seal. Outdoors, in sunlight, this tends to make a difference, but
it's not always as essential when filming in low light conditions, or when working with a
camera you know to be sufficiently light-tight.

Supply reel (A)

The starting point for the film is the supply reel. In 100ft-loading 16mm cameras (like the Bolex, for instance), this is usually located on the top portion of the camera's inner chamber. The film is loaded onto a spindle from which the unexposed film is unreeled through the mechanism. When the film is supplied on a daylight spool, as is the case with a 100ft roll, the outer part of the film is exposed to light. The spool, and the outer windings of the film itself, protects the film inside from being exposed. When the film is first loaded into the camera, the first seven seconds of film are the "flares" – the transition from the fully exposed to unexposed film. On screen, the effect is of undulating light washing over the image, transitioning from white through a veil of yellow, orange, and red (or shades of gray, in the case of black and white film). Sometimes the sprocket holes on the film allow some light

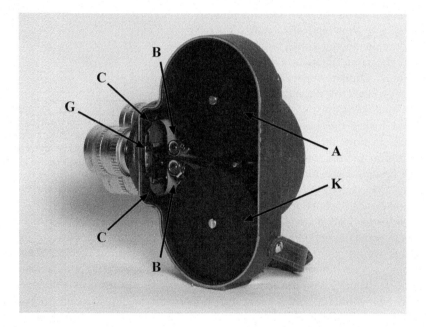

Figure 1.3 The components of the camera, as found inside of the 16mm Bell and Howell Filmo, with the door removed: A: Supply reel; B: Sprocketed rollers; C: Loops; G: Pressure plate; K: Take-up reel.

Figure 1.4 A super-8 cartridge and 16mm daylight spool. The super-8 cartridge contains the supply and take-up, along with the pressure plate.

to pass through, stenciling the outline of the sprockets onto the emulsion of the coiled up roll during the flares. To avoid losing a shot to the flares, the film is usually advanced seven seconds when 100ft daylight-loading spools are used.

Filmmakers who have used light flares as a technique include Christopher Harris, in his film *28.IV.81 (Descending Figures)* (2011), and Guy Sherwin, in *Window/Light* (2013). In both these cases, the camera door was opened at points during the filming, resulting in mid-roll camera flares momentarily obliterating the image. Camera flares can be used as a transition to end a sequence (with careful timing by the filmmaker to have the film run out at the right moment), which is seen in the portrait films of Marie Losier, such as *Tony Conrad, DreamMinimalist* (2008) and *Byun, Objet Trouve* (2012).

Film magazines

An alternative to the self-contained camera is the magazine-loading version. In the case of a magazine-loading camera, holding 400 feet of film, the film comes supplied on a two-inch plastic core (a size referred to as a "camera core") with no protection from complete exposure apart from the metal can and an opaque black plastic bag inside. Film on a core must be loaded in darkness so as not to entirely expose the film to raw light. Magazines come in different configurations, based

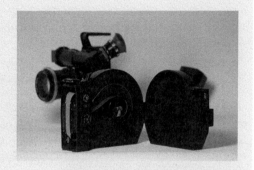

Figure 1.5 The 400ft coaxial magazine of the Arriflex SR, showing the take-up side of the magazine. Camera courtesy of The New School Film Office.

upon the camera: The twin-chambered "Mickey Mouse ears" magazine found on cameras such as the Auricon; the single-chamber magazine on the Arriflex S, M, or BL; the compact, coaxial magazine, with the supply and take-up chambers arranged side by side – the Arriflex SR, Aaton, and Éclair NPR and ACL are fashioned in this manner.

200ft magazines can also be found in both 16mm and 35mm, but these are of limited usefulness (16mm film is no longer supplied in 200ft lengths, consequently needing to be wound down from 400ft rolls).

The magazine will typically have a core adaptor for loading the plastic camera core the film is supplied on into the magazine. With the core adaptor removed, the square spindle will accept a daylight spool instead, although this is usually avoided due to the additional noise produced by the spool scraping against the interior of the magazine compartment. When unloading the film, be sure the core adaptor remains with the magazine. Sometimes the take-up will be equipped with a collapsible core and the film sent off to the lab coreless within the black plastic bag and can.

As the film leaves and re-enters the magazine, it travels through a slit or set of rollers arranged to prevent light from entering the magazine, known as a "light trap." Sometimes a "velvet light trap" is used, with black velvet making contact with the film to prevent scratching of the film's surface.

Sprocketed rollers (B)

From the supply reel, the film is propelled by a pair of sprocketed feed rollers located above and below the gate. On some magazine-loading cameras, like the Arriflex SR, these rollers may be located within the magazine itself. Some cameras have just a single roller; others two. The rollers will propel the film in constant motion as the camera runs, distinct from the intermittent movement of the film as it arrives at the gate.

Loops (C)

As noted above, the film moves continuously from the supply to the take-up, but as the ribbon of film arrives at the gate, the film must come to a stop during the moment of exposure and then move again to advance to the next frame. This requires some form of transition between the film's constant movement from supply and take-up and the intermittent movement at the gate: The loops are the slack, allowing this to happen. They appear as short, curving lengths of film on either side of the camera gate and pressure plate. As Arnold Eagle, with whom I had studied, would say, "The film loops are there because the film cannot stretch, or else it would snap."[7] The two curved loops of slackened film will be seen to flutter as the camera runs.

The camera is designed for the loops to be of a particular size, and consequences can arise from the loops being larger or smaller: A loop that is too big may slap against part of the inside of the camera, causing scratching of the emulsion. Or in the case of a loop that is too small, the intermittent motion of the film at the gate may be impeded by the rollers tugging at the film and causing it to move during exposure. The consequence is a vertical smearing of light during exposure – especially noticeable in bright areas of the image – which might appear as a mistake but could hold possibilities for experimentation.[8]

An example of footage shot with bad loops is seen in the first few minutes of Bruce Baillie's *Castro Street* (1966). An engineer walks beside a diesel train, the scene cloudy with what seems to be early morning fog, but it could also be the blurring of the image due to the movement of the film during exposure – the white stenciled letters painted

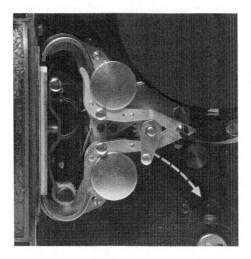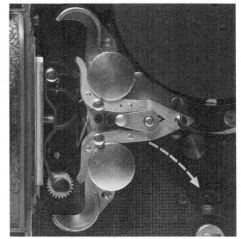

Figure 1.6 D: The loop formers on a Bolex camera, showing the open and closed positions. Chapter 5 will cover the use of the loop formers when loading the Bolex.

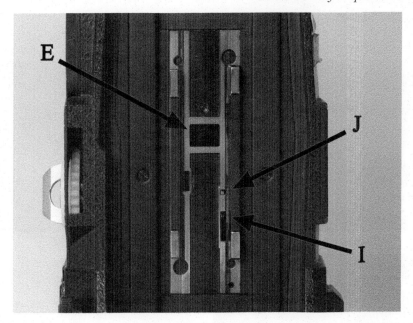

Figure 1.7 The components of the camera, continued. An Arriflex SR, with magazine removed. E: The gate; I: Pulldown claw; J: Registration pin.

on the side of the train engine sending streaks of white downwards as a result of the bad loops. The inclusion of the seemingly spoiled footage, with its smudged, mist-like qualities, enhances the gradual build-up of the film's opening stages.

The Bolex camera may experience collapsing loops if the pulldown claw has grown dull and the camera is run at 64fps (for slow motion) or used for single-frame shooting (for animation and time lapse). Even if a camera runs perfectly at 24fps, it may still have loop trouble at high speed or single frame. An example of a filmmaker making use of collapsing loops when shooting single-frame sequences on a Bolex camera can be found in the films of Jenny Perlin. Her animated works are made by creating drawings a little at a time before the lens, rather than the more traditional method of a series of drawings replacing one another. The loops in her Bolex camera shift out of place during single-frame sequences, resulting in a stuttering and trembling image; the dark lines on white paper, as well as the frameline of the gate itself, create a series of vertical smears from frame to frame as the film moves during the exposure time. She typically switches to shooting at 24fps at the end of a sequence, and the image steadies itself. The effect is not unlike seeing the pages of a flipbook fluttering from image to image.

Loop formers (D)

To aid in making the ideal-sized loops, some 16 cameras, such as the Bolex and Canon Scoopic, will have a pair of guides known as loop formers. The loop formers have two positions – open (for shooting) and closed (for loading). The film is run through the camera during loading, snaking its way along the path from supply to take-up. Once the loop formers have guided the film during loading of the camera, they are opened for shooting, allowing the loops to provide slack unimpeded.

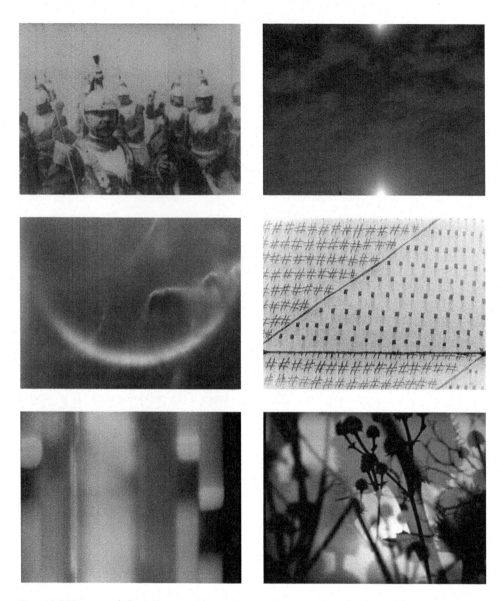

Figure 1.8 **Top row left:** Auguste and Louis Lumière's *Cuirassiers à cheval* (1896). **Top row right:** Mike Gibisser's *Blue Loop, July* (2014). **Middle row left:** Saul Levine's *Only Sunshine* (2003) from his *Light Lick Series.* **Middle row right:** The shifting frameline from Jenny Perlin's Bolex camera in *Tender Not Approved* (2016). Courtesy of the filmmaker and Simon Preston Gallery, New York. **Bottom row left:** A misloaded camera produced the vertical smear in the image in Paul Sharits's *Bad Burns* (1982). **Bottom row right:** Multiple exposures created by film moving through the camera in overlapping segments in Paul Clipson's *THE LIGHTS AND PERFECTIONS* (2006). Courtesy of the Paul Clipson Family.

Cameras without loop formers

16mm cameras like the Bell and Howell Filmo, various old home movie cameras, or magazine-loading cameras like the Arriflex SR are designed to have the loops above and below the gate made the correct size by hand. This is done by following a threading guide inscribed on the inside of the camera. In the case of the Arriflex SR, the loops are made by pulling out the film from the magazine to align with a notch before threading the film back inside to the take-up side of the magazine.

The gate (E)

The gate is the rectangular window allowing light to pass from the camera lens to the film's photosensitive emulsion. It acts as a rectangular mask, blocking stray light from exposing the frames above and below the gate.

Interestingly enough, there are instances where a bright source of light may seem to bleed around the edge of the gate and onto the neighboring frames. This is not actually light spilling around the edge of the gate but the light reflecting off the back surface of the base of the film, exposing the emulsion beyond the barrier of the camera gate as it ricochets and scatters. While the film might not seem very thick, as a three-dimensional object there is enough thickness for the light to scatter in this manner. This appearance of bending of the light around dark edges is known by the term halation. Color film is produced now with a black anti-halation coating on the back of the base to minimize the effect.

Boston-based filmmaker Saul Levine has produced a number of short films referred to as the *Light Lick Series*, making use of the phenomenon of light bouncing off the back surface of the film, with the camera shooting light directly from the sun. The pattern reveals the vertical movement of the strip of film in the camera: lower arc, white frame, upper arc. These are repeated in quicker and slower succession, at times giving the impression of the rotation of the whole of the image itself within the rectangle frame. In the more rapid sections, the arcs of light sometimes converge, like the overlapping circles of a Venn diagram. What is impressive as well is the variety of nuances within the bleeding light; sometimes there's a reddish glow at the top or bottom of the frame; then an orange arc spreading still further into the center of the image, resembling the glowing aurora around the sun viewed during an eclipse, seemingly produced on the light-sensitive emulsion by the edges of the lens elements catching the light; blue-white rays, the fleeting appearance of rippled light suffused with a faint rainbow arcing across the frame in a pattern known as Newtonian rings; in black and white film, the glowing solar flares become more lunar in appearance, like

Figure 1.9 The indicator on the outside of the camera of a reflex Bolex H16 camera showing the position of the film plane.

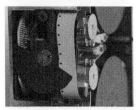
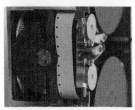
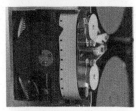
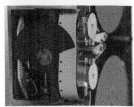

the thin sliver of a crescent moon. Weathered mountainous crags catching the light of dawn are probably irregularities in the glass elements made visible through the acute angle of the ricocheting light.

The phenomena of the light from one frame bleeding over the edge of the gate can also be seen in Mike Gibisser's single-shot short film *Blue Loop, July* (2014). The film is composed of a static shot of the sky with telephone lines crossing the frame. The sense of spatial orientation is ambiguous due to the horizon being placed somewhere just outside the shot. Towards the end of the film, we see distant fireworks and hear voices of spectators, a coda giving a sense of the quiet melancholy of the lone individual observing far-off celebrations, reminiscent of the high-spirited carnival heard by Violetta from her sickroom window in the third act of Giuseppe Verdi's opera, *La Traviata*. The bright, yellow-hued light of a streetlamp is positioned so as to just touch the bottom edge of the frame, just slightly right of center. A spreading beam of yellow light trails upward from the bottom of the frame. But the halation around the gate also places a second, yellowish light beam falling downward from the top of the frame, creating the uncanny impression of a sky illuminated by the rays from two suns.

Things can get stuck in the gate – such as a hair or a film chip that broke off while loading – and are photographically reproduced as part of the image as a consequence. Some cameras are more of a magnet for hairs than others, hence on a film shoot with a coaxial magazine-loading camera, you might hear someone on the crew call out "Check the gate!" at the end of a take. The assistant cameraperson will remove the lens and inspect the gate up close with a small flashlight, answering (to everyone's relief) with "The gate is good!"

The gate should never be cleaned with a metal tool, as this can damage the carefully machined parts, creating a bur in the metal that can scratch the film as it passes through. An orangewood stick, used for cleaning fingernails, is the ideal choice. Super-8 cameras are particularly prone to getting a hair (or other debris) in the gate, made all the more troublesome by the small size of the film causing the debris to appear all that much larger on the screen.

The gate with debris stuck on the edge of it can thus become the inadvertent contributor to the result, as in the case of a short film by Jack Smith called *Scotch Tape* (1959–62). The title refers to the piece of tape seen stuck on the

Figure 1.10 The shutter of a non-reflex Bolex H16, with the front of the camera removed to better see the rotation of the shutter.

edge of the camera gate during filming; the mistake is embraced – foregrounded by defiantly making it the title of the film, rather than screening the film with the hope of the audience overlooking the defect or taking some extraordinary measure such as enlarging the frame with the optical printer to crop the offending tape out of the image.

Film plane (F)

The film plane is not a mechanism of the camera but a term used to denote the film's position in the gate. The film plane is shown on the outside of the camera as a symbol resembling the planet Saturn turned on its side. If setting focus using a tape measure rather than focusing by eye, the distance between this point and the subject is measured.

Pressure plate (G)

The pressure plate is found on the opposite side of the film from the gate. Its function is to act as a brake, stopping and steadying the film during the moment of exposure. The film, sandwiched between the gate and pressure plate, is in motion as the pulldown claw advances the film between exposures. The pressure plate, as its name suggests, exerts pressure on the film to halt it, so as to prevent the inertia from its frame-by-frame movement that causes the film to be unsteady during the time of exposure.

The shutter (H)

The shutter resembles a half-circle constantly rotating in alternating with the movement of the pulldown claw. The shutter is open when the film has come to a stop on the gate, and it closes to prevent the film from being exposed as it is advanced. This cycle occurs at 24 frames per second (24fps) when shooting at the standard motion picture speed.

Canadian filmmaker Vincent Grenier made use of the shutter of his 16mm Pathé camera (which happened to have a two-bladed shutter) by attaching red and green filters to tint the image in alternating frames, in a short work entitled *Tremors* (1984). This intervention is a nod to the Kinemacolor process, an early color process pre-dating modern color film; it was conceived at the beginning of the twentieth century, using black and white film and color filters. Grenier's film is not a re-creation of Kinemacolor but rather a usage of the idiosyncrasies of this process. By rapidly alternating between two of the primary colors of light, additional colors were produced through the rapidly moving images seeming to merge. But Kinemacolor had its deficiency with any moving object: The colors would go off register from each other. It is precisely this aspect Grenier utilizes, where a rapid pan of a building creates a double image in green and red: The faster the camera movement, the greater the displacement between the off-register colors.

The filmmaker Marie Menken made use of the shutter's ability to create flicker when it is slightly out of phase with some repeating pattern. In *Arabesque for Kenneth Anger* (1958–61), she rapidly pans across Moorish tiles in the Alhambra. In another film, titled *Mood Mondrian* (1961), rows of squares in Mondrian's *Broadway Boogie Woogie* are filmed in rapid camera movements. The cycle of the shutter sometimes places a tile or square a little ahead or a little behind the one in the previous frame, depending on the speed of the camera movement, giving the impression of the patterns moving in the opposite direction from that of the camera. This curious layering of movement produced through phasing is the same phenomenon that causes the wheels on a vehicle to appear to turn backwards when seen on film.

Most movie cameras have a fixed shutter, but a few, most notably the Bolex, possess what is known as a variable shutter. The variable shutter can be moved out from behind the fixed shutter. Decreasing the shutter angle creates a shorter exposure time, consequently decreasing the amount of light exposing the film. On the Bolex, this can be used to fade to black while filming. A change in the shutter angle will also affect the appearance of movement (camera movement or movement of objects within the shot) because of the reduced amount of motion blur. Looking at a freeze-frame, it becomes apparent there is a significant amount of motion blur when shooting at 24fps. Decreasing the shutter angle renders a hard-edged sharpness to moving objects, appearing similar on screen to the sharp-edged artifice of shooting fast motion.

Pulldown claw (I)

The pulldown claw is the mechanism that appeared in Louis Lumière's late-night thoughts, a fork-like metal talon turning determinately on its cog to advance the film, from one frame to the next. It engages with the sprocket at the moment the shutter has closed, pulls the film to advance from the just exposed frame to the subsequent unexposed frame, and releases from the sprocket hole as the shutter opens.

The claw not only advances the film between exposures but is also responsible for positioning the frame in the precise place as the previous frame. This is so the image doesn't wobble from one frame to another, in what is referred to as registration of the image (more on this below, regarding the registration pin). On cameras like the Bolex, the action of the claw to register the image only happens as the camera is run forwards. But when the camera is run backwards (as can be done with an external electric motor like the MST, or with the use of the backwind crank), the claw will not place film squarely in the gate. The short film *Shift* (1972) by Ernie Gehr looks out from an upper story window down at the asphalt expanse of a city street, with the use of a telephoto lens to confuse our sense of orientation. The frameline sometimes appears within the shot, rather than aligning with the frame of the projector gate. It seems as if these sections of the film were shot with a Bolex camera running in reverse, the claw releasing the film off register. The film's title may refer to this shifting of the image or to the shifting sense of perspective due to the flattening of the image by the telephoto lens.

Registration pin (J)

Not all cameras have a registration pin, as oftentimes the pressure plate and pulldown claw themselves suffice in registering the frame in the gate. But in certain cameras, there is the addition of a registration pin to steady each frame by grabbing hold of a sprocket as the pulldown claw releases from the film.

A camera with poor registration can serve to illustrate the effect the registration pin is designed to counteract: Brian Frye's film *Broken Camera Reels 1&2* (2000) uses old 16mm home movie cameras of the type found at the flea market. In one reel, the image makes small, spastic jolts up and down as footage is captured of Brooklyn backyards viewed from a fire escape; a staccato stumbling movement of the film through the mechanism. When Rudy Burckhardt began making films, he used a Victor camera, not dissimilar from the classic Bell and Howell Filmo. Its inconsistent registration can be seen in Burckhardt's early films: At the beginning of a shot the image seems to jump for just a moment until it finds its bearings.[9]

Super-8 cameras, with the pressure plate built into the plastic cartridge, tend to have poor registration. Jem Cohen, speaking[10] about his film *Lost Book Found* (1996), explained the decision to shoot the film entirely handheld as a consequence of de-emphasizing the wobbling registration inherent in working with super-8; handheld shooting acting to camouflage the wobbling of the film in the gate.

Austrian filmmaker Kurt Kren's *31/75:Asyl* (1975) uses multiple exposures and a complex series of black mattes to create a jigsaw puzzle view of a country landscape, each exposure moving slightly in relation to the others. Another example can be found in the superimposed main title of Rudy Burckhardt's *Under the Brooklyn Bridge* (1953), with the text moving in a slight up and down motion in comparison with the still image behind it; presumably, the entire film has this slightly imperfect registration, but after the title shot it goes unnoticed when the whole frame has this subtle wobble.

It should be added that even when film is shot with a camera with a registration pin there is still a question of the registration of the projector as well (or even the integrity of the sprocket holes in an older piece of film that is worn or simply shrunken). Yet, this subtle breathing movement of the image, present even in a static shot, is what contributes to the "film look." By contrast, there is no issue of registration of one frame to the next in digital (or analog) video.[11]

Take-up (K)

Finally, at the end of this sequence of steps, the exposed film coils up on the empty take-up spool (or onto a plastic core contained within the 400ft magazine of a camera).

Once the film has run entirely through the camera, the film goes back into its plastic box or metal film can to be processed by the lab (or by the filmmaker). Don't use tape to attach the film to the spool or the core; the built-in slot should be used for this, otherwise the lab will be concerned that tape residue may dirty up the rollers on the processing machine.

The film moves in linear fashion from supply to take-up. But exceptions to this one-way movement exist in the form of reloading the film back into the camera to double expose images on top of images. The San Francisco-based filmmaker Paul Clipson took advantage of the feature available on some super-8 cameras to backwind the film for a couple of seconds to create layer upon layer of superimpositions: city lights at night, extreme close-ups of an eye, with signs reflected. Interestingly, the super-8 cartridge is designed to propel the film forward onto the take-up and not to go in reverse. Super-8 cameras equipped to rewind the film will only send it back a few seconds before the film begins to jam inside the cartridge. This entails filming short shots and rewinding, filming and rewinding, in a "two steps forward and one step back" movement of the ribbon of film through the camera.

Camera motors

Driving all of this is a motor. On many 100ft-loading cameras (the Bell and Howell Filmo, the Bolex, the Kodak K100), it is a spring that is wound between shots. The spring on the Bolex will run the camera for twenty-eight seconds. Electric motor-driven cameras include the Canon Scoopic and Beaulieu and 400ft-loading magazine cameras. Electric motors might run at a fixed speed, variable speeds for fast and slow motion, or crystal-governed speed for sync sound shooting. Motor-driven cameras often have an "inching

knob" to manually advance the film during loading or to move the shutter into position in the case of a mirror-shutter camera.

Some cameras, like the Bell and Howell Filmo, can be run hand-cranked in the old style with an external accessory crank. The classic hand-cranked movie camera would expose eight frames per revolution; two cranks per second, equaling a frame rate of 16fps.

Film gauges: 35mm, 16mm, 8mm (Regular 8), super-8

While the size of the image itself forms the basic distinction of one format of film from another, factors such as cost, bulk of the equipment (including its obtrusiveness when filming out in the world), and specific features of the camera equipment (either desired or on hand) will factor into the choice (or necessity) of what gauge of film is used.[12] 16mm film may be one of the most prevalent for experimental filmmaking, but it is by no means the only option.

35mm

The format dating back to the earliest days of the movie camera – established by Thomas Edison and William Kennedy Dickson in the Kinetoscope – 35mm has held a longstanding place as the commercial film industry standard.

The full, unmasked frame is the height of 4 perforations of the film. The aspect ratio of 35mm was a squarish frame, eventually standardized as 1.37 (more precisely 1.375:1), known as the "Academy Aperture." To adapt the boxy ratio of 35mm into a widescreen format, a mask (in the form of a small metal plate with a rectangular cut-out) is commonly used on the projector, hiding the top and bottom of the 1.37 image recorded onto the film, producing a ratio on screen of 1.85 (1.85:1). This masking of the image was adopted so that the many 35mm cameras then in use would not all have to be rebuilt or scrapped. In Europe, a ratio of 1.66 was also put into use, also using a mask in the projector.

35mm film runs at 90 feet per minute, with a frame rate of 24fps. Therefore, a 100ft roll of 35mm is a little over a minute of film; a 400ft roll of 35mm is just a little under four and a half minutes; and a 1,000ft roll is just about eleven minutes. There are 16 frames per foot of 35mm film.

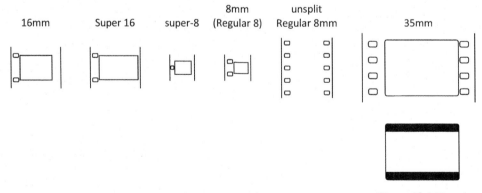

Chart 1.1 Film gauges.

While most early avant-garde films were produced in 35mm, it became less and less common over time as 16mm became prevalent for non-theatrical screenings. While the eleven-minute film *The Life and Death of 9413, a Hollywood Extra* (1928) was produced by Robert Florey and Slavko Vorkapich for a total of $97, nowadays working with such a modest budget in 35mm would be a challenge.

The primary exception to the generally scarce usage of 35mm film for avant-garde work has tended to be in regions of the world where there was never much of a market for 16mm equipment for home movies, educational films, or commercially produced industrials.

Despite the advantages of 35mm in terms of the sharpness and richness of the image in comparison to smaller-gauge formats, there is a drawback worth noting as something particular to the palette of experimental filmmaking techniques: It is a format not well suited for in-camera multiple exposure when reloading the film into the camera. Because there are four perforations per frame, the film may be off by a quarter or half a frame, with the frameline sitting somewhere in the middle of the image as a result.

Commonly encountered 35mm cameras (among the vast array made from the beginnings of cinema onwards) include the compact, spring-driven 100ft-loading Bell and Howell Eyemo; the Arriflex IIC with a 400ft magazine (smaller 200ft magazines exist for it as well); or other heavier Arriflex cameras such as the Arriflex III and Arriflex BL and the Éclair Cameflex CM3 and its Russian-produced counterparts.

Some 35mm cameras have been adapted to shoot 3-perf or 2-perf frames, with a smaller and wider image. The advantage of this is a longer running time per roll of film.

16mm

First manufactured by Kodak in 1923 as a home movie format to make use of the newly developed alternative to nitrate film, known as "safety film," 16mm was eventually adopted for instructional and educational films, television use, independent films, documentary, and experimental films. The width was a consequence preventing home movie film being made by splitting down 35mm stock: "Since this was not a convenient subdivision of 35mm film, it greatly reduced the risk that others might supply dangerous nitrate-based films, instead of what Eastman saw as the obligatory safety film."[13]

It is the most widely used format for film schools (at least in the US) and experimental cinema. It is the primary format of the films cited in this book.

The aspect ratio of 16mm is 1.33, but in 16mm this is more commonly referred to as 4x3. When digitizing 16mm to HD, with its widescreen format of 16:9, it is common to have black on either side of the 16mm image, known as applying a "pillarbox" to reconcile the different aspect ratios.

There are 40 frames per foot of 16mm film. At 24fps, there are 36 feet of film per minute. A "100ft" roll is actually spooled with 108 feet of film: exactly three minutes long. The extra film on the 100ft roll is included so as to compensate for the loss of unexposed film on either end of the daylight spool. A 400ft roll of 16mm film provides eleven minutes of running time.

When first introduced, 16mm ran at 16fps (although, in keeping with the practices of the time,[14] projection could be at an indeterminate speed. Most home movie projectors were equipped with a rheostat governing the motor). This was subsequently changed to the standard of 24fps, with the introduction of sound and 18fps referred to as "silent speed" primarily for home movie usage.

There are numerous types of 16mm cameras to choose from. In broad categories, there are 100ft-loading spring-driven, non-reflex cameras (with a separate viewfinder) such as the Bell and Howell Filmo, and early models of the Bolex camera; 100ft reflex cameras (viewing through the lens) with either spring drive or an electric motor, such as the reflex Bolex, Krasnogorsk K3, Arriflex S, Canon Scoopic, and Beaulieu; and cameras for sync sound shooting, with a 400ft magazine, including the CP-16, Éclair NPR and ACL, Arriflex SR, and Aaton XTR.

Super 16

Super 16 is an adaptation of 16mm film, wherein single perforated 16mm film is used in a modified camera with an extended gate to expose the image into the area where the soundtrack would be printed. As a consequence, Super 16 cannot be printed as a composite answer print with a soundtrack in the same manner as standard 16mm. The modified camera gate gives Super 16 an aspect ratio of 1.66 (1.66:1) rather than the ratio of 1.33 of standard 16mm. The lens of a camera modified for Super 16 is remounted to the center of the wider Super 16 frame. Some lenses designed originally for use with standard 16mm will accommodate the larger image area, but others may vignette around the edges.

Super 16 was developed to allow shooting in 16mm (for budgetary reasons, or to work with lighter-weight equipment) and completion in 35mm via an optical blow-up. The advantage of Super 16 is an aspect ratio closer to the widescreen format of 35mm (1.85). Added definition in the final print is due both to the additional size of the frame and the need to crop away less of the image during the blow-up, as would be the case with standard 16mm. It could sometimes prove a complicated format for completing work, since it could not be directly printed in 16mm.[15]

Interestingly enough, Super 16 has gained new viability due to its wide aspect ratio of 1.66:1 fitting nicely within the 16:9 aspect ratio of High Definition digital video. The issue of the 16mm soundtrack area being used for additional space for the image is a moot point when finishing in a digital format.

There are a few cameras that can be switched between standard 16mm and Super 16, such as the Arriflex SR3 and the Aaton XTR. Other cameras require a permanent conversion to the format.

8mm (Regular 8)

8mm film, sometimes referred to as Regular 8 to distinguish it from super-8, was a home movie format dating back to the 1920s. It has long been discontinued but is worthy of discussion here due to its use by experimental filmmakers. Occasionally, it makes a reappearance when some resourceful person re-perforates 16mm filmstock for use with an 8mm camera. The frame rate for 8mm is 16fps, and most simple 8mm home movie cameras will only run at this speed, although a few more sophisticated 8mm cameras will be able to run at a variety of speeds.

The curious aspect of the 8mm format is that it arrives on a small spool holding about 25–33ft of what appears to be 16mm film, but the critical difference is that it is manufactured with twice as many perforations as 16mm. In the camera, one side of the film is exposed and the film is reloaded into the camera to expose the other side, much like

flipping a cassette tape from side A to side B. After development, the 16mm film is split in half, and the resulting two 8mm-wide rolls are joined with a splice. At a request to the lab, the film can be returned unsplit and subsequently projected as 16mm, with a grid of four images appearing in the 16mm frame (more on this in Chapter 7).

A variety of 8mm cameras turn up at the flea market. A box-like camera should realistically be priced no more than $10, although some, like the 8mm Bolex Paillard cameras, have a somewhat greater collectability and a higher price. One important word of caution regarding these cameras: They will sometimes fool the impulsive purchaser into thinking that what is on offer is a 16mm camera because 8mm uses its own form of 16mm film for shooting. A careful look at the camera gate will show that the frame is a quarter of the size of a 16mm gate, or the fact that the spools themselves are smaller and of a different design than 16mm daylight spools. The 100ft-loading Bolex 8mm camera looks very much like the 16mm variety.

A few examples of the use of 8mm include the early films of George and Mike Kuchar; the early films of Takahiko Iimura; and the *Songs* of Stan Brakhage.

Super-8

In the late 1960s, super-8 was introduced by Kodak as an improved 8mm home movie format. The film is supplied on a pre-loaded cartridge. The cartridge contains supply, take-up, loops, and pressure plate, with the film pre-threaded inside. The cartridge is snapped into place to load the camera. Super-8 has a larger image and a smaller sprocket hole than Regular 8mm.

The frame rate of 18fps was chosen as the standard speed for super-8. Some cameras will only shoot at 18fps, and others are capable of also shooting at 24fps. There are 72 frames in one foot of super-8 film. A 50ft cartridge of super-8 film has 3,600 frames. The running time of a cartridge is two minutes and thirty seconds at 24fps or three minutes and twenty seconds at 18fps.

In Japan, the same format of filmstock was introduced by Fujifilm in a differently designed cartridge (capable of being fully rewound), called single-8, using a thinner, polyester-based stock rather than the standard acetate base used in most camera films. The format is now discontinued.

Commonly encountered super-8 cameras include those made by Canon, Bauer, Nizo, Bolex, Nikon, and Yashica, and with numerous other manufactures and models.

Filmmakers who are known for their work with super-8 film include Storm De Hirsch, Bill Creston, Joe Gibbons, Saul Levine, Anne Charlotte Robertson, Luther Price, Vivienne Dick, and John Porter, among many others.

Ultra 16mm and ultra super-8

Not dissimilar to Super 16, the ultra formats use a widened camera gate in comparison to their standard counterparts (The super-8 camera recently introduced by Kodak, for instance, has a 1:1.5 ratio image, rather than 1:1.33). These adaptations use a small part of the space between the sprocket holes and soundtrack area and crop out the top and bottom of the frame. The principle advantage is a less costly modification of the camera to shoot in a widescreen format in comparison to Super 16, owing to the lens not needing to be re-centered.

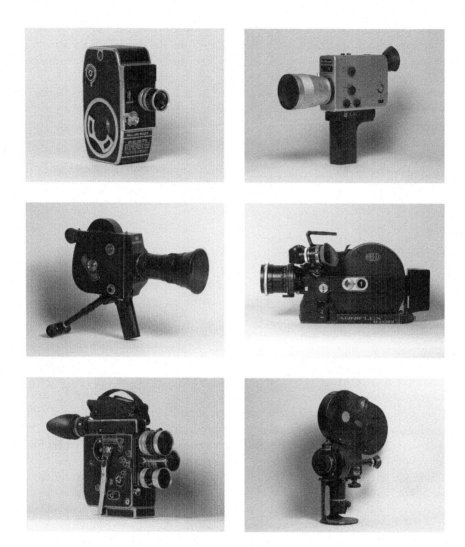

Figure 1.11 **Top row left:** Bolex L8 8mm. Camera courtesy of Michael Stewart. **Top row right:** Nizo super-8. Camera courtesy of the Cooper Union Film Department. **Middle row left:** 16mm Krasnogorsk K3. **Middle row right:** 16mm Arriflex SR crystal sync camera with 400ft coaxial magazine. Camera courtesy of The New School Film Office. **Bottom row left:** Bolex H16 Rex5. Note the magazine door on top. This feature makes it easy to tell the difference between the Rex5 and earlier models of reflex H16 Bolex cameras, such as the Rex4. Camera courtesy of The New School Film Office. **Bottom row right:** 35mm Arriflex IIA modified to replace 3-lens turret with single lens Nikon mount.

The illusion of motion and the motion picture camera

The phenomenon of persistence of vision has long been credited as the means by which the illusion of movement transforms a series of still images into a moving picture on the screen. While the concept goes back to ancient times, it was the polymathic Dr. Peter Mark Roget (of *Roget's Thesaurus* fame) who observed:

> A curious optical deception takes place when a carriage wheel, rolling along the ground, is viewed through the intervals of a series of vertical bars, such as a palisade or Venetian window-blind. Under these circumstances the spokes of the wheel, instead of appearing straight, as they would naturally do if no bars intervened, seem to have a considerable degree of curvature.[16]

Expounding upon what was occurring to produce this trick of the eye, he concluded that what was perceived was the small portion of the turning spoke visible through the slot of the blind producing an after image created by the combination of two movements: the revolving of the wheel and the carriage's lateral movement. When a wheel was turned in place, even viewed through such a slotted blind, the curvature of the spokes did not occur. This illusion was, Roget explained, caused by the phenomenon, wherein ". . . an impression made by a pencil of rays on the retina, if sufficiently vivid, will remain for a certain time after the cause has ceased."[17]

This would nicely explain the appearance of continuous motion out of a series of still images. As Susan J. Lederman and Bill Nichols explain:

> Common sense would suggest that the positive afterimage is a plausible explanation for motion perception in film since it allows one image-frame to "bleed" into another, despite the fact that the beam of light projecting the film-frame is itself intermittent . . . the intermittent mechanism of the projector that blocks the projection of light during the interval when one frame replaces another in the projector gate.[18]

However, as Lederman and Nichols point out to the contrary: "The impression of movement is not due to the persistence of vision."[19] As Terry Ramsaye wrote in his history of the development of the motion picture, this initial explanation of still pictures being perceived as moving images is really " . . . too simple to be true."[20] Much more occurs to construct the semblance of moving images in the brain's codification of the visual information it ingests. As Ramsaye states:

> Following the researches of the experimental psychologists, we must admit the eye can only see what it there to be seen, namely a series of still pictures. The mind does the rest. By simile, we may say that the screen shows the eye a row of dots and the visual imagination makes a continuous line of it.[21]

Gestalt psychologists have identified "many kinds of apparent motion" (in contrast to the perception of actual motion), collectively referred to as "phi phenomenon."[22] The nature of this transformation of a series of still images and the mind's ability to "connect the dots" has been a subject of experimentation by more than a few filmmakers.

Marie Menken's rapid camera movement, panning across close-ups of repeating patterns in *Arabesque for Kenneth Anger* (1958–61) and *Mood Mondrian* (1961), as noted previously, create overtone-like pulsations. These occur through phasing of the moving pattern before

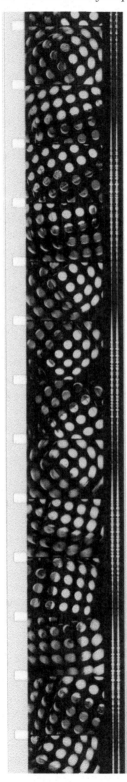

the lens and rotating shutter as the camera rapidly pans. A similar effect is present when filming a slotted fence along a roadside, viewed from the window of a moving car. In Menken's *Moonplay* (1962), she shoots a frame at a time, repositioning the camera between images: The bright disc of the moon becomes several moons in the sky at once, as if in superimposition.

Interference patterns include the flicker of fluorescent lighting unseen by the eye but revealing itself on film as a strobing or throbbing of the light. This is due to the difference in cycles between the 60Hz flicker of the light and the motion picture camera shutter running at 24fps. Likewise, film footage taken of cathode-ray television sets will reveal the roll bar produced by the difference in cycles between the 30fps television and the 24fps film camera.[23]

Experimental musician and filmmaker Tony Conrad produced *The Flicker* (1966) using rapidly alternating patterns of white and black frames. The screen is an empty field, imageless, and yet motion and color are produced from this pulsating light. The main subject of *The Flicker*, as Conrad puts it, is ". . . the ambiguous outer limits of human sensation . . .,"[24] the alternating clear and dark frames starting at 24 alternations per second, progressing downwards to 4 per second, and gradually ramping back upwards again. The film's phantom color effect is produced through a phenomenon known as Fechner color, for the nineteenth century philosopher and psychologist Gustav Fechner, who discovered this with a rapidly rotating disc painted with black and white geometric patterns. When viewing *The Flicker*, the mind tries to piece together the eye's experience of the rapidly pulsating blank screen, attempting to understand it through the visual syntax of depth, movement, and space. The result is an impression of the flickering screen expanding ever forward without ever arriving: a seemingly paradoxical form of moving stasis.

For the filmmaker Nathaniel Dorsky, there is little disconnect between our senses of perception and the cinematic apparatus carving up time into brief fragments:

> On a visceral level, the intermittent quality of film is close to the way we experience the world. We don't experience a solid continuum of existence. Sometimes we are here and sometimes are not, suspended in some kind of rapid-fire illusion.[25]

(In light of this, it is not insignificant that Dorsky commonly shoots and projects his films at 18fps, rather than 24fps.)

Figure 1.12 Frames from Mike Stoltz's *With Pluses and Minuses* (2013). Courtesy of the filmmaker.

The filmmaker Rose Lowder has worked extensively with single-frame shooting. Her series of thirty one-minute films known under the collective title of *Bouquets*[26] are short pastoral works, filmed in the French countryside (what Lowder refers to in her program notes for the work as "ecological sites"). The films, made up of different short sequences, show a field of flowers shot in single frame intervals; the gentle breeze transforms the movement into an agitated trembling. Often there are two shots, such as flowers of contrasting color, alternating a frame at a time, merging in a seeming superimposition. The use of two alternating images – rather than a complete superimposition – withholds the impression of the two images fusing together, as a superimposition would otherwise appear to the viewer.

The filmmaker Tomonari Nishikawa has used the perceptual merging of consecutive still frames in *Market Street* (2005). The film, black and white and silent, is shot in single frame increments of the urban environs of San Francisco. The shots are framed tightly enough to never show the totality of a street scene: the gray curb of the sidewalk set against the dark asphalt street composed as a diagonal across the frame, the outline of a rooftop against the sky, the edge of a doorway set against the texture of building exterior. Through careful alignment of the composition in the film's single-frame progression from image to image, these unrelated images merge as geometric forms: a triangle on the screen, each side produced from the framing of contrasting surface textures before Nishikawa's lens. If one were to look at the strip of film itself, this geometric shape would be absent. It operates in a manner similar to the image-merging thaumatrope (a simple two-sided disc rapidly spun to merge its two images into one). To watch the film and see a triangle on the screen is to perceive something that is not actually there in any given frame of the film.

A short film by Mike Stoltz, *With Pluses and Minuses* (2013), uses a grid of circular holes as a matte in front of the lens, the landscape on the other side appearing like small floating globes, which, like the moon in Menken's *Moonplay*, seem multiplied and superimposed through the extremely rapid shifting of the camera.

Even the slight difference in registration from one frame to the next gives the film its distinctive visual feel. Even if nothing is moving in the frame, footage from the camera will feel quite different than the all too immobile stasis of a freeze-frame. A sense of unfurling time is inferred by the viewer, from the subtle motion of the ribbon through the projector: The lens senses life, whereas the freeze-frame sits there; impassive, stone-like.

The next chapter will examine further this unfurling of time in the motion picture: factors of time for exposure of the film; fast and slow movement created through the speed of the camera; experiments with duration; camera movement; and protracted stillness.

Notes

1 While the comparison of the sewing machine and the motion picture camera comes by way of Louis Lumière: "The solution consisted of adapting for the camera the mechanism known by the name of 'presser foot' in the drive device of the sewing machine" (Toulet, Emmanuelle, *Birth of the Motion Picture*. New York: Harry N. Abrams, Inc., 1995, p. 40), the addition of the machine gun arrives here by way of a passing remark made by Gustav "Skip" Landon, the Chair of the Department of Cinema and Photography at Ithaca College. The correlation of firearm and camera also exists in the motion-study camera of E. J. Marey, fashioned in the form of a gun, with images photographed on a photosensitive disc rotating much like the cylinder of a revolver.

2 Toulet, Emmanuelle, *Birth of the Motion Picture*. New York: Harry N. Abrams, Inc., 1995, p. 40. At the commemoration of the 40th anniversary of the *cinématographe*, one of the speakers, Charles Fabry, quotes from Auguste Lumière: "In the brief intervals afforded us by the management of our industrial concern, we considered this problem [cinema] and I had conceived of a theory, the basic elements of

which I no longer remember, when one morning towards the end of 1894, I entered my brother's room. He had been unwell and had taken to his bed. He then told me that, having been unable to sleep, he had enumerated the conditions required to attain our goal and thought up a mechanism capable of fulfilling those conditions ...This was a revelation and I realized that I must abandon the precarious solution which I had been thinking of. In one night, my brother had invented the Cinematograph!" (*Lumirère Letters*, Jacques Rittaud-Hutinet with Yvelise Dentzer. Pierre Hodgson, trans. Faber and Faber, 1995, 238n). C. W. Ceram, in *Archeology of Cinema*, makes reference to a conversation he had with Auguste Lumière wherein it was during a sleep of troubled dreams – rather than a wakeful insomnia – that the *cinématographe*'s pulldown claw was initially visualized (Ceram, C. W., *Archeology of the Cinema*. New York: Harcourt, Brace & World, Inc., 1965, p. 149).

3 "There is only one best way to hold the average home movie camera, and that is to hold it somewhat as you would a gun" (*How To Make Good Movies*. Rochester, NY: Eastman Kodak Company, 1953. p. 25).

4 Ceram, *Archeology of the Cinema*, pp. 146–148.

5 Frazer, John, *Artificially Arranged Scenes: The Films of Georges Méliès*. Boston: G.K. Hall & Co., 1979, p. 33.

6 Barnouw, Erik, *Documentary, A History of Non-Fiction Film*. Oxford: Oxford University Press, 1974, p. 6.

7 The use of these loops in camera and projector go back to the early innovators of the motion picture, referred to as the "Latham loop," named for Woodville Latham, who, together with his two sons, exhibited movies contemporaneously with Edison's Kinetoscope.

8 The movement of the film during the exposure means that rapid pans left and right will turn the vertical streak of light into a diagonal. From here, it's not hard to imagine filming multiple exposures of something like lights at night to create intersecting, darting diagonal lines from the rapid panning movement combined with the movement of the film during exposure called by ill-sized loops.

9 It's even possible to infer in a film like *The Climate of New York* (1948), where sequences were shot as with a series of in-camera edits and where there was a splice made or a shot was trimmed down by the presence or absence of this consistent registration issue whenever the camera began rolling.

10 At a guest artist talk at The New School.

11 Too much registration correction in digital post-production can make film footage look fake; as if it has been shot with a digital camera and then doctored up a bit to attempt to make it look like film.

12 Other formats, such as 9.5mm, have existed but are no longer manufactured, or still do exist but are not so commonly used as others, such as 70mm. The formats described here are the formats most germane to experimental filmmaking.

13 Coe, Brian, *The History of Movie Photography*. Westfield, NJ: Eastview Editions, 1981, p. 166.

14 see Amid, John, *With the Movie Makers*. Boston: Lothrop, Lee & Shepard, 1923, pp. 24–25.

15 Back in the 1990s, the Maryland-based motion picture lab Colorlab offered an option to optically "blow down" a Super 16 negative to standard 16mm as a form of stopgap solution to this filmmaker's dilemma.

16 Roget, P. M., "Explanation of an Optical Deception in the Appearance of the Spokes of a Wheel Seen through Vertical Apertures," *Philosophical Transactions of the Royal Society of London* vol. 115, 1825, p. 131.

17 Ibid. p. 135.

18 Lederman, Susan J. and Bill Nichols, "Flicker and Motion in Film" (Appendix A), in Bill Nichols, *Ideology and the Image: Social Representation in the Cinema and Other Media*. Bloomington: Indiana University Press, 1981, pp. 294–296.

19 Ibid., p. 294.

20 Ramsaye, Terry, *A Million and One Nights*. New York: Simon and Schuster, Inc., 1926, p. 168.

21 Ibid., p. 169.

22 Lederman and Nichols, "Flicker and Motion in Film", p. 297.

23 Special film cameras were produced for filming televisions without a flicker by altering the shutter angle to bring it in sync with the cathode-ray television's scan lines (see Samuelson, David W., *Motion Picture Camera & Lighting Equipment: Choice and Technique*. Boston: Focal Press Ltd., 1977, p. 22). But present-day flatscreen televisions do not produce a flicker when shot on film.

24 Conrad, Tony, "On 'the Flicker,'" in Robert Russett and Cecile Starr, *Experimental Animation*. New York, Cincinnati, Toronto, London, Melbourne: Van Nostrand Reinhold Company, 1976, p. 151.

25 Dorsky, Nathaniel, *Devotional Cinema*. San Francisco: Tuumba Press, 2003, p. 30.

26 *Bouquets 1–10* (1994–1995), *Bouquets 11–20* (2005–2009), *Bouquets 21–30* (2001–2005).

2 The machine of light and time

This chapter looks at how the speed of the film moving through the camera effects exposure; how the camera can be used for slow motion and fast motion filming; experiments in duration from short shots to long takes; and the use of camera movement.

Looking at a strip of developed film, and observing the displacement of images from frame to frame, there is an intriguing relationship between spatial movement and span of time. From one frame to the next, time itself can be measured in displacement of objects in space: protracted stillness from the lack of change in the image from frame to frame; slowness in the slightest displacement; or rapidity in a greater displacement of an object from one frame to the next. Brightness and darkness are also a measure of time: A bright flash frame, for instance, represents a longer amount of time the photosensitive film was struck by light from the world beyond the lens. Time, light, and motion, in this flat strip of pictures, pressed like a flower.[1]

Film speed, shutter speed, aperture

Photographic exposure is described with a number of durational-sounding filmmaking terms: "speed," "slow," "fast." These may refer to:

- The light sensitivity of the film (a "slow" film needs more light for exposure).
- The duration of time the shutter is open (usually a consequence of the frame rate of the camera and different than normal when shooting slow or fast motion).
- The setting of the aperture of the lens (a "fast" lens, capable of shooting in low light, is one with a wide aperture when opened up).

These are the three basic elements of exposure: film speed, exposure time, and aperture setting.

Film speed

Only a small part of the film is light sensitive. The elements that compose the film are the clear perforated strip of material known as the base, which is the film's underlying structure, much like canvas and stretcher. And then, in darkness, a thin layer is applied: the film's emulsion. Within the emulsion are the minute grains of photosensitive silver crystals. These flecks of silver are the light sensitive part, the silver halides. It's usually not hard to

tell which side of the film has the coating of emulsion; the emulsion is dull and the base is shiny.

Different filmstocks are designed for use in bright daylight, indoor light, or shooting in low light. The size of the grains of silver determines the light sensitivity. This aspect is referred to as film speed. Fast films, designed for shooting in low light, are grainier in appearance, and slow filmstocks for shooting in bright conditions are fine-grained.

ASA, ISO, EI

The measurement of film speed is a set of numbers known as ASA (for the American Standards Association). On a light meter, this same set of numbers could be called ISO (for the International Standards Organization). On the box of film, the film speed may be called EI (for Exposure Index). The three scales are really one and the same: ASA = ISO = EI.

The range of speeds is anywhere from 50 to 500 for motion picture films. On the one end of the scale, 50 ASA is a slow stock, very fine-grained and requiring quite a bit of light, therefore suitable for use out of doors during the day. Medium speed stocks will be in the 200 or 250 ASA range, suitable for outdoor shooting or indoors with adequate light. 400 or 500 ASA are fast stocks, good for shooting indoors with available light, or at night outdoors, or other low light situations. Hi-contrast film and other lab stocks may have an ultra-slow ASA around 12 or less.

Filmstock

The choice of filmstock itself – beyond the practical aspect of a slow film for brightly lit environments or a fast film to best cope with low lighting – has a significant effect on the resultant image. The age of the stock past its date of manufacture may also affect the look of the image.

Reversal and negative film

The use of reversal or negative film can be an expedient of affordably or preferred production method, or a matter of what stocks are currently being manufactured in a given format: Reversal film produces a positive image directly from the camera original, and negative entails the additional step of a film print or digital transfer to view the footage (unless, of course, the images are intended to be seen in negative). But there is a difference in look to consider: Black and white reversal film is crisper, with richer blacks than black and white negative. Color reversal and color negative result in differences of tonality and visual character as well.

Color temperature of filmstock

Color filmstock is manufactured in two varieties: one for use with daylight, the other for shooting with artificial light. Light has warm or cold hues produced by different sources. We don't perceive this most of the time, although the yellow-orange light of a campfire gives a sense of these distinctions. Film is more sensitive to this quality of light, known as color temperature, measured in the Kelvin scale.[2]

Daylight is on the blue end of the scale, and incandescent light is more orange in hue. Daylight-balanced film registers naturalistic color from 5400° Kelvin light (although

daylight does vary in color temperature depending on the time of day). Indoor film is designed for the use of movie lights with a tungsten filament. These lights provide a fairly consistent color temperature of 3200° Kelvin. Other types of bulbs vary in color temperature (LEDs may be daylight balanced, while fluorescent lights tend to be a bit green).

Shooting in daylight with daylight-balanced film or with incandescent light with tungsten-balanced film is the usual practice. Shooting with daylight stock under tungsten-balanced light will result in an overall orange cast to the image, while shooting in daylight with tungsten film will give a washed-out blue appearance to the film image.

Color filters

Filters may be used to correct for a difference in color temperature between the light and the film stock. A typical example is using tungsten film outdoors with the addition of an orange-hued number 85 filter, designed for the purpose of converting daylight to the color balance of tungsten light. A blue 80A filter will do the opposite. However, this dark blue filter will block a great deal of light, necessitating a significant increase of light to compensate for this. Consequently, if shooting a mix of outdoors and indoors on the same roll, tungsten film and an 85 filter may be preferable.

Color filters may also be considered for their own sake, as seen in *Bridges-Go-Round* (1958) by Shirley Clarke. Here, scenes of steel bridges are suffused in red or green or yellow. While the tints in this film are a result of Clarke's reprinting the footage with colored filters rather than using color filters on the camera, the same effect can be achieved while shooting. Stom Sogo's "Three Moods in a View" from *3 Films for Untitled* (1995) also makes use of color filters, in combination with a multiple-exposed matte shot, dividing the frame into thirds. Color filters will reduce the exposure by subtracting some portion of the light, so exposure compensation by opening up the f-stop is usually done when a filter is used.

Expired film

Film has a shelf life; unexposed film will go stale, eventually. It can be difficult, sometimes, to pinpoint the exact moment when it becomes too stale to use; refrigerating (or freezing) the film will keep it fresh longer. Slower stocks tend to hold up better over time compared to faster stock, and color film will shift in its tonalities after years of sitting around unused. To work with expired film, it may be prudent to overexpose and pull-process: The goal here is less development of the latent fog without under-processing the photographed images.

High-contrast film and other lab stocks

Beyond the stocks manufactured for use in the camera, there are other types of film for laboratory use for printing or producing optical soundtracks that may be spooled down and used in the camera. Lab stocks tend to be incredibly slow in comparison to camera stocks, with an ASA in the range of 6 or 9 or 12.

Hi-con film, such as 7363, is a black and white stock designed to be processed as either negative or reversal. Because it's intended for creating images with little or no gray tones, it can be a difficult stock to expose without risk of severe under- or overexposure. But when

it is correctly exposed, the results can have considerable intensity. Dominic Angerame's use of hi-contrast film in *Continuum* (1987) is such an example. Here, workers on a sunlit rooftop apply hot tar with mops, the slick tar rendered like Junichiro Tanizaki's description of Japanese lacquerware seen by candlelight in *In Praise of Shadows*:[3] gleaming flecks of gold set against a pitch black void like a still, dark pond.

Many of these lab stocks are printing stocks, manufactured with a longer pitch – the distance between sprocket holes – than camera stocks (this is so that the film can snugly wrap around the outside of the round, sprocketed hub on the motion picture laboratory contact printer). With most cameras, the difference in pitch is not an issue, although some cameras with registration pins, like the Arriflex SR, have a pitch adjustment screw to reduce camera noise.

Shutter speed

The amount of time the shutter is open is also a factor in the amount of exposure of the silver halides. The shutter speed of a movie camera is a combination of the shutter angle and the frames-per-second of shooting speed.

If the shutter is open half the time and closed half the time (50%–50%) and the camera is running at 24fps, the exposure time will be half of 1/24th of one second: 1/48th of a second. The shutter angle, in this case, is 180° (50% of 360°). This 1/48 of a second is commonly rounded off to 1/50th of a second and referred to as "cine speed" – the exposure time of a motion picture camera shooting at 24fps.

Not all cameras have a 180° shutter, and this should be taken into account when determining the shutter speed. Additionally, on the Bolex camera, some of the light is channeled away to the viewfinder. If this were not addressed in some way, the footage would be underexposed. It is common practice to make up for the light loss due to the viewfinder by considering the Bolex to have a shutter speed of 1/80th of a second (what is sometimes called the "adapted shutter speed"). The actual amount of time of exposure on the Bolex, without the compensation, is 1/65th of a second.[4]

For those who have a working knowledge of still photography, the inability to adjust the shutter speed to one's liking might seem like an impairment: Photographers will work with the selection of either aperture or shutter speed to favor one or the other. In cinematography, the frame rate (24fps or otherwise) dictates the shutter speed of the camera. Setting the aperture becomes the means of compensation, when needed, rather than shutter speed.

There are some cameras where the shutter angle can be adjusted, as is also the case with the Bolex, producing a smaller angle. This will affect not only the exposure but also the appearance of motion, due to the decrease in motion blur.

Shutter speed and the film look: motion blur

Looking at a freeze-frame where there is movement, it becomes evident that 1/50th of a second is a fairly long exposure time: Moving objects will be blurry rather than crisp. This blurring is distinctive from softness of out of focus optics, where the light scatters in all directions. Motion blur occurs as an elongated, directional smearing of the image during the time of exposure. The lack of this motion blur is what gives fast-motion footage the look of odd fakery.

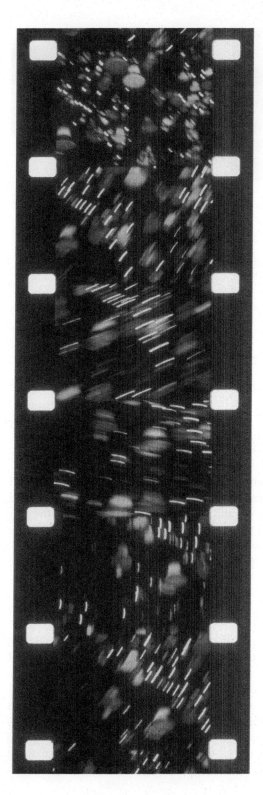

The aperture (iris)

The choice of filmstock is oftentimes the first step in exposure control (i.e., a slow stock for filming outdoors on a sunny day). The aperture, or iris, of the lens is then used to fine-tune the exposure of the film. It is also used to compensate for any changes in exposure due to running the camera for fast or slow motion (which increases or diminishes the time the film is exposed to light) or when exposure is affected by the use of a filter.

In terms of light sensitivity, lenses that open to a very wide aperture are referred to as "fast" lenses, whereas ones that do not (such as long telephoto lenses and some zoom lenses) are "slow."

F-stops

The scale used to measure the size of the aperture is a set of numbers called f-stops. These can seem confusing at first, since the values seem backward: f-22 is a much smaller amount of light than f-4. The f-stop scale is seen in this accompanying chart.

The reason for this seemingly inverted scale, where larger numbers denote smaller aperture settings rather than bigger ones, is due to these numbers actually being denominators of fractions: f-4 representing an iris opening of 1/4th of the focal length of the lens, f-8 as an opening of 1/8th, and f-16 being 1/16th of the length, and so on.

Opening by one f-stop will give you twice as much light, and closing by one

Figure 2.1 Frames from Marie Menken's *Lights* (1966), showing the motion blur produced by the camera moving rapidly while shooting. Courtesy of The Film-Makers' Cooperative.

Figure 2.2 The aperture setting of a lens on a Bell and Howell 70-D. **Left:** f-2.8 **Centre:** f-5.6 **Right:** f-16.

f	1.4	2	2.8	4	5.6	8	11	16	22
←	opening up the aperture				closing down the aperture				→
←	more light hits the film				less light hits the film				→
←	low light shooting conditions★				bright shooting conditions★				→
←	less depth of field				more depth of field				→
	(★Generally speaking.)								

Chart 2.1 F-stops.

f-stop will give you one half as much light. Just looking at the numbers themselves, it might seem as if f-4 would be twice as much as f-8, but going from f-8 to f-4 would actually give you four times as much (twice and then twice again). Opening the lens from f-8 to f-5.6 (for example) will give you twice as much light. Conversely, closing the lens from f-2 to f-2.8 (for example) will give you half as much light. This relationship of f-stops is useful for calculating exposure compensations, such as when filming fast or slow motion.

Overexposure and underexposure

While the general goal is a representation of the world with naturalistic values of bright and dark, "correct" exposure is not purely such an objective measure. It is what you want; darkness or blinding brightness: just change the f-stop. There is always a measure of educated guesswork and experience, rather than a complete and unquestioning allegiance to the light meter. Kevin Brownlow's history of silent cinema points out: "...back in the early days at Universal, there was a sign outside the camera department which read:'If in doubt, shoot at 5.6.'"[5]

Of course, the key is what you want, and consequently light readings may be critical. The goal may be as straightforward as not to end up with a piece of blank

F-stops and t-stops

Some lenses, particularly zoom lenses, will have two sets of numbers on the aperture ring, with f-stops typically in white and t-stops in red. The t-stops (transmission stops) are a form of pre-determined exposure compensation to make up for the loss of light from the optical elements in the lens itself, which explains why t-stops are often found on zoom lenses with their multiple glass elements.

T-stops should be used for setting exposure, so as not to underexpose the image. However, the t-stop is not a real aperture setting. Once the t-stop is set, the corresponding f-stop will indicate the actual setting for purposes of determining depth of field. (More on the subject of depth of field will be covered in Chapter 3).

film. When shooting outdoors at night, it's not uncommon to not even bother with a light meter reading but completely open the lens so as to get as much of the dim light as possible.

"Overexposure" and "underexposure" exist more as concepts than as measurements in relation to the desired look of the footage; for instance, if wanting to film a statue in a cemetery as a silhouette against the azure autumn sky, as in Joseph Cornell and Rudy Burckhardt's *Angel* (1953), the exposure is set to favor the bright sky, letting the subject of the shot, the statue (backlit against the sun), fall into complete darkness. This subjective choice in how to expose the contrasting elements of the image (favoring silhouettes of people and buildings) also forms the recurring motif of Kenji Onishi's super-8 feature-length film *A Burning Star* (*Shosei*) (1995).

The film *Glass Shadows* (1976), by Holly Fisher, is set in loft space, filmed during the hours of the early morning's amber-colored light. The interior space is left dark while the perfectly exposed windows show the outside world floating as rectangles in the featureless black void that fills the screen.

Changing the aperture setting while shooting

The Labyrinth Tale (*Meikyu-tan*) (1975) and *The Reading Machine* (*Shokenki*) (1977), short films by the provocative multi-disciplinary filmmaker, poet, and playwright Shuji Terayama include iris changes while filming, with the use of black and white high-contrast film further amplifying the brightening and darkening of the image. In these two films, the lighter elements of the shots become obliterated in sheer white as the iris opens while filming.

Stan Brakhage's short film *The Wold Shadow* (1972) makes use of iris changes while brightening and darkening the image of a woodland view of a grove of birch trees, bark peeling from their trunks. Guy Sherwin's *Eye* (1978) uses a light with a dimmer to effect the widening and shrinking of the iris of an eye in close-up, the image becoming bright as the eye's iris closes and getting darker as it opens. The camera's iris is also opened and closed during the filming.

A series of films by Nathaniel Dorsky – *Elohim* (2017), *Abaton* (2017), *Coda* (2017), *Ode* (2017) – also make use of racking the iris while shooting. All are filmed in a

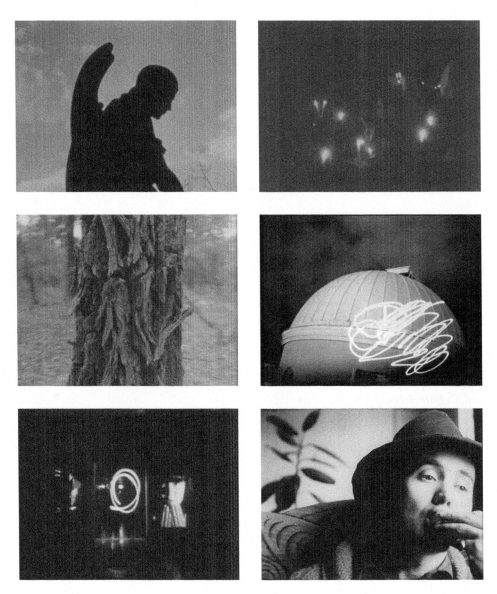

Figure 2.3 **Top row left:** Joseph Cornell and Rudy Burckhardt's *Angel* (1953). © 2019 Estate of Rudy Burckhardt/Artists Rights Society (ARS), New York. **Top row right:** The "Greek Epiphany" sequence from Marie Menken's *Notebook* (1962), filmed at night by candlelight. Courtesy of The Film-Makers' Cooperative. **Middle row left:** Richard Tuohy's *Iron Wood* (2009). Courtesy of The Film-Makers' Cooperative. **Middle row right:** Jeanne Liotta's *Observando El Cielo* (2007) uses long time exposures throughout. In this image the squiggle of light on the observatory has been produced by the light of a moving flashlight during the long exposure. Courtesy of the filmmaker. **Bottom row left:** Long exposures, shot a frame at a time, were used to create the trailing light in Takashi Ito's *Thunder* (1982). **Bottom row right:** Andy Warhol's *Eat* (1963). © 2018 The Andy Warhol Museum, Pittsburgh, PA, a museum of Carnegie Institute. All rights reserved.

bucolic setting (albeit one hidden within the city rather than away from it; the films were photographed in the Arboretum in San Francisco's Golden Gate Park). A profusion of the green leaves, twisting branches, and dainty, clustering flowers change from dark to light and back again with discrete changes of the aperture. Some shots begin in near darkness, brightening to reveal the scene of foliage and flower. The mostly static shots avoid a singular compositional subject, letting the eye wander around the greenery on screen. The changes in exposure accentuate this; subjects in the shadow are

revealed, and brighter areas lose definition and detail as the iris is opened. The focus of the shots modulates from hard to soft as well, due to the changes in depth of field as the aperture is changed.

Curt Heiner's short film *Limited Sight Distance* (2017) is mostly set in residential neighborhoods in Boulder, Colorado. It is a cascade of brief shots of matching duration on high-contrast black and white film, the aperture of the lens racking from fully closed down to completely opened up. The rapid sweep through the entire range of tones is reminiscent of the story of how Beethoven was inspired to compose the second movement of his ninth symphony with its strident octave-tuned timpani. The entire movement ". . . is not only founded upon – it may also be said to consist of – one single phrase of three notes, which is said to have come suddenly into Beethoven's mind as he stepped from darkness into brilliant light."[6] While each shot is ostensibly still and static, there is the impression of movement from the change of exposure itself; the light spreading itself from the sky to the walls of white wood-shingled houses, moving outward from these bright elements as the exposure increases, in a sweeping rack of the iris, changing the scenes from black to gray to white. In compositions framed within the canopy of trees, this takes the form of the light enveloping the outer periphery of the thinnest branchlets, moving as the exposure brightens, down along the branches and thicker limbs, erasing all but the main branches and trunk in the white light of overexposure.

Some situations call for working with the film at the very periphery of its exposure range. An example of this can be seen in Marie Menken's *Notebook* (1962), during the Greek Epiphany sequence, with a procession in front of a church, lit by just the candles the participants hold. The faces of the congregants are illuminated and glimmers of light are reflected from the burnished metal of the ecclesiastic implements, but the rest of the image remains obscure, consumed in a grainy, gray darkness.

Figure 2.4 Frames from Curt Heiner's *Limited Sight Distance* (2017), showing the change in exposure resultant in opening the aperture while shooting. Courtesy of the filmmaker.

Filming in such extreme lighting conditions can make for interesting images on the screen, in contrast with the jejune qualities of bland (yet perfectly exposed) sights of mid-day. The painter James McNeill Whistler expressed something of this when describing the London waterfront of his painted Nocturnes. This was a time of the day

> when the evening mist clothes the riverside with poetry, as with a veil, and the poor buildings lose themselves in the dim sky, and the tall chimneys become campanili, and the warehouses are palaces in the night, and the whole city hangs in the heavens, and the fairy-land is before us . . . [7]

Built-in light meter aperture control

Most 16mm cameras have only manual control of the aperture setting (with a few exceptions like the Canon Scoopic). Super-8 cameras frequently have a built-in light meter designed to directly change the f-stop, based on the light a photoelectric cell inside the camera receives through the lens. With such super-8 cameras, the film speed (ASA) is automatically set via notches on the cartridge. Some will allow for the automatic light meter to be switched off and the aperture of the lens to be set manually.

Cameras with automatic light meters are sometimes looked down upon as unprofessional, with even the amateur-praising Stan Brakhage decrying:" . . . please NO 'automatic exposure' photo-machine, either – that 'seeing eye' dog of a camera."[8] But depending on the particulars of the filmmaker's needs, these cameras have both bad points and good points. The usefulness of automatic exposure is the likelihood of reasonably well-exposed footage, especially in situations of "catch-as-catch can" filming. In some cases, there may not be very much of a difference in the result of shooting with manual settings of the iris or use of the automatic meter, such as in the diffuse light of an overcast day.

There may be undesirable results when using an automatic exposure camera. When the subject is backlit, or lit with the hot spots of stage lighting, or the light is not constant during a shot, the automatic exposure meter has a difficult time knowing what to do. The drawbacks of automatic exposure can be seen when simply panning across a room, with a day-lit window entering and exiting the frame during the pan. As the bright light from the outside world is seen by the automatic exposure meter, it will average out the shot by making the whole room go dark, the exposure of the room suddenly brightening again when the window is no longer in the frame as the camera pans. Outside on a sunny day, a car driving by with the sun reflected on the windshield will have a similar effect, causing the shot to dramatically darken and lighten as the bright reflection enters and exits the frame. These fluctuations in exposure are an element of the home movie "look" and may be acceptable if this amateur-associated quality fits with the intended visual aesthetic.

Slow and fast motion

It sounds a little strange at first to say running a camera faster produces slow motion and running a camera slower will result in fast motion. Why shouldn't slow filming produce slow motion?

It is the relationship of relative speeds between the camera and the projector: If the film projector is running slower, then there will be slow motion on the screen. But,

Exposure control: combining all the variables

Control of exposure is usually considered to be a process of setting the f-stop on the camera, but there are several ways to achieve this besides the aperture. For example, a neutral density filter may be used because a particular f-stop is needed for reasons involving depth of field.

ASA/ISO/EI of filmstock – Choosing a fast, medium or slow filmstock is the first step in the variables of exposure control. For instance, a very slow filmstock in a low-light situation may make it very difficult to avoid underexposure.

Lighting – The inherent lighting conditions – shooting outdoors during the day, outdoors at night, indoors with available lighting, indoors with movie lights – are a factor to consider. For instance, if desiring little depth of field (by having the aperture of the lens opened up rather than closed down) while shooting in bright daylight, it may be useful to have neutral density filters at hand.

Push processing/pull processing – Push processing, leaving the film longer in the developer (or heating it up), increases the sensitivity of the film. The film will be more grainy and contrasty as a consequence. Pull processing, with a shorter processing time (or cooler developer), will have the opposite effect. Push/pull processing is useful as a form of exposure control when filming in conditions of extremely low light, or when the wrong filmstock is all that is on hand (such as a slow stock when a fast one is needed).

Shutter angle – On many cameras, the shutter angle is fixed. But some offer the feature of an adjustable shutter. The variable shutter on the Bolex camera has settings to change the angle to subtract light equivalent to 1/2 or one full f-stop. A change in shutter angle will affect the appearance of movement on screen.

Frame rate/shutter speed – Typically, the shutter speed is simply a given due to filming at sound speed, fast motion, or slow motion. But there are instances where the frame rate may be used as a form of exposure control: When filming scenes without any moving subjects in low light, the camera speed may be changed to 12fps to add more light. The lack of moving subjects on screen will not make it apparent that this material was filmed in fast motion.

Neutral density filters – These are gray filters absent of any color (hence "neutral"), designed to subtract light. ND.3 subtracts one f-stop of light, ND.6 subtracts two f-stops, and ND.9 subtracts three f-stops. These filters are particularly useful in situations where it is desirable to decrease depth of field by shooting at a lower f-stop.

Single-frame time exposures – On a camera like the Bolex, shooting single-frame time exposures (with the I/T switch set to T) is a method to shoot in extremely low light conditions, holding the shutter open for a longer time than running the camera continuously, albeit with a very different result than shooting at 24fps.

since projection speed is a constant 24fps, this is not how it's done. Running the camera faster (such as 48fps) will result in a slower projector in comparison to the camera. Shooting fast motion is sometimes referred to as "undercranking," a term that has remained in the technical lexicon of filmmaking from the hand-cranked days of silent movies.

René Clair's jovial avant-garde revisitation of the trick-film *Entr'acte* (1924), produced collaboratively with Francis Picabia and Erik Satie, makes use of both slow and fast motion in the funeral procession, beginning with the mourners taking leaping strides in slow motion and ending with a fast motion chase as the hearse breaks loose and careens ahead down the road.

Some things lend themselves better to slow motion than others. City traffic filmed in slow motion might appear to be just moving slowly, while flowing water, falling objects, the actions of people and animals, for example, tend to read more clearly as slow motion on screen.

24fps projected at 18fps / 18fps projected at 24fps

When 16mm first appeared in 1923, its frame rate was 16fps. 24fps became the standard speed for use with sound at the end of the 1920s. Some 16mm projectors provide the option to switch to 18fps for running at "silent speed." Shooting at 18fps and projecting at 24fps may be done to obtain the manic look of an old-time movie.

Conversely, 24fps footage can be slowed down after the fact when shown on film, as Joseph Cornell notably did with his found footage film *Rose Hobart* (1936) and as did Andy Warhol for many of his early films as well. Not all film projectors provide the option to run at "silent speed" and only run at 24fps. This sometimes results in a search for an 18fps-capable projector when the venue does not have one readily available.

The term "silent speed" should not be a source of confusion. It is an arcane standard often used for shooting in 16mm and super-8 for home movies. It is not necessary to shoot at 18fps when shooting without sound. In many ways, you're better off shooting at 24fps, with or without sound.

Exposure compensation for fast motion and slow motion

Filming fast or slow motion will also result in a change in exposure time (the shutter speed).

In the case of fast motion, if the camera runs at 12fps (half the speed of 24fps), the exposure time will be twice as long as normal. With slow motion, if the camera runs at 48fps (twice as fast as 24fps), the exposure time will be one half. Since each f-stop changes the exposure by the factor of double or half, it's fairly straightforward to compensate for 12fps or 48fps by opening or closing one stop.

If changing the frame rate of the camera while shooting – rather than between shots – the image will lighten or darken on screen in addition to the change to faster or slower motion. Slower motion (the camera running faster) will be darker and faster motion (the camera running slower) will be lighter. It is possible to simultaneously change the f-stop while changing the speed of the camera (with enough free hands to do all this while shooting), although near perfect results will take a great deal of finesse.

	Frame rate	Shutter speed: 180° shutter (cine speed)	Shutter speed: Reflex Bolex*	Exposure compensation**
Fast Motion	12 fps	1/25 sec	1/40 sec	Close 1 stop
↑	18 fps***	1/36 sec	1/60 sec	Close 1/2 stop
"Sound speed"	24 fps	1/50 sec	1/80 sec	No compensation
↓	36 fps	1/72 sec	1/120 sec	Open 1/2 stop
↓	48 fps	1/100 sec	1/160 sec	Open 1 stop
Slow Motion	64 fps	1/128 sec	1/215 sec	Open 1–1/3 stops

* With compensation for the light loss from the viewfinder prism
** Opening by one stop will give you twice as much light and closing by one stop will give you one-half as much light
*** Fast motion, if projecting at 24fps (or simply "silent speed" if projecting at 18fps)
N.B. Some rounding is involved in these calculations (i.e. 1/48 sec cine speed rounded to 1/50)

Chart 2.2 Exposure compensation for fast motion and slow motion.

Time lapse: single-frame shooting

Time lapse can be thought of as a form of fast motion, although the method of shooting is not the continuous process of filming but rather a frame-by-frame method. The effect on screen is that of ultra-fast motion.

A 100ft roll of 16mm film (actually 108ft of film) is three minutes long and comprised of 4,320 frames (sometimes considered as 4,000 frames when counting only the footage between the end-flares). This sizable number gives a greater appreciation to the effort involved in shooting time lapse and other forms of frame-by-frame shooting.

Marie Menken's single-frame New York portrait *Go Go Go* (1964) contains an array of time-lapse techniques: The scrutiny of the patterns of human activity include workmen scurrying on a building site; musclemen striking poses at a competition; a university commencement; office workers appearing to be expelled from a revolving door at the end of the workday; the camera filming from a car roaming along the connective arteries of Manhattan; ferries scurrying across the waters in the confluence of the Hudson and East River filmed from a rooftop.

Cassis (1966), by Jonas Mekas, is described by the filmmaker as: "One day shooting, single frame, from just before the sunrise until just after the sunset."[9] This short film is an extraction from the first reel of the longer work *Diaries, Notes, and Sketches, also known as Walden* (1969), comprised of a hilltop view (with a few occasional pans out to sea) looking down at a harbor with a lighthouse and breakwater. The light changes during the course of the film; from bright yellowish sunlight, with cotton ball clouds, to a somber blue-gray as the day becomes overcast, to pastel shades of late afternoon and dusk. The effect seems reminiscent of the variations in Claude Monet's studies of light in the series of paintings of haystacks in the French countryside. The single-frame shooting itself is not continuous throughout the day; the interval between frames changes as the sailboats glide in and out of the harbor. Their movements are syncopated between slow and fast every second or so of screen time. There is a longer interval between clicks for the fast sequences, and clicking rapidly for the slower movements of the sailboats on screen.

Tomonari Nishikawa's *Market Street* (2005) (as mentioned previously in Chapter 1) uses handheld single-frame shooting along the titular San Francisco thoroughfare, joining together individual frames through their compositional structure: a building outline,

architectural details, the curb of the street. Each seems to conjoin with its disparate visual counterpart, forming patterns through their single-frame combinations.

Richard Tuohy's *Iron Wood* (2009) also uses a handheld camera, shooting a frame at a time and making orbits around the Australian iron wood tree, the camera pointed inward towards the axis of the rotating movement. The roughly grooved bark of the tree trunk seems to be twisting and rotating itself, due to the rapidity of the single-frame circling movements of the camera, the background landscape oftentimes indistinct. Using the structure of a theme and variations, the film begins with orbiting camera and tree trunk, followed by a section of rotations with the camera on its side, the trunk spinning

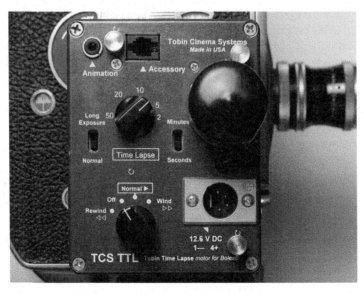

Figure 2.5 **Above:** The Tobin intervalometer attached to a 16mm non-reflex Bolex H16 M. **Below:** Detail of the controls on the Tobin intervalometer.

horizontally in the frame, followed by movements up and down the trunk. The camera then looks upward, and the crown of the tree seems to blithely twirl around in the frame. It finishes with a series of matte shots, the trees now side by side, turning as if the ridges in the bark were like teeth on two cylindrical cogs, the soundtrack of ratcheting metal clanks accentuating the machine-like revolutions of the tree trunks.

The intervalometer

The intervalometer is an accessory motor attached to a camera, allowing for automatic time-lapse shooting. Some super-8 cameras are equipped with a built-in intervalometer, typically controlled by a dial to change the interval between exposures but without precise setting for the number of seconds between frames.

Some rather sophisticated intervalometers exist, such as the ones produced by NCS Products, allowing for programming the interval, shutter time, the total number of frames to shoot, shooting a few frames at a time before pausing (shooting "bursts" of frames), or the option of a time delay before starting. Shooting with an intervalometer provides a welcome relief from the generally tedious process of extended time-lapse shooting, but it doesn't necessarily allow the filmmaker to just turn on the intervalometer and walk away (as when the camera is set up somewhere where it may be stolen, the filmmaker will have to spend time sitting guard over the automatically operated, clicking machine).

Time exposures

The Bolex camera, most notably, will allow the filmmaker to make the exposure time independent of the frame rate when filming a frame at a time, by holding the shutter open manually. (This feature is only applicable to single-frame shooting; the camera's time-exposure setting won't affect the image when shooting constantly at 24fps or some other continuous speed.)

Time exposures will allow for filming in very low light, the shutter speed of the camera no longer being limited to a fraction of a second. The exposure time may be several seconds, or even minutes for each frame (ideally, with the aid of an intervalometer). For those conversant with still photography, this is the equivalent of the "bulb" setting on a still camera, allowing the shutter to be held open manually.

An example of the use of long exposure times is the celestial-centered 16mm film by Jeanne Liotta, *Observando El Cielo* (2007), filmed with the tripod-mounted camera pointed upward at the nighttime sky, the extremely long exposures revealing the faint canopy of constellations. The long exposures and the passage of time from frame to frame reveal not just the dim light of the distant stars but also the imperceptible rotation of the earth: the duration of the night compressed into a transient moment. The sky above seems to steadily move in an arcing pivot, like a sweeping second hand on the face of a clock. The gradualness of the movement of the heavens in Liotta's film is in contrast to the moments when the dome of an astronomical observatory is foregrounded in the frame, turning rapidly and briefly illuminated by flashlight. Very few shots contain a view of sky alone: A New England pitched-roof house appears at the edge of the frame, trees intrude into the margins in many other shots, the round-domed observatory disappears into the darkness, blending in with the night sky behind it but still hiding the stars behind its invisible silhouette. The camera's marginal byproducts – end-roll flares, flash frames, the reframing of the shot – are employed by Liotta to stress the circumstances of the filming

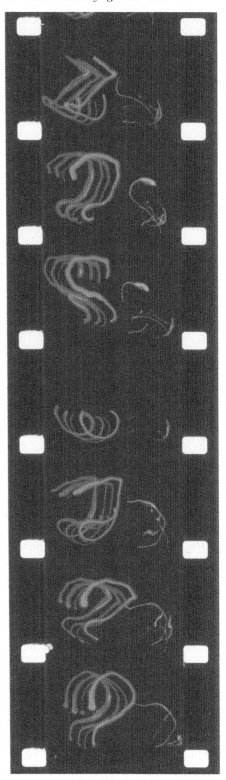

process, of the camera's struggle to contain on a narrow strip of celluloid a view of the immeasurable celestial realm.

Long exposures are used to render a moving point of light from a flashlight as a long, flowing line. In the short film *Thunder* (1982), by the Japanese filmmaker Takashi Ito, a woman covers and uncovers her face with her hands: It is a repeating gesture that is animated as a series of photographic slides projected onto the interior surfaces of an empty office building, the image bending and distorting on the columns and surfaces of the architecture. A long, bright, flowing ribbon of light – sometimes white and sometimes red – rapidly unfurls, moving in waving undulations, curls, and spirals. The ribbon of light is produced a frame at a time by a person wielding a handheld flashlight while moving through the building's hallways and foyers during the long single-frame exposures.

Handheld time exposures: night writing

The use of a handheld camera for time-exposure filming is the basis of a section entitled "Night Writing" within Marie Menken's *Notebook* (1962). Filming lights outdoors at night, the aperture is stopped down just enough to obscure the scene in darkness, except for the lights themselves against the black background. Menken moves the camera itself while manually holding open the shutter of the Bolex camera, with the I/T switch set to "Time Exposure." She moves the camera in patterns: a circle, a round-cornered zigzag, advancing to the next

Figure 2.6 Still frames from the "Night Writing" section from Marie Menken's *Notebook* (1962), created through the use of long exposures with a Bolex camera and handheld camera movement while filming lights at night. Courtesy of The Film-Makers' Cooperative.

frame, doing it again. A similar use of the night writing technique appears in Menken's *Lights* (1966).

The use of handheld time exposures can typically be identified in the resultant footage by multiple points of light creating erratic ribbon-like lines of movement in exact parallel with one another. A blinking light will produce a dotted line from the combination of time exposure and camera movement.

Extreme slow motion with a high-speed camera

16mm cameras capable of shooting fast or slow motion typically will go up to 64fps. There are also specialty cameras, designed for scientific motion study, which can shoot thousands of frames per second. Harold Edgerton at MIT produced some of the earliest examples of high-speed cinematography. The particulars of a high-speed camera are the lack of a pulldown claw and shutter in favor of a rotating prism and the necessity of polyester-based filmstock, rather than the more typical acetate-based camera stock, so as to prevent the film from falling to pieces at its breakneck speed through the camera.

Yoko Ono's *Film No. 5 (Smile)* (1968) is an example of the use of a high-speed camera to considerably extend and amplify a brief moment into a substantial duration: the expression on a face (that of John Lennon) going from a blank look to a smile. The film has a pulsing unsteadiness as a consequence of the roll of film's momentum through the high-speed camera. The action itself is not as linear as the concept suggests: A range of expressions take place from the start to the end, the grin disappearing as it slowly grows and then re-emerging in the progression through the extended act of smiling.

The long take

The Russian filmmaker Andrei Tarkovsky has stated: "One cannot conceive of a cinematic work with no sense of time passing through the shot, but one can easily imagine a film with no actors, music, decor or even editing."[10] Here is the most elemental aspect of cinema: time itself, sometimes, as it unfolds on the screen, as the film's premise. Narrative cinema provides numerous filmmakers working with the long take, including Tarkovsky, Chantal Akerman, and Béla Tarr, to name a few. Additionally, what may be deemed "experiments" in narrative filmmaking are the single-take feature films: Alfred Hitchcock's *Rope* (1948), Robert Frank's *C'est Vrai (One Hour)* (1990), *Timecode* (2000) by Mike Figgis, and Alexander Sokurov's *Russian Ark (Russkij Kovcheg)* (2002), for example.

But among filmmakers who work within the experimental paradigm, Andy Warhol deserves attention for his use of the long take. Warhol's films are often known through their notoriety rather than by way of experience. As Stephen Koch points out about *Sleep* (1963), a six-hour film of a man sleeping:

> People who have never seen *Sleep* (in other words, almost everybody) are sometimes under the impression that Warhol's notoriously immobile camera remains rigidly fixed for the full six hours, a mere mindless sentry perpetually at attention, gazing at a sleeping man. As a matter of fact, if not properly speaking edited, *Sleep* was assembled and constructed from several different shots of the somnolent nude.[11]

Eat (1963) features the artist Robert Indiana (and an appearance by his scene-stealing cat). Indiana sits in a high-backed wood-carved chair and throughout the film is slowly eating a white mushroom. The film's sense of unhurriedness is made all the more manifest by the filming at 24fps and projecting it at the slower rate of silent speed (16fps according to the artist's specifications, although most projectors will run at 18fps for silent speed). The film actually is a series of three-minute camera rolls rather than a continuous 39-minute take, the image fading to white as the roll runs out and the image re-emerges from the light flares at the beginning of the next roll. Descending dots appear at the outset of each roll as well, these being the hole-punched numbers Kodak used at the time to indicate the emulsion batch. The holes are first seen in the clear light-struck film and then an echo of these dots reappears a moment later, from the light that was exposed through the holes onto the next winding of the roll of film.

Indiana, in his rumpled, dark felt hat, is filmed in natural light (unlike many of the more moody film portraits from the Warhol Factory). Koch describes the visual qualities of the image as " . . . richly contrasted, graded blacks and whites seemingly bathed in the photographic luminescence of sunlight flooding in from a source at a window – very much like the fashionable French portraiture of the 1940's and 1950's, calling to mind Cartier-Bresson, for example."[12] Indiana furtively glances at the camera a few times before eventually deciding it's okay to look directly into the lens. As in many of the Warhol *Screen Tests* (1964–66), the impression is not so much one of looking at a person as much as it is the act of looking at the vague discomfort of someone who is being filmed. About mid way through the succession of camera rolls, the aforementioned cat hops up on Indiana's shoulder. He later holds the cat – the cat seeming to only mildly tolerate this before hopping down out of view. While the mushroom is devoured slowly, the next-to-last roll seems to be out of order, the half-eaten cap reappearing as Indiana chews absentmindedly.

Warhol used a Bolex equipped with an accessory electric motor, allowing for shooting an entire three-minute roll of film in one take, rather than the Bolex's usual limitation of about twenty-eight seconds for each full winding of the spring. In *Empire* (1964), and his later sound films, Warhol used an Auricon camera, allowing for longer continuous takes. A 400ft magazine, allows for an eleven-minute take. But a larger capacity magazine, holding 1,200ft of film at a time, provided Warhol with the half-hour takes in his eight-hour observation of the Empire State building. The camera was operated by Jonas Mekas, who gave a droll account in the pages of the *Village Voice*[13] of the filming of *Empire*, transcribing a few of the highlights of the conversation among the crew and Andy Warhol: "Henry: Andy?! NOW IS THE TIME TO PAN. John: Definitely not!"[14] and later, "Henry: The script called for a pan right at this point. I don't see why my artistic advice is being constantly rejected."[15]

The early Warhol films – black and white, with fixed camera and single subject, seen in contemplative silence – are not unlike the one-minute films produced by the Lumières, shot without ever stopping, ending when the film ran through to the end. The Lumière *Actualités*, burdened with the rigidity of this limited and seemingly quaint form, are oftentimes described dismissively in Darwinian terms as primitive early specimens in the evolution of the art of cinema. Yet these films take on a retrospective formal minimalism, an inadvertent modernism, in light of Warhol's usage of such similar constraints of production. Peter Hutton, also working with the long take and the static camera, said about the straightforward unpresumptuousness of these works, when

interviewed by Scott MacDonald: "The Lumière films are a revelation when you see them in this day and age, because there's a certain kind of innocence to how they were structured."[16]

The long duration and static nature of the early Warhol films may try one's patience, but that's part of the point. The experimental composer John Cage once wrote: "In Zen they say: If something is boring after two minutes, try it for four. If still boring, try it for eight, sixteen, thirty-two, and so on. Eventually one discovers that it's not boring at all, but very interesting."[18]

The long-duration film allows the viewer to not be passive: It provides the time for the mind to think and reflect on what the eye sees. As Walter Benjamin noted, one of the differences between painting and cinema is the matter of the time available for sustained rumination on the work of art:

> The painting invites the spectator to contemplation; before it, the spectator can abandon himself to his associations. Before the movie frame, he cannot do so. No sooner has his eye grasped a scene, that it is already changed. It cannot be arrested. Duhamel, who detests the film and knows nothing of its significance, though something of its structure, notes this circumstance as follows: "I can no longer think what I want to think. My thoughts have been replaced by moving images."[19]

The long take seems to satisfy this desire for the time to think about what one sees on screen.

In Thom Andersen's *Melting* (1965), an ice cream sundae stands at attention in the center of the composition. A photographer's seamless paper backdrop makes this appear like an advertising image or an extract from an educational science film. The film is a single, extended take, without edits. Organ music gives a solemnity to the proceeding. The film's raison d'être, as the title suggests, is a motion study of the melting of the ice cream under the hot movie lights. The cherry on top is an early victim of the process, sliding downward and plummeting to the clear glass plate below. The sundae becomes a seething cauldron, with drips descending down the stem of the glassware. The film concludes as the melting subsides. In Larry Gottheim's *Fog Line* (1970), a white fog obscures the image, save for thin, black pairs of power lines, hanging in a slight curve, trisecting the image. The fog obscures the rural landscape but for the vague outline of a tree poised on a hillside. The fog slowly dissipates, revealing other trees further behind.

James Benning has made use of the long take and the 400ft roll of film in works observing the American landscape with a fixed camera in *13 Lakes* (2004), *Ten Skies* (2004), and *RR* (2007). *RR* uses the passing of a long train car to create something of a tracking shot in the inverse: The camera remains static while the passing railroad cars continually move through the shot. With *13 Lakes* and *Ten Skies*, the static camera views scenes with more subtle movement. Stephanie Lam describes the first of these works:

> *13 Lakes* unfolds entirely through a series of still frames, each lasting ten minutes. There is a symmetry and minimalism in composition . . . [providing] the standard by which the spectator measures the minutest of changes: a bird flying through the frame, a cloud floating across the sky, its shadow doubled on the glass-like surface of water, the occasional ripple.[20]

The tripod

When shooting in the fixed, long-take manner, the tripod can be a critical component to the quality of the results. Too flimsy a tripod (or one that is simply poorly matched to the weight of the camera) can result in an unsteadiness of the image. This can be all the more apparent if using a longer focal-length lens. However, the answer is not always so simple: Stability versus portability forms the conflicting factor in seeking out the ideal tripod. A very stable tripod may be so heavy as to be a significant inconvenience, especially when filming solo.

Tripods designed for shooting film and video differ from those for still photography, having what is known as a fluid head (a fluid-filled chamber built into the head acts to smooth out the panning and tilting movements). Still photo tripods don't have such a need and are usually designed as friction heads, with metal plates inside the head, rather than fluid.

Leveling the tripod

It's not always best to level the tripod by what is seen in the viewfinder alone, due to the effect of distortion known as keystoning (for the trapezoidal keystone in an arch), which makes it difficult to tell if a shot that has been eyeballed in the viewfinder will look askew once the footage comes back and is projected. The keystoning effect is more pronounced when using the wide-angle lens.

Panning and tilting

While a wide lens may be tempting to use for panning shots because of its inherent minimizing of unwanted camera movement, the narrow view of a longer lens provides more space to transverse with a panning shot and consequently more screen time devoted to the camera movement. As Bruce Baillie noted, in the making of *All My Life* (1966):

> I got the tripod, fixed it really solid. Then I practiced and had her call off the minutes: we had about three minutes to get up into the sky in one roll, one continuous shot. Then we shot it and it went as smoothly as possible – I panned with the three-inch telephoto lens and pulled focus as I panned.[17]

For working in the manner of the purposeful Bruce Baillie-esque panning shot, it is critical to not stop and pause the pan once it has started. Also helpful is determining, as Baillie did in the making of this short film, the compositional end position of the pan, rather than have the camera movement just trail off into nothing.

Lock-down shot

There are also cases when an exacting steady shot is a necessity, such as when utilizing a type of time-lapse shooting where the camera should be perfectly immobile, or filming the double-exposed "ghost" shot: A transparent figure appears in an

environment that has been exposed twice (once with, and once without, the spectral figure). The term "lock-down shot" refers to tightening all the adjustments of the tripod: pan, tilt, leveling head, legs, so that the camera is as stable as possible. Care should be taken not to inadvertently bump the tripod leg and spoil the alignment in such a situation.

Tripod use and care

A few more words of counsel regarding the tripod:

- The knob controlling the tilt may be loosened when setting up a shot and when shooting (so as to be ready to make any discreet adjustments needed while film-ing), but be sure to lock the tilt before letting go of the camera to prevent it from flopping down (and in the case of a very heavy camera, completely falling over as a consequence).
- Be sure not to carry the tripod around by the arm. Grab hold of the legs instead.
- When not using the tripod, try not to lean it up against a wall, since the head is the heaviest part and gravity will induce it to fall over, potentially damaging it. You're better of laying it flat on the ground when not in use.

Seattle filmmaker Jon Behrens used a 400ft roll loaded in an Auricon to document the implosion of the King County Domed Stadium in *The Last Ten Minutes of Exist-ence* (2000). The first half of the film is spent in anticipation of the expectant scene of apocalypse, its arrival seeming all the more shocking after the long period of proceeding inactivity.

Kevin Jerome Everson's *Old Cat* (2009) uses a 400ft roll to witness the slowly changing landscape viewed from boat on a lake, the camera gazing forward from a steady handheld vantage. A man in a white tee shirt is seated at the bow, his back to us. Every so often the camera pans to the left, where another man is seated in the boat, a sullen look on his face, crutches by his side, and his right leg outstretched with a large elastic brace wrapped around his knee. The camera pans back to the man at the bow as the silent voyage contin-ues. The film's object seems more to do with the experience of the journey, taking in the serene environment with our two untalkative companions rather than the goal of reaching the destination at the opposite shore. To let time unfurl – elegant, unembellished – works in cinema.

Short duration shots: the "burst" of frames

While the long take is notable for its concentration upon the relentless progress of the passing of the present moment, the short duration shot reveals the passage of time as a series of ephemeral experiences: bounding from one moment to the other, with the breaks between shots as a form of forgetfulness. It is like a flash of fleeting memory.

The term "burst" refers to a brief flicking of the camera trigger, shooting only a short cluster of frames. It falls between continuous shooting and single-frame shooting, being

small fragments of continuousness, often composed in a succession of bursts. An early example of this technique as the basis for a short film is *Walking from Munich to Berlin* (*München-Berlin Wanderung*) (1927) by Oskar Fischinger (better known for his animated interpretations of music using arrangements of color and shape). The film consists of a rapid succession of briefly glimpsed images from the journey he took on foot, with the trip itself, from one point to another, structuring the film.

Very short duration shots are the basis of the diary films of Howard Guttenplan and Greg Shartis. The technique proliferates in many episodes of the diary films of Jonas Mekas, where it is often mixed together with single-frame shooting, so it can be difficult to see the subtle difference between the two.

A difference between single-frame sequences and "bursts" is the quick pulse of light that begins each burst of images, owing to the fact that it takes a few frames for the camera speed to go from completely stopped to running again, resulting in a longer exposure and a brighter frame or two at the beginning of a shot. This doesn't call too much attention to itself, except when several are clustered together in an extended series of short bursts of frames.

Reverse motion

At the time when double-perforated film was readily available, reverse motion could be created with any 16mm camera, regardless of its ability to run in reverse. It was merely a matter of holding (or mounting in some manner) the camera upside down. The resultant footage would then be flipped from tail to head, uprighting the image, while the film would now be run starting at the wrong end. This results in the motion occurring in reverse with the image right-side up. With single-perforated film, this is not so easy, since flipping the film from tail to head will also leave it with the sprocket holes on the wrong side.

Some cameras may be able to shoot in reverse, while others lack this capability. The Arriflex S will only be able to shoot in reverse with the use of an electric motor that can be switched between forward and reverse. Sometimes a camera may be able to run in reverse, but the 400ft magazine may lack this ability. The Bolex camera may be rewound but will not properly register the image if filming in reverse.

Sidney Peterson's *The Cage* (1947) makes interesting use of reverse motion. The reverse motion appears as the film's woebegone protagonist wanders San Francisco's Chinatown with a wire birdcage over his head, and then later in the film, in a frantic chase sequence. The characters are filmed running backwards, so that they appear to be running forward in a world encountered through the looking-glass, where everything else happens in reverse.

Superimposition and time

A double-exposure combines images shot in multiple passes through the camera, although usually the effect does not highlight the difference in time: two (or more) images melding together various incarnations of the past with the present. Kurt Kren's *31/75:Asyl* (1975), made from three rolls of film, with the flares on the end visible, is composed in a fixed lock-down shot, assembling a landscape made from a complex series of cut-out mattes placed in front of the lens. The differences in the time which are fused together are made all the more apparent by the greenery in one view and the snowfall in another fragment of the same landscape.

Camera movement

For the earliest cameras, movement of the camera while shooting was not so easy: The cranking of the film through the machine would make handheld shooting impractical in comparison to the spring-wound cameras that would follow. A charming and early example of camera movement can be seen in Edwin S. Porter's *Coney Island at Night* (1905), surveying the electrically illuminated amusement park in slow panoramic movements.

Some unusual handheld moving shots tracing the outlines of the round arches of a building façade appear in Jean Vigo's *À propos de Nice* (1930) as a brief visual drollery, punctuating the longer sections of the film. But otherwise the film is shot with a lively, but fairly conventional, use of handheld.

Marie Menken used unconventional forms of movement in several of her works. Stan Brakhage described her use of camera movement in *Visual Variations on Noguchi* (1945) in a chapter on Menken in *Film At Wit's End*:

> This is one of the first films that took full advantage of the enormous freedom of the handheld camera. In the history of cinema up to that time, Marie's was the most free-floating handheld camera short of newsreel catastrophe shots; and "Visual Variations on Noguchi" liberated a lot of independent filmmakers from the idea that had been so powerful up to then, that we have to imitate the Hollywood dolly shot, without dollies – that the smooth pan and dolly was the only acceptable thing. Marie's free, swinging, swooping, camera pans changed all that, for me and the whole independent filmmaking world.[21]

Unconventional camera movement was a long-held taboo, labeled "amateurish" perhaps more so than many other techniques of experimentation. Guides for the home movie-maker, such as Eastman Kodak's *How To Make Good Movies*, published in 1953, sternly warned against too much camera movement:

> Many movie makers, in fact, use a tripod for almost all their shots, no matter what lens is on their camera. They do so not because of any desire to impress onlookers with their cinematographic professionalism, but because they know that rock-steady screen results are far more pleasing than those suggesting that the cameraman has fallen victim to an advanced case of St. Vitus dance.[22]

Yet the smooth, conventional use of movement is an artifice of the vocabulary of cinema, having more in common with the mental image of how we contrive our sense of sight. According to Nathaniel Dorsky,

> ... in film, pans often feel artificial or forced. This stems from the fact that one never pans in real life. In truth, when we turn our heads we don't actually see a graceful continuum, but a series of tiny jump cuts, little stills joined, perhaps, by infinitesimal dissolves.[23]

In Marie Menken's *Visual Variations on Noguchi*, the outlines of the artist's sculpture are traced in tight close-ups with a perpetually moving camera. Caressing their shapes with the lens, she gives a sense of the spatial mass and ebbing surfaces in a manner beyond what a static shot could express. In Menken's *Arabesque for Kenneth Anger* (1958–61) the handheld camera exuberantly careens through the Alhambra in Granada, Spain. At times,

the movement is so rapid that the brief exposure creates a smear of moving light. There is no motion blur as the camera transverses the portico around a fountain with carved lions in the center of a courtyard. This is due to the sequence having been shot single frame, as a form of time lapse. Her New York City portrait film, *Go Go Go* (1964), contains time-lapse sequences shot with a handheld camera, a very daring defiance of traditional tastes in camera steadiness.

While experimental filmmakers have expanded the possibilities of camera movement beyond the constraints of convention, some principles are worth consideration with regard to the way the medium itself responds. Camera movement ought not to be limited by the notions of the correct and incorrect use: The desired outcomes based on foreseeable expectations are worth consideration.

The focal length of the lens (discussed in more detail in Chapter 3) will affect movement on the screen, with a wider lens generally having less shakiness for handheld shooting. A telephoto lens magnifies the subject in the frame and also the camera movement. The term "fire hose" camerawork is sometimes used dismissively for shooting with a telephoto lens and having the movement resemble the rapidly whipping mayhem of an out of control hose that has escaped from the firemen's grip. The "clop" of each footfall when walking with a camera sends a shudder through the image more apparent on the screen than is experienced by the eye, so the technique of taking gliding steps without one's feet leaving the ground may be employed.

Camera movement and the tripod

When a tripod is used, the movement of the camera tends towards pans and tilts stemming from the two-axis design of the tripod head, with its vertical and horizontal pivots. To wish something as simple as turning the camera on a third axis during a shot, to tilt it sideways challenges the limitations of apparatus. But these linear movements of the tripod, the pan and tilt, can be in themselves the source of visual possibility, as in the case of Michael Snow's preoccupations with the structural elements of cinema in a film like <—> (*Back and Forth*) (1969), with its moderate to whip-like pans in an institutional classroom space, or the domestic study in camera movement found in *Standard Time* (1967).

Panning speed

The perception of an image on screen in a panning shot, filmed handheld or on a tripod, differs depending on the speed of the movement. In a slow pan, the image remains sharp, but as the camera accelerates, the image takes on the fuzzy smear of motion blur. As the camera goes faster still, the blur and visual energy of the movement take over. There is a speed between slow and fast that can be a bit unsatisfying on screen: The image blurs a bit but doesn't have the sense of energy or the painterly blur of rapid pans.

In Snow's *Standard Time*, the camera revolves around the central axis of the tripod in the midst of a living room, repeatedly passing by a brushed metal and wood-encased hi-fi, the sound of voices fading in and out to mimic the effect of a microphone rotating towards and away from the source of sound. The speed of the camera is never slow, but the differences in moderate to swift movement serve to illustrate the difference in visual sensation depending upon the rapidity of the movement. The more moderate pans serve as a build-up to the extremely swift pans that follow. The rapid pans give the illusion of the image dividing up into evenly spaced duplicates of the objects seen in the room, creating a

false sense of superimposition of the image. The film then changes to tilting upwards and downwards, with the wooden tripod leg visible in the downward movement. A woman in a robe reclining on a bed, speaking on the telephone, is glimpsed in passing, along with an unexpected pet turtle ambling on the floor, attracting the attention of an orange tabby cat.

In Snow's <—> (*Back and Forth*), the camera pans constantly from left to right and back again within a classroom: the blackboard and door on one side, windows on the other, views of the green lawn and trees of the campus outside. At first, its robotic reiteration is like the repeating Taylorized movements on an assembly line: back and forth again and again. People pop in and out of the classroom in Méliès-like jump-cut fashion, sitting facing the backboard, throwing a ball, making out, gathered in a group with two men engaged in playful fisticuffs. Just as in *Standard Time*, the camera gives up its side-to-side repetitions and begins tilting from ceiling to floor. A police officer peers into the window from outside and walks away. In an extended post-credit coda, the pans and tilts are layered in superimposition through what seems to be multiple pass printing.

The use of camera movement may go to the other extreme, as an unwaveringly slow and steady continual pan in the visual premise of Bruce Baillie's *All My Life* (1966). The film's simplicity of form is its virtue: just a single pan, slowly moving right to left, then turning up. The subject is a white picket fence with the occasional red-flowered bush passing by the lens of the camera, ending with the slow tilt upward to an azure sky intersected with a few telephone lines. The film uses a song by Billie Holiday on the soundtrack, but the film is not "illustrative" of the music. The two elements, parallel occurrences: picture and music.

Dolly shots

The dolly shot traditionally requires an array of equipment and personnel to be implemented, but an alternative approach is found in *Hotel Cartograph* (1983) by Austin-based filmmaker Scott Stark. The camera points downward from a rolling cart, filming carpets in a succession of patterns in a hotel. The cart is pushed into elevators and glides down hallways during a long uninterrupted take, shot on a 400ft roll of film. The interminable carpeted surfaces rolling past in procession of gaudy rococo carpet patterns as the film's principal element gives the work its sense of biting wit.

Handheld static shots and movement with static subjects

Even when the camera is not moving per se, as in static shots, there is a difference in the subtle movement of handheld or the steadiness produced with the camera on the tripod. The San Francisco-based experimental filmmaker Nathaniel Dorsky shoots impeccably steady handheld static shots through the use of a stance that braces his arms against his body.

Camera movement and still subjects are sometimes combined to bring a sensation of life to the inert, such as Barbara Van Meter reshooting photographs of the solemn faces of family members from decades past. She combines a handheld camera with the sound of footsteps, paralleling the trudging motion of the camera in small up-and-down footfall-like movements. Filmmaker Carolee Schneemann used handheld camerawork to bring movement and gesture to black and white journalistic photographs of the war in Vietnam in *Viet-Flakes* (1966), together with the use of a magnifying glass in front of the camera lens to shoot the small images in close-up. The camera moves laterally and vertically, and also in and out from the image, in the manner of a handheld dolly shot. The shallow focus

of the lens results in the camera movement creating a continuing change of focus from shot to shot, transitioning from blurry to sharp, this in itself a form of animation of the static images. Viewing scenes of war, the agitated camera movement itself takes on the qualities of empathetic anguish baked into the strip of film.

Camera movement and moving subjects

Moving camerawork tends to draw less attention to itself when paired together with movement of people, or other moving subjects within the shot. What may be perceived as clumsy, shaky camerawork in a shot of an empty landscape may seem elegant when playing off the movements of the subject in the frame.

Examples of camera movement and its interplay with a moving subject can be found in *Nine Variations on a Dance Theme* (1966) by Hilary Harris, with its combined use of camera movement and a dancer's movements in the studio. In *Walking Dance for Any Number* (1968), by choreographer and filmmaker Elaine Summers, the camera follows legs walking on cobblestone city streets, with constant interplay between the panning camera and the movement of the film's anonymous pair of legs. *Element* (1973) by Amy Greenfield shows the movement of an unclothed woman in a muddy bog, slithering and collapsing down, sunlight glinting off of the surface of the thick wet mud. The camera sometimes follows the movement or sometimes moves independent of the woman slowly writhing and quickly toppling down into the mud.

The interplay of movement of the subjects and the camera finds droll expression in a short film by Stuart Sherman titled *Edwin Denby* (1978), an ostensible film portrait of the poet and dance critic. Edwin sits at a table in a New York loft, about to have a cup of tea. He picks up a spoon to stir the contents of the teacup, and as he does so the camera shakes violently, as if it were mirroring the stirred tea's viewpoint from within the cup. The camera comes to a rest as the spoon is lifted away and placed on the table.

The choice of camera lens affects the perception of movement on screen as well. When a person is coming towards the lens, for instance, a wider lens will create the impression of rapid movement, due to its increased sense of perspective. A person approaching a telephoto lens from a distance will seem to be advancing slower. In the next chapter, the lens will be examined in thorough detail.

Notes

1 These three elements of cinema formed the title of an experimental filmmaking course taught by Alan Berliner at The New School in the 1990s: "Experiments in Time, Light, and Motion."

2 The color temperature scale of degrees Kelvin is derived from changes in color of an iron ingot heated in a furnace.

3 Tanizaki, Junichiro, *In Praise of Shadows*, Thomas J. Harper and Edward G. Seidensticker trans. London: Vintage Books, 2001, p. 22–24.

4 Albeit that the shutter angle is slightly different on some models of the Bolex camera, a topic thoroughly detailed in Andrew Alden's *Bolex Bible* published by A2 Time Based Graphics, West Yorkshire UK, 1998.

5 Brownlow, Kevin, *The Parade's Gone By*. Berkeley: University of California Press, 1968, p. 213.

6 Grove, George, *Beethoven and his Nine Symphonies*. New York: Dover Publications, Inc., 1962, p. 355.

7 Whistler, James McNeill, "Mr. Whistler's 'Ten O'Clock'" (1888), in *The Gentle Art of Making Enemies*. New York: G. P. Putnam's Sons, 1922, p. 144.

8 Brakhage, Stan, "A Moving Picture Giving and Taking Book" (1971), in Bruce McPherson ed., *Essential Brakhage*. Kingston, NY: Documentext/McPherson, 2001, p. 106.

9 *The Film-Makers' Cooperative Catalogue No. 7*. New York: The New American Cinema Group, Inc., 1989, p. 363.

10 Tarkovsky, Andrei, *Sculpting in Time*. New York: Alfred A. Knopf, 1987, p. 113.

11 Koch, Stephen, *Stargazer: Andy Warhol's World and His Films*. New York and London: Marion Boyars, 1973, p. 36.

12 Ibid., p. 43.

13 Mekas, Jonas, *Movie Journal: The Rise of the New American Cinema 1959–1971*. New York: Collier Books, 1972, pp. 150–153.

14 Ibid., p. 151.

15 Ibid., p. 151.

16 MacDonald, Scott, *A Critical Cinema 3: Interviews with Independent Filmmakers*. Berkeley and Los Angeles: University of California Press, 1998, p. 246.

17 MacDonald, Scott, *A Critical Cinema 2: Interviews with Independent Filmmakers*. Berkeley and Los Angeles: University of California Press, 1992, p. 121.

18 Cage, John, *Silence*. Cambridge, MA, and London: The MIT Press, 1961, p. 93.

19 Benjamin, Walter, "The Work of Art in the Age of Mechanical Reproduction," in Hannah Arendt ed., Harry Zohn trans. *Illuminations*. New York: Schocken Books, 1969, p. 238.

20 Lam, Stephanie, "Experimental Ecocinema and Nature Cam Videos," in Tiago De Luca and Nuno Barradas Jorge ed., *Slow Cinema*. Edinburgh: Edinburgh University Press, 2016, p. 210.

21 Brakhage, Stan, *Film at Wit's End*. Kingston, NY: McPherson and Company, 1989, p. 38.

22 *How To Make Good Movies*. Rochester: Eastman Kodak Company, 1953, p. 54.

23 Dorsky, Nathaniel, *Devotional Cinema*. San Francisco: Tuumba Press, 2003, p. 30.

3 Camera eye

From cine-flâneurs to experimental optics

This chapter explores how the lens works and how filmmakers make use of it in various modes of observational cinema.

Our eyes see only as much as evolution found necessary to be human. The camera also presents a vision of the world tinged with its own particular perception of things. The motion picture image is bound by the film's emulsion, the optical qualities of the camera's glass lenses, the fleeting exposures from frame to frame. The boundaries of the rectangular frame do not show the world in its completeness but a circumscribed representation of it.

Observation as the subject

A path taken by the makers of observationally centered cinema is the city portrait. The epic city symphony, eyeing the grand spectacle of the bustling human anthill, often receives the most attention, but there are also more modest city portraits, wandering the side streets rather than striding the broad avenues. Consistent with the musical analogy in the term of "city symphony," these smaller city-portrait films are chamber music pieces: preludes, sonatas, bagatelles.

Joris Ivens, in describing the reception of his short film *Rain* (*Regen*) (1929), pointed out how the small details were the most affecting elements for the viewers:

> One thing that spectators always commented on was the film's identity with the simple things of daily life – revealing the beauty in these things. It was, I think, a new field for the close-up, which until then had been used only for passionate or dramatic emphasis. These close-ups of everyday objects made *Rain* an important step in my development.[1]

These observational films of city life may be considered a cinematic mirroring of the sensibility of the flâneur. The arch-flâneur, poet, and critic Charles Baudelaire described this sensibility as such:

> For the perfect *flâneur*, for the passionate spectator, it is an immense joy to set up house in the heart of the multitude, amid the ebb and flow of movement, in the midst of the fugitive and the infinite. To be away from home and yet to feel oneself every-where at home; to see the world, to be at the centre of the world, and yet to remain hidden from the world – such are a few of the slightest pleasures of those independ-ent, passionate, impartial natures which the tongue can but clumsily define.[2]

It's hard to understand the nature of the flâneur without the aid of an element of paradox; they are within the crowd but not part of it, disinterested but keenly observing, blasé to the excitements and preoccupations of those around but a witness to the pursuit of these follies with an acute alertness. The flâneur journeys through the streets of the metropolis with no particular destination, taking in the pageant of the city's shifting scenery and players who are unknowingly performing a private harlequinade for the lone wanderer.

But with a camera, the filmic flâneur takes this paradox further: taking both the roles of the drama's audience, as seen through the camera viewfinder, and those of the author of the farce played out on the film's emulsion – to wander about, filming one's discoveries, simply observing.

Films in which the maker is "the flâneur with a movie camera," so to speak, often have an affinity with street photography, capturing the characters of everyday life, social interactions among neighbors and strangers, the patterns of people going to and fro along the sidewalks, the neighborhood cats prowling cautiously, the gesticulations of those caught up in conversation, people (and also cats) looking out from windows at the comings and goings on the street below.

In the Street (1948), made collaboratively by Helen Levitt, James Agee, and Janice Loeb, is such a film, centering mostly – but not exclusively – on children at play and later trick-or-treating during Halloween.

Rudy Burckhardt came to the medium of film through still photography, with many of the films and photographs of his prolific career taking the form of the urban portrait. A Rudy Burckhardt photograph often feels like it is a still frame from one of his films. His films of New York forgo the city's immensity for pockets of localized character. The neighborhood that would later become DUMBO is seen in the era when it was the place of industry and warehouses in *Under the Brooklyn Bridge* (1953). The discount clothing shops of 14th Street in *East Side Summer* (1959) give way to the street life of the East Side, introduced with an intertitle reading: "Know your Avenues: A B C." The crowded streets of Times Square become a fanciful nocturne of illuminated signs and promenading tourists in *Square Times* (1967). His collaborations with Joseph Cornell include the setting of the Lower East Side in *What Mozart Saw on Mulberry Street* (1956) observing scenes of playing children and prowling stray cats. Union Square and its pigeon population is the subject of *Aviary* (1955). A cemetery in Queens is the location of the autumnal *Angel* (1957).

Peter Hutton's *New York Portrait, Chapter I* (1979) – silent, black and white, the camera fixed in consummately composed shots – seems more austere. Where Burckhardt, in the flâneur-like manner, is within the crowd as he observes it, Hutton's New York is a place of repose, sometimes a place of seeming loneliness. Shots fade to black, each editorially compartmentalized from the ones before and after by this cinematic technique, as with the raising and lowering of the curtain in the theater. The sky makes reoccurring appearances as an object of visual fascination in his New York films, with slow-moving clouds or smoke wafting from a chimney, the silhouetted skyline placed far towards the bottom of the frame. Sometimes the movie screen becomes a single, unified texture, such as the play of light on the surface of the Hudson River, reminiscent of the studies of patterned movement of the ebbing and bobbing of water in Ralph Steiner's *H2O* (1929). The lack of a horizon within the frame gives the visual impression of the surface of the water continuing boundlessly beyond the frame of the screen.

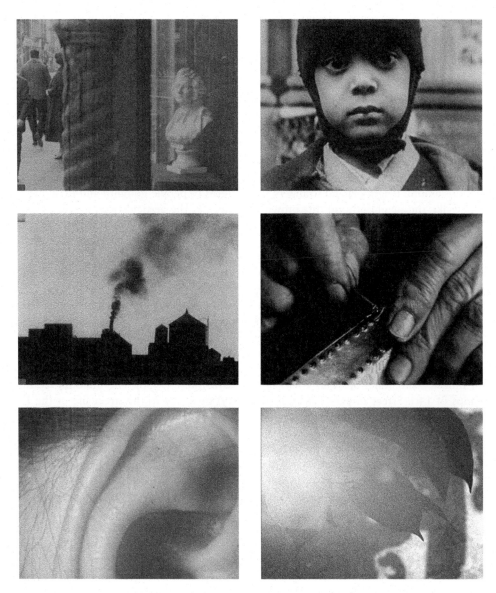

Figure 3.1 **Top row left:** Rudy Burckhardt and Joseph Cornell's *What Mozart Saw on Mulberry Street* (1956). © 2019 Estate of Rudy Burckhardt/Artists Rights Society (ARS), New York. **Top row right:** Helen Levitt, James Agee, and Janice Loeb's *In the Street* (1948). **Middle row left:** Peter Hutton's *New York Portrait, Chapter I* (1979). Courtesy of The Peter Hutton Estate. **Middle row right:** Phill Niblock's *The Movement of People Working* (1973–1992). **Bottom row left:** Willard Maas's *Geography of the Body* (1943), filmed with a magnifying glass in front of the camera lens. **Bottom row right:** *Light Leaves* (1978) from Guy Sherwin's *Short Film Series* (1975–2014). Courtesy of the filmmaker and LUX.

Hutton, interviewed by Scott MacDonald, described his films as opportunities to notice what is hidden all around us:

> What often strikes people about my New York portraits is the fact that the moments revealed in those films are experiences that most people just don't have the time to stop and behold, because they're always moving from point A to point B. When you step away from the kinetic opera of city life and go out on an early Sunday morning, it's such a reprieve.[3]

In a more personal and diaristic vein are the works of Andrew Noren. Jonas Mekas described his work in the *Village Voice* as: "Light, light, and again light. Only filming through the light are these materials revealed to us. So he keeps filming light on these textures, on materials. Light falling from the windows, light falling on the floor, on the materials."[4]

Jim Jennings, like Burckhardt and Hutton, works with the city street as inspiration, but unlike them, Jennings seeks out the fleeting moment of light, reflection, color, and movement, often seen in fragmentary close-up. From this, the larger city scene is pieced together in puzzle-like fashion. Jennings's *Made In Chinatown* (2006), in vibrant color, is a neighborhood portrait using a varied repertoire of observational modes: reflections in the stainless steel and chrome on storefront window frames and phone booths. The camera seeks out the visual distortions from a dent in the sheet metal surfaces and reflections in glass storefront windows. At moments, the reflections are out of focus, reduced to painterly puddles of color and darkness. Shot in black and white, his short film *Lost Our Lease* (2013) concerns the activities around the fashion district, deliverymen pushing bins from which long bolts of fabric protrude, people walking hurriedly along the sidewalk, metal shutters pulled down on storefronts. A sign made from a bedsheet announces "LOST OUR LEASE," while a cardboard sign makes a wryly bitter joke to prospective customers: "Business Sucks Sale."

The films of Phill Niblock are often shown as the visual component in concerts of his experimental music usually taking place on the solstice. Niblock's *The Movement of People Working* series, with images of people performing skilled forms of labor, from farming to fishing to handcrafts, in extended locked-down takes, was filmed in Central America, Asia, and Eastern Europe. We see shots of hands using a chisel to carve wood, spinning wool with a drop-spindle, weaving on a handloom, braiding fishing nets, weeding in a field of corn, using a hoe, cutting reeds, bricklaying with a mortar and trowel, and wider shots of fishermen casting nets, farmers working a field with a horse-drawn plow, dock workers unloading cargo using wood-handled baling hooks. The musical compositions at the concerts are comprised chiefly of long-held notes in thickly amassed harmonies and dissonances. The many overtones created by these combinations, and the reverberation of the concert hall, serve to thicken and add further complexity to the auditory experience. The images of work bring to mind the visually striking documentaries such as those created in the 1930s by Ralph Steiner, Willard Van Dyke, and Pare Lorentz. Niblock avoids lionizing or sentimentalizing the subjects of his films; they are just there working. The music reinforces this interpretation, although not in any explicit manner: Music and image amplify the sense of somber labor of the world, rather than the camera's depiction of an overly allegorical image of the worker.

A crowd of flag-waving attendees of a ticker-tape parade is the subject of Jem Cohen's *Little Flags* (2000). The crowd is jubilant. The camera studies the scene from a vantage around chest level, pointed upwards. Observed from this low angle, the viewer experiences

a sense of menace. We never see the parade itself; just the onlookers. Every so often, a wider shot reveals the streets covered in paper, like a snow scene composed of litter, and a few indifferent passers-by trudging through it and kicking it up under their feet.

Robert Todd's *Evergreen* (2005) begins with long, slow pans and tilts, executed with care and precision. The first of several chapters has been shot with high-contrast film, observing the light late in the day illuminating forest and wild grasses. The scene shifts to color. A super-8 sequence observes an errant fly visiting a painter's palette, shot in extreme close-up. Industrial blight takes the place of scenes of nature: harbors with massive ships and cranes unloading metal shipping containers. The word "Evergreen" on the side of a metal container is a stark note of dissonance in the treeless environ of sooty rail yards behind barbed wire perimeters.

The lens of the camera is central to these works. But the possibilities of the optical components of the camera may be taken further still into other visual territory. The survey of the motion picture camera lens that follows includes examples from the works of film-makers where particular aspects of the lens are utilized. Following this, we will examine paradigms of camera sight and survey the work of filmmakers for whom the act of seeing holds a significant place in their films.

Focal length, prime lenses, and zoom lenses

Much as with still photography, cinema lenses are engineered to different focal lengths, producing an expansive view with the wide-angle lens and a narrow, magnified view of the telephoto. The normal lens is between the two: neither expanding nor narrowing that which we see, approximating the normal perspective of human vision.

Focal length is measured in millimeters (or inches on older lenses). For those familiar with focal length in 35mm still photography (where a normal lens is 50mm), the 16mm motion picture equivalents are halved:

- A normal lens is 25mm (or sometimes 26mm or its non-metric equivalent: a one-inch lens).
- Wide lenses are those with a shorter focal length, such as 16mm or 10mm.
- Telephoto lenses are typically 50mm or 75mm (the non-metric versions being a two-inch lens and a three-inch lens, respectively) or may go higher still, such as 150mm or more.

Super-8 focal lengths are half of those of 16mm, with a normal lens being 12.5mm.

Wide lenses can be referred to as "short" and telephotos as "long." This often describes the physical appearance of the lens itself, but there are a few exceptions to this. The 10mm Switar lens for the 16mm Bolex camera is physically longer than the 25mm, even though it has a shorter focal length. These sets of lenses are known as prime lenses, or fixed focal-length lenses. To go wider or longer, the lens is switched on the camera. Some cameras are designed with a turret to accept three lenses (usually a complement of wide, normal, and telephoto). The zoom lens, which may also be referred to as a "variable focal-length lens," possesses an additional adjusting ring, allowing for the focal length to be changed between shots or while filming.

Prime lenses or zoom lenses may be advantageous for particular reasons owing to the nature of each type: Characteristics favoring prime lenses include the compact nature of the lenses themselves, with less bulk protruding from the front end of the camera and less

weight compared to a large zoom lens. Prime lenses tend to be faster than zoom lenses, allowing for shooting in low light conditions. There are fast zoom lenses, but these can be quite expensive for the sake of gaining an f-stop or two. Prime lenses are also generally sharper than zoom lenses, due to the presence of fewer elements of glass in the design of a prime lens. Other characteristics may be particular to certain lenses; for instance, a 10mm Switar will focus very close (even though it is not a macro lens).

Zoom lenses have advantages; principally, the ability to rapidly change from one focal length to another, including zooming while shooting (which obviously can't be done with a prime lens), or even to shoot at any gradation of focal length within the range of the lens, rather than the limited choices from a set of prime lenses.

Wide, normal, or telephoto lenses are differentiated by their field of view, but each has a more nuanced set of characteristics for the filmmaker to consider:

The wide-angle lens

The wide-angle lens gives an appearance of greater compositional depth, with objects in the foreground larger and those in the background smaller in scale. For this reason, it is a lens suited to working with compositional planes, with foreground, mid ground, and background seeming distinct from one another.

The wide lens is a good choice if shooting handheld with the objective of having steady shots, in comparison to the results from shooting with a longer lens. When shooting close-ups with the wide lens, there is a sense of extreme intimacy – or even an awkward sense of discomfort – from the necessity of the camera being so close to the subject in the frame and so much within the subject's personal space.

Maya Deren described her use of the particular properties of the wide-angle lens in her film *A Study in Choreography for Camera* (1945) for an article in *Popular Photography* magazine:

> In one shot for this film, I used a certain lens because of its effect on a time-space relationship. The location of this particular shot is the Egyptian Hall of the Metropolitan Museum of Art. The Hall (which has natural illumination through a glass roof) is square, and small enough to permit a dancer to travel its length and back in a short period of time. If I had used the regular one inch lens, the shot might have been pleasing but hardly startling. However, I used a wide angle lens – my main purpose in doing this was not so much to solve the follow-focus problem, as it was to use the exaggerated perspective of a wide angle lens to achieve a startling relationship between time and space.
>
> Through the lens, the dancer – moving towards the back of the hall – seemed to become distant in terms of size without taking a normally long time to do so. In terms of normal vision, the dancer would have had to run much longer and farther. But in a matter of seconds, with the aid of the wide angle lens, through which the hall appeared much deeper, the dancer, starting in closeup, danced into the depth of the hall, where he looked tiny and distant, and, returning rapidly became large and close again.[5]

Of the three types of lens, it is the wide angle that may be hardest to focus through the viewfinder. This may seem incongruous with its inherent characteristic of deep focus. But its depth of field will make everything appear in focus, or nearly so, when viewing the

small image on the viewfinder's diminutive groundglass. Once the footage is projected on the large movie screen, one may realize too late that the focus was set at the outer boundaries of lens's depth of field, focused a little in front or behind the subject.

The telephoto lens

The telephoto lens will flatten depth, giving less exaggeration of scale between near and far objects, allowing for longer pans due to its narrow, confined view of an environment and conveying the sense of (sometimes dramatic) distance between camera and subject. Due to its magnification of the image, it will produce unsteady images shooting handheld, but by this same token, it may be useful for creating painterly motion blur with extreme movements of the camera, reducing the image to a smear of colors.

The short film *Shift* (1972) by Ernie Gehr looks out from an upper story window down at an asphalt city street, using a telephoto lens to flatten the image. Filmmaker Sarah J. Christman made exclusive use of the 75mm lens in *Broad Channel* (2010), a visual and aural portrait film of a patch of shoreline along Jamaica Bay in Queens, New York. Her film observes details in close-up, such as debris bobbing in the inlet's waters, or a distant view of the A-train subway line, snaking its way to and from the Rockaways. Scrupulously avoided is a classical "establishing shot" of the Broad Channel (a film of a broad channel without a broad view of it); instead, she presents an environment to be puzzled out from its pieces as it is revealed in narrow fragments.

The telephoto lens is somewhat easier to focus by eye: Things will either appear focused or not. But its shallow depth of field means that if the camera or the subject changes their respective distance from one another, the focus can change precipitously from in focus to out of focus.

The normal lens

The normal lens can be thought of as defined through a negative: neither this nor that. Falling between wide and long, it does not possess the characteristics of pronounced depth and distortion of the wide-angle lens or the compression of the distances between objects as with the telephoto lens. It presents a neutral effect, a zone of spatial equanimity of the image, neither stretched nor flattened.

The artist René Magritte created paintings sharing the title *The Human Condition*, each an intriguing variation of the same subject matter. We see a canvas on an easel before an open window, the scale of its painted image matching seamlessly with the natural landscape behind it. While these paintings were not created to be illustrative of a photographic principle, it can be useful to consider how the normal lens views the world in a similar way to Magritte's enigmatic painting.

Fisheye

This lens is an extreme wide-angle lens. It produces a highly pronounced distortion of the image, bending the edges of the frame while the center portion of the image seems greatly enlarged.

StanVanDerBeek's *Spherical Space No. 1* (1967) makes use of the contorted space produced with a fisheye lens. Dancer Elaine Summers, sometimes clothed, most times unclothed, dances in a verdant wood, balancing on a wall of piled gray stones. Filmed entirely in fisheye, the image bends dramatically at the edges, an outer circle of blue is produced by

chromatic aberration of the unusual lens, and the round image is vignetted within the rectangular frame of the film. As the camera moves closer, the fisheye lens causes the center of the image to expand like the surface of a balloon being inflated.

Fisheye lenses sometimes take the form of adaptors to screw onto the front of a wide lens. A door peeper from the hardware store, added to a makeshift mount like a lens cap, can be used to make an improvised fisheye lens. Additionally, highly convex mirrors (of the type found at the automotive shop to expand the limited vantage of a rear view mirror) can also produce a fisheye effect, though it may be hard to avoid the camera's own reflection in such a wide field of view.

Figure 3.2 A door peeper used as a fisheye lens, mounted in front of a 25mm Switar lens using the cap from the plastic container for 35mm still film.

The zoom lens

The zoom lens allows the change in focal length while shooting. This has made it the choice for documentaries where time is of the essence and the pause needed to change lenses cannot be spared. But zooming may be a central element to a film; for example, Michael Snow's *Wavelength* (1967), notable for its slow and extended – but not

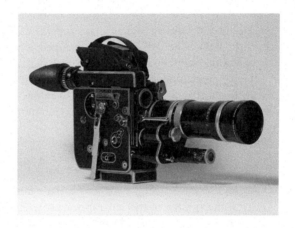

Figure 3.3 The Switar 18–86mm zoom lens mounted to a Bolex Rex5.

constant – zoom during the film's 45-minute running time. Ernie Gehr's *Serene Velocity* (1970) zooms inwards and outwards down a long institutional hallway while shooting in single frames, the rapid changes in focal length growing greater as the film progresses.

The focusing ring

The focusing of a lens is a matter of moving the primary glass element closer or further from the film. Moving this element away from the film will bring closer objects into focus. Moving it closer will cause it to focus on more distant objects, to the point on the focusing ring with the infinity sign. The distance between lens and film, when focused at infinity, is what defines the lens's focal length. In some cases it is more effective to measure distances with a tape measure and set focus using the settings on the ring; in other cases, focusing by eye is more effective. An instance where focus might be worked out through measurements would be a rack focus shot, refocusing on near or far subjects. A lens's depth of field is shallower at closer distances, especially with regard to macro shots. (This is also

useful knowledge when wishing to film entirely out of focus: This is easier to accomplish by setting the lens closer rather than further away.)

Depth of field

While the lens is focused on only one plane, perpendicular to the camera, the term depth of field describes deepness or shallowness of focus in front of, and behind, the plane of focus. The distances indicated on the focusing ring of the lens spread out as focus gets closer and closer. Depth of field behaves in this same manner, extending about one third in front of the plane of focus for every two thirds behind.

The degree of depth of field is determined by the focal length of the lens and the stopping down of the aperture. Shorter lenses have greater depth of field, and long lenses have a shallower depth of field. Stopping down the lens to higher f-stops extends depth of field for all lenses.

How these variables act upon the depth or shallowness of focus can be determined through consulting depth of field tables found in publications like the *American Cinematographer Manual*. But many lenses will have a built-in depth of field indicator in the form of a curved line that will either expand or contract as the aperture is closed down or opened up. On the later model Switar lenses for the Bolex, a series of orange dots will show the depth of field. When the f-stop is changed while shooting, the depth of field will also change as the shot becomes brighter or darker.

Having everything in focus all the time is not always the optimal aesthetic choice. Many times, an effort must be made to reduce depth of field so that only the key element of the shot is in focus, standing out from the rest, or entirely out of focus in some satisfying manner.

A common method of reducing depth of field is the use of a long lens (telephoto). A neutral density filter may be used to allow the opening of the iris to reduce depth of field. In the instance of filming indoors with movie lights, one may simply back the lights away to reduce illumination levels, allowing for a wider f-stop.

A good reason to keep your lens surface free of dust is the appearance of dark spots. Dust on the surface of the lens, appearing as little round smudges, begins to come into view when the lens is closed down owing to depth of field. These fuzzy dots have a tendency to stand out especially against a neutral background like the sky.

Depth of field will also have a role in the next chapter, with regard to the sharpness or softness of the seam of a matte shot.

Figure 3.4 The depth of field indicator on a Switar 25mm lens. Note how the depth of field increases with the closing of the lens. Later models use orange dots to indicate the depth of field as the aperture setting is changed.

Depth of field: hyperfocal distance

It is possible to set a lens to take greatest advantage of the depth of field through use of what is termed the hyperfocal distance. If the focusing ring is set to infinity within the further end of the depth of field indicator, then everything from infinity to the closer distance within your depth of field range will appear in focus. This method tends to work best with the wide-angle lens. A word of caution regarding this method of filming: If the f-stop needs to be changed (as when filming outdoors and a cloud passes over) this will affect the hyperfocal distance.

Out of focus

The unfocused image – with the subject distant from the camera and the lens focused very near, for instance – has its particular optical characteristics. "Circles of confusion" is the term used for the spreading of a pinpoint light outward to form a circle. While the image is a blur, the round edge of the "circle of confusion" itself may appear sharp and distinct or sometimes appear as a polygon due to the outline of the blades of the lens's iris. To achieve a completely out of focus shot – and not just produce a shot that is slightly out of focus – a telephoto lens tends to work best.

To produce an out of focus image without circles of confusion, as more of an overall haze, a diffusion filter may be used in the camera filter holder or in front of the lens. Material that is partly transparent and translucent can be used to create a gradation between soft and sharp within the shot. One method to obtain this effect is to spread Vaseline on a piece of glass mounted in front of the lens. Canadian filmmaker Guy Maddin has commented[6] that when shooting his first feature film, *Tales from the Gimli Hospital* (1988), at a location where telephone lines could not be easily framed out of the shot, the use of Vaseline on the glass in front of the lens allowed him to "paint" them out of the shot. The offending telephone wires were rendered out of focus enough to disappear. (Of course, always be sure to put Vaseline on a piece of glass in front of the lens and not on the lens itself.)

In his super-8 film *The Desert* (1976), Stan Brakhage films details of the interior of a hotel room with the camera out of focus, so as to bring attention to the bright exterior light slipping into the room from around the edges of the curtains, rather than the details of the environment.

The use of shooting out of focus as an aesthetic choice, as in the Brakhage film, sometimes demands a full embrace of the technique, since a shot that is just a little out of focus tends to suggest a mistake. A single shot that is out of focus in a film that is otherwise in focus, for instance, might seem unintended.

Racking focus

The term racking focus refers to refocusing while shooting. Since it relies on some things in the frame being out of focus and others in focus, a longer lens, with its limited depth of field, tends to lend itself to rack focus shots. Shooting at a lower f-stop to lessen depth of field is useful in this situation. Framing up the shot to accentuate the distance of the near and far subjects is essential.

British filmmaker Nicky Hamlyn has used racking focus as a central element in works such as *Matrix* (1999). Paul Clipson's *THE LIGHTS AND PERFECTIONS* (2006) uses

constant rack focusing to bring subjects, such as tree branches and chain-link wire fences, in and out of focus, with each plane appearing starkly against the blur of foreground and background of the extremely shallow depth of field of the shot.

A method of refocusing the image is seen in Stan Brakhage's early work *Desistfilm* (1954), where the handheld camera moves in and away from the faces of young people at a house party. The image comes into focus through the change of camera distance, rather than through adjusting the focusing ring. Interestingly, this use of focusing through camera movement is reminiscent of a conversation on nearsightedness between the poet Charles Olson and the filmmaker, described in *Metaphors on Vision*:

> And now, how YOU, Brakhage must get clear about focus – right? . . . I mean, do you hear me? . . . that is: Hold your hand in front of your face and find OUT just how far away you can take it and how close, without throwing all the lines in your hand out of focus.[7]

Macro lenses

The macro lens allows ultra-close focusing, filling the screen with the minute. Non-macro lenses will allow the focusing ring to be turned from infinity to a certain near distance, but a simple macro lens will allow the focusing ring to go another revolution or two outwards. The markings on the ring will no longer be applicable as the front lens element is moved further from the film plane. On the Switar lenses of the Bolex camera, a red band is revealed as the focusing ring is turned beyond the first revolution of the ring; an indication that the lens is now in the macro range.

In a pinch, a normal or telephoto lens can be slightly unscrewed (or unlatched and slid slightly out from the mount on a camera such as an Arriflex S) so as to focus a bit closer. But this must be done with some caution so as not to unscrew the lens too far and have it drop to the ground and get damaged!

With prime lenses, macro focusing is found on certain telephoto and normal lenses but usually not wide-angle lenses. The wide-angle lens is much more sensitive to the distance of its seating from the film plane (referred to by the term "back focus"). However, the 10mm Switar for the Bolex camera, while not a macro lens, has the advantage of being able to focus extremely close.

Some super-8 cameras are outfitted with macro zoom lenses, which operate a bit differently to the macro prime lenses: A release on the back of the lens will shift an internal element within the lens, allowing it to focus only at an extremely close distance to the camera.

Figure 3.5 A set of c-mount extension tubes.

It's also worth keeping in mind that macro shooting will result in a drastic decrease in depth of field.

Extension tubes

A telephoto or normal lens can focus in the macro range with the help of a set of extension tubes. These increase the distance from the lens to the film and change the range of focus to extreme close-ups. There is a loss of exposure with the use of extension tubes, so the f-stop should be opened to compensate for this. The degree of exposure compensation will differ depending on the focal length of the lens, thus making a catch-all rule for extension tube light loss a bit difficult.

Diopters and magnifiers

A close-up adaptor that may be screwed onto the front of a lens is referred to as a diopter, although the term should not be confused with the diopter on the camera viewfinder used for focusing by eye.

The short film *Geography of the Body* (1943) by Willard Maas was made without a macro lens or extension tubes. The ingeniously low-tech method of filming the human form in extreme close-up was done by use of a magnifier: "Marie [Menken] had gone out and bought a dime-store magnifying glass, which she taped to the camera lens, and with this crude equipment photographed most of 'Geography of the Body.'"[8] Menken did this again in her film *Glimpse of the Garden* (1957). The film begins with exterior garden scenes and then enters into the garden greenhouse, the view of the garden shrinking down into the diminutive realm of buds and blossoms, shot in extremely magnified close-up shots.

Investigation of a Flame (2003), by Lynne Sachs, merging the genres of documentary and experimental film, uses a magnifying glass to examine photographs and documents relating to the actions of a group of Vietnam-era anti-war protesters. The technique and subject matter seem to echo the use of a magnifier used in front of the camera lens in another anti-Vietnam war film (noted in the previous chapter), Carolee Schneemann's *Viet-Flakes* (1966).

Simple magnifiers, such as the type found from the stationery store or a condenser lens salvaged from a projector, tend to produce effects such as distortion, uneven focus, and color fringing at the edges of the image. This can easily be considered an effect rather than a defect; for instance, by bringing the center of the image into greatest clarity to direct the viewer's attention there.

Lens flare

When light directly hits the lens, it can bounce around the surfaces of the glass elements, causing small, round reflections known as lens flare. Oftentimes the image will also be washed out. A lens shade can be used to prevent or minimize it. Lens flare can be used as a technique, especially in the case where a zoom lens creates a long row of circles due to the many elements within the lens.

The viewfinder

The image in the camera viewfinder is always an approximation of what is actually exposed upon the surface of the film. With a non-reflex finder, there is the obvious issue of parallax (the offset of viewfinder and lens). But even with a reflex system, the filmed image may be the slightest bit off from the mask in the viewfinder.

Non-reflex

The non-reflex viewfinder does not provide an image through the taking lens of the camera but uses a separate lens system. The finder may be built into the camera, or mounted on the side of the camera next to the lens.

The Bell and Howell Filmo 70-DR uses a set of gears to rotate the lens turret together with a smaller viewfinder turret with a corresponding set of viewfinder objectives with matching focal lengths. More commonly, non-reflex viewfinders use an internal mask that may be changed to crop the image at a variety of focal lengths. A non-reflex viewfinder known as a "sports finder" is a very simple type of viewfinder, without glass elements.

Sometimes the advantage of a non-reflex finder (even when mounted on a reflex camera) is the bright image in the finder when the camera lens is set to a very small aperture.

Focus finder (focus preview finder)

Some non-reflex cameras allow for through-the-lens focusing but not at the time of shooting. On a non-reflex Bolex, this is behind the top lens position on the turret; on the Bell and Howell Filmo, it's a small, round finder on the opposite side of the turret from the taking lens position.

Rackover

Another non-reflex system for focusing through the lens – but not while shooting – is a rackover viewfinder; the front of the camera can shift over to allow the viewfinder to take the place of the film gate. It's a feature that was found on older, professional non-reflex cameras like the Mitchell.

Reflex viewfinder

The term "reflex" refers to mirror or prism systems that allow viewing through the taking lens while filming. This eliminates the issue of parallax inherent in a non-reflex viewfinder, and the focus can be set or changed by eye while shooting. In a reflex viewer, the image comes into focus on a frosted surface known as the groundglass. The groundglass is the same distance as the film plane and therefore when something is in focus on the groundglass surface in the viewfinder it should then also be in focus on the film plane. Sometimes the groundglass will have "safe area" lines inscribed on it.

Super-8 cameras will often have a groundglass that is not "ground" with an etched surface, making the image fairly bright but seem deceptively clear compared to the image recorded on the film. A round "critical focus" area in the center is used to determine focus. This may also take the form of a "split focus finder" with two half circles: The subject will be in focus when the edges seen crossing the divide are not "split" but appear unbroken.

Prism viewfinder

The prism reflex system is found on cameras such as the Bolex, Canon Scoopic, and most super-8 cameras. This is also the method used for reflex-conversion zoom lenses with built-in eyepieces designed for use with non-reflex cameras. Some of the light is

channeled away to the viewfinder with a prism acting as a beamsplitter. The disadvantage of the prism is a relatively dark image in the viewfinder, since most of the light (rightly enough) is directed to the film. In some cameras (like the Bolex), an exposure compensation is done when taking a light reading to make up for the loss of light from the prism.

Mirror shutter

The mirror-reflex viewfinding system is found on cameras like the Arriflex, the

Figure 3.6 The mirror shutter of the Arriflex SR.

Beaulieu, and the Krasnogorsk K-3. The camera shutter is mounted at a 45-degree angle and has a mirrored front surface, directing the image from the lens to the viewfinder when the shutter is closed. The image in the finder is brighter than with a prism viewfinding system, and no exposure compensation is needed: 100% of the light exposes the film while the shutter is open, and 100% of the light reflects off of the mirror while the shutter is closed. The image does flicker in the finder while shooting. If the camera stops between shots with the shutter open, there will be no image in the viewfinder, and the camera's inching knob will need to be turned to bring the mirror into place at the gate. Never use a canned aerosol dust remover around a mirror shutter, as it will fog the mirror.

Diopter

The diopter is used to bring the image on the groundglass itself into focus. The diopter is located in the vicinity of the eyecup of the viewfinder, often with "+" and "-" symbols on the adjuster.

Setting the diopter is a requisite step (regardless of the filmmaker's eyesight) to sharpen the focus of the image on the groundglass. For the bespectacled filmmaker, it may be possible to focus the groundglass without eyeglasses, depending on the severity of the prescription.

Filming without use of a viewfinder

When the Japanese filmmaker Takahiko Iimura made *Filmmakers* (1969), his portrait of the New York underground film artists of the 1960s, he shot the work without looking through the viewfinder of the camera at all. His reason was to engage with the subjects with eye contact while filming, rather than have the camera as a physical obstacle to this connection. He knew generally how the compositions would be framed, just based on experience, but also wished to leave a little of this up to chance, inspired by John Cage. The final section of Takahiko Iimura *Filmmakers* (1969) is a self-portrait; the camera turned 180 degrees, the lens facing back towards the film's author. A handheld magnifying glass is rapidly moved back and forth between the camera and the partial, out of focus view of the filmmaker's face. Rather than setting focus, the movement of the magnifier is used to pass through intervals of focus and then out again: the eye, black plastic eyeglass frames, and nose briefly coming into sharp focus.

Setting focus

The steps to insure the image will be exposed in focus are slightly different for prime lenses and zoom lenses, although the underlying concept is the same for both: reducing depth of field to better gauge the focus of the image.

Setting focus on a prime lens

The steps for focusing a prime lens are:

1. Open the iris to its widest f-stop prior to filming. This makes the image brighter in the viewfinder as well as reducing depth of field.
2. Then focus the lens.
3. Set the aperture once the camera is focused. Be sure to close down!
4. Then shoot.

It is an easy enough mistake to forget to close down the f-stop reading once the focus is set, resulting in an overexposed shot standing out sorely from the rest.

Setting focus on a zoom lens

Focusing the zoom lens is done by:

1. Zooming in to the longest focal length prior to filming. This enlarges the image and reduces depth of field for critical focus.
2. Focus the lens.
3. Zoom back out to the composition you desire.
4. Then shoot.

Following this procedure will prevent filming a zoom-in that starts out sharp but goes out of focus as you move into the telephoto range.

Setting focus on a super-8 camera

Most super-8 cameras have a critical focus area in the center of the viewfinder – either a split focus set of half circles or a textured area in the center of the frame. It is best to use this rather than to trust the image outside of the critical focus area.

Turret

To quickly change from one lens to another, many cameras have a three-lens turret, usually set up with one lens of each type: wide, normal, and telephoto.

Whichever lens is in front of the camera gate is referred to as the "taking lens," the other two waiting in reserve. Care should be taken to avoid the mistake made in haste of setting the f-stop of the wrong lens rather than the taking lens. When switching from one lens to another, the turret will click into place as the lens is seated in place. If the lens is not seated

directly in front of the gate, the image will vignette on the top or bottom of the frame and also be underexposed. It is possible to switch lenses on the turret while shooting, resulting in the image sliding up or down as it vignettes, with a moment of black in between. All three lenses should have the f-stop set at the outset of filming if changing lenses while shooting in this manner.

A curious feature of the Bolex is that the turret can be swung open so that no lens is in front of the gate, which can be used to create a transition to white (rather than to black) when rotating the turret from lens to lens while shooting.

Lens mounts

The most typical means of attaching a lens to a 16mm camera is a screw-type mount known as C-mount. Usually a c-mount camera will have a three-lens turret. It is found on the Bell and Howell Filmo, the Bolex, the Beaulieu, Kodak K-100, and many other cameras.

C-mount lenses have also been used for video surveillance cameras and early forms of video camera. Therefore, in addition to the high-quality cinematic c-mount lenses (such as the Switar), there are a variety of low-end lenses that may be fodder for experimentation despite the general disdain for these lenses among the professional users of film equipment.

Bayonet lens mounts are found on the three-lens turret of the Arriflex S, and a type of lens called the PL (positive lock) mount is found on later Arriflex cameras. Bolex SBM and electric motor- driven Bolex cameras use a single bayonet mount to allow for heavier zoom lenses than the c-mount turret would comfortably support. Bayonet mounts are threadless, with some form of clasp designed to hold the lens in place.

Lens mount adaptors

Various types of adaptors exist to attach a lens onto a camera with a differing type of mount. A common example of this is pairing a lens made for a still camera (such as a Nikon or Canon lens) onto a film camera. This allows for the use, for instance, of a very long focal length compared to what would be generally available for a 16mm camera.

A caveat to note about this: When using adaptors, the lens should be of a type designed with a mount further from the camera to accommodate the additional distance resulting from the adaptor (except if the lens is going to be used for extreme close-up work, with the adaptor serving as an extension tube).

Pinhole lenses

The *camera obscura*, distant ancestor of the camera, produced an inverted image on a white wall in a darkened room. A small hole on the opposite wall acted as the lens. Following this principle, it is possible to

Figure 3.7 A Nikon/c-mount lens mount adaptor mounted on a 16mm Bolex camera, allowing a 55mm Nikkor micro lens to be used for macro shooting.

film with an image produced by substituting a minute hole for a glass lens. Pinhole cameras typically use a puncture in a piece of aluminum foil (or a slightly thicker disposable aluminum pie plate) mounted in place of the lens. Much less light is produced from a pinhole, and so some combination of the following is usually necessary to produce an image:

- Brightly lit environments (shooting outdoors during the day).
- Long exposures, such as produced when filming at a low frame-rate, or shooting time exposures on a Bolex with the I/T switch set to "T." To film at a slow frame-rate, filmmaker Thomas Comerford used a Bell and Howell Filmo, which could be very slowly hand-cranked when shooting pinhole films.[9]
- High-speed film stocks, such as a 500ASA stock (which may be push-processed to increase its sensitivity).

The size of the hole may be increased to allow for more light to pass through it, but this will in turn produce an image less in focus than what is produced from a smaller hole. The focal length of the lens (wide, normal, telephoto) of a pinhole lens is literally the distance from the film plane inside the camera to the pinhole itself. Telephoto pinhole lenses can be produced using extension tubes. A highly detailed set of instructions for preparing a pinhole lens for a 16mm camera can be found in Kathryn Ramey's *Experimental Filmmaking: Break the Machine*, "Chapter 10: Pinhole photography: film/video/digital" (pp. 283–317). This includes the reprinting of Thomas Comerford's *Pinhole Notes* (2002), a zine describing his working process. (Other filmmakers using pinhole filmmaking techniques will be encountered in Chapter 7)

A pinhole-lens 16mm film by Christopher Harris, *Sunshine State (Extended Forecast)* (2007), cuts between shots of the sky, a green lawn, and a chlorine-blue pool, in sunny suburban Florida. The images are in-focus just enough to be discernible. The sun is seen reflected in the water's surface in the pool; a little girl draws a smiling sun with yellow chalk on the cement walk; a yellow pinwheel turns in the wind. The soundtrack is a cut-up of science documentaries – describing the cosmic mortality of the sun's finite hydrogen fuel – mixed with Florida weather reports. The little girl spins in her white dress, centrifugal force causing the hem to expand outwards around her, as we hear: "And as we take a look outside, boy, what a bright sunshine over Daytona Beach and other parts of Central Florida, but how long are we going to see that sun?" The question seems to echo the astronomical inquiry made moments earlier: "How long are we going to see that sun?" Beach balls float in the pool like the celestial orbs. The sun appears as a bright white puncture in the blue rectangle of a shot of the sky.

Prisms

A piece of faceted glass will produce multiple images through refraction: crystal suncatchers, cut glass decanter stoppers, toy "bug eye" viewers. Each of these may yield an interesting result when placed in front of the camera lens.

Figure 3.8 A multi-faceted "suncatcher" used in front of the camera lens, handheld.

Differing results will occur with differing focal length lenses but, generally speaking, to avoid seeing the edges of the prism in front of the lens, it's better to use the normal or telephoto lens for this.

Adapted from a story by Edgar Allan Poe, *The Fall of the House of Usher* (1928) by James Sibley Watson and Melville Webber makes use of prisms throughout the film, often creating double versions of the film's characters as they prowl through the expressionist-inspired set. Double exposures are also abundant, the two camera effects seemingly related: By prism or superimposition there is a doubling of people within the frame. Watson and Webber's film takes its visual inspiration from expressionist sets of Robert Wiene's *The Cabinet of Dr. Caligari (Das Cabinet des Dr. Caligari)* (1920), but the differences between these films are more notable than the similarities: With the exception of a brief sequence with superimposed text on screen appearing near the film's conclusion, and despite all the distortion of its painted sets, there is a dearth in *The Cabinet of Dr. Caligari* of any optical metamorphosis of the image. Abundant with prism shots and multiple exposures, Webber and Watson's *The Fall of the House of Usher* contains barely anything else.

While Storm De Hirsch's *Peyote Queen* (1965) is mostly comprised of cameraless animation, two short sections demonstrate the use of a glass prism held in front of the lens, creating multiple images of a nude breast filmed with unsplit Regular 8mm film and, towards the end of the film, a close-up of an eye gazing at the camera.

Albert Alcoz's short black and white super-8 film, *Triple exposure (Triple exposición)* (2013), makes use of a prism as the camera moves in handheld arcs and pans around tree branches and leaves. The prism splits the image up in a manner similar to a matte shot, the frame divided in three sections. The prism rotates to break up the image in diagonals first one way and then another. Because super-8 film cannot be easily rewound, the use of optical experimentation in front of the lens to divide up the image serves as an alternative to creating a matte effect through rewinding the film.

Anamorphic lenses

Anamorphic lenses are generally used for the purpose of creating widescreen images by way of compressing the image during shooting and then expanding it during projection. The image recorded onto the film is referred to as "squeezed," appearing vertically elongated on the film itself, and then "unsqueezed" by an anamorphic lens on the projector, stretching it back to normal-looking proportions. The UK-based experimental filmmaker Ben Rivers has used the 16mm anamorphic process to film in widescreen for *Ah, Liberty!* (2008).

Anamorphic lenses may also be used for distortion of the image as can be seen in a few shots in the French filmmaker Germaine Dulac's *The Seashell and the Clergyman (La Coquille et le clergyman)* (1928). Sidney Peterson, working in San Francisco in the 1940s, is known for a thoroughgoing use of anamorphic distortion in his films. In *The Dark of the Screen*, he writes:

> My own discovery of an anamorphic lens was entirely by chance, an encounter with a found object covered in dust at a camera shop . . . The lens had been manufactured as a novelty number to enable amateur movie-makers to amaze and amuse their friends by making the fat thin and vice versa . . . It had been made for an 8mm.

camera and we made a crude adapter for a Cine Special. The results were not always predictable but we were sufficiently impressed to go on using it. A kind of readymade expressionism was one of the effects.[10]

The lens is used in several Peterson films – *The Lead Shoes* (1949) most extensively.

Distortion through reflection and refraction

The "fun-house mirror," or its optic counterparts, may be used for distorting the image on screen. An early novelty film comedy, *The Madness of Dr. Tube* (*La folie du Docteur Tube*) (1915), by Abel Gance, makes use of distorted images produced from reflections in a warped mirror (the technique is betrayed as the Doctor writes out the antidote for his delusion-producing compound: He uses his left hand, writing in mirror image from right to left). In a starkly different aesthetic sensibility, Ralph Steiner's *H2O* (1929) depicts the constantly ebbing and undulating reflections in the surface of water, reflecting reeds or docks, or the protean striations of light itself reflected off of ripples and waves.

Joyce Wieland's *Water Sark* (1966) begins with the depiction of a "still life" arrangement of a water glass, a robin's egg, a blue ceramic teapot, and a vase with fern leaves. A mirror intrudes into the arrangement, held by the filmmaker, reflecting Wieland's face, with movie camera held up to her eye during the act of filming. The camera moves in to observe the teapot filling the water glass and the refractions viewed through the water. The handheld mirror and water glass alternately reflect and transmit a contorted view of the arrangement of objects. "You take prisms, glass, light and myself to it,"[11] as she described the film.

Another film making use of the refraction of images in a water glass is Leighton Pierce's short work *Glass (Memories of Water #29)* (1998). The drinking glass in the foreground is slowly filled with water framed within a scene of suburban tranquility. In the background, children are playing on a swing. The long camera lens is racked, transforming the background into soft-colored patches of light, bringing the glass into sharp focus as water is poured into it, obliterating the discernible background in a torrent of contorted refractions – bubbles and splashing liquid – within the drinking glass. Smoke from a barbeque seems like some theatrical special effect, and later we see the reflection of fire within the water glass as if some alchemical merging of these contrary elements was taking place within this microcosm.

Stan Brakhage's *The Text of Light* (1974) uses the painterly distortions produced by a glass ashtray placed directly in front of the camera lens. As William Wees describes it:

> In *The Text of Light*, light does flow, pool, fall in streaks, shoot upwards, and take on innumerable forms in an ambiguous space that sometimes seems open to infinity and other times appears as flat as the screen itself. Some viewers see landscapes, cities, forests, oceans, sunsets, faces, and myriad living forms; other see chiefly light, color, texture, and rhythmical movement.... Moreover, the glass itself gives the light a certain density or "materiality," like that of physical objects. The light seems to take on the shapes, textures, movements, even the three-dimensionality of things, yet, things in the film look like light.[12]

The transmitted light is often unraveled through refraction, like strands of the tail end of a rope disentwined, the trailing fibers forming a rainbow of yellow to orange-red on one side, white in the center, and gradations of cyan and sapphire on the other side. The film's overall arc is one of alternating sections of what seem to be sequences appearing to be shot in daylight and others shot at night. The intensely hued light at the start of the film may be a sunset, the film seeming to chronologically document the cycle of changing light of three days and two nights.

Filming with a broken lens

A sequence midway in Jennifer Reeves's *Chronic* (1996) has the camera wandering a hilly landscape comprised of the skin of the hands, feet, arms and legs of the film's protagonist, the troubled, demoralized, teenaged Gretchen. The shots are in extreme close-up, focused with extreme sharpness upon the surfaces of the pads of the toes and a rough-textured callus on the sole of the foot. Beach grass-like hairs and the minute creases on the back of the hand resemble the reticulated landscape of a dried lakebed. Small droplets of blood from lacerated flesh appear: The despondent Gretchen has become a cutter. The sequence was shot with a broken lens that could only focus on whatever was just a few millimeters from it, the extreme proximity also acting to distort the image as with a fisheye lens.

No lens

Filming with no lens at all on the camera is possible and can result in more than simply a blank piece of film, in the right circumstances. Alternations between lensless single-frame shooting and covering up the gate can produce sequences of pure, imageless flicker. Color gels may add a tint to the lensless frames as well. Owing to the lack of control of exposure, shooting at night has the advantage of not producing a completely washed-out frame.

When shooting with no lens using a reflex Bolex, the camera's viewfinding prism will make its presence visible: Out of focus dust spots and imperfections on the prism's surface create a shadowy impression in the otherwise imageless picture.

It's possible to break up the overall fog of light produced with no lens in front of the camera by holding one's fingers over the open gate of the camera. This produces something akin to a slot-like pinhole camera effect from the narrow opening between one's fingers.

Shooting through the viewfinder

Light entering the viewfinder can fog the image. For this reason, reflex viewfinders often can be closed off when shooting without looking through the camera. Guy Sherwin's *Light Leaves* (1978), a three-minute black and white silent film from his *Short Film Series* (1975–2014), uses this particular quality of the camera, with a fixed tableau of the play of sunlight in the shadow of a tree, dark heart-shaped leaves in the foreground and the light-dappled sidewalk in the background. The camera, pointed downward, sometimes catches the light coming between the branches entering the viewfinder, filling the image with haze. The blades of the aperture mask off the light bouncing off the inner elements of the lens, creating a polygon-shaped shadow, more visible on the right side of the image. As the breeze gently moves the leaves above, back and forth, the haze from light through the viewfinder comes and goes.

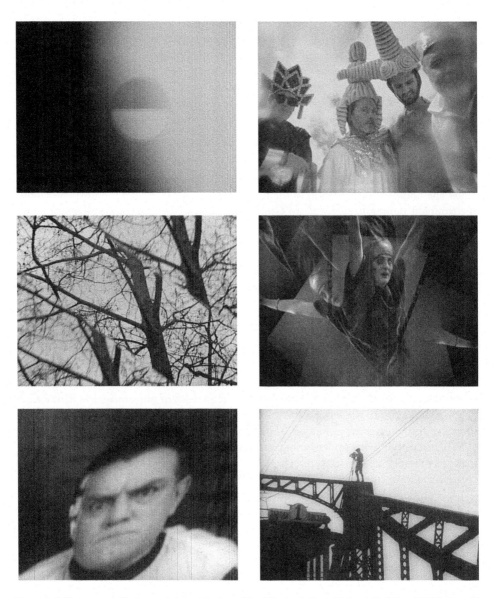

Figure 3.9 **Top row left:** Around the midpoint of Saul Levine's *Born Under A Bad Sign* (2003) from his *Light Lick Series*, the super-8 camera's split focus finder briefly appears in the film, likely due to light bouncing into the camera through the finder. **Top row right:** The Vaseline technique provides softness around the edges of the image, while the center of the frame remains sharp, in Marie Losier's *L'Oiseau de la nuit* (2015). Courtesy of the filmmaker. **Middle row left:** Albert Alcoz's *Triple exposure* (*Triple exposición*) (2013). Filmed in super-8, using a prism in front of the lens. Courtesy of the filmmaker. **Middle row right:** Prisms used in James Sibley Watson and Melville Webber's *The Fall of the House of Usher* (1928). **Bottom row left:** An anamorphic lens used to distort the image in Germaine Dulac's *The Seashell and the Clergyman* (*La Coquille et le clergyman*) (1928). **Bottom row right:** Dziga Vertov's *Man with a Movie Camera* (*Chelovek s kinoapparatom*) (1929). Courtesy of Anthology Film Archives.

Camera sight

The author William Wees begins his book on experimental film, *Light Moving in Time*, by contrasting two divergent approaches of thinking in relation to the camera and sight; namely, the mechanical eye, superior to its human original, as exposed by Dziga Vertov, and Stan Brakhage's concept of using the camera to represent the glossed-over idiosyncrasies of human sight, what he referred to as the "untutored eye."

The untutored eye

The question might be posed: How much do we observe the act of observing? The raw vision taken in by our eyes is processed, codified, made comprehensible by our minds. But what would the world really look like, if this veil of visual processing was lifted away? In his book *Metaphors on Vision*, published in 1963, Brakhage begins with a thought experiment on this question:

> Imagine an eye unruled by man-made laws of perspective, an eye unprejudiced by compositional logic, an eye which does not respond to the name of everything but which must know each object encountered in life through an adventure of perception. How many colors are there in a field of grass to the crawling baby unaware of "Green?"[13]

We disregard the moments when we blink. We assume a steady, clear field of vision before our eyes rather than the darting around from point to point. The constant refocusing of the lens of the eye is mostly ignored. The effect of looking away from a bright light produces a slowly fading after-image of a splotch of color that seems to hang in some dimensionless plane within our vision, but it is seen more as a distraction. Closing our eyes, we are not wholly in the total darkness we presume to be there: We see the light through our eyelids and the glowing static patterns on the retina.

The viewing of the world through sight itself, rather than the polished-up image we imagine we see became the inspiration for Brakhage, starting with *Desistfilm* (1954):

> From open-eyed engagement with the light of the world; to closed-eye visions of dots, sparks, grainy fields of light, and hypnagogic images; to intimations of the electrical patterns of thought itself – Brakhage has pursued the implications of that early, crucial decision.[14]

But even for Brakhage, the camera is not a device to produce an exact facsimile of vision.[15] The camera still reacts as a camera, rather than like a human eye. As Wees indicates ". . . cinematic equivalents of seeing cannot be divorced from the materials and processes of filmmaking . . ."[16] and so such things as unconventional camera movement act as the nearest equivalent (rather than as something identical) to the eye's method of seeing:

> Such camera movements [in *Desistfilm*] are indeed characteristic of the way the eyes actually scan a scene. Rather than slide smoothly from point to point, they make a series of short jumps, or saccades, with intervening pauses of 1/10 to 3/10 of a second. When the eyes follow a moving object, their movements is less saccadic but never absolutely smooth. Even when "fixed" on one point, the eyes are engaged in

three involuntary movements: a slow "drift" away from the point of fixation, a series of tiny saccades that flick the fixation point back to the center of the fovea (where the focus is sharpest), and a continuous high-frequency tremor.[17]

Brakhage's concept of the untutored eye takes the idea of his films being "abstract" and the observational filmmaker's work, considered "realistic," and stands this notion on its head: Traditional filmmaking is artifice. It's cinema shaped into a pretty picture of the world, mirroring the way the mind tidies up our what the eye nakedly sees. If we were really to take a glimpse of the world, as our eyes see it, without our mind's codification and structuring of the raw material of sight, it would appear as a wholly uncanny place.

The mechanical eye: kino-eye

For the filmmaker Dziga Vertov, working in the Soviet Union in the 1920s and 30s, the camera was not a device to emulate vision, as it would be for Brakhage. The camera-eye had an even greater potential, as a supra-human oculus: a machine-eye. In Vertov's words: "We . . . take as the point of departure the use of the camera as kino-eye, more perfect than the human eye, for the exploration of the chaos of visual phenomena that fills space."[18]

> Kino-eye is understood as "that which the eye doesn't see,"
> as the microscope and telescope of time,
> as the negative of time,
> as the possibility of seeing without limits and distances,
> as the remote control of movie cameras,
> as tele-eyes,
> as X-ray etc,
> as "life caught unawares," etc., etc.[19]

In Dziga Vertov's *Man with a Movie Camera* (*Chelovek s kinoapparatom*) (1929), the cameraman, Mikhail Kaufman (Vertov's brother), strides with a heavy wooden tripod over his shoulder as ". . . a heroic participant in Soviet life."[20] On the tripod, the distinctively square metal form of a Debrie hand-crank camera is mounted. It is a film structured around a day, moving about from disparate locations, from factory to fairground. The film foregoes intertitles in favor of total visuality. Its enduring attraction is the sheer ebullience of the mechanical eye's vision of the world. An "overture" of sorts begins the film, with scenes of vacant streets and empty factories in the early hours of dawning light. The drama of this "montage" of the empty stage on which activity will soon commence has the same churlish charm of the long tension-building pause that follows the opening section of a Rossini overture.

The cinematic progeny of Vertov's suprahuman kino-eye – the camera's vision traveling where the person's eye cannot – includes the microscopic views of spermatozoa in Marie Menken's *Hurry! Hurry!* (1957), and Barbara Hammer's *Sanctus* (1990), using footage of X-rays of the human body shot by Dr. James Sibley Watson (the co-maker of *The Fall of the House of Usher*), with depictions of skeletal extending arms, images of food descending from mouth to stomach while eating, and footage of translucent torsos rotating.

Yoko Ono's *Apotheosis* (1970) tethers the camera to a rising balloon, anticipating the use decades later of the camera drone. Jeanne Liotta's *Observando El Cielo* (2007) brings out the hidden movement of the earth under the canopy of the cosmos, pointing the camera upwards at night for long-exposure time-lapse views of the star-filled sky.

The malign side of the mechanical eye is the surveillance camera, ever snooping on shoppers, looking down on highway traffic and passers-by. This form of mechanical eye is the subject of Michael Klier's *The Giant* (*Der Riese*) (1983). The work is prescient of the prolific use of surveillance cameras; the public square turning into something more like a prison yard under the ever-watchful eyes of observers in the guard towers. The title suggests the elevated cameras' view resembling a POV shot of some hulking giant, eyes cast downward. The film's soundtrack, a medley of Romantic-era orchestral music, provides a somewhat farcical gravitas and accentuates something of a visual pun upon the high prospect vistas in Romantic-era paintings such as Caspar David Friedrich's *The Wanderer Above the Sea of Fog* (*Der Wanderer über dem Nebelmeer*).

Outside of avant-garde cinema, one encounters the familiar slogan "Big Brother is Watching You" in George Orwell's novel *1984*, aligning the act of seeing as a statement of power and control. With the Egyptian revolution of 2011, the camera acted as a witness to confront power, in providing video footage of its abuses – images that would otherwise take place obscured from widespread public view. Counteracting surveillance was the impetus of the activist documentary *Red Squad* (1972) by the filmmakers Howard Blatt, Steve Fischler, Francis Freedland, and Joel Sucher (working together as the Pacific Street Film Collective). The film turns its cameras upon the NYPD surveillance unit, who have been monitoring anti-war protesters with their own cameras.

Turning cameras back upon cameras also has its droller instances within experimental filmmaking, such as Hollis Frampton and Joyce Wieland spying upon one another with 16mm cameras in *A and B in Ontario* (1984). A rooftop duel of Bolex cameras took place between Andy Warhol and Marie Menken, scenes of which can be seen in Martina Kudláček's documentary *Notes on Marie Menken* (2006).

For Vertov, the camera's ability to see beyond the human did not make it a tool for surveillance. It was ally to the masses, enabling them to gain insight beyond their own confined conditions. It could see deeper into an object, viewing the history of its production, learning about the people who brought it about, with each vision cascading backwards to the previous aspect of its current state:

> The textile worker ought to see the worker in a factory making a machine essential to the textile worker. The worker at the machine tool plant ought to see the miner who gives his factory its essential fuel, coal. The coal miner ought to see the peasant who produced the bread that is essential to him.[21]

The camera's power to look has also inspired filmmakers seeking to wrest its vision from the authority wielding it. *Symbiopsychotaxiplasm Take One* (1968) by William Greaves gives the camera an autonomy from the director's dictates over the production. The camera's vision is clandestinely hijacked by the crew, who use it to create something of a cinematic letter to the director, offering their critique of the project. Greaves related the film's provocation to the Heisenberg Principle of Uncertainty.[22] It also may be liked to experimental composer John Cage's notion of indeterminacy. Cage had been using chance operations, occurring within a fixed set of parameters, in his compositions. Indeterminacy was a means of taking the notion of chance even further:

> In the case of chance operations, one knows more or less the elements of the universe with which one is dealing, whereas in indeterminacy, I like to think . . . that I'm outside the circle of a known universe, and dealing with things I literally don't know anything about.[23]

Susan Sontag, writing about the photograph, points out how the camera, as a Heisenbergian instrument altering what is perceived, is also an accomplice:

> While the camera is an observation station, the act of photographing is more than passive observing. Taking pictures, like sexual voyeurism, is a way of tactically – often explicitly – encouraging whatever is going on to keep on happening.[24]

While the desire to look has its salacious aspect, artists have used the camera to question the nature of the desiring gaze. The experimental film can use obfuscation. The ephemeral glance may take the place of the steady stare. The body may be viewed as an abstract landscape. The act of looking may be subverted to lampoon the loutish effrontery of the voyeur.

Willard Maas's *Geography of the Body* (1943) isolates parts of the body, disorienting our sense of what we see, as does James Broughton's *Erogeny* (1976). In Elaine Summers's *In the Absence and the Presence* (1985), filmed in stark black and white, a curving line undulates between darkness and light in a slightly serpentine diagonal. We eventually perceive this to be the thighs, knees, and calves of a dancer in black tights. In Mary Paterino's *Rove* (1990), the opening shot views the passing landscape from the window of a train: dry brown reeds and a black iron bridge. From this external world, the scene shifts to the interior of a bedroom, where sunlight through a window blind creates stripes of light and shadow on a nude body, the effect resembling a tract of newly tilled farmland, with the body-turned-landscape not dissimilar to the one seen earlier from the train.

Andy Warhol's film *Blow Job* (1964) taunts the audience's lascivious expectations. A close-up of a young man's face is the subject of the film, at times expressing various states of pleasure. The film withholds a wider shot to confirm the supposition of the film's title. J. J. Murphy writes that

> Because *Blow Job* does not focus on the sexual act itself, but on a reaction shot of the recipient, there's no way of knowing for certain whether the act is actually occurring offscreen. It could be a hoax . . . The film forces the attentive viewer to seek out the small visual cues to verify that an oral sex act is indeed taking place beneath the frame.[25]

The voyeuristic aspect of underground cinema was also gently jeered when Yoko Ono suggestively titled a film *Erection* (1971). The film depicted a building constructed in time lapse.[26]

Shuji Terayama's *Laura* (1974) also treats the subject of the salacious gaze in a mocking manner. If the title, *Laura*, seems to be an oblique reference to the name of author and filmmaker Laura Mulvey, this is just uncanny happenstance. Terayama's film was produced the year before Mulvey had published her influential essay, "Visual Pleasure in Narrative Cinema." Mulvey wrote:

> There are three different looks associated with cinema: that of the camera as it records the pro-filmic event, that of the audience as it watches the final product, and that of the characters looking at each other within the screen illusion. The conventions of narrative film deny the first two and subordinate them to the third, the conscious aim being always to eliminate the intrusive camera presence and prevent a distancing awareness of the audience.[27]

In Terayama's *Laura*, three sinister women with wild hair and heavy white stage make-up, like the hostesses in a cocktail lounge of some haunted netherworld, break the convention of the fourth wall, inviting us to be aware of "the intrusive camera presence." After taking a few bites from a raw fish, they then speak to the camera as if they can see us, the audience within the movie theater:

> There's the type who've just bought and 8mm or 16mm camera. Do they just copy what they see? They're curious what other guys have made. That's why some guys come. Other guys think "avant-garde" means a naked lady. I'll give you a peek if you like. That's what some of them want. We get pervy Peeping Tom businessmen, too. And aspiring literary critics.

Provoked by this taunting, a man gets up from the audience within the movie theater and leaps into the screen to confront the women face to face. Reminiscent of a William Castle movie gimmick, Terayama would stage this using a hidden slot cut into the fabric movie screen so the actor seated among the audience in the theater could slip through on cue with his sudden appearance in the film.

While Warhol's *Blow Job*, described by Gerard Malanga as "A passionate matter handled with restraint and good taste,"[28] alludes to what remains unseen, other filmmakers confront the audience's gaze in a more direct manner. *Near the Big Chakra* (1970) by Alice Anne Parker (Anne Severson) is a seventeen-minute film of static shots of thirty-eight vulvas made to counteract the sense of embarrassment and shame resulting from the constant media diet of idealized artifice regarding the body. For Severson, the power of looking was to be co-opted rather than denied: "*Near the Big Chakra* assumes that it's a good idea to take a look at things, even if they're forbidden, or taboo, or frightening, or exciting, or mysterious, or dangerous."[29]

The camera's gaze is central to Anja Czioska's three-minute super-8 film, *Shower (1994)*, shot in a single take, facing a curtainless shower stall. During her ablutions, the lens begins to mist up from the steam, the scene vanishing from the frame, and Czioska comes rushing up to the camera to wipe the condensation off the lens with the corner of a towel.

While looking may take the form of an uncomfortable power dynamic, so too does the refusal to look – the shunning from sight. Filmmaker Kazuo Hara, while working as an aide at a school for disabled children in Tokyo, accompanied a student in a wheelchair to the metro station, observing that " . . . as soon as we got out onto the platform, everyone would shoot these awful looks at the student."[30] Making his film about people with cerebral palsy, *Goodbye CP* (*Sayonara CP*) (1972), Hara wanted to disrupt this dynamic he was witnessing, in a similar way to how, at the time, Japan's very active student protest movement was disrupting the streets. How the camera was situated in this relationship would be part of his approach:

> Films about people with disabilities that were made for the purposes of social welfare always showed them in the position of being looked at. But what we were about to do was different. In our film, they would return the gaze – that is, reverse it. In practice this meant that Yokotsuka held his own camera, which constantly operated in opposition to mine.[31]

While the sight of death may be an uncomfortable confrontation for many people, it was a resolution to confront his own fears that led to Stan Brakhage filming autopsies in the

Pittsburg morgue in *The Act of Seeing with One's Own Eyes* (1971). The film's long, steady takes – austere and unadorned with superimposition, nor staccato cutting, nor hand-painting, nor any number of other techniques in Brakhage's extended repertoire – suggest an unshrinking determination to look, confronting the fears of death through the gruesome sight of the dismembered corpse.

Brakhage's film is analogous to a Buddhist meditation practice known as *maranasati*. In this practice, human mortality is acknowledged by the prolonged viewing a rotting corpse. This also seems to have been a proscriptive in early-modern Europe as well. The author Joanna Ebenstein, writing about Zumbo's waxwork "Theatres of Death," relates these objects to a time when " . . . meditation on the deposition of the body in the tomb with as much detail as possible was recommended as a spiritual exercise."[32]

Kenji Onishi's feature-length super-8 eulogy *A Burning Star (Shosei)* (1995) presents a mournful (at times macabre) witnessing of the funerary rites and cremation of the film-maker's deceased father. The camera is static, with unhurried scenes oftentimes fading in or fading out to black. The film's climax comes at the crematorium, the filmmaker in white dress shirt facing away from us, crouching with camera, the point of view shifting to the round porthole of the cremation chamber where, in glowing orange flames, the father's skull lays back in serenity, the defleshed rib cage stands erect, and the ashes slowly begin to resemble the craggy landscape of some fiery underworld.

Jerry Tartaglia's *See For Yourself* (1995) and *Ceci N'est Pas* (1997) by Jeanne Liotta also use the camera to view the silent repose of the recumbent corpse; the camera's sight opening our eyes to what we may be too uncomfortable to otherwise perceive.

Consideration of the camera's ability to observe may begin with the principles of optics, but its ability to capture the sight of what is before its gaze may merit thoughtful consideration of its potency.

We have introduced the basic functions of camera in these first three chapters: the mechanism; film and exposure; lenses and optics. In the next chapter, the camera will become the catalyst for creating visions born of the imagination, rather than externally observed; the conjuror's magic box with lens attached, for an array of camera tricks, created by Méliès and adopted by avant-garde experimenters from Hans Richter onward.

Notes

1 Ivens, Joris, *The Camera and I*. New York: International Publishers, 1962, p. 40.
2 Baudelaire, Charles, "The Painter of Modern Life (1863)," in Jonathan Mayne ed. and trans., *The Painter of Modern Life and Other Essays*. London and New York: Phaidon Press, 1964, p. 9.
3 MacDonald, Scott, *A Critical Cinema 3: Interviews with Independent Filmmakers*. Berkeley and Los Angeles: University of California Press, 1998, p. 245.
4 Mekas, Jonas, *Movie Journal: The Rise of the New American Cinema 1959–1971*. New York: Collier Books, 1972, p. 371.
5 Deren, Maya, "Creating Movies with a New Dimension: Time" (1946), in Catrina Neiman with Millicent Hodson ed., *The Legend of Maya Deren Volume I Part Two Chambers (1942–47)*. New York: Anthology Film Archives/Film Culture, 1988, p. 613.
6 During a master class at The New School in 2011.
7 Brakhage, Stan, *Metaphors on Vision*. New York: Film Culture, Inc., 1963 (no page numbers).
8 Brakhage, Stan, *Film at Wit's End*. Kingston, NY: McPherson and Company, 1989, p. 37.
9 Ramey, Kathryn, *Experimental Filmmaking: Break the Machine*. Burlington, MA: Focal Press, 2016, pp. 298–299.
10 Peterson, Sidney, *The Dark of the Screen*. New York: Anthology Film Archives and New York University Press, 1980, p. 20.
11 *The Film-Makers' Cooperative Catalogue No. 7*. New York: The New American Cinema Group, Inc., 1987, p. 490.

12 Wees, William C., *Light Moving in Time*. Berkeley and Los Angeles: University of California Press, 1992, pp. 101–102.

13 Brakhage, *Metaphors on Vision*, 1963 (no page numbers).

14 Wees, *Light Moving in Time*, p. 105.

15 As if filming with the camera in hand were like the martyred St Denis carrying about his decapitated head.

16 Ibid., pp. 84–85.

17 Ibid., p. 86.

18 Vertov, Dziga, *Kino-Eye: The Writings of Dziga Vertov*, Annette Michelson ed. and Kevin O'Brien trans. Berkeley and Los Angeles: University of California Press, 1984, p. 14.

19 Ibid., p. 41.

20 Leyda, Jay, *Kino: A History of the Russian and Soviet Film*. London: George Allen & Unwin Ltd., 1960, p. 251.

21 Vertov, *Kino-Eye: The Writings of Dziga Vertov*, p. 52.

22 MacDonald, *A Critical Cinema 3: Interviews with Independent Filmmakers*, p. 56.

23 Teitelbaum, Richard, "'Live' Electronic Music," in Richard Kostelanetz ed., *John Cage*. New York and Washington: Praeger Publishers, 1970, p. 141. Ellipsis in the original.

24 Sontag, Susan, "Photography," *New York Review of Books Anthology*. New York: New York Review of Books, 1993, p. 102 (NYRB October 18 1973).

25 Murphy J.J., *The Black Hole of the Camera: The Films of Andy Warhol*. Berkeley and Los Angeles: University of California Press, 2012, p. 26.

26 James Broughton and Joel Singer's *Hermes Bird* (1979) provides audiences with the sight they may have expected in Ono's film.

27 Mulvey, Laura, "Visual Pleasure in Narrative Cinema" (1975), in Patricia Erens ed., *Issues in Feminist Film Criticism*. Bloomington and Indianapolis: Indiana University Press, 1990, p. 39.

28 *The Film-Makers' Cooperative Catalog No. 4*. New York: Film-Makers' Cooperative, 1967, p. 152.

29 MacDonald, Scott, *A Critical Cinema 2: Interviews with Independent Filmmakers*. Berkeley and Los Angeles: University of California Press, 1992, p. 326.

30 Hara, Kazuo, *Camera Obtrusa: The Action Documentaries of Hara Kazuo*. New York: Kaya Press, 2009, p. 69.

31 Ibid., p. 76.

32 Ebenstein, Joanna, *The Anatomical Venus*. London: Thames & Hudson, 2016, p. 96.

4 Cine-magic

The trick film and beyond

This chapter covers the influence of the work of Georges Méliès on the avant-garde filmmakers of the 1920s and provides details on filming multiple exposures, matte shots, and other avant-garde in-camera techniques.

It is the trick film, its new possibilities, we will look at next. For filmmakers like Hans Richter, this development – more than the work of the brothers Lumière – was the genesis of cinema. The use of the camera as a means of creative experimentation has its roots in theatrical magic and stage effects by way of the films of Georges Méliès.

The stage magician, in the tailcoat and white gloves of late nineteenth-century evening dress, made use of hidden trapdoors and false-bottomed cabinets to bring about sudden appearances and disappearances; used reflections on a sheet of glass to superimpose a transparent specter in an effect known as Pepper's Ghost; and would command objects to rise, fall, and float – suspended on near invisible wires.

Long before the cinema, the magic lantern show had made use of the trickery of sudden transformations by means of a two-paned "slip slide," and superimposition effects with two lanterns and a graduated shutter known as a "comb dissolver." Moving images projected on a screen existed before cinema. Cinema itself may have been an exciting new novelty but, in this respect, not a wholly unfamiliar experience. As Murray Leeder points out, in *The Modern Supernatural and the Beginnings of Cinema*, the story of the audience reacting in panic at the approaching locomotive in the Lumières' *The Arrival of a Train* (*L'arrivée d'un train en gare de La Ciotat*) (1896) " . . . may be as specious as it is persistent."[1]

Cinema itself operates like a masterfully performed card trick. The quickness of the moving hand can switch one card with another, transforming it from heart to spade within the blink of an eye. The projector likewise performs a quick switcheroo with every frame. The camera must be considered a place of magic transformation too: From inside the box, like the magician's top hat, is pulled the film roll!

For the stage magician, one of the skills to master was the art of misdirection; guiding the audience's attention elsewhere to distract from the mechanics behind the magic. Cloth hides trapdoors; the waving of a magician's wand may direct the eyes of the audience away from the sleight of hand taking place elsewhere. The camera acted as a substitute for the audience when Georges Méliès, owner of the theater founded by the renowned magician Robert Houdin, began making films. His first camera had been constructed from the workings of a projector purchased from the London-based cinematic pioneer Robert W. Paul.[2] But it was not long before the camera took on a different role; that of participant in the magic-making rather than an observer of it.

In *The Vanishing Lady* (*Escamotage d'une dame au théâtre Robert Houdin*) (1896), the camera is stopped as Méliès, performing in the role of the magician, has placed a piece of fabric over a seated woman. She leaves the set while the camera is not rolling. As shooting resumes, Méliès pulls away the fabric, displaying the empty chair. Then, apparently much to the surprise of the magician, a skeleton suddenly appears from nowhere in the chair, also done by stopping the camera and making a substitution. As John Frazer writes in his book about Méliès and his films: "The first part of the trick substituted a film device for a stage device. However, when the skeleton appears out of nowhere, a different order of thinking is involved. There is no longer a stage drape to cover the action."[3] Here, in this appearance of the skeleton coming from nowhere into the chair, with no cloth to hide what goes on, with none of the magician's misdirection, is a sudden materialization impossible in life, impossible through the illusions of the stage but innate to the medium of cinema.

The Méliès repertoire of cine-magic included appearances, disappearances, and substitutions by means of stopping the camera; double exposures, with or without a black background, from the fairly simple to the highly complex multiple exposure; the human fly seeming to crawl up a wall that is actually the floor with the camera placed above; counterfeited underwater scenes with fish swimming in a fish tank in front of the camera lens; giants and diminutive homunculi produced through shooting matte shots at varying distances from the camera; models and miniatures substituted for their life-size counterparts; and pyrotechnics, sometimes produced through a double exposure rather than on the set itself. Méliès also used stage machinery of various sorts, such as the moving eyes in the grotesque face of the telescope-eating moon in *The Astronomer's Dream* (*La lune à un mètre*) (1898), or steamer trunks that convert into miniature railroad cars in *The Merry Frolics of Satan* (*Les Quat'Cents Farces du diable*) (1908).

The short Méliès films – *The Four Troublesome Heads* (*Un homme de têtes*) (1898), *The Man With the Rubber Head* (*L'homme à la tête de caoutchouc*) (1901), and *The Melomaniac* (*Le Mélomane*) (1903) – demonstrate his virtuosity in multiple exposure through playful variants on tricks of uninjurious decapitation. In *The Four Troublesome Heads*, a black background serves to allow for additional exposures of the detached heads to rest upon a table. The tabletop is incorporated into the double exposure so that the heads can rest solidly on it without appearing transparent against the table's surface. *The Melomaniac* is another version of this technique, all the more impressive for the greater number of re-exposed elements.

In *The Man With the Rubber Head*, a ramp was used so the expanding head would remain in the proper position in the frame. As Frazer explains:

> To give the illusion of the head being inflated, Méliès could have moved the heavy camera forward on rails. Instead, he moved the figure toward the camera, a device he used again in the famous close-up of the face of the moon in *A Trip to the Moon* . . . The distances on the ramp had been calculated so that the focus could be progressively changed by the cameraperson as the head came closer to the lens.[4]

The ramp was key to the illusion, since it allowed the head to appear to grow upwards while still resting on the surface of the table. Without the ramp, the head would have expanded equally, on both the top and bottom, and would have no longer appeared to be resting on the table.

After making hundreds of trick films (and a smaller number of theatrically staged recreations of newsworthy events), Méliès eventually began to face financial difficulties not

only from the cost of his productions but also due to the business arrangements among the consortium of film distributors. However, as Frazer points out, the trick film itself was losing its vogue: "Audience tastes were also changing because of a new kind of cinema that began to appear . . . The twentieth century had arrived and Méliès was no longer in his century."[5] His company, Star Films, ceased film production in the early 1920s.

The trick film was quite a passé genre by the late 1920s, when its techniques found a second life in the films produced by avant-garde artists. Hans Richter, one of the artists to embrace the medium of cinema, described this:

> While the fantastic film only survived more or less at the periphery of the fiction film, it was reinvented and rediscovered by the avant-garde cinema, which once again put the emphasis on the miraculous and the inventive enjoyed for their own sakes – René Clair's slow motion funeral, Richter's flying hats, Disney's shooting organs. Twenty years after the possibilities of the camera had been discovered, they were rediscovered by the avant-garde.[6]

Richter's short film *Ghosts Before Breakfast* (*Vormittagsspuk*) (1928) best exemplifies this rediscovery. It pulls out all the stops in a grand toccata of cine-magic: a flock of flying bowler hats is the iconic image from the film, levitated by means of thin strings on the ends of sticks. Within the film are the use of such trick-film techniques as reverse motion, with a fire hose reeling and unreeling, water pouring in reverse back into the hose; revolvers appearing through Méliès-style jumps; a row of men scratching their chins (Richter is in the center of the group) while disheveled beards grow and disappear by means of a dissolve; people disappearing behind a light pole by means of a matte shot; multiple superimpositions of a target refusing to hold still as a pistol-wielding man attempts to take aim; cut-out animation of a waving hand disjoining itself from the wrist; superimposition of gramophone records (in negative) hovering on strings; a combination of animation and reverse motion when leaves appear growing on a branch, shot by clipping off the leaves and branches rather than adding them on; animation of coffee cups on a table, filling themselves. There is another use of reverse motion to allow the flying bowler hats to alight perfectly upon the heads of the participants of the outdoor coffee klatch, this artful manoeuver done by filming in reverse and pulling the hats on strings off of the heads. A few effects in the film are obviously done through post-production rather than in-camera, such as the freeze-frames as the shattered cups reassemble themselves and come to rest on the waiter's tray. The waiter's halting gait is also the result of a series of freeze-frames produced through some post-shooting method.

The film was not merely a work of experimental whimsy; it was seen at the time as a subversive political statement:

> The film's political overtones appeared obvious to censors and caused difficulties for Richter. The Nazis, too, saw the film as a political satire that was intended to convey destabilization of the status quo. This was significant, as National Socialism was rapidly gaining ground in Germany, especially in the big cities. *Vormittagsspuk* was looked upon as an invitation for people to be critical, to ask questions and to keep watch on the way political events were developing.[7]

Ghosts Before Breakfast shares the sense of unbounded absurdity so profuse in the world of Méliès. The chaos of inanimate objects gone awry in *Ghosts Before Breakfast* is also present

Figure 4.1 **Top row left:** The skeleton appears through cine-magic in Georges Méliès's *The Vanishing Lady* (*Escamotage d'une dame au théâtre Robert Houdin*) (1896). **Top row right:** Georges Méliès's *The Man With the Rubber Head* (*L'homme à la tête de caoutchouc*) (1901). Note the black background behind the head. The black background allows the head to appear solid, rather than transparent, in the superimposition. **Middle row left:** Georges Méliès's *The Four Troublesome Heads* (*Un homme de têtes*) (1898). **Middle row right:** Filming in reverse allows for the hats to land precisely on the heads in Hans Richter's *Ghosts Before Breakfast* (*Vormittagsspuk*) (1928). **Bottom row left:** Marjorie Keller's *Superimposition (1)* (1975). Courtesy of The Film-Makers' Cooperative. **Bottom row right:** The trompe l'oeil effect was used to created the appearance of a double-exposed image of "ZuZu und Wienglas" in Julie Orlick's *Trauer Natur* (2018).

in such Méliès films as *The Inn Where No Man Rests* (*L'Auberge du Bon Repos*) (1903). Méliès was, in Richter's words, ". . . the first to unlock the secret powers of the camera,"[8] telling Herman G. Weinberg in 1951: "We're all lineal descendants of Georges Méliès . . . He was the first to know what the cinema was for – not because he invented the trick film, but because he instinctively knew what the main esthetic of the film is."[9]

The admiration was returned when Henri Langlois arranged for Méliès to see *Ghosts Before Breakfast*, and the two artists met in Paris in 1937.[10] Richter planned to work with Méliès on an adaptation of the famed tall tales of Baron Münchausen, a film to be called *Baron de Crac*, but Méliès passed away before the project could get started, closing this beguiling possibility of the union of cine-magic and avant-garde. The story of this unfulfilled collaboration is recounted in Harry Waldman's book on unmade, lost, and unfinished films, *Scenes Unseen*.[11]

Some makers of the avant-garde incarnation of the trick film displayed the same zealous enthusiasm for these techniques that had desensitized the audiences to the effects proliferating the early trick films. P. Adams Sitney comments on this predicament, with regard to Sidney Peterson's film *The Cage* (1947), with its frenzied bricolage of varied forms of camera magic including: optical distortions, reverse motion, cut-out animation, slow motion, and superimposition. "Peterson attempted so many things that the film is much more interesting than it is successful."[12]

A survey of the contents of cine-magic's cabinet of wonder begins with an adaptation of stage magic.

Pepper's Ghost

The distinctly photographic effect of double exposure has its precedent outside of the camera, remarkably enough, in a theatrical effect known as Pepper's Ghost. The effect is named for its innovator John Henry Pepper, the nineteenth-century showman of scientific demonstrations for the stage. A large pane of glass was placed at an angle, the edges obscured in some manner so as to make it "invisible" to the audience. An actor in ghostly attire stood offstage in front of a dark background and would then be illuminated, the spirit's reflection appearing in the glass but, from the audience's perspective, seeming to have become manifest as a semi-transparent phantom there upon the stage itself.

This archaic bit of stage magic has its usefulness as a cinematic technique, as well. Filming reflections in a window, as Stan Brakhage did when filming the elevated trains at the request of Joseph Cornell in *The Wonder Ring* (1955), takes advantage of this naturally occurring superimposition. As P. Adams Sitney puts it, the film unfolds in

> . . . a continual flow of movements; not only of the train itself, whose forward motion is inferred from the passing sights outside the window, but also of the reflections moving in the opposite direction within the car, and of the bouncing patches of sunlight intersecting both the movement of the train and the inverted movement of its reflection.[13]

Holly Fisher's *Glass Shadows* (1976) also uses a variation on the technique of Pepper's Ghost, with reflections in a glass door appearing as a transparent layer of superimposition against an illuminated window further in the background of the shot.

The use of reflections as a form of naturally occurring superimposition can be especially effective when the edges of the window or glass pane are outside of the film frame, hiding the secret of the simple technique. When done in a more controlled situation, the relative brightness of the lighting may be adjusted between what is seen through the glass and what is reflected in it to achieve the desired balance, such as using lights with a dimmer. Obviously enough, unlike double exposure, which must be shot in multiple passes through the camera, the superimposition from a glass reflection can be seen through the viewfinder at the time of shooting, rather than the results seen for the first time when the film is back from the lab.

The reflection, naturally enough, will be in mirror image, so the Pepper's Ghost effect has its drawbacks where left-right orientation is needed, as with text, unless it can be created in mirror image, so as to read correctly upon reflection.

The adaptation of Pepper's Ghost for filming is especially useful when the film cannot be adequately rewound in the camera, as is the case with super-8 cartridges. "You can create double-exposures without backwinding – with simple mirror shots,"[14] writes Rod Eaton in the February 1976 *Super8 Filmmaker Magazine* in the first of several articles touting the merits of this technique. Eaton suggests use of a beamsplitter or a half-silvered mirror (also known as a two-way mirror) rather than an ordinary sheet of glass. Differing results, using these materials, are to be expected.

The term "glass shot" might be used for describing this type of superimposition by means of reflections in glass, but the term has already been taken for another low-tech technique in the classic special effects repertoire. The term "glass shot" usually refers to the painting of fanciful background elements added to a scene by filming through the pane of glass. The film's ultimately flat image on the screen helps to bring about this trompe l'oeil illusion.

The in-camera cut

Starting and stopping the camera, the cornerstone of Méliès cine-magic, is said to have begun with an incident as dubious as the story of the audience reacting to the Lumière train:

> Méliès supposedly discovered the substitution trick, which permits one object to change instantaneously into another, because his camera jammed while he was filming *The Place de l'Opéra* in 1896 ... When the film in question was screening it could be seen that the break in shooting (while the jammed film was freed) had caused an omnibus to change into a hearse.[15]

The hearse just seems all too perfect a transmutation, and the footage is not extant to verify this. However it came about, it was repeatedly and masterfully employed by Méliès: "One is struck in ... [*The Vanishing Lady*,] as in all of Méliès' films, by the precise way in which Méliès is able to hold or regain nearly exact positioning of his body."[16]

Starting and stopping the camera, in many cases, will produce an overexposed frame as the camera starts and goes up to speed from a full stop. Where the camera does not have a system for stopping with the shutter closed (as spring-driven cameras mostly do), a white flash frame appears between shots. The absence of a flash frame in the Méliès films is the result of edits rather than purely in-camera cuts.[17] So one could rightfully contend that Méliès did not work with wholly "in-camera" effects.

While the effect goes back to *The Vanishing Lady*, it is also the principal effect in Méliès's films *The Astronomer's Dream* (*La lune à un mètre*) (1898) and *The Inn Where No Man Rests* (*L'Auberge du Bon Repos*) (1903) to name just two of the numerous examples in the extant Méliès oeuvre.

Maya Deren brings this effect into the territory of the experimental film, with the appearances and substitutions of key and knife as the woman and her doubles sit at the table together in *Meshes of the Afternoon* (1943). The technique is also used as the woman instantly changes location in the frame in a sequence looking down the stairway. Katherine Bauer's *Circa I* (2009) has a seated sorceress facing the camera, performing magic spells through this same method of Méliès cine-magic.

Reverse motion

Curiously enough, it was not the magician Méliès who made early use of reverse motion as a magical effect on screen. At a screening of Lumière's *Demolition of a Wall* (*Démolition d'un mur*) (1895), the projector was run forward and then backward to show the wall reassembling itself. Reverse motion effects are also used quite a bit in Hans Richter's *Ghosts Before Breakfast* (*Vormittagsspuk*) (1928), as noted previously.

Double exposure

Re-exposing an exposed piece of film will fuse together two layers of images, and while the term double exposure implies just two passes through the camera, the term may refer to any number of multiple exposures on the same piece of film. The term "double exposure" is offhandedly used as a term synonymous with "multiple exposures," generally speaking.

Superimposition of images may also be created after the fact, in post-production, which has some obvious advantages over the effect in-camera. Post-production superimposition allows for the selection of takes; synchronizing of images; adjustment of relative exposure; and combinations impossible in-camera: black and white with color, or negative with positive, or the same footage superimposed with itself. Despite all of this, there is something quite satisfying in achieving this effect through shooting. The sense of virtuosity of the cinematic craft may give gratification in itself. But there is a subtle advantage of double exposure done in-camera: The enmeshing of the images will have a different look than when combined in post-production, feeling less like a synthetic digital effect. If working more within the analog realm, the superimposition is present in the footage without the need to go down an additional generation, as would be the case with superimposition created as an optically printed effect.

Some films making extensive use of double exposure include Harry Smith's series of *Late Superimpositions* (1964), Ron Rice's *Chumlum* (1964), and Marjorie Keller's *Superimposition (1)* (1975).

Methods for filming double exposures

With a camera that has the capability to run in reverse or, like the Bolex, be back-wound, multiple exposures can be filmed conveniently in-camera without resorting

to unloading the film. This is useful in the case where two specific images align with each other to minimize the possibility of the camera shifting. Make careful note of the start-point of footage and frame counters and the duration of the shot. A lens cap can be used on camera that does not have a variable shutter to close when rewinding the film.

Rewinding and re-exposing the film may require a very meticulous attention to the steps involved. But meticulous attention does not mean shooting in a rigidly wooden manner. In the multiple-exposed works of Paul Clipson, the camera is backwound a few seconds, shot for a few seconds more, and then backwound again. Thus, each image appears up on screen somewhere in the midst of another shot, the layers of exposure easing in rather than starting and stopping in exact unison. The layered exposures are stacked not unlike the alternating courses of bricks in a wall.

In other situations, it may be advantageous to shoot through the entire roll, backwind to the very beginning, and expose again from start to finish, rather than double exposing each sequence one at a time. A word of caution regarding this: If backwinding in the camera, then care must be taken that the roll has not gone entirely through the camera and is now just sitting on the take-up reel. On a camera that uses 100ft daylight spools, it is prudent to stop shooting at around 95ft and then backwind to the beginning (or maybe less than 95ft if the roll was spooled down, in which case it may be slightly shorter than 100ft). If the film has run out, then the camera will need to be opened up and threaded from the take-up to the supply (an awkward but not impossible thing to do on a camera like the Bolex) before backwinding.

A camera that cannot be backwound or run in reverse is still capable of being used for double exposures. But it requires the additional step of rewinding the film in a darkroom with a pair of rewinds (the same step-up as is used for respooling film from 400ft on a core onto 100ft rolls on daylight spools) after shooting through the entire roll. This method of rewinding an entire roll and reshooting does not really lend itself to working with specific shots in a precise manner with two exposures beginning and ending at the same time. The footage and frame counters lose their exact point of reference when the film is reloaded into the camera.

In the days when double-perforated film was more common, it was easier to rewind an entire roll, threading the tail-out film into the camera again and running it through with the shutter closed, thus using the camera as a rewinder.

While the term "double exposure" designates the use of superimposition over the whole frame, discreet areas may also be masked off and re-exposed to create another form of double exposure: the matte shot. In the absence of a physical matte in front of the camera lens, the use of dark areas of the image (such as filming with a black background) will also leave unexposed areas in the frame to receive another image in a somewhat similar manner.

Multiple layers of exposure can affect the brightness of the image, each layer adding to the exposure of the film. The use of double exposure tends to favor bright subjects superimposed against dark backgrounds. Exposing the film is a one-way process: Once the silver halides are exposed, a darker image cannot vampirically suck away brightness from the exposed areas of the film. An example of the additive nature of exposure is found in the problem of pairing together bright and dark layers of exposure: The dimly lit image is a barely discernible wraith-like tracing behind the brighter image. This is not an uncommon occurrence when double exposures are shot in a variety of lighting

conditions. Passing moments within Harry Smith's *Late Superimpositions* (1964) and Marjorie Keller's *Superimposition (1)* (1975) are examples of this. Also worth noting is that the order in which different exposures are shot onto the film does not matter: A bright image may overwhelm a darker one regardless of being exposed first or last. For this reason, an exposure compensation may be useful, although the type of exposure compensation can vary, depending on the nature of the two images being superimposed. Sometimes a catch-all compensation of closing the lens one f-stop is suggested, but this is the case in only certain instances.

Exposure compensation

Double exposure with a lock-down "ghost effect"

The effect of a transparent figure within a solid environment is produced by shooting the same composition twice: once with the empty space and, after rewinding the film to the starting point, a second time with the person in the frame. Great care should be taken that the camera does not shift at all between the two exposures – what is known as a "lock-down shot" – otherwise the result will have an off-register effect (not unlike the appearance of off-register printing). When the background of the shot has been double exposed over itself in exact alignment, it will appear as if it has not been superimposed. The "ghost" is only in one of the two exposures; the other exposure visible through its body.

The exposure compensation for this type of ghost effect is made by closing the lens one f-stop. In this case, the background image is exposed twice on the same piece of film, and the reduction by one f-stop corrects for this. This can be altered to add or subtract transparency to the ghost in the shot: Shooting the exposure of the empty background with a compensation closing down by two thirds of an f-stop and the shot with the figure present shot at by closing one third of an f-stop will produce a less transparent specter.

An example of a more contemporary use of this antiquated in-camera effect is found in Rachael Amodeo's fairy-tale film *Rest in Peace* (1997).

Double exposure with similarly lit subjects

Double exposures with the same general type of lighting will usually call for an exposure compensation by closing down by two thirds of an f-stop for each image. This will produce a fairly equal range of things being a little darker or brighter than normal with two superimposed images.

It's well worth asking why this would not be one full f-stop if two exposures is "doubling" the light. Closing the lens by one full stop in this instance may produce a result that appears underexposed: The overlapping bright areas of the image will not be any brighter than normal (one stop under plus one stop under equals normal exposure), while darker overlapping areas of the frame will be underexposed. Closing two thirds of a stop allows for the brighter overlapping areas to be a little brighter while the rest is a little darker, effectively centering the exposure between bright and dark areas of the frame when superimposing two images.

Matte shot or a black background

When images are combined in multiple exposures using a matte or black background, then no exposure compensation is needed: The unexposed areas of the frame (the matte) add no additional exposure to take into account.

Examples of this can be seen in a number of Méliès films, beginning with *Four Trouble-some Heads* (*Un homme de têtes*) (1898), wherein the set incorporates a black background. This is done so that the superimposed figure doesn't appear transparent against the background. Black fabric is also used to mask elements such as the headless body in the film. Other films using matting techniques include scenes from Maya Deren's *Meshes of the Afternoon* (1943), Peter Cramer's *Black & White Study* (1990), and Tomonari Nishikawa's films of the Tokyo metro system.

Other instances of exposure compensation for double exposure

Simple exposure compensations work well in instances where the subjects are relatively equal in terms of tonal value. But when there are different lighting conditions or combinations of subjects and backgrounds that are very bright or dark, there is the possibility of one exposure overpowering the other, with the darker image appearing as the faintest ghost-like suggestion.

This is not to say that light backgrounds should never be used but that there will be a different effect produced. With a dark subject and light background, the background acts more like a stencil, with the other image more prominently visible within the object. An example of this is Margaret Rorison's *vindmøller* (2014), which uses multiple exposures of wind turbines seen against an overcast sky (a still from this film is reproduced in Chapter 6).

So what does one do when wanting to double expose images of a disparate nature and not end up with the washed-out effect? To a certain extent, underexposing the brighter image while overexposing the darker image may compensate for this. But by how much is the question. Taking a reflective exposure meter reading of the light bouncing off of the subject may assist in this undertaking. But other, alternative, methods may also prove effective.

Working with light and dark

In much the same way as a black background was incorporated into the painted backdrop of Méliès films in the form of the black space beyond an archway, for instance, double exposures can make use of any type of naturally occurring shadow areas within the frame to act as a form of matte shot. An example of this is the concluding shot of James Broughton's *Dreamwood* (1972): A man stands on a hill facing the camera, backlit, his form in silhouette. Superimposed in the void of his chest is the moon against the black night sky. The silhouette acts as a "matte," allowing the two images to appear without one interfering with the other.

Rosalind Schneider's short film *On* (1972) uses dark and light areas of the frame for superimposing. The dark, chiaroscuro shadows on the skin of a nude couple are superimposed with neon lights shot at night. The film's sense of the playful centers on combining images of private nature and public displays of advertising slogans loaded with double

entendre. Schneider's short film *Irvington To New York* (1972) also makes use of dark areas of the frame, but whereas *On* is a nocturne of superimposition, *Irvington To New York* takes the form of a daylight train ride, with the framing of the train's dark interior providing areas for the second layer of images to be discerned, contrasted with the bright exterior views of the Hudson River seen from the train window.

Changing the exposure while shooting

Changing the f-stop while filming layers of double exposure allows each of the images to become more discernible in turn, rather than sit statically on a shot, where one image is dominant. Marjorie Keller's *Superimposition (1)* (1975) contains some instances of changing the iris while filming bright exterior shots, allowing the darker images of night and interior to rise to the film's surface.

Changing focus while shooting

In the same way that changing the f-stop while shooting can be preferable, rather than simply sitting on a shot where one image is obscured by the other, changing focus while shooting can give each image the appearance of advancing and receding as it comes in and out of focus.

Moving the camera while shooting

Constantly reframing the shot by filming with a moving camera is another solution to avoid a superimposition that lingers on a less than successful combination of images.

Short shots

The short shots in Rosalind Schneider's *Irvington To New York* (1972) allow the superimposed images to appear and be replaced in varying combination, with an image appearing midway through its companion exposure. This allows for the variation in exposure and subject matter to ebb and flow; if one combination is not as effective as another, it is soon replaced by something else rather than the camera lingering on an awkwardly balanced set of exposures.

In-camera dissolves

Cameras like the Bolex allow for the variable shutter to be opened and closed, fading the image in or out. Double exposing a fade in over a fade out can be used to produce a lap dissolve. Fades may be used throughout a roll to allow images to enter and exit in a layered manner, coming in midway through the other image's presence. The films of the San Francisco filmmaker Paul Clipson provide many examples of this technique.

Matte shots

While full-frame double-exposure shots create an effect of transparency of the images overlaid with one another, the matte shot is a means of maintaining opacity of combined

images, dividing the frame into separately exposed areas rather than the exposures blending together over the whole image.

A basic example of the use of mattes is the "split screen," which may have disparate images on either side or an invisible seam joining separately shot halves of a single, lock-down composition. A prime example of this is found in Hans Richter's *Ghosts Before Breakfast* (*Vormittagsspuk*) (1928), in a sequence where several people stroll along a path in a city park, giving shifty glances before disappearing behind a light pole, seeming to vanish in thin air rather than emerge on the other side of it.

Half of the image was masked, with something like black cardboard in front of the lens, and the scene exposed with the empty side of the light pole. The film was rewound in the camera to the start of the shot. The matte's complementary half was put in front of the camera, masking off the exposed half of the frame. The row of people sneaking behind the pole was then filmed, completing the exposure of both halves of the frame.

This type of matte effect is also used briefly in Maya Deren's *Meshes of the Afternoon* (1943), when two incarnations of the same woman sit at a kitchen table. A third incarnation appears, but her presence is established through careful eyeline edits rather than a matte effect.

The lock-down matte shot is also the basis of two similar sequences in works old and recent: *The Fall of the House of Usher* (1928) by James Sibley Watson and Melville Webber and Marie Losier's film portrait of experimental theater director Richard Foreman, *The*

Figure 4.2 The matte shot from Maya Deren's *Meshes of the Afternoon* (1943). The images here simulate the two exposures and the result: a pair of corresponding mattes placed in front of the camera lens during filming.

Ontological Cowboy (2005). In both of these films, people walk from either side of the frame to a seam between the two exposures in the center of the frame, disappearing into a void that has no visual camouflage as with the use of the light pole in Richter's city park.

Working with the matte shot seam

Oftentimes the challenge of a matte shot is the matter of avoiding the visible seam between the two halves of the frame. A bright streak of overexposure comes from the two mattes having a gap between them, or a dark unexposed line from the two mattes overlapping rather than meeting perfectly. A few methods can be utilized to reduce the chances of this:

- Having a very carefully designed system of aligning the mattes.
- Having some form of visual camouflage to obscure the seam, such as the light pole in *Ghosts Before Breakfast*.
- Adjusting the focus of the matte, through control of depth of field. A matte with a soft edge will allow for some discreet blending of the two images rather than a hard-edged seam.

Control over the sharpness or softness of the edges of the matte involves a number of interconnected factors:

A: Focal length of lens

The focal length of the lens will affect the matte. A harder edge is produced with a wide lens. A telephoto lens often proves impractical for matte work, since the shallow depth of field can render the matte so completely out of focus as to be practically unseen in the frame.

B: F-stop setting

Changing the f-stop will alter depth of field and consequently make the matte's dividing line sharper or softer. Changing the distance of the matte from the lens can be used to counteract this if the matte is too sharp or soft. Neutral density filters may be helpful for fine-tuning the depth of field for a matte shot.

C: Distance of the matte from the lens

The matte is typically very close to the camera lens, rendering it out of focus when focusing on subjects further away. Moving the matte closer to the lens will soften the edge, and moving it farther away will sharpen it. A matte box with sliding rails is useful for making this adjustment.

As may be obvious from the above, a cleanly composed matte shot may be challenging in instances where the two sides are to be filmed with differing focal length lenses, or in lighting situations requiring different f-stops, or when focusing at different distances. Each of these can produce a mismatched seam, sharp on one side and soft on the other.

A vertical splitting of the image with mattes occurs in *Dream of a Rarebit Fiend* (1906), Edwin S. Porter's short trick film based on the comic strip by Winsor McCay, created in a manner which somewhat emulates the style of Méliès: In a dream, three little imps emerge from the pot of Welsh rarebit. Later in the film, the inebriated sleeper clings to his bed as it flies over the city.

Matte shots are a central element to the short film *Black & White Study* (1990) by Peter Cramer. Peter Cramer and Jack Waters are filmed unclothed against a blank background of photographic set paper, one background black, and the other white. The use of these spare elements and the term "Study" in the title may suggest an impersonal work of formalist concerns. While the film is structurally rigorous, it is not impersonal. *Black & White Study* is a filmic love poem between two men, black and white, Jack and Peter. After a series of intercut shots of each of them, alone, they turn in towards one another. The frame is bisected by a matte, the men's hands reaching from either side towards the center seam. They pull each other inward, arms and legs and torsos protruding from the matte shot seam on either side. Towards the film's conclusion, four mattes divide the frame with close-ups of the two men's bodies.

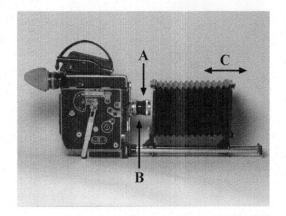

Kurt Kren's *31/75: Asyl* (1975) uses a complex combination of mattes and multiple exposures on a fixed composition of a landscape. Tomonari Nishikawa's *Tokyo - Ebisu* (2010) and *Shibuya - Tokyo* (2010) work with a grid of mattes to divide up the image. The multiple exposures in these films become an effect not just of space but also of temporality, showing different moments of time taking place simultaneously. Nishikawa's *Ten Mornings Ten Evenings and One Horizon* (2016) uses multiple slats to expose vertical strips of a landscape shot at different times. A photograph taken by the filmmaker of the Bolex camera with

Figure 4.3 **Above:** The sharpness or softness of the edges of the matte are controlled by the following factors: A: Focal length of lens. wider = sharper/longer = softer; B: F-stop setting. closing down = sharper/opening up = softer; C: Distance of the matte from the lens. further away = sharper/closer = softer. Neutral density filters may also be used to control the sharpness or softness of the matte. **Below:** The matte box used by filmmaker Tomonari Nishikawa for *Ten Mornings Ten Evenings and One Horizon* (2016). Courtesy of the filmmaker.

Figure 4.4 Gaffer tape used to create a matte with a 10mm lens, taking advantage of the extreme depth of field of the wide lens to mount the handmade matte directly, without the need for a matte box.

matte box reveals the working method used for this film.

The matte box

The matte shot often entails a level of precision in aligning mattes and using the matte's distance from the lens to adjust the sharpness or softness of its edges. This is done before filming, by sliding the front end of the matte box back and forth along the rails while looking through the viewfinder to find the preferred distance. This should be done with the lens set to the f-stop that will be used for shooting. Otherwise, closing down the lens will change the matte's sharpness from what was seen in the viewfinder due to the change in depth of field.

Sometimes the matte box is used without a matte as a large, adjustable lens shade.

Working without a matte box

While the matte box offers considerable control in shooting a matte shot, it does not prevent working with mattes in other ways.

Black gaffer tape can be affixed to the top and bottom of a 10mm lens; a smaller inside piece and longer outside piece are stuck together to create the matte. The accompanying illustration shows how this is accomplished. It won't produce as exacting a matte as the matte box, but if you align the second matte on the lens before taking away the first one, it becomes easier to avoid too much of a seam between the exposures. It's also easier to work in this manner with just one lens mounted on the turret (the others will get in the way).

Bruce Baillie wore a black glove for the matte shots in the opening sequence of *Castro Street* (1966), allowing him to show a smokestack within a small circle on the screen, created with his hand in front of the lens and performing an "iris out" by opening his fingers.

Stan Brakhage's 8mm film *Song 7* (1964), filmed during a visit to San Francisco, appears to use fingers in front of the lens to create mattes as well, blocking out different sections of the frame in halves, thirds, or crosswise to allow the other layers of exposed images to appear within these expediently created matte shots.

When filming through a window, mattes can be attached to the glass. This technique is suggested by trying to puzzle out the methods used in Kurt Kren's *31/75: Asyl* (1975), although it may not have been his means of creating the film's complex series of mattes building – in jigsaw puzzle fashion – the film's composite image.

Using a mirror instead of a matte

A variation on the Pepper's Ghost effect is a matte shot made with a mirror rigged in front of the lens at an angle, only partly covering the image. To have the edge of the mirror not reveal the nature of this camera trick but make it appear closer in nature to the seam in a

matte shot, the mirror should be placed close enough to the lens so that it is out of focus, the edge of the reflected image thereby blending with the view directly in front of the lens.

As with Pepper's Ghost, this is a useful way to create a split screen in super-8, since rewinding is usually not an option.

Superimposed color separation

Early color processes like Technicolor would expose black and white film with color filters, a beamsplitter in the camera allowing for two or three rolls of film to be exposed in tandem. The corresponding negatives, each shot with color-filtered light, would then be used to reconstitute the color onto one strip of film in printing. The three filters in three-strip Technicolor correspond to the primary colors of light: green, blue, and red. A combination of any two of these will produce the secondary colors of light: magenta, cyan, and yellow. White light is produced by the combination of all three.

This method has inspired filmmakers to experiment with color separation through shooting multiple passes with color gels to be combined later, as in the case of Tomonari Nishikawa's *45 7 Broadway* (2013). Guillaume Cailleau and Ben Russell's collaborative film, *Austerity Measures* (2011), also uses this technique. In these experimental color separation films, the color elements are not shot simultaneously. They are filmed one after the other, allowing for differences in each exposure to diverge: A person, or car, or bicycle transversing the scene disrupts the merging of colors, producing a magenta or cyan or yellow "ghost" image passing through the shot.

Miniatures

Filming miniatures to substitute for their full-scale counterparts typically invites advice to create a convincing sense of illusion of scale: The height of the camera should correspond to an eye-level view proportional to the height of the shrunken-down models, rather than looking downward from on high. It's also advisable to shoot at an aperture with the requisite depth of field to counteract the shallow depth typical of a macro shot.

Méliès's films, especially the journeys by airship, space capsule, train, and submarine, make use of miniatures. Edwin S. Porter's trick film, *Dream of a Rarebit Fiend* (1906), includes a sequence where the hapless protagonist throws the covers over his head, and the film cuts to a long shot of the bedroom where the bed raucously whirls and cavorts around the room before leaping out of the window. The cut has substituted a miniature room, with the miniature bed spinning and jumping from the tugging of unseen marionette wires.

Moving from the trick film into the work of the avant-garde, *The Seashell and the Clergyman* (*La Coquille et le clergyman*) (1928) by Germaine Dulac has a recurring series of miniature sequences, showing a subterranean sea and an island citadel resembling the isle of Mont Saint-Michel, appearing and expanding upwards in a series of dissolves. A model of a galleon at full sail bobs unsteadily in the water towards the island fortress. Its artifice seems accentuated by the bird's-eye view, in terms of scale and camera position.

In George Kuchar's 8mm film, *A Town Called Tempest* (1963), a Midwest tornado unleashes its wrath upon plastic miniatures arranged in a water-filled fish tank. A disturbance from off-screen ripples the water, sending the houses, fences, and electrical poles swirling about in the vortex. "The special effects were costly (for us) . . . $120."[18]

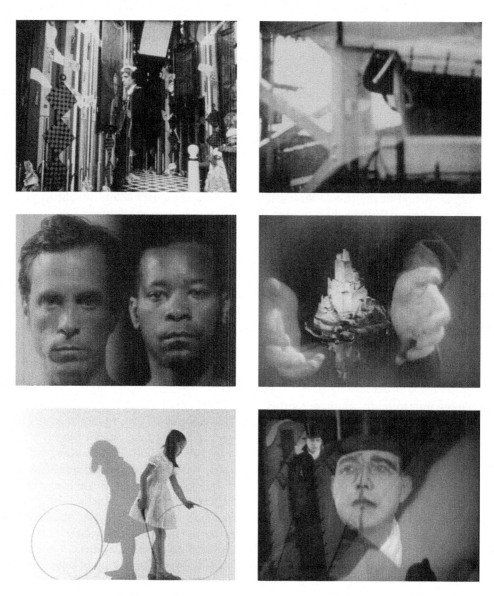

Figure 4.5 **Top row left:** Figures emerge and disappear mid frame with the use of mattes dividing the frame during a sequence in Marie Losier's *The Ontological Cowboy* (2005). Courtesy of the filmmaker. **Top row right:** Rosalind Schneider's *Irvington To New York* (1972) makes use of the dark and light areas of the frame for combing images through superimposition. Courtesy of The Film-Makers' Cooperative. **Middle row left:** Matte shots are used throughout Peter Cramer's *Black & White Study* (1990). Courtesy of the filmmaker. **Middle row right:** A miniature from Germaine Dulac's *The Seashell and the Clergyman* (*La Coquille et le clergyman*) (1928). **Bottom row left:** An independently moving shadow created with a backlit screen in Shuji Terayama's *Shadow Film – A Woman with Two Heads* (*Nito-onna – Kage no Eiga*) (1977). **Bottom row right:** Artifice and inventiveness are the appeal of James Sibley Watson and Melville Webber's *The Fall of the House of Usher* (1928).

In a similar vein, the Méliès films *Divers at Work on the Wreck of the "Maine"* (*Visite sous-marine du Maine*) (1898) and *The Kingdom of the Fairies* (*Le Royaume des fées*) (1903) include underwater scenes created by filming through a fish tank, with little fish swimming in the foreground of the shot.

Trompe l'oeil

A demonstration of the illusions associated with perspective and perception is found in the form of a miniature room with a peephole in the wall. Looking in, the black and white checkered floor is observed, and the whole chamber seems constructed in good order. But when viewed from an opening in the side wall, all is stretched and distorted, the elongated diamond-shaped pattern on the floor only appearing as a squarely formed grid from the peephole's perspective.

Such effects produced by the eye's reading of the flattened photographic image can be found in the whimsical trope of the tourist standing in the foreground and pretending to push against the Leaning Tower of Pisa. The tower has been aligned in the background of the composition with the prankster's outstretched hands grasping out in the foreground. It was the quirks of how the three-dimensional world transformed into the two-dimensional film image that led Hollywood montagist Slavko Vorkapich to become interested in Gestalt theories of perception; the starting point of his influential lectures on film at the Museum of Modern Art.[19]

Examples of the trompe l'oeil finding its way into experimental cinema include two short works by the wide-ranging filmmaker, poet, and playwright Shuji Terayama: *The Labyrinth Tale* (*Meikyu-tan*) (1975) and *Shadow Film – A Woman with Two Heads* (*Nito-onna – Kage no Eiga*) (1977). In *The Labyrinth Tale*, a man wearing the nineteenth-century western clothing evocative of Japan's Meiji era carries a doorway in a frame, placing it in various locations, with other environments revealed as it is opened. Sometimes there's a flat painted backdrop on the other side of the door, attached to the frame, and at other times the door opens and reveals the unaltered space behind, only giving the impression of some extra-dimensional portal by implication. *Shadow Film – A Woman with Two Heads* takes place against a white background, the shadows projected from the rear side by another actor mirroring the movement of a girl playing with a hoop and stick. Later, a couple is seen together in bed. They lay there, indifferent to each other, while the couple's shadows embrace. Objects also appear with painted shadows rather than produced through back-lighting of the scrim that forms the rear wall of the set. The painted shadow of a man remains behind on the wall after he has left; a woman with a water bucket washes it away.

The case for in-camera effects and the appeal of cinematic artifice

A distinction is made (although with some gray area falling in the middle) between the "in-camera" effect and the one created through post-production.

While the post-production effect (through optical printing or digital editing) allows for considerably more control (the effect is not "cemented" into the image as with an in-camera effect), there are some sensible reasons to favor creating effects in-camera:

- Expediency of having the effect completed in the production of the film.
- The avoidance of the degradation of the image through optical printing's generation loss, since the effect is in the original material.

- Other aspects of the particular "look" of an in-camera effect seeming less "synthetic" than a post-production effect.
- The gratification present in the self-challenge of creating the effect successfully in this sometimes risky manner, where a mistake cannot be undone with a keystroke.
- The feeling of walking in the footsteps of film history, working with methods dating back to the dawning of cinema.

If an in-camera effect might not always be destined to produce the most convincing visual experience, that may have its own particular merits rather than serve as a detriment to the work. But this may require the acceptance and embracing of cinematic artifice.

Artifice is a source of fascination in itself, with its puzzling blend of the real and imaginary. In J. K. Huysmans's novel *A Rebours*, the esthete Des Esseintes sometimes spends his leisure time in a small room; "like those Japanese boxes that fit one inside the other, this room was inserted within a larger one" outfitted to resemble the stateroom on a ship, with

> ... a large aquarium filling in the whole space intervening between the portal and the real window in the real house-wall ... he could picture himself in the 'tween-decks of a brig as he gazed curiously at a shoal of ingenious mechanical fishes that were wound up and swam by clockwork past the port-hole window and got entangled in artificial water-weeds ... In fact, it appeared to him a futile waste of energy to travel when, so he believed, imagination was perfectly competent to fill the place of the vulgar reality of actual prosaic facts.[20]

The fake cinematic effect – where the wires are seen, the miniature looks too much like a miniature rather than a full-sized object, the sparks fall unconvincingly downward from the tail end of the space rocket, the monster looks like a man in a rubber suit, the superimposition seems out of alignment – has an impish appeal in its failure at visual veracity. The fantastical stories of Baron Münchausen substantiates the allure of unconvincing confabulation. Neil Harris, writing about P. T. Barnum's famous hoaxes, describes this strange charm of flimflam that falls somewhere just short of being wholly convincing:

> [The] delight in learning explains why the experience of deceit was enjoyable even after the hoax had been penetrated, or at least during the period of doubt and suspicion. Experiencing a complicated hoax was pleasurable because of the competition between victim and hoaxer, each seeking to outmaneuver the other, to catch him off balance and detect the critical weakness ... Barnum understood, that the opportunity to debate the *issue* of falsity, to discover how deception had been practiced, was even more exciting than the discovery of fraud itself. The manipulation of a prank, after all, was an interesting technique in its own right as the presentation of genuine curiosities. Therefore, when people paid to see frauds, thinking they were true, they paid again to hear how the frauds were committed. Barnum reprinted his own ticket-seller's analysis. "First he humbugs them, and then they pay to hear him tell how he did it. I believe if he should swindle a man out of twenty dollars, the man would give a quarter to hear him tell about it."[21]

Watching a Méliès film today, we may understand how the effects were created through such simple techniques as stopping the camera or re-exposing the film, but like the victim of the hoax, we remain fascinated to see how artfully the trick was accomplished. In *The*

Man With the Rubber Head, it is not just the re-exposure and the ramp but the fantastical expressions of glee, anxiety, and maniacal grimacing on the rubber head that give it charm. The odd attraction of *The Fall of the House of Usher* (1928) by James Sibley Watson and Melville Webber, based on the story by Edgar Allan Poe, outweighs the utter flimsiness of the film's expressionist sets, and the even greater flimsiness of the gesticulating performances. The film is incoherent for those who have not read the Poe story and yet equally incoherent for viewers who are familiar with the Poe story. But all of this doesn't matter. Its visual beauty is that of a moldering cathedral somehow held together with paint and shoestrings.

The earthquake in *Flaming Creatures* (1963), achieved in low-fi manner by shaking the camera and knocking plaster down from above, has a similar glib appeal. Jack Smith, the maker of the film, wrote about this charm in reference to his adoration of campy Hollywood B-movies, such as *Cobra Woman* (1944):

> These were light films – if we really believed that films are visual it would be possible to believe these rather pure cinema – weak technique, true, but rich imagery. They had a stilted, phony imagery that we choose to object to, but why react against that phoniness? That phoniness could be valued as rich in interest & revealing. Why resent the patent "phoniness" of these films – because it holds a mirror to our own, possibly.[22]

Even before cinema, sights imbued with the rich and the unreal found expression in such entertainments as the traditional puppet theater of Japan, where the puppeteers appear on stage manipulating the undersized cloth and wood figures. The puppeteers, dressed in black and wearing hoods, hover behind the characters of the drama as strange unspeaking giants.

> The appearance of the puppeteers themselves on the stage may be initially distracting, making the stage appear cluttered with all too solid alien bodies, but this is a convention which can be soon accepted. The puppets, which at first seem mere diminutive bundles of clothes beside the human bulk of the puppeteers, will grow gradually before the visitor's eyes in stature and in personality until they seem wholly credible creatures of flesh and blood.[23]

But, as Susan Sontag writes: "Then the operators loom once more and the puppets re-become fragile, persecuted Lilliputians."[24] Always there is the strange inconsistent blending of life and artifice in the little animated characters and the visible puppeteers. One more example is opera's strange artifice, in a realm of song. We don't sing that much, or least not most of us, in our daily lives.

The work of Canadian filmmaker Guy Maddin – who has moved nimbly between short experimental and narrative feature filmmaking – is another example of this allure of cinematic artifice. As William Beard describes in his book on Maddin's films:

> Silent movies, even those made under rather elaborate studio conditions in the 1920s, were a gold mine of simple methods to create ambitious dramatic and emotional effects. Irised and vignetted shots are easy to achieve, and give instant access to a more elevated form of portraiture. Double exposures – in Maddin's case conducted in the camera just as in pre-1920s cinema – not only allow an easy-as-pie entry into the realm of mental and spiritual events, but are always-already poetic . . . [The] effect,

however backward looking it may be, has the strong contrary flavour of modernist self-consciousness, and indeed, avant-gardness.[25]

A finely crafted articulation of the misfit charms of low-tech cinematic shenanigans can be seen in James Felix McKenney's dystopian sci-fi feature film *Automatons* (2006). It is shot in shoestring-style with black and white super-8 film and depicts an apocalyptic future: Robots are sent out from underground bunkers to battle each other in the poisoned and irradiated atmosphere of a decimated world. In the film's exterior shots, it is undeniably obvious the robots tramping through the wasteland are windup toys that have been restyled to match the old-school tinplate robot costumes used in the interior scenes. The effect of billowing fog appears to be the result of someone just off camera blowing smoke from a cigarette onto the miniature set. One of the robots has the unmistakable texture of duct tape on its shoulder pads, divulging the diminutive scale of the tabletop exterior world.

New York-based Julie Orlick works with a filmic palette inspired by Dada experiments of the 1920s, the smoky black and white of tintype photographs, and the commedia dell'arte tableau of the lovelorn Pierrot, by way of either Odilon Redon or Kenneth Anger's *Rabbit's Moon* (1950/72). Her work with in-camera Méliès transformations and magical matte shots has as much to do with her vintage aesthetic as that of the practicalities of production. It is a matter of creating a film authentically with these vintage tools and techniques.

The appeal of low-tech inventiveness is also about choosing sides between the work of the creatively resourceful renegade versus the monumental ostentation of the cinematic consumer product of the corporate colossus. There is a desire to root for the success of the upstart working with spit and baling wire; this is one us – one of our chums, so to speak – to cheer along. The fact that we can see the stage machinery just makes us all the more a fellow conspirator to the endeavor, as if we were in on the hoax. We can admire the plucky no-budget filmmaker as representing the non-monetizable virtues of creativity itself.

The camera trick's self-contradictory position, seeming both eerily magical and technically comprehensible, is more interesting than were it wholly one or the other. Utter rationality seems rather drab and lacking in joy, while utter credulity seems the dominion of the rube. Here, within this paradox, the two dichotomous convictions may arrange their assignation. As Thomas Mann once wrote:

> Everybody has had his little glimpse into the equivocal, impure, inexplicable nature of the occult, has been conscious of both curiosity and contempt, has shaken his head over the human tendency of those who deal in it to help themselves out with hum-buggery, though after all, humbuggery is no disproof whatever of the genuineness of other elements in this dubious amalgam.[26]

It is as if by means of some trick of superimposition these two perspectives of "both curiosity and contempt" were felt at the same time when viewing an impressive work of camera magic. It is a nesting place for the inexplicably miraculous within the world we mostly accept as rational.

In the next chapter we will move from what up to now has been a general survey of the motion picture camera's possibilities for experimentation to examining the workings of a specific model of movie camera; the camera that is most associated with experimental filmmaking and most likely to be utilized in learning the craft of 16mm filmmaking: the Bolex.

Notes

1 Leeder, Murray, *The Modern Supernatural and the Beginnings of Cinema*. London: Palgrave Macmillan, 2017, p. 52.

2 Frazer, John, *Artificially Arranged Scenes: The Films of Georges Méliès*. Boston: G.K. Hall & Co., 1979, p. 34.

3 Ibid., p. 60.

4 Ibid., pp. 91–92.

5 Ibid., p. 53.

6 Richter, Hans, *The Struggle for the Film*. Aldershot: Wildwood House, 1986, p. 58.

7 Hofacker, Marion von, "Richter's Film and the Rose of the Radical Artist 1927–1941," in Stephen C. Foster ed., *Hans Richter: Activism, Modernism, and the Avant-Garde*. Cambridge, MA: The MIT Press, p. 132.

8 Richter, *The Struggle for the Film*, p. 53.

9 Weinberg, Herman G., "A Visit With Hans Richter" (1951), in *Saint Cinema: Writings on the Film 1929–1970*. New York: Dover Publications, Inc., 1973, pp. 92–93.

10 Waldman, Harry, *Scenes Unseen*. Jefferson, NC, and London: McFarland & Company, Inc., 1991, p. 139.

11 Ibid., pp. 139–141.

12 Sitney, P. Adams, *Visionary Film: The American Avant-Garde*. New York: Oxford University Press, 1974, p. 55.

13 Ibid., p. 179.

14 *Super8 Filmmaker* vol. 4, no. 1, Feb 1976, p. 50.

15 Hammond, Paul, *Marvelous Méliès*. New York: St. Martin's Press, 1975, p. 34.

16 Frazer, *Artificially Arranged Scenes*, p. 60.

17 Additionally, splices are sometimes distinctly visible in Méliès films, usually at the top of the frame (but sometimes bottom) as a fine white line.

18 Kuchar, George and Mike Kuchar, *Reflections from a Cinematic Cesspool*. Berkeley: Zanja Press, 1997, p. 11. Ellipsis in the original.

19 Kevles, Barbara L., "Slavko Vorkapich on Film as Visual Language and as a Form of Art," *Film Culture* vol. 38, 1965, pp. 1–46.

20 Huysmans, J. K., *Against the Grain (A Rebours)* (1884). New York: Dover Publications, Inc., 1969, pp. 18–20.

21 Harris, Neil, *Humbug: The Art of P. T. Barnum*. Chicago and London: University of Chicago Press, 1973, p. 77.

22 Smith, Jack, "The Perfect Filmic Appositeness of Maria Montez" (1962), *Wait for Me at the Bottom of the Pool*. New York: High Risk Books, 2008, p. 33.

23 Hironaga, Shuzaburo, *The Bunraku Handbook*. Tokyo: Maison Des Arts, Inc., 1976, p. 2.

24 Sontag, Susan, "A Note on Bunraku," in David Rieff ed., *Susan Sontag: Later Essays*. New York: The Library of America, 2017, p. 340.

25 Beard, William, *Into the Past: The Cinema of Guy Maddin*. Toronto: University of Toronto Press, 2010, pp. 6–7.

26 Mann, Thomas, "Mario and the Magician," *Stories of Three Decades*, H. T. Lowe-Porter trans. New York: Alfred A. Knopf, 1936, p. 552.

5 Tool of the experimenter
The Bolex H16

This chapter covers an in-depth look at how to use the many features of the Bolex camera.

"The camera of choice for the experimental filmmaker was the Bolex, a lightweight, spring-wound camera, which was sturdy, portable, and capable of yielding professional results in the right hands,"[1] as Gwendolyn Audrey Foster and Wheeler Winston Dixon state in the pages of *Experimental Cinema, The Film Reader*. Like many other 16mm cameras, it was first developed for the amateur enthusiast who wanted higher quality in a consumer camera. Yet, if there were a movie camera designed with the experimental filmmaker in mind, it would be the Bolex.

While its many features were designed for the hobbyist to add fades and other embellishments to their home movies, when this camera was placed in the hands of an artist like Marie Menken, it found its true purpose. Menken had been a painter, working with assemblage techniques but recollected that as a student

> ... I made flip books out of the corners of my textbooks while I listened to a drone in school. All of this came into my work when I finally got Francis Lee's camera. He went into the Army, bequeathing me the pawn ticket for his camera. I made good use of it exploring, along with Willard Maas, my husband, when he made *Geography of the Body* with George Barker.[6]

The Bolex became, in Menken's hands, the tool for an expanded vocabulary of cinematic technique. The "trick shot" was transformed from a sporadic cinematic novelty effect to the intrinsic visual palette of a short experimental film. The filmmaker Peter Kubelka had this to say when interviewed about Marie Menken and her films:

> The Bolex is a fantastic teacher. I think Marie learned her filmmaking from letting the Bolex talk. Her films are expeditions, like Columbus into a country which she had not seen before herself. When she made these films using the catching of the now-now-now-now-now – go go go go, yeah?

Figure 5.1 Marie Menken with Bolex camera. Courtesy of Martina Kudláček/*Notes on Marie Menken*.

Experimental filmmakers and the Bolex

Maya Deren

The Bolex camera was significant to Maya Deren's filmmaking practice, as described by Louise Levitas in the pages of *P.M.* magazine:

> Miss Deren broke free when she started to make her first movie because she didn't like the kind of Hollywood pictures she was seeing. And she hopes the story of her experiences with a $300 Bolex will influence any readers with film cameras to break away from the Hollywood idea of movie making, too – for instance, the idea that you need a lot of money and equipment to make a picture.[2]

Jonas Mekas

Jonas Mekas expressed his affection for the camera by observing:

> When you shoot with a Bolex, you hold it somewhere, not exactly where your brain is, a little bit lower, and not exactly where your heart is – it's slightly higher And then, you wind the spring up, you give it an artificial life You live continuously, within the situation, in one time continuum, but you shoot only in spurts, as much as the spring allows.[3]

Andrew Noren

The Bolex makes an appearance in Mekas's description of the filmmaker Andrew Noren: ". . . one of the great artists of America who is walking the streets of New York with his head in the sky, with his fingers on his Bolex."[4]

George Kuchar

Underground filmmaker George Kuchar lauded the Bolex in his typically wry manner: "The 16mm movie cameras themselves were Swiss things of clicking excellence. They had kind of a black hide bordered by gleaming metal and spun numbers around in little portholes of mystery and mathematical perfection."[5]

Jon Behrens

Seattle filmmaker Jon Behrens has expressed his affinity for the camera by using the moniker "Bolexman."

– working, taking in slowly and then projecting in a condensed way she put the medium at its best usage; there the medium, film, really transports the user to a new world.[7]

While her film *Notebook* (1962) is something of an inventory of the camera's possibilities, her work more typically centers on the correlation of a specific technique (or finite

Identifying the Bolex

The Bolex went through many incarnations and improvements over the decades of its production. For a more detailed and comprehensive survey of the Bolex camera, see Andrew Alden's *Bolex Bible* (1998).

The earliest Bolex cameras used a side-finder, lacking such features such as the reflex viewfinder, filter holder slot, variable shutter, and the 1-to-1 shaft for using accessory motors. Over time, these features were incrementally added to the camera.

Non-reflex Bolex camera H16

The design of the optical viewfinder was changed over time on the non-reflex Bolex: A focus preview finder was added to the camera and a 10mm attachment for the side-finder appeared later. Non-reflex Bolex cameras with a single lens mount were also produced. These, and other non-reflex Bolex cameras, may be used with a zoom lens with a reflex viewfinder built into the lens rather than the camera.

Bolex H16 Rex1 through 5

The early reflex Bolex cameras have the drawback of a rather small image in the viewfinder (x6), making these cameras more of a challenge to focus by eye in comparison to the later models. The Rex4 has a larger image in the viewfinder (x10). The Rex5 is essentially the same as the Rex4, with the addition of a door on the top of the camera to add a 400ft magazine. Later Rex5 cameras introduced greater magnification in the viewfinder image (x13).

Round bottom or flat bottom

Early models can be identified by the round bottom of the camera, with a single 3/8–16 threaded hole for mounting the camera on a tripod. An adaptor can be used to convert this for use with the more common 1/4–20 tripod mounting screw. One of the disadvantages of the round-bottom cameras is that they must be laid flat on their side when the camera is put down, rather than stand upright on a surface. The round-bottom camera also lacks mounting screws for the use of a Bolex matte box. A supplemental round-to-flat adaptor plate was made for these cameras.

The Rex4 and Rex5 have a flat bottom with three threaded holes for mounting the camera to the tripod (in different positions to accommodate centering the weight when a heavy lens or a motor is used). Two are 3/8–16 and one is 1/4–20.

RX and non-RX lenses

The reflex Bolex has a greater depth between the lens mount and the film gate than the non-reflex Bolex camera owing to the presence of the viewfinder prism. The lenses for the reflex are designed differently to take this into account. The red letters RX will identify a lens as a reflex lens. Non-reflex lenses will have the white letters AR (or none at all). Using a non-reflex lens on a reflex camera (or

the other way around) will poten-
tially result in focusing issues. This
is only an issue for wide and normal
lenses; non-reflex telephoto lenses
can be used on a reflex Bolex.

Bolex EBM and EL

These two models of electric-driven
Bolex cameras are quite different
from their spring-driven cousins.
Notable dissimilarities include the
lack of a variable shutter and the
presence of a bayonet mount instead
of a three-lens turret. The EBM is
not capable of single-frame shooting.
The EBM may be manually back-
wound with an accessory rewind
crank. The EL can be backwound

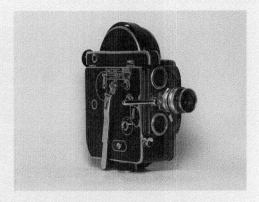

Figure 5.2 The round-bottom reflex Bolex cam-
era is of an older vintage than the flat-
bottomed version. Note the lack of a
variable shutter and 1-to-1 shaft on this
camera. Camera courtesy of Mono No
Aware.

with the camera motor. The electric Bolex, fitted with a zoom lens (and 400ft
magazine), will be significantly heavier than a spring-driven Bolex camera.

Bolex H8

While there are a variety of compact 8mm Bolex cameras, there is also a version
designed to shoot 100ft rolls of 8mm film. The H8 superficially resembles the Bolex
H16. It's possible to encounter what appears to be a 16mm Bolex camera for sale
not realizing it's actually an 8mm camera until closer inspection.

range of techniques) with subject matter: various types of handheld camera movement in
Visual Variations on Noguchi (1945), *Arabesque for Kenneth Anger* (1961), and *Mood Mondrian*
(1961); single-frame shooting in *Moonplay* (1962), *Go Go Go* (1964), *Andy Warhol* (1965),
Wrestling, and *Excursion* (1968); macro photography in *Glimpse of the Garden* (1957); time
exposures and camera movement in *Lights* (1966).

Controls on the Bolex, A to Z

What follows is a detailed look at the functions of the Bolex. While it's useful to know
the camera well for those features you plan to use, it is also important to be familiar
with other features of the camera, such as the variable shutter, to avoid the mistake
of shooting a film with it closed rather than open. Wherever possible, this survey of
the camera has been arranged to roughly correspond to the order for loading and
operation.

Right side of the Bolex camera

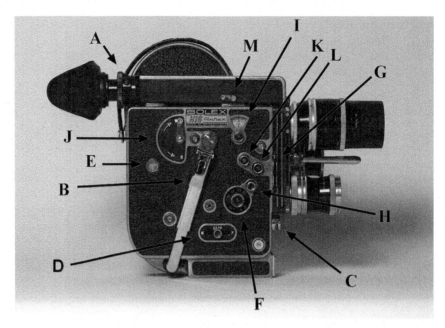

Figure 5.3 Right side of the Bolex Rex4 camera. A: Diopter. B: Winding handle. C: Run button. D: Run switch. E: Footage counter. F: Speed dial. G: Variable shutter. H: I/T switch. I: Frame counter. J: Spring disengage switch. K: 8-to-1 shaft. L: 1-to-1 shaft. M: Viewfinder switch. Camera courtesy of The New School Film Office.

(A) Diopter

On a reflex Bolex, this is used to put the groundglass into focus prior to shooting. Early Bolex cameras had a small round knob to adjust the diopter. The most commonly encountered design is a combination of grooved outer locking ring and inner adjustment ring (recognizable from the screw inset within it) with a scale of - to + indicating its setting. Later model Rex5 cameras have another design: a small knob for locking/unlocking and the entire back part of the eyepiece used as the ring to adjust focus on the groundglass surface of the prism. Since the groundglass is the same distance as the film, a subject in focus on the groundglass should also be in focus on the film.

Setting the diopter is most easily accomplished by turning the turret so that the prism is exposed, with no lens in front of it. This gives you a view of the groundglass itself with no distracting image and consequently no depth of field from the lens interfering with focusing the groundglass. It is possible to focus the diopter with a lens in place, but it is best to open up the aperture of the lens all the way, so that the image in the viewfinder is bright and the depth of field of the lens is reduced. Pointing the camera towards something bright can make it easier to see the groundglass. Look for the grainy pattern etched into its surface and adjust the diopter so that the grain appears as sharp as possible. Sometimes looking for

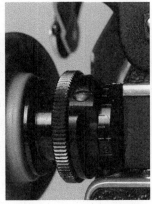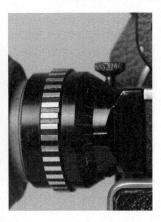

Figure 5.4 Three types of diopter. **Left:** An early reflex camera. **Middle:** A Rex4. **Right:** A late-model Rex5.

any stray bits of dust on the groundglass, seen as little black dots, can be helpful for adjusting the diopter. (These bits of dust are on the top portion of the prism and won't appear in the image being filmed.)

The two-ring (lock and adjustment) version of the Bolex diopter has a small screw on the adjustment ring. One should avoid removing this screw: It's quite difficult to realign the parts to get it back into place. If the locking ring is unlocked and can't be turned, check that it hasn't been loosened to the point where it cinches up and is frozen.

(B) Winding handle

The Bolex runs with a spring that is wound between shots. A full wind will run the camera for about twenty-eight seconds. It's a prudent practice to always fully wind the camera before every shot, even shorter ones, so as to avoid the spring running out mid shot. After all, even if your shot is only five seconds long, you don't want to start shooting only to discover there's only two seconds of wind left on the spring.

To wind the camera, gently pull the handle off the pin that holds it in place near the bottom of the camera. Engage the handle onto the hub and turn counter-clockwise. When the winding handle will no longer turn, the camera is wound. Be sure not to leave the handle on the hub, but return it to the pin near the bottom of the camera (the hub turns as you run the camera).

The Bolex is designed to stop the camera with the shutter closed between shots. This prevents a white flash frame from appearing. However, the exception to this occurs when the spring has totally run to the end and the camera stops arbitrarily. A single bright white frame will be exposed between shots. Consequently, when doing a film using in–camera editing where flash frames are not desired (these won't

just be cut out later), it's best to stop the camera before the spring has completely run out. But if the footage is going to be edited, then this hardly matters. As the spring begins powering the camera at the beginning of the shot, it hasn't quite reached full speed for a frame or two. This can often go unnoticed but sometimes, depending on the lighting conditions, give a slight visual accent of momentary brightness at the beginning of a shot.[8]

When shooting is completed and the Bolex is ready to be put away and not used for a while, the camera should be run until the spring is completely unwound to preserve its tensile power.

The winding handle can be removed from the camera (to attach an external motor, for instance) by turning it clockwise rather than counter-clockwise. Care should be taken when putting the handle back on, so as to not cross the threads.

(C) Run button

On the front of the camera is a round silver button that will run the Bolex as long as the button is held down. When the button is released, the camera will stop with the shutter closed.

(D) Run switch (slide release: M-STOP-P)

The switch on the side of the camera also runs the camera when pulled back to M (as in the spring "Motor" of the camera. In French this is "marche," for running). The standard term for this is the "slide release"[9] or "release controls,"[10] which may not be as straight-forward as calling it the "run switch." Pulling the switch all the way back until a "click" is heard will allow the camera to run on its own, hands free. This is useful for shooting long takes, having an additional hand free for manipulating the lens while shooting (when not handholding the camera), or when shooting handheld by holding the strap on the top of the camera rather than gripping it. To stop the camera, move the switch back to the center position, marked STOP.

Moving the switch forward to P will expose a single frame (P stands for "pose" in French, but this can be rendered in English as "pixilation"). Keep in mind that when shooting with the Bolex one frame at a time, the spring motor hasn't quite reached full speed, and so the exposure time is longer than when shooting continuously at 24fps. An exposure compensation should be made by closing the lens one stop. Otherwise, combined sequences of 24fps and single-frame exposures will not match, with the single-frame footage appearing brighter.

The setting of the I/T switch (H) is important to check when shooting single frame.

(E) Footage counter

The footage counter displays ascending numbers, from 0 to 100. It automatically resets whenever the camera door is opened. Initially, the dial reads "ft" when film is loaded into the camera. This is to account for the end-flares on the daylight spool. The roll of film is actually 108ft (rather than 100ft) because of the flares. The camera may be run to 0 upon loading so as not to lose the first shot in the light-flares. The time from ft to 0 is approximately seven seconds.

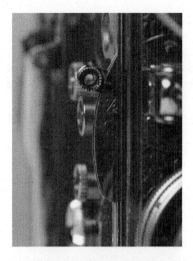

Attention should be paid to the footage counter between shoots. The camera still runs even after the film has run out. A subtle "click" is heard as the film runs out, but if filming in a noisy location, it's quite possible not to notice it. Also, if planning to backwind the entire roll, keep track of the footage counter so the film doesn't run out at the end, since it's easier to wind back if the film is still threaded.

The face of the footage counter can be rotated 180°, revealing another set of numbers under the red half-circle indicator. These start with the letter "m" and count up in meters rather than in feet.

(F) Speed dial (frames per second dial)

A black dial on the side of the camera indicates the frame rate, marked with a small dot on the camera body. The dial does not easily turn, and that is intentional, so as not to inadvertently change the speed. It has settings of 64fps, 48fps, 32fps, 24fps, 18fps, and 12fps. These speeds are approximate, as with any spring-driven camera.

As the spring slowly loses some of its tensile power over years of use, the speed of the camera will drift away from the settings on the dial. Rather than take apart the whole camera to recalibrate the speed dial, the camera can be speed tested,[11] and a small piece of tape trimmed into a triangle is used to show where the camera should be set to more accurately shoot at 24fps.

It is advisable not to run the camera at high speed (64fps) with no film loaded, since this can snap the camera spring.

(G) Variable shutter

The variable shutter is a second shutter hidden behind the camera's primary shutter and is controlled by a lever on the right side of the camera,

Figure 5.5 The variable shutter. **Top:** Open and locked in place. **Middle:** Unlocked. **Bottom:** Closed.

Figure 5.6 The warning triangle for the variable shutter, as seen in the viewfinder.

Figure 5.7 The newer version of the I/T switch is a small knob with a notch indicating the setting of the switch.

allowing the shutter angle to be reduced while shooting. The variable shutter can be closed to the point where the two shutters form a complete circle and the camera gate receives no light at all through the lens.

The variable shutter lever locks into place when pushed in. It must be pulled out to move it up or down. The variable shutter can be used to create an in-camera fade in or fade out. Combining fades in and out with back-winding the camera produces an in-camera dissolve.

The variable shutter is also used to prevent exposing the film when rewinding the film inside the camera. When backwinding, the whole mechanism will run, including the camera shutter opening and closing. If the variable shutter is left open, the film will be re-exposed while backwinding.

It is important to realize the variable shutter is located in the camera behind the viewfinder prism. This means an image still appears in the viewfinder when the variable shutter is closed, but no image is filmed. The film will come back from the lab completely blank. On later-model cameras, a visual warning was added in the viewfinder, in the form of a small black triangle in the lower left hand side of the image that appears when the variable shutter is partly or wholly closed. But don't count on this all the time, since older Bolex cameras don't have this warning indicator, and it can be difficult to see it if filming in low light conditions when the image is dark in that part of the frame. When getting ready to shoot, it's a good idea to check the variable shutter to make sure the lever is in the up/open position, rather than closed.

The variable shutter can also be set to reduce shutter angle, marked 1/2 and 1 to indicate the equivalent f-stop reduction of exposure. Reducing the exposure time of the shutter will affect the appearance of motion, with less motion blur smearing the image, sometimes resulting in a vaguely fast-motion appearance to the footage. Setting the variable shutter to 1 can be useful as a compensation when mixing single-frame shooting with footage shot at 24fps. Just be sure to remember to set it back to the fully open position when shooting at 24fps.

(H) I/T switch

The two settings on the I/T switch stand for "Instantaneous" and "Time Exposure." Shooting time-lapse footage, or animation, the camera should be set to I. This will cause the shutter to open and close for a brief but consistent amount of time as the run switch (D) on the side of the camera is moved to P. Changing the setting to T will allow the camera shutter to be held open for as long as the switch is held forward. Always check the setting of the I/T switch when shooting single-frame footage, since it may have been left on T.

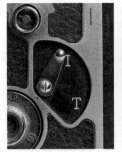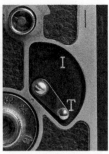

Figure 5.8 With the older version of the I/T switch, it is easier to see if the camera is set to I or T.

Shooting single-frame exposures at T by accident will result in your footage appearing overexposed and erratically exposed. The setting of the switch does not matter for continuous shooting.

The I/T switch can also be used when checking the gate for hairs or other debris. Set the switch to T and hold the run switch on P to open the shutter to inspect the gate.

(I) Frame counter

The Bolex frame counter comprises of two dials: the upper one counting single frames and coming around to zero again after fifty frames, and the bottom dial counting hundreds of frames (the 50-frame mark is denoted with a dot on the lower dial), repeating the cycle after 1,000 frames.

While the footage counter (E) is automatically reset when the camera door is opened, the frame counter must be manually set back to zero. Two separate knobs are used to reset the upper and lower counters: The small knob just below the frame counter resets the 100s dial, and the 8-to-1 shaft (K) also functions as a knob to reset the upper dial of the frame counter.

(J) Spring disengage switch

The switch labeled "MOT – 0" is used to disengage the spring for backwinding the film or attaching a motor to run the camera externally, like a time-lapse motor.

When set to MOT, the camera's spring motor will run the camera. When set to 0, the spring is disengaged, although to fully disengage the spring, the run switch (D) also needs to be set to M.

(K) 8-to-1 shaft (backwind shaft)

This shaft is engaged with the drive mechanism of the camera, allowing the film to be manually advanced or rewound.

To use it to backwind film, the spring motor must be disengaged (see double-exposure steps for the Bolex). An arrow indicates the direction for rewinding the film. When back-winding the film, this shaft will run the mechanism of the camera, opening and closing the shutter. Consequently, the variable shutter (G) should be closed to avoid an inadvertent re-exposure of the film while rewinding. As the name of this component suggests, one revolution will rewind (or advance) the film by eight frames.

If wishing to film hand-cranked footage by turning the crank forward, you should be aware that the small crank does not operate as smoothly as on early hand-cranked motion picture cameras. Consequently, the exposure may be uneven, pulsating with each revolution of the crank. But it can be used and is especially helpful for shooting in extreme low light through use of a longer than usual exposure time. Setting the frame rate on the speed dial (F) to 64fps will relax the governor of the camera, making it easier to hand-crank. Remember, of course, to set the frame rate back to 24fps when you're done.

Examples of hand-cranked films using the Bolex are Guy Sherwin's *Portrait With Parents* (1975), *Handcrank Clock* (1976), and Kevin Jerome Everson's *Undefeated* (2008). While the camera can also be wound in reverse as a means of shooting, it should be noted that the registration will be off and the frameline will appear in the shot.

The outer hub of the 8-to-1 shaft, as mentioned above, is also the knob for resetting the frame counter (I). Some external electric motors were designed to use this shaft to run the camera.

(L) 1-to-1 shaft

The 1-to-1 shaft is used for attaching either a single-frame motor (animation motor, intervalometer) or an external electric motor, like the MST, to the Bolex camera. The spring must be disengaged for this. One revolution will advance the film by one frame. There is a small red dot on the 1-to-1 shaft to indicate the shutter position, which is an issue when mounting a single-frame motor to the camera: When the dot is on the side of the shaft towards the front of the camera, the shutter is closed. When a 24fps motor is used, the camera governor should be set to 64fps (F) to prevent damage to either the camera or the motor.

(M) Viewfinder switch

This switch will flip up a small metal flap hidden inside the viewfinder to close off light to the viewfinder on reflex Bolex cameras. It's a good idea to do this if filming while not looking through the camera, such as when shooting a time-lapse sequence, to keep stray light from creating a glare or fog on the film. When looking through the viewfinder while shooting, your head prevents light from entering this way. It's not necessary to close off the viewfinder between shots, since the camera's shutter is designed to be closed when the camera isn't running. Finally, if there is no image in the viewfinder, check this switch.

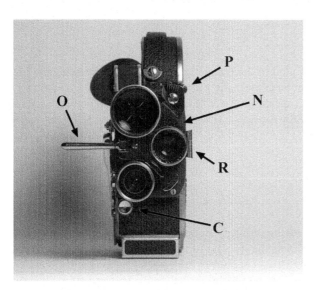

Figure 5.9 The front of the Bolex Rex4 camera. C: Run button. N: Lens turret. O: Turret handle. P: Turret lock. R: Filter holder. Camera courtesy of The New School Film Office.

Front of the Bolex camera

(N) Lens turret

When mounting the three lenses on the turret – wide, normal, and telephoto – the

normal lens should always be put in the center position of the turret. The wide and telephoto lenses should not be mounted next to each other on the turret. The wide lens (especially the 10mm lens) is wide enough that the telephoto lens will be in the shot when the two are mounted side by side, appearing as a rounded black shape in the corner of the frame. While it seems like it would be obvious when looking through the viewfinder, there are times when it can go unnoticed until the footage is back from the lab.

The other advantage of mounting the lenses with the normal lens in the center position on the turret is that when the turret is turned one way or the other, the lens will go either wide to normal to long, or long to normal to wide, making for quicker lens selection when shooting. Sometimes, as when using a matte box, it's better to have just one lens of the turret rather than all three.

The turret will click into place as each lens becomes seated directly in front of the gate. It is possible to film with the lens not completely seated in place, in which case the lens will vignette on either the top or bottom of the frame, with a curving arc of black at the edge of the image. When the lens isn't seated, the film will also be underexposed, so intentionally filming with the lens not completely clicked into place may also necessitate opening up the aperture to compensate for the difference in exposure.

The turret can be switched between lenses while shooting, a technique the filmmaker Robert Beavers has used in some of his work. The entire image will swing upwards or downwards, revealing the round edge as it momentary becomes black and a new image, wider or longer in focal length, takes its place. It's a good idea, when shooting with this in mind, to set the f-stop and focus on all the lenses prior to shooting to avoid the new image appearing too bright, dark, or out of focus.

A curious feature of the Bolex is that the turret can be swung open so that no lens is in front of the gate. This is actually a useful feature when setting the eyepiece diopter (A).

(O) Turret handle

It's advisable to use the turret handle, rather than the lenses themselves, to turn the turret. The handle can be folded in to keep it out of the way when winding the camera.

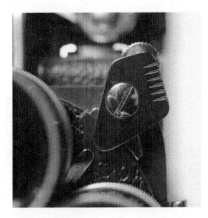 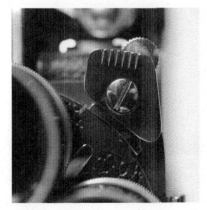

Figure 5.10 The turret lock. **Left:** The turret may be locked in place when using a heavy lens on the camera. **Right:** To set the turret lock out of the way, tighten the small disc to hold it in place.

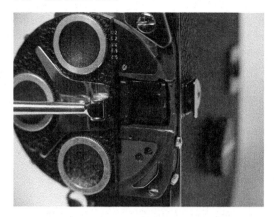

Figure 5.11 The prism on a reflex Bolex. This is the prism of a Rex4 with a x10 viewfinder.

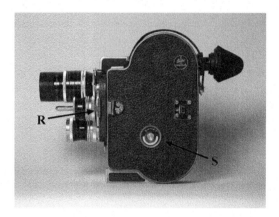

Figure 5.12 Left side of the Bolex Rex4 camera. R: Filter holder. S: Door latch. Camera courtesy of The New School Film Office.

(P) Turret lock

This is used when a large, heavy lens, such as a zoom lens, may cause the turret to rotate from the weight of the lens. But most of the time, the turret lock just interferes with turning the turret. To prevent this from becoming a constant inconvenience, you can move the turret lock out of the way: Turn the tab away from the turret and tighten the small disc designed to hold it in place.

(Q) Prism

The prism of the Bolex reflex camera channels off light to the viewfinder, with about 75% exposing the film. Because it is located in front of the shutter, the image in the viewfinder is flicker free.

The prism is mounted on a small hinge. It can be swung open – for inspection or the occasional cleaning of the gate – by removing the filter holder (R) and carefully flipping the prism away from the gate, using a fingernail. Set the I/T switch (H) to T and hold open the shutter by moving the run switch (D) to P to access the gate.

Figure 5.13 The filter holder. Don't shoot without the filter holder in the slot on the camera, even when the holder itself is left empty.

Left side of the Bolex camera

(R) Filter holder and filter holder slot

The Bolex has a built-in filter holder for use with gelatin or Mylar filters. These can be cut and placed in the filter holder. Be sure not to get fingerprints on the filter when installing it in the holder. A small removable silver clip helps clamp the filter holder together, although the silver clip is not absolutely essential to the filter holder's function.

The filter holder should always be used when filming with the camera, even when not using a filter. Otherwise, stray light comes in through the empty slot and will cause a band of light to appear on the right side of the frame.

The filters can include those for either simple color temperature correction, exposure control (neutral density filters), or aesthetic effect. Experimentation with the filter holder itself may include multicolor "collage" filters or mattes using a partially blocked filter holder, although this later technique can be a challenge owing to the filter holder's proximity to the film and the consequent need for extreme depth of field. There is a slightly different type of filter holder for bayonet-mount Bolex cameras.

(S) Door latch

The latch to open the door of the camera is labeled "O" and "F" for the French terms: "ouvert" and "fermé." The door is held in place by three metal tabs that engage with slots inside the chamber of the camera. When putting the door back in place, be sure that the latch is set to O ("open") or else the door won't seat in place. The door should be gently pressed down when relatching to counteract the spring-loaded rod that resets the footage counter. If the door doesn't easily fit on, then check that the pressure plate (Y) isn't disengaged, since there is a bump built into the door to prevent the door from going back on when the pressure plate is open.

Later Bolex cameras have a latch in the form of a knob with a triangle pointing in the direction to open the door.

Inside the Bolex

(T) Supply and take-up spindles

When the camera is opened up, an empty daylight spool should be inside. This will become the next take-up reel. The spools can be removed from the camera by pulling them out with a finger, or using the spool ejector (U). The spools snap in place: The square hole must be aligned, then push the spool down. The supply reel goes on top. White arrows indicate the direction the film should be coming off the spool in the correct orientation for filming.

(U) Spool ejector

The spools can be removed simply by pulling them off of the spindles, but this silver lever can be pressed down to quickly eject both spools from the spindles.

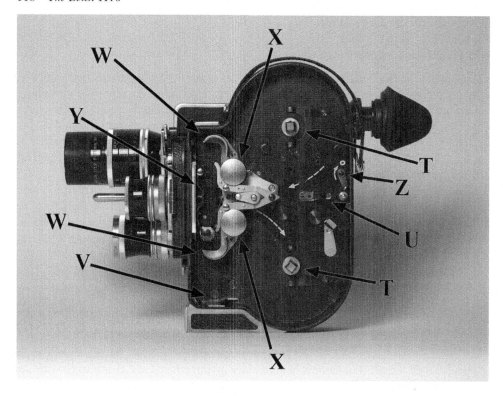

Figure 5.14 Inside of the Bolex Rex4 camera. T: Supply and take-up spindles. U: Spool ejector. V: Film cutter. W: Loop formers. X: Sprocketed rollers. Y: Pressure plate. Z: Audible counter. Camera courtesy of The New School Film Office.

Figure 5.15 The film cutter. **Left:** Properly cut film. **Right:** Film cut with a broken sprocket may result in a film chip in the gate.

(V) Film cutter

Because the Bolex is designed as an automatic-loading camera, the film is fed into the camera and goes along the film path, emerging from the other end. But to prevent the film from getting stuck along the way, the end of the film needs to be cut at a slight diagonal prior to threading. The camera has a built-in film cutter for this. The film is placed between the blades and the top one pushed firmly down.

It's prudent to cut the film between sprockets, as the accompanying illustration shows, so as to avoid breaking a sprocket, also shown. Cutting into a sprocket can lead to a film chip lodging in the gate of the camera, appearing as a dark piece of debris on the edge of the gate.

(W) Loop formers

The loop formers are the guides used in loading the camera to make proper-sized loops as the film first goes along its path through the camera.

The loop formers have two positions: closed for loading and open for filming (see Figure 1.6). The lever between the sprocketed rollers (X) will close the loop formers, and the button in the center will open them. The button is activated automatically when the camera door is closed to insure the loop formers are open for shooting.

Older Bolex cameras have just a lever, with no button mechanism to open the loop formers, which need to be opened manually.

(X) Sprocketed rollers

The rollers feed the film from the supply and take-up to and from the gate, turning constantly, with the loops serving as the slack. The film is fed under the upper roller during loading, with the camera running.

The rollers are sprocketed on the one side only, making it easy to see if the film is facing the correct way. If a roll is already exposed, the sprocket holes on the film will be on the opposite side from the teeth on the roller.

(Y) Pressure plate

The source of pressure for the pressure plate on the Bolex camera is a small spring, acting to hold the film steady during exposure. The whole plate is removable and may be disengaged, which is useful for removing the film if there's a camera jam; for cleaning the film gate; or using a special viewing prism when aligning the image when the Bolex is used on an optical printer.

It is possible to inadvertently load and run the camera with the pressure plate disengaged, resulting in an image where the light is smeared in a short vertical blur and the image may be totally out of focus, as the film is no longer held firmly on the film plane at the gate. It's therefore advisable to check the pressure plate when loading the camera, by gently pushing against it to make sure it is engaged. The pressure plate will move around ever so slightly, even when it's in place. But if a "click" is heard, then the film shoot has been saved from disaster.

There is a small bump on the camera door to prevent the camera from being loaded with the pressure plate disengaged. But, disappointingly, it's not uncommon to see a large dent in this "failsafe" component of the camera door.

To disengage the pressure plate, pull on the silver knob at the top of the pressure plate and move it back. The silver knob has a pin on its underside, which fits into a small hole to engage the plate. To then fully remove the pressure plate, the black knob at the bottom is unscrewed and the pressure plate can be pulled out of the camera, shifting it further away from the gate while pulling it away. The entire process is reversed for reinstalling the pressure plate.

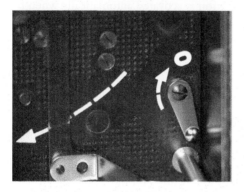

Figure 5.16 The audible counter. It may be turned off by moving the switch to 0.

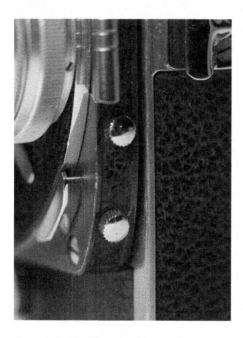

Figure 5.17 The blooper covers on the Rex5.

(Z) The audible counter

This little switch will produce an audible "click" once per second (it is actually producing a click every eight inches of film, which is closer to 26/27 frames, but close enough to be rounded down to "one second" per click). It can be quite useful to determine how many clicks are in a single wind of the camera spring beforehand and then to time long takes based on the number of clicks. It's a good way to be sure the spring doesn't run out midway and cause a flash frame for an in-camera edited sequence or film.

If filming where the clicking sound of the audible counter will be intrusive while filming, the switch can be set to 0.

Other features of the Bolex

The features of the Bolex camera detailed above are either the most essential or found on almost every model of camera (except for some of the very early ones). Other features worth noting are specific to only some models of camera.

Magazine door

The Rex5, SBM, and electric Bolex cameras have a magazine door on the top of the camera. Aside from its use for 400ft capacity, it makes it easy to tell the difference between the Bolex Rex4 and the Rex5, since the two cameras are quite similar, with the exception of the magazine door on the Rex5.

Blooper cover caps (Rex5)

Some later models of Rex5 have two silver knobs near the filter holder, which may be removed to add the MST electric motor's blooper, used for cable sync shooting. The common trouble with these is the tendency for these caps to go astray, and the open hole for the blooper causes a potential light leak. It's not uncommon to seal up the hole for the blooper attachment with black epoxy for this reason.

Bayonet mount (SBM, EBM, and EL)

The bayonet mount Bolex camera, like the SBM and EBM, is designed for use with a single zoom lens; the larger mount is designed for supporting these heavier lenses. A c-mount adaptor can be used to convert a bayonet Bolex to accept a single c-mount lens.

The filter holder on the bayonet mount Bolex is of a different design than the turret camera, accessible with a long silver handle on the end. The filter holder has two positions, either in front of the gate, or off to the side (inside the camera) held in reserve rather than in use.

Lenses for the Bolex

C-mount lenses made specifically for use with the Bolex camera are Switar, Yvar, and Pizar: The Switar is the highest quality and commands the highest price, while the Pizar is the economy line.

A word of caution: Some c-mount lenses were designed for use with the 8mm version of the Bolex, the H8, and these will vignette when used on a 16mm camera.

Other brands of lenses made specifically for the Bolex include zoom lenses manufactured by Angenieux and SOM Berthiot (Pan Cinor), including zoom lenses with built-in viewfinders to add a reflex finder to a non-reflex camera.

RX and non-RX lenses

When the reflex Bolex was introduced, the distance from the lens mount to the film was extended to accommodate the prism. Lenses marked with the red letters "RX" are designed for use with reflex Bolex cameras. Non-reflex lenses will not have an "RX" but may be marked "AR" in white letters instead (the "AR" is not a signifier of non-reflex but of the anti-glare coating on the lens).[12] If a lens does not have either of these sets of letters, it is likely to be a non-reflex lens.

The lens depth difference between reflex and non-reflex cameras does not have much of an effect on telephoto lenses but is a concern with normal and wide lenses, which are more sensitive to what is termed "back focus." Sometimes a telephoto lens, like the 50mm Macro, will be labeled "RX," but a non-RX telephoto lens may also be used on a reflex Bolex.

Figure 5.18 Non-reflex and reflex lenses are identified by the letters AR in white or RX in red, respectively.

There is a school of thought that non-reflex lenses can be used on a reflex camera if you stop the lens down, creating enough depth of field to bring the image into focus. This is partly true, but only partly, since the image will still have some subtle but discernible aberration of focus.

Depth of field indication

Lenses made for the Bolex have a built-in depth of field indicator. As the lens is closed down, a curved line or orange dots will show the amount of depth of field for the f-stop setting (see Figure 3.4). It can be useful (with the wide lens especially) to set the focus by setting the hyperfocal distance: Adjust the focusing ring so that the infinity symbol is within the furthest orange dot (or within the line) indicating the lens's depth of field range. But be sure to remember that if the f-stop is subsequently changed, the hyperfocal focus setting will need to be changed as well.

Switar lenses with an aperture lever

Later-model Switar lenses added a lever designed with two handles to control the f-stop, the premise being that the two can be moved together to set the aperture and then one of them moved to open the lens for focusing. The smaller lever acts as a placeholder, allowing the lens to be closed down again by feeling for the levers to come together, rather than looking at the f-stop setting. In practice, these levers tend to slightly shift around a bit when opening and closing the aperture, so it's advisable to not rely on this system too much, but rather set the f-stop in the usual manner.

The lens-mounting system for Switar lenses with the aperture lever is slightly different, since the lever sticks out enough to collide with other lenses on the turret when mounting the lenses. The rear ring of the lens is designed to turn independently, allowing the lens to be attached to the turret by turning the back ring while holding the lens in place. Be sure to mount the lens so that the line indicating focus and f-stop is facing upwards or outwards, since it can be repositioned facing any direction.

Macro lenses

Switar lenses with an aperture ring lever include several macro lenses: a 26mm macro normal lens; and 50mm and 75mm telephoto macro lenses.

To focus the lens in the macro range, the focusing ring can be turned an additional revolution beyond the closest setting on the ring. As this is done, a red line on the barrel of the lens, otherwise hidden under the focusing ring, now appears. Once in the macro range, the numbers on the focusing ring are now irrelevant for determining focus. On the 75mm macro lens, the ring may be turned an additional rotation, and a red line is followed by a green line on the barrel of the lens.

The 26mm macro is what is sometimes called a "super-speed" lens, opening to an f-stop of f-1.1 rather than f-1.4, making it both desirable and costly.

It's worth noting that the 10mm Switar lens, while not a macro lens, will focus extremely close: Eight inches is the closest setting marked on the ring (although it will focus even a bit closer than this).

Turret cap

These caps are similar in purpose to lens caps, used to prevent dust from getting behind the turret and onto the prism.

Turret locking cap

When using a heavy c-mount zoom lens on the Bolex, the turret can shift from the weight of the lens. To prevent this, a turret locking cap can be screwed into the camera body, holding the turret in place. It's identifiable by the red ring when installed on the camera. A warning about this camera accessory: With a locking cap in place, the turret cannot be turned, and it's possible to think the turret is stuck and snap off the turret handle (O) when trying to turn it too aggressively.

Bolex accessories

Side finder

While the non-reflex finder is essential to the non-reflex camera, it may be used on a reflex camera. The side finder can be helpful in the case when closing down the lens causes the reflex viewfinder to become very dark.

Backwind crank

The backwind crank, also called the rewind crank, is essential for shooting double exposures and in-camera dissolves. The camera cannot be rewound without it. There is a hole and slot on the end of the crank, which engage with the 8-to-1 shaft.

Earlier Bolex cameras use a rewind crank with a smaller sized center hole. Therefore, be sure to test the crank to be sure it's the compatible type for the camera.

Pistol grip

The Bolex pistol grip is designed with a built-in trigger to operate the run switch (D) or the run button (C), depending on the model of grip. Different grips are designed for use

Figure 5.19 The turret locking cap is used when mounting a heavy zoom lens on the camera to prevent the turret from shifting.

Figure 5.20 **Above:** The backwind crank. **Below:** The crank engaged with the 8-to-1 shaft (K) to backwind film in the camera.

Figure 5.21 The Bolex cable release adaptor, with cable release attached for single-frame shooting. The adaptor can also be mounted in the other direction for continuous shooting.

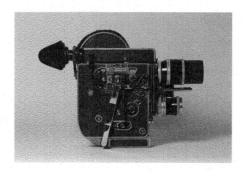

Figure 5.22 The Rex-o-fader installed on a Bolex Rex4.

with either the round-bottom or the flat-bottom models of Bolex camera. The flat-bottom version uses a round quick-release shoe, so be sure to keep track of the shoe so it's not gone astray when needed.

Before deciding to shoot with the grip, try handholding the camera without it. Using the grip is a matter of preference, and it may be preferable to handhold the camera directly without it.

Cable release

The Bolex cable release attaches to the camera by means of a cable release adaptor, which is attached to the run switch (D) by turning the large silver knob one quarter-turn. The Bolex cable release is not compatible with standard photographic cable releases, screwing onto the adaptor with its own size of thread. The end is also a straight-threaded screw, rather than the conical shape of a photographic cable release.

Rex-o-fader

The Rex-o-fader is a rather unusual device for creating highly controlled fades and dis-solves. A pin on the end of a small arm engages with the camera's variable shutter lever. While the camera is running, a switch will cause this arm to move up or down, fading in or fading out for exactly forty frames. It's powered by the camera's spring, using a special geared winding handle, substituted for the camera's standard one. Additionally, the Rex-o-fader will automatically stop the camera at the exact end of a fade out when the run switch (D) on the side of the camera is set to "M."

The Rex-o-fader allows the creation of precise cross-dissolves in the camera, exactly forty frames long. The mechanical fade of the Rex-o-fader can also be a smoother-looking fade than one done by moving the variable shutter lever by hand while shooting.

To install the Rex-o-fader on the camera, a small screwdriver is needed, and sometimes a small plug must first be unscrewed from the threaded hole below the hub of the winding handle. The winding handle is removed from the camera by turning it clockwise; typically it takes a little extra effort to loosen it at first. The variable shutter lever (G) is pulled out to unlock it when using the Rex-o-fader. Pull back on the spring-loaded pin on the Rex-o-fader to insert it into the round knob on the end of the variable shutter lever.

Two models of Rex-o-fader were made; an earlier one with a short handle and a later one with a long, curved handle. The mechanics are the same. The Rex-o-fader will only create a forty-frame long fade; no less and no more.

Using the Rex-o-fader to create a cross dissolve

The steps for creating a cross–dissolve with the Rex-o-fader are as follows:

Use the run switch (D) on the side of the camera for shooting, pulling it all the way back to M so that it will run the camera continuously (when the "click" is heard).

At the desired moment, push down on the handle at the back of the Rex-o-fader and hold it down while the fade out occurs (ostensibly the Rex-o-fader will keep going when activated, but sometimes it doesn't, and therefore letting go of the handle may pause it midway through the fade). The camera will automatically stop at the end of the fade.

Reset the frame counter (I) to read "40" by turning the knob that is also the 8-to-1 shaft (K).

Disengage the camera's spring motor by simultaneously bringing down the spring disengage switch (J) to 0 and pushing in the run switch (D) to M.

Engage the backwind crank with the 8-to-1 shaft (K) and wind back from 40 on the frame counter to 0 (Tip: Go back just a slight bit before 0, as the camera's mechanism will catch with the next frame when the spring is re-engaged).

Re-engage the spring by first setting the run switch to STOP and then turning the spring disengage switch to MOT.

Wind the camera. It's easy to forget to do this when paying attention to all of these other steps.

Before starting to shoot, push upward on the Rex-o-fader lever, so that the Rex-o-fader will immediately begin fading in as the camera starts running.

Use the run switch on the side if you intend to end with another dissolve (or either the switch or the run button on the front of the camera if this is not the case). As the fade in begins, keep pressing up on the Rex-o-fader lever until the variable shutter lever is completely up, otherwise the fade in may stop midway through.

Matte Box

A matte box designed for the Bolex camera uses a special mounting plate that is attached to the front of the camera. The mounting plate can only be used with flat-based Bolex cameras.

While other matte box rigs may be considered, such as those for use with DSLR cameras, attention should be given to the fact that the Bolex taking lens is not aligned with the center of the camera. It is displaced by approximately 11/16ths of an inch to the left from the center of the tripod screw. Therefore, if a matte box is not designed specifically for the Bolex, it may have to be adjusted or adapted.

MST and ESM motors

The MST motor is a constant-speed electric motor for the Bolex camera, designed either to run at 24fps or 25fps. It is not switchable between these two speeds but manufactured to run at one or the other. The ESM is a variable speed motor, capable of going at speeds from 10fps to 50fps.

When installing the motor, it is very important to set the camera speed (F) to 64fps to avoid damaging the camera or the motor.

The MST will run either in forward and reverse, which is useful for double exposure, but as with any Bolex camera, if filming while running in reverse, the frameline will appear in the shot. The motor prevents the use of the variable shutter, so if backwinding the film, use a lens cap instead.

The MST was designed for cable-sync shooting, generating a 60Hz tone (or 50Hz in the 25fps European model) corresponding to the speed of the motor. A built-in blooper can be used to flash a light in the gate of the camera while sending a tone to the audio recorder to be used in lieu of a slate. Despite this, the Bolex is a bit noisy to be a practical camera for sync shooting. (More on the subject of sync shooting in Chapter 7.)

400ft magazine

The 400ft magazine for the Bolex camera attaches to the top of a Bolex equipped with a magazine door. The Rex5 will not run the magazine via the camera's spring drive: An external electric motor, like the MST, must be used. The magazine employs a torque motor to reel up the film, drawing its power from a connection on the external motor. The torque motor attaches to the magazine on the take-up and is exchangeable from one magazine to the other with a quarter-twist. Unlike the daylight spools used in the camera, a changing bag (or completely darkened loading room) is needed to load the film into the magazine. A roller on the end of a spring-loaded arm inside the magazine is linked to the footage counter pointer on the outside of the magazine; the roller may be exchanged for a smaller version to use with daylight spools.

The magazine has a pair of accessory rollers used inside the camera on the supply and take-up spindles. When using the magazine, the camera is manually loaded: Pull the spring-loaded film guides away from the sprocketed rollers (X) to insert the film from the side (on some models of Bolex there is a built-in clip to hold the film guides open). Disengage the pressure plate (Y) by pulling up and back on the small silver knob, and slip the film between the pressure plate and the gate. Be sure to close the loop formers (W) to check that the loops are the correct size, and pull open the guides to adjust the film if necessary.

Other accessories

The Bolex 3-D attachment and underwater housing will be introduced in Chapter 7. Items made by other companies for the Bolex include electric motors (such as those made by a firm called Stevens) suitable for use with older Bolexes with the 8-to-1 shaft. Animation motors made by J-K (also known for the manufacture of optical printers), and time-lapse motors by Tobin and NCS, use the 1-to-1 shaft. (Keep in mind that older Bolex cameras may not have the 1-to-1 shaft.) The Film Group, Inc. has made a crystal control for the MST motor, requiring the motor cable connection to be rewired prior to use.

Tobin intervalometer

The Tobin intervalometer (time-lapse motor) uses a rheostat to set the interval between exposures, the numbers providing a close approximation of the number of seconds or minutes dialed up. It can be set for either standard exposures, with the shutter opening

briefly and remaining closed in the interval between exposures, or set to film time exposures with the shutter remaining open before briefly closing to advance to the next frame. The intervalometer can be set to fast forward and rewind for loading or backwinding the film. The exposure time is much longer than when shooting single frame with the Bolex: the equivalent of five f-stops more exposure than shooting at 24fps. Neutral density filters are useful for compensating for this long shutter speed. The Tobin intervalometer is powered by a twelve-volt battery, connected to the motor via a four-pin XLR cable.

Care should be taken when mounting a time-lapse or animation motor onto the 1-to-1 shaft. There is a small red dot on the 1-to-1 shaft to indicate the shutter position. It is critical to have the shaft in the correct position, otherwise the shutter will close when it's meant to be open and be open when it is meant to be closed, creating either completely overexposed footage or flash frames between sequences. When the dot is on the side of the shaft towards the front of the camera, the shutter is closed. To verify the external single-frame motor is correctly mounted to the camera, turn the turret so that no lens is in front of the gate. Run the camera with the motor, looking at the gate to see the shutter closes after exposing a frame of film, rather than closes as the motor runs and then stops in the open position.

Shooting with the Bolex

One of the first things to get used to doing is winding the spring (B) between shots. Every so often, this gets overlooked, and the camera will stop running mid shot if it's at the end of the wind.

A good deal can be learned by listening to the sound of the camera, such as anticipating when the spring is nearly wound down during a longer shot, or hearing the telltale crunching sound of misloaded film. Sometimes the Bolex spring can produce a disconcerting clunk, but this is usually not a sound to merit concern.

While the Bolex may not appear to be an ergonomic camera for handheld shooting, it is quite stable when gripped from below with one's right hand, with a finger on the front run button (C). The left hand either clutches the top of the camera (with fingers under the strap on top of the camera) or steadies the camera by operating the focusing ring.

There is no need to close the variable shutter (G) or the viewfinder switch (M) between shots to prevent light leaks. If you are concerned about light leaks, then put gaffer tape around the camera door.

When done shooting, be sure to run the camera until the spring is fully unwound, as this is the best way to store the camera when not shooting to maintain the strength of the spring.

Single-frame shooting

When shooting single-frame exposures with the Bolex, be sure the I/T switch (H) is set correctly: I for instantaneous exposures or T for longer time exposures. With the camera set on I, an exposure compensation should be made by closing one f-stop. This can be done on the lens or by setting the variable shutter (G) to 1, remembering to change the setting back when shooting at 24fps.

Preparing to shoot with the Bolex: a step-by-step guide

Prior to shooting

Is there a take-up spool?

Is the filter holder (R) in place (with no filter in it already)?

Is the variable shutter (G) open?

Is the speed dial (F) set to 24 (or the speed-test mark)?

If shooting a single-frame sequence (time lapse, animation), be sure the I/T switch (H) is set to I.

Be sure the wide and telephoto are not mounted next to one another (25mm normal lens should be in the center position).

Make sure that all the caps are put away in the camera case.

For newer lenses (with a lever used to set the aperture), the back ring of the lens turns separately from the rest of the lens, so be sure that the lens is mounted with the indicator for focus and f-stop facing out.

(N.B. if you want to clean the lenses, roll up a piece of lens tissue and gently brush off dust, or use a drop of lens cleaner on the tissue. Don't apply the lens cleaner directly to the lens. Never scrub a lens with dry lens tissue; this will likely scratch the delicate anti-glare coating on the lens.)

Loading the Bolex

Wind camera (B).

Open camera door (S).

Take out take-up spool (U).

Put roll of film on the upper spindle. Be sure it's coming off the roll in the correct direction (check the white arrow).

Cut the end of the film in the film cutter (V) (being sure to take the cut bit out of the camera).

Close the loop formers (W) (the lever closes them; the button opens them).

Feed the film into the upper roller (X) and run the camera (C) (the film should run from the upper loop former to the gate and then to the lower loop former and out from the lower roller).

Run about one foot or so of film out, and feed the film into the slot on the take-up reel.

Gather the film up onto the take-up reel and place on the lower spindle (be sure that the film isn't wound around the spool ejector etc., but is going directly from the roller to the take-up reel).

You can open the loop formers (push the button) and run a "burst" to check that the loops are good.

Figure 5.23 Tape placed around the camera door after loading to prevent light leaks.

Check the pressure plate (Y): Push against it with your finger to make sure it is engaged.

Close the camera door.

Use gaffer tape around the camera door to prevent light leaks (especially when shooting outdoors).

Run the camera, advancing the footage counter (E) from ft to 0.

Set the diopter

Rotate the turret using the handle (O) so that there is no lens in front of the gate.

Loosen the locking ring on the diopter (A).

Look through the viewfinder and adjust the diopter setting ring so that the groundglass appears grainy.

Tighten the locking ring (while holding the setting ring so that it doesn't shift as you lock the diopter).

Double exposure

A thorough review of the considerations regarding double-exposure shooting is found in Chapter 4 (pp. 88–92). Here are some key things to keep in mind when shooting double exposures with the Bolex:

- Be sure to close the variable shutter (G) when backwinding the film, otherwise an inadvertent additional exposure will be shot (such as the view from the camera lying sideways on a table) while rewinding. (A lens cap can also be used instead.)
- Don't forget to wind the spring before shooting the second exposure.
- Be sure not to film beyond the end of the roll and then attempt to rewind (the unthreaded film will just turn around on the take-up and not be rewound). Also be sure not to rewind too far back and unthread the camera at the beginning of the roll.

Troubleshooting

There may be troubles attributable to malfunctioning equipment but also to unfamiliarity with the camera. The list of issues below are some commonly encountered problems, but if an answer isn't found here, then consult an expert for additional help.

Camera won't wind

- The camera is already fully wound.
- The motor is disengaged: The switch (J) is set to 0 instead of MOT.
- The spring has snapped (as may happen every few decades from routine use of the camera, or from running it at high speed without film).

Double-exposure steps for the Bolex

Before shooting, make note of the footage counter (E) if intending to rewind
to the start of the shot. Optionally, the frame counter (I) can be reset before
shooting the first exposure to backwind precisely to the starting frame of the
shot.

Shoot the initial exposure (with a double-exposure compensation, if needed)
while keeping track of the timing of the shot. The audible counter (Z) can be
useful for this.

Close the variable shutter (G) by pulling the lever out to unlock it, and then
move the lever all the way down. Push it in to lock it closed.

Disengage the spring by simultaneously turning the spring disengage switch (J)
from MOT to 0 while moving the run switch (D) to M until it clicks into
place.

Insert the rewind crank onto the hub of the 8-to-1 shaft (K) and turn in the direc-
tion of the small arrow to backwind the film, observing the footage counter to
see how far to go (or the frame counter, if it was reset, as noted above).

Re-engage the spring by first moving the run switch to STOP and then turning
the spring disengage switch to MOT.

Open the variable shutter by pulling it out, moving it up, and pushing it back in
to lock it in the open position.

Wind the camera's spring (B).

Shoot the second exposure (with a double-exposure compensation if needed)
while keeping track of the timing of the shot, so as to stop the camera at the
same point in time as the first exposure (if necessary). (The audible counter
(Z) can be useful for timing double exposures.)

Loading the film from the take-up side

If the film runs all the way through the camera and one is intending to rewind the
entire roll for a double exposure, it is still possible to rewind the film. The easy way
is to take the roll into a darkroom with a set of rewinds. But it is also possible to
rewind the film in the camera by threading the camera manually (a similar process
to threading the Bolex when using a 400ft magazine):

With the spool on the take-up spindle, pull out about a foot of film.

Disengage the pressure plate (Y).

Hold open the film guides on the rollers and insert the film between the guides
and the rollers (X).

Open the pressure plate (Y) by pulling the small silver knob and moving it back.
Thread the film between the pressure plate and the gate.

Snap the pressure plate closed by pushing it against the gate.

Close the loop formers (W) to check that the loops are the correct size and pull
open the guides to adjust the film if necessary.

Thread the film onto the supply spool and snap the spool in place on the upper
spindle (T).

Close the camera door.

Close the variable shutter (G) prior to backwinding the film.

Setting the frame rate (F) to 64fps will relax the camera governor, making it easier to rewind. (Remember to set it back to 24fps.)

When rewinding the film, be aware that the footage counter (E) will have been reset to "ft" when the camera door was opened, so it will be necessary to listen for the click of the film, having gone all the way through to the supply reel. You will also feel the mechanism relax while rewinding to confirm the film is completely rewound.

Rethread the film into the camera before shooting.

Camera won't run

- The camera's spring isn't wound (B).
- The motor is disengaged: The switch (J) is set to 0 instead of MOT.
- The run switch (D) on the side of the camera has jammed. This can happen sometimes when shooting single frame, especially when the spring is nearly run down. Try winding the camera or nudging the winding handle back and forth while gently pushing on the run switch to get it unstuck.

Attempted to load camera with loop formers (W) open

This can happen when unaccustomed to the Bolex and in a rush to load the film. The film will jam after exiting the upper sprocketed roller (X).

Pull the film guide away from the roller to extract the film. Or, break the film between the supply spool and the roller. You can then run the camera to get the film out from the roller while pulling on the small strip of film to remove it from where it has jammed.

Close the loop formers and recut (V) the end of the film before proceeding to load the film.

Turret won't turn

Check to see if there is a turret locking cap in the lower mount of the turret, or if the turret lock (P) is engaged.

No image in the viewfinder

- The viewfinder switch (M) is closed.
- The image may be difficult to see if not looking straight into the viewfinder.
- The aperture is closed down. The image is there but just extremely dark in the finder.
- The turret has shifted, so the lens isn't seated in front of the gate.
- Check that there isn't a lens cap on the taking lens.

Lens won't focus

- The diopter (A) isn't set.
- The wide-angle lens won't be able to focus to infinity if it is a non-reflex (AR) lens mounted on a reflex camera, especially when the aperture is wide open (although when the lens is closed down then depth of field may allow this to be fudged).

- If using a macro lens, check that it isn't set to the macro range: The red ring is revealed just behind the focusing ring.

Light leaks on footage

- The door isn't providing a complete seal: Use gaffer tape around the door after loading the film.
- The door was not completely closed: Push down on the door on the right side when closing the camera after loading.

Footage is jumpy, out of focus, with smears of light

Pressure plate was not engaged. In particular, if the footage is in focus for just a frame or two at the beginning of each shot and goes out of focus, then the issue is with the pressure plate (and not the lens).

Hair in the gate

Unlike most super-8 cameras or 16mm cameras with a snap-on 400ft magazine, the Bolex is not a hair-prone camera. It is usually not necessary to obsessively check the gate of the camera as is done with a camera like the Arriflex SR, but it should be checked every so often, or cleaned when footage comes back from the lab with a hair present in the image.

To check the gate: Turn the turret using the handle (O) so the gate is exposed, and remove the filter holder (R). Use your fingernail to flip the prism away from the gate. Set the I/T switch (H) to T, and push the run switch (D) forward to P to hold the shutter open so that you may visually inspect the gate. In the event there is a hair or some other debris in the gate, you may clean it through the gate or remove the pressure plate (Y) to access the gate from inside the camera. Never use any type of metal tool to clean the gate, only use something like a wooden orange stick.

"Letting the Bolex talk"

There are times when one sees a film with certain visual elements – fades created by the variable shutter, in-camera double exposures, or even flaws like the streak of light from the filter holder not being in place – and one may say to oneself, by way of conclusion: "This film must have been shot with a Bolex." Marie Menken's films, as Kubelka has observed, let the camera's many possibilities speak on the screen. Her films have many notable "this film must have been shot with a Bolex" moments.

The aptitude of the compact Bolex for single-frame shooting is put to full use in Menken's semi-sardonic portrait of " . . . the city of New York, the busy man's engrossment in his busy-ness . . . " [13] titled *Go Go Go* (1964). The film mixes handheld and single-frame shooting:

> Perpetual jerks and jumps amplify the stop-motion gaps from one frame to the next as Menken shoots most of the film holding her camera in hand. Only during steady time-lapse views of the harbour shown near the start and at the very end of the film, are eyes "unclenched" from the onslaught of images. [14]

In *Notebook* (1962), a collection of fragmented sketches Menken has called "too tiny or too obvious for comment," [15] there are close-ups of raindrops in black and white, a candlelit procession for Greek Epiphany, conveying the visual appeal of 16mm film, yet

not seeming like footage exclusive to the capabilities of the Bolex. Later in the film, the Bolex's unique qualities appear in a section titled "Night Writing." Long exposures created through the I/T switch set to T are used to film lights at night while moving the camera to create shapes, such as the circles and triangles of bright colorful lines on a black background. A film titled *Lights* (1966), "made during the brief Christmas-lit season, usually between the hours of midnight and 1:00 A.M., when vehicle and foot traffic was light,"[16] expands upon the "Lights" and "Night Writing" sections of *Notebook*. Midway through *Lights*, the camera looks at the city from a tall vantage, viewing passing airplanes, illuminated buildings, streetlights, and car headlights. The long exposures produce parallel lines of light in contracted squiggles. Such are Menken's films: the Bolex's potential, used by an artist.

The goal of the next chapter is to look at how more than a few experimental filmmakers have made use of a form intrinsic to the 100ft-loading 16mm camera: the three-minute camera-roll film. While the unedited roll of film may seem like a recipe for producing similar work, we will see there is a surprising diversity of approaches to this singular concept.

Notes

1 Foster, Gwendolyn Audrey and Wheeler Winston Dixon ed. *Experimental Cinema, The Film Reader.* New York: Routledge, 2002, p. 3.

2 Levitas, Louise, "How to Make Your Own Movies on a Shoestring" (1946), *The Legend of Maya Deren* vol. 1 part 2. Anthology Film Archives, 1988, pp. 388–389.

3 Mekas, Jonas, "The Diary Film," in P. Adams Sitney ed., *The Avant-Garde Film Reader of Theory and Criticism.* Anthology Film Archives, 1978, p. 195.

4 Mekas, Jonas, *Movie Journal: The Rise of the New American Cinema 1959–1971.* New York: Collier Books, 1972, p. 371.

5 Kuchar, George, "Gazing Back" (ca. 1994), in Andrew Lampert ed., *The George Kuchar Reader.* New York: Primary Information, 2014, p. 180.

6 Mandell, Leslie (assisted by Paul Sitney), "Interview with Marie Menken," *Wagner Literary Magazine* no. 4., Gerard Malanga and Paul Katz ed. Staten Island, NY: Wagner College, 1963–64, p. 48.

7 Peter Kubelka, interviewed in Martina Kudláček's *Notes on Marie Menken* (2006).

8 It should be noted that this is less pronounced than the same effect from an electric motor camera, which oftentimes takes a little longer to go from a full stop up to speed.

9 Alden, Andrew, *Bolex Bible.* West Yorkshire: A2 Time Based Graphics, 1998, p. 9.

10 Surgenor, A. J., *Bolex Guide*, 4th Edition. London and New York: The Focal Press, 1956, p. 12.

11 This is done using a stroboscopic wheel that fits onto the camera's shaft and is viewed with a fluorescent light, which will produce a strobe based on its 60Hz cycle, or an analytical strobe set at twenty-four pulses per second.

12 Alden, *Bolex Bible*, p. 30.

13 Ibid., p. 370.

14 Joosse, Angela, "The Irrepressible Rush of Marie Menken's Go! Go! Go!," *Cineaction*, issue 93, 2014, p. 24.

15 *The Film-Makers' Cooperative Catalogue No. 7.* New York: The New American Cinema Group, Inc., 1989, p. 369.

16 Ibid., p. 370.

6 The camera-roll film
The film with no editing

This chapter covers strategies in shooting unedited footage as an experimental filmmaking method.

The "camera-roll film" may be described in humble terms as an expedient to creating finished work with modest means and the fewest of steps, or in a more grandiose manner, as a filmic Athena, the goddess of wisdom, emerging from the camera's light-tight, skull-like enclosure immediately ready for projection (after a brief stopover to the laboratory). As in the Greek myth, born full grown from Zeus's head, complete with armor. The film skips entirely past the slow process of maturation in the nursery of the editing room, with the completed film arriving back from the lab – instant cinema!

The 100ft camera roll is three minutes in duration. There are about seven seconds of the flares at the head of the roll and shorter flares at the tail end. The 100ft roll is actually 108ft long (4,320 frames), accounting for the extra few feet supplied by Kodak. If discounting the end-flares, the roll can be considered to have 100 "useable" feet (4,000 frames).

Given the three-minute camera roll's finite screen time (short, even by the standards of a short film), R. H. Blythe's observations regarding haiku may be useful to consider:

> [Haiku] belongs to a tradition of looking at thing, a way of living, a certain tenderness and smallness of the mind that avoids the magnificent, the infinite and eternal ... Haiku record what Wordsworth calls those "spots of time," those moments which for some quite mysterious reason have a particular significance.[1]

In this spirit, poet and filmmaker James Broughton's three-minute film, *High Kukus* (1973), contemplates the slight ripples in the surface of a pond within a shadowy woodland in a single uninterrupted shot, while Broughton reads his short whimsical verses on the film's soundtrack.

Defending the music of Erik Satie, John Cage countered the complaint that, with a few exceptions, Satie composed no "big" works: "He wrote, more often than not, short pieces, as did Scarlatti and Couperin ... The length of a work, however, is no measure of its quality or beauty, most of post-Renaissance art-propaganda to the contrary."[2]

The temporal economy of the camera-roll film can be examined from the standpoint of its production time, as well as the resultant screen time. Warhol's *Screen Tests* (1964–66) were conceived to require very little setup time; Stephen Koch relates,

> ... a Bolex had been installed on a fixed tripod in the Factory, a huge pile of film rolls beside it, and that it was never taken down. Any new guest – remember that in

1963 Warhol was entering the most conspicuous era of his fame; there were *hundreds* of guests – was put into a chair before the camera as soon as he or she arrived. They would sit through the roll, their film portrait being made.[3]

If shot as a continuous take, the camera-roll film will take no more than three minutes of production time, plus whatever is required for loading, setup, exposure readings, and the like. This is not to diminish the commitment of effort in shooting a three-minute take. Valuations of scale and duration of this nature bring to mind James McNeill Whistler's testimony regarding the time involved in producing *Nocturne in Black and Gold: The Falling Rocket*.

> "The labour of two days, then, is that for which you ask two hundred guineas!"
> "No; – I ask it for the knowledge of a lifetime." (*Applause.*)[4]

Author and historian Mark Katz has described how the three-minute record influenced the composers of the first half of the twentieth century. Some were disposed to shape their music to the recording time of the disc: Igor Stravinsky, Edward Elgar, Fritz Kreisler, and Roy Harris, by way of example.[5] The three-minute record and three-minute camera roll possess such a tidy durational equivalency that it has led to the combination of the two, as in Jack Smith's *Scotch Tape* (1959–62), or Bruce Baillie's *All My Life* (1966).

The filmmaker Storm De Hirsch referred to her super-8 films as *Cine Sonnets*. Her intention in these works was akin to a cinematic form of sketching or note-taking:

> When I made "The Tattooed Man" with a grant from the American Film Institute, I used 16.mm and carried around a tripod and the whole works. But, occasionally, when I wasn't shooting, I used a Super-8 camera to record interesting things that I saw as reminders for some future project. You see, I use Super-8 as a notebook, or a sketchbook when I'm traveling, not necessarily intending to blow it up to 16mm, but just as memorandum for me.[6]

The camera roll as aesthetic self-restriction

The restriction of going without editing may seem like a needless, or arbitrary, form of self-constraint. And yet, working without any constraint whatsoever isn't really possible. An unlimited budget isn't typical of independent filmmaking. Nor is an unlimited amount of time. Outdoors, a passing cloud doesn't stop its progress so as not to interfere with the lighting. Nor does the sun wait to set while the filmmaker prepares for a retake. Constraint and creativity are always in conversation with each other.

The camera roll can be thought of as a self-imposed creative challenge, akin to the rules imposed by Danish filmmaker Lars von Trier on his former film teacher, Jørgen Leth, in von Trier's *Five Obstructions* (*De fem benspænd*) (2003). Teacher and student reverse rolls, with von Trier assigning Leth the task of remaking a short film, *The Perfect Human* (*Det perfekte menneske*) (1967), each time imposing some form of constraint: one version using only half-second shots; another version remade in animated form rather than live action. For the second version of *The Perfect Human*, Leth has hidden the setting demanded by von Trier – the slums of Bombay – behind a white curtain. Von Trier feels that Leth has circumvented the obstruction, rather than found a creative way to work within it. They

discuss the third version of the film Leth is to make: "We haven't achieved what I wanted. So I have to punish you somehow. What should the punishment be?" . . . "I can't say. But I prefer you to make the decisions." "So make a film with no rules from me! . . . I am sorry, but to assert my authority I'll take to ask you to make that film again the way you think best. *The Perfect Human* in 2002. Just make it." "How diabolical" reacts Leth, after a pause, to the constraint of having no constraints at all.

The obstruction of "complete freedom" may seem a blessing rather than a restriction, but it may also leave the filmmaker floating at sea, with nothing to grasp onto. The natural limits of tools, time, and budget may be considered a puzzle to unlock: A creative way to make use of these constraints is the key.

It's too familiar a dilemma to shoot the first ever roll of film and find disappointment in results falling short of expectations. There may be an out of focus shot; a less than striking arrangement of the composition in the confined rectangle of the frame of the screen; clumsy handheld or faltering tripod pans and tilts of an unmotivated nature; and other forms of sundry mistakes and false starts. As a form of artistic training, the three-minute roll of film acts as a teacher of concision and resoluteness. No room for shilly-shallying in its formulation. It allows only so much to be said within the brackets of its end-flares.

A wealth of possibilities within an economy of means

While it has its inherent limits proscribed by the medium itself, the camera-roll film is at its most interesting through the diversity of approaches it may take rather than some singular formula for its realization.

It may be a rigorous formal work of precision, where its unedited aspect calls for impeccable technique. It might be a casual diary-like unreeling of a finite time and experience. The camera roll may be improvisatory and spontaneous, or shot with exactingness of in-camera editing, the sequence of shots pre-arranged with an editor's eye. A single theme and its visual variations may be the structure. Or the distillation of a variety of ideas may be compressed into a series of fleeting fragments within the roll's three minutes. The camera roll may be an overwhelming single-frame adventure of visual ebullience. It can be a serene meditation on the singular image. The camera-roll film might be shaped as a tangled amalgam of superimpositions. Or its economy (of a financial nature) may allow for a strange experiment risked because so little film would go to waste in the event of its failure.

If every camera roll had to be approached with the same solution, it would not be an interesting form of creative experiment.

Harry Smith's *Late Superimpositions* (1964) strings together several camera rolls, with images exposed on top of others. The ones placed at the start and end of the film use darkness and mattes to arrange the images within different sectors of the frame. In the middle rolls, with footage of the Folkways Records offices and a sequence showing Native American dance in Oklahoma, the double-exposed images are overlaid more broadly across the frame.

Shuji Terayama's *Young Person's Guide to Cinema* (*Seishonen no tame no eiga nyumon*) (1974) was made as an occasional piece for a camera-roll screening: the 100 Feet Film Festival organized by Image Forum in Tokyo. Its title is a mocking reworking of Benjamin Britten's symphonic variations, *The Young Person's Guide to the Orchestra*. Three divergent 100ft rolls are projected simultaneously on screen. Each was printed in its own color tint: pink, green, and violet. The triple projection seems a mischievous dodge of the film festival's premise: getting to shoot and project nine minutes of footage at a three-minute

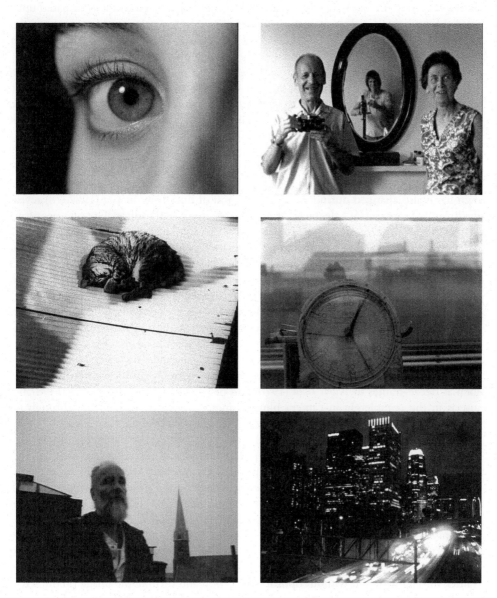

Figure 6.1 **Top row left:** Guy Sherwin's *Eye* (1978). Courtesy of the filmmaker and LUX. **Top row right:** Guy Sherwin's *Portrait With Parents* (1975). Courtesy of the filmmaker and LUX. **Middle row left:** Guy Sherwin's *Cat* (1977–78). Courtesy of the filmmaker and LUX. **Middle row right:** Guy Sherwin's *Clock and Train* (1978). Courtesy of the filmmaker and LUX. **Bottom row left:** Marie Losier's *Snowbeard* (2009). **Bottom row right:** Echo Park Film Center's *The Sound We See: A Los Angeles City Symphony* (2010).

camera-roll screening. The notion of the "young person's guide," with its paternal qualities and undercurrent of condescension, is also lampooned through Terayama's infamous subversive ethos. The edifying cinematic lesson ends with the camera lens urinated upon, viewed from behind a clear protective panel.

Guy Sherwin *Short Film Series* (1975–2014) are silent black and white camera-roll films with a single subject and oftentimes a single fixed shot. The films invite the audience's contemplation of the subject and its cinematic interpretation over the course of the three minutes of the roll. Techniques such as hand-cranking, racking focus, single-frame shooting and racking f-stop are paired together with some corresponding aspect of the subject of the film. The change in aperture accompanies the inhalations of globe-like flesh in *Breathing* (1978), with the windowsill in the background coming into and out of focus due to the changing f-stop's increasing and diminishing depth of field. *Eye* (1978) uses a light with a dimmer to effect the widening and shrinking of the iris of an eye in close-up, the image brightening or darkening as the eye's iris narrows and opens, while the camera's own iris is also changed during the filming. A roll of time lapse in *Cat* (1977–78) reveals the breathing motions of a sleeping cat on a corrugated metal rooftop. The cat's occasional spasms suggest dreaming, before it awakes and pads away on cue, just in time for the end-flares. In *Clock and Train* (1978), the hands on a clock move both forward and backward in hand-cranked double exposures filmed from the start of the roll then from the end back to the beginning. The Bolex camera makes an appearance reflected in a mirror in *Portrait with Parents* (1975), *Handcrank Clock* (1976), and *Hand/Shutter* (1976). The shadow of a bicycle wheel rolls in an arc across the frame while riding around in a circle. A close-up of a blinking eye is filmed with short bursts of grainy black taking the place of the image as the camera "blinks" back at it. A metronome's swinging arm moves in strange undulations during its circuit back and forth when filmed in single-frame exposures, the interval close to the metronome's rate of ticking. A few of the films use post-production techniques, such as freeze-frames in *Night Train* (1978) and bi-pack printing in *Coots* (1997–98), but, just as in the completely in-camera films, a single concept is worked out through the three-minute roll, rather than a miscellany of techniques and ideas.

Marjorie Keller's camera-roll films – *Ancient Parts/Foreign Parts/Private Parts* (1988) – adopt a home movie subject matter while photographed with extreme care and craft: Keller's use of editorial shot relationships of parallel editing, reaction shot and cutaway give the impression of a constructed film rather than impromptu process. Glimpses of family life with picnics, boys launching toy rockets, and other scenes of friends, youngsters and relatives in social gatherings are the subjects of these camera-roll films.

Stom Sogo's *3 Films for Untitled* (1995) – described as "1. Sun Sets in My Room 2. Short Time With My Grandmom 3. Three Moods in a View"– each use a constricted palette of techniques worked through the roll's three-minute time span. Here are short bursts of frames; filming with and without optical obfuscation and turning the image on the screen into three vertical panels with the use of mattes and color filters. The first camera roll is a study of an apartment interior, handheld and filmed in short staccato shots as the lens roams around, showing the surface texture of the layers of paint on the moldings around door and window, a pair of crutches leaning up against the wall, and the view looking down at the city from the window as the sun sets in the distance. The second is a film portrait of Sogo's grandmother, beginning with color filters cut in diagonals and distorting glass, creating patterns of color and shape on the screen, followed by scenes of an elderly Asian woman inside her home (Stom's grandmother) giving a benevolent smile to the camera. Incidentally, the band of bright light on the right side of the frame informs us that Sogo filmed these sequences with the filter holder absent from a Bolex camera. This

is followed by footage taken outside, showing summertime sauntering in bright sunlight, flowers, and wild grass, with the camera freely meandering in handheld shots. The camera returns to the grandmother, a handheld magnifier briefly studying the light entering the partly drawn shades inside the house. The three-minute film roll ends as it began, with cut up red filters and abstracted optical distortions. The third camera roll shows New York City's streets, buildings, and people, filmed in careening camera movements. The entire film takes the form of a three-sectioned matte shot: left, right, and center. The mattes overlap each other – the dividing line sometimes indistinct – while color filters act to counterpoint the three exposures: blue and green on the sides and a combination of a wedge-shaped red triangle and a yellow band arranged in the center exposure.

Canadian filmmaker John Price has an extensive number of camera-roll films. The silent film *Party #1* (2005) shows an infant and mother sitting in a city park, the color palate of the film a strange combination of faded and lush due to the hand-processing of an old roll of Ektachrome. Ebullient movements of the handheld camera go roving over the scene, with the images doubled over themselves, upside down, and right-side up, which was done by reloading the double-perforated roll of film back into the camera and shooting it from tail to head to produce the inverted image.

Seattle filmmaker Jon Behrens's *Six Arms - Homage to Mekas* (2006) – filmed at the Pike Street tavern in the film's title – was produced for the occasion of a screening of work responding to the diary films of Jonas Mekas. The handheld camera performs pans and tilts, in constant motion. Daylight comes streaming in through the large windows. A close-up of a pint reoccurs through the film; its amber-colored contents diminish in each appearance like an ebbing tide. A celestial chandelier comprised of chrome sphere and radiating rods hangs over the bar and becomes a transfixing object in the camera's arcing movements.

Marie Losier's *Snowbeard* (2009) uses a 100ft camera roll as a means to bid adieu to friend and cinematic mentor Mike Kuchar. It was filmed in New York before his relocation to the Bay Area, with three minutes of handheld tracking shots of him on a rooftop, the New York City skyline in the background. The camera gazes upon his bearded face during each of the short shots, repeatedly moving from far to near.

Filmmaker Christopher Harris's *28.IV.81 (Bedouin Spark)* (2009) uses a single visual tableau filmed at different speeds – from languorous and slow to frantic and fast. An extreme close-up of flat mirror-like five-pointed stars, floating and colliding in a clear semi-viscous fluid, appears at the film's outset. The drifting star-shaped bits of Mylar catch the light, in brief spark-like moments of radiance: Single-frame sequences speed up the motion, punctuating the longer takes in the film. *28.IV.81 (Descending Figures)* (2011) is composed of two camera rolls, projected side by side, showing a modern-day re-enactment of the Passion Play. The camera door is opened every so often to bleach the image out, as a series of recurring mid-roll camera flares, suggesting the maxim from the Sermon on the Mount, "Ye are the light of the world,"[7] or a divine visitation inexplicably appearing in the midst of the chintzy banality of the outdoor performance. In another camera-roll film, *Distant Shores* (2016), Harris uses images gathered on a tour boat – scenes of banal sightseeing – as a means of considering the perils of seaborne migrants through the use of the film's audio montage of news reports. Image and sound form a poignant juxtaposition.

In Margaret Rorison's *DER SPAZIERGANG* (2013), the filmmaker wanders with a Bolex through Berlin, moving from one location to another in rapid single-frame sequences. This rapid-fire single-frame shooting stands in contrast to her three-camera roll film *PULL/DRIFT* (2013), documenting a dance performance[8] taking place in the woods and on a raft floating on a river, using long takes and static camera. Her camera-roll

film *vindmøller* (2014) studies the movements of wind turbines in Amager, Copenhagen. Double and triple exposures cause the slowly turning blades from the layered images to interact on screen, turning in unison or meshing with each other like a pair of cogs as they rotate in opposite directions.

Craig Scheihing's *Chance Imagery* (2014) begins in grainy black and white with a close-up of a page from a book showing a quote from Tristan Tzara declaring life to be more interesting than art. Photographs on a refrigerator follow this, as well as a dark-haired woman making coffee by the window in a kitchen. Out on the streets of San Francisco, the camera careens along, shooting rapid single frame, pausing every now and then for a longer shot (as if pausing for breath) to show a narrow alleyway, a man sitting on a building's steps, the view looking down a street at distant hills half-hidden in the fog. *Wind in a City* (2015) wheels its way through Chicago by bicycle, sometimes in quick single-frame sequences and other times as long flowing tracking shots. A series of *Home Movies* includes views of a sunset from a rooftop, interiors of a large communal Brooklyn artists' loft, a visit to the beach, and visits to family. There is a more impromptu-like quality in these films, shot with handheld camera, with occasional sequences of single-frame shooting and in-camera double exposure.

Aiming for (unedited) perfection

One form of shooting without editing is working with the goal of creating a flawless roll of film in-camera. This demands shooting in one's top form. It can serve as a demonstration of one's filmmaking proficiency, investing in every shot to make it one's best. It can mean shooting in a state of exultation, knowing that every shot (every frame, in fact) matters profoundly to the work, since it cannot be taken away through the face-saving trimmings of the splicer.

The notion of the perfect camera roll is much like what Hans Richter expressed in writing about his quest for the perfect painting:

> It seems that in the background of the 1920's loomed something like the promise that we could or should discover or rediscover the formula for the original magic, the perfect and ultimate painting. That is what Mondrian tried, and Malevich, and closer to me, Eggeling; something that had that magical power, lost to our art, but upon which the *raison d'être* of art, as such, ultimately would depend.[9]

Film director Allan Dwan, interviewed by Kevin Brownlow about his career during the silent era, described the pressures of the perfect in-camera effect, created back in the days when a screw-up would necessitate redoing the whole of it from the beginning. It mirrors the anxiety and tension in the midst of filming the "perfect" camera-roll reliant on flawless shooting. It also captures the sense of triumph when, somehow, it proves successful. In Dwan's case, the scheme was to shoot a sequence of twenty-five dissolves, each one done in-camera, from scene to scene:

> The cameraman would start on the first scene . . . and at a certain point I'd say "Fade," and he'd start to count, "One, two, three, four, five, six, seven, eight," and he'd be out . . . Now when we're ready for the second scene, he'd have to black his camera out, wind back eight, and we'd be ready to start. He'd fade in, and the scene would go on until I said "Ready – fade," and he'd count again and fade out. He had to do that twenty-five

times on one piece of film. Any mistake on any one of them would wreck the whole works. Now the thing was sensational. When it went to the theater, people stood up and cheered. Everyone wondered how we did it … But the cameraman was so nervous by the time he had fifteen of them on there, he'd take that roll of film and sleep with it! And he'd get up with his notes in the middle of the night and work it out to see if his numbers were right. When he put it in the camera his hands would shake so much that his assistant would have to take it away from him to be sure it was reloaded at exactly the right spot. I guess I was showing off a little. Twenty-five dissolves! It was a task to give a cameraman – I thought afterward it was a mean thing to do.[10]

The film series of *Bouquets*[11] by Rose Lowder are a good example of the masterful, highly controlled use of in-camera-created work. Her method of single-frame shooting is particular to these works, with alternating frames shot in two passes through the camera. The images seem to merge but with less of a fusing together as is the case with complete superimposition. This is done by shooting a single frame and then covering the lens, exposing frames 1, 3, 5, 7, 9, and so on. She then rewinds the camera back to that starting point, this time covering the lens for each of the previously exposed frames. The second image is filmed on the unexposed frames: 2, 4, 6, 8, 10, etc. Detailed notebooks are used to keep track of the exposures and shot lengths, including colored images of the flowers she has filmed and other subject matter, so as to combine complementary images together. Tara Merenda Nelson calls attention to these films as being carefully constructed semi-extemporaneously in "the circumstances of the moment" while Lowder is shooting: "This consciousness of the present is an essential quality of her work, and distinguishes her practice from the traditions of the Structuralist approach to filmmaking, which often follow a predetermined configuration of sequences."[12]

Other means of working in a highly proficient manner with the structure of the three-minute roll may involve simpler computations, such as dividing the 100ft into sections: 50ft, 33ft, 25ft, 10ft, using the footage counter rather than the frame counter to keep track of the subdivisions used to organize the film roll. On the Bolex camera, the audible counter switch inside the camera can be set to click every second and then used to regulate shot length: The camera roll could conceivably become a three-minute film with every shot a very uniform two seconds in length, structuring the images around a steady, rhythmic approach to in-camera editing. The structuring of a film around a series of in-camera sequences is the basis of *The Sound We See: A Los Angeles City Symphony* (2010), produced by the Echo Park Film Center as collaboration shot by thirty-seven young filmmakers taking an introductory 16mm filmmaking workshop. Each of the twenty-four one-minute sections takes place at a different location and hour of the day, using the clock as the template for the film's design.

Musical forms may also be adopted as a means of structuring the film roll: A 100ft of film in rondo form would have symmetrically divided sections, such as A-B-A, or A-B-C-B-A, or A-B-A-C-D-C-A-B-A. Harry Smith described the arrangement (not for the structure within a film roll but the arrangement of camera rolls themselves) of his *Late Superimpositions* (1964) as something equivalent to rondo (or palindrome) structure: "122333221."[13]

Filming the camera-roll film demonstrates the creative process of erasureless fine art, much like sumi-e ink drawing. The tradition of the ink drawing prohibits under-drawing and editorial erasures.[14] It must come off in the stroke of a brush. The abstract expressionist painter Franz Kline's paintings likewise immobilize the momentary energy of the moving brush. In a similar manner, filming without editing demands the use of the camera

in a way that doesn't end up feeling overly careful and too stiff – awkwardly scrawled with a tense hand. With an unedited roll of film there may be vitality present in the footage: Every shot is a triumph against failure. To film without fear – that is the lesson of the film roll, without editing.

At the same time, the difficulty of the perfect camera roll is not always some small flaw recorded on the film (a flash frame or a brief shot out of focus) but the sense of it as an all too clever showpiece for the camera. A film that feels too carefully worked out in advance may feel too stiff, too artificial and formulaic, too absent of spontaneity. Mannequin-like, it may lack that all too human quality of the imperfect. Hans Richter gave up his quest for the perfect painting owing to this type of dilemma: "Only very slowly did I recover from this inflated idea, to find myself again in more humble, human proportions. Not to try magic but to find the balance between an inner voice and an outer occasion."[15]

The filmmaker's creation of a camera roll is like a musician's performance when improvising with an instrument. A more traditional approach to filmmaking begins with script and preproduction; it then arrives on location for hours of setup before shooting, and thereafter it spends an inordinate amount of time shut away in the editing room to finally produce something ready for the screen. The camera-roll film can reform this lumbering process, the creation of the work happening in the moment, not unlike the way a jazz musician can pick up an instrument and create a fully complete work, as if summoned up from nowhere. It's not a wholly instantaneous process for the musician: To arrive at this level of extemporaneous proficiency has required prior practice and the refinement of performance skills.

The experimental filmmaker may use the camera's capabilities as the experimental musician uses "extended technique" in performing with an instrument, to take filmmaking further than the more commonplace cinematic palette. In Jonas Mekas's diary films, he frequently used the run switch on the side of the Bolex camera much like a musician performing on a fingered instrument, switching briskly between single-frame shooting, bursts of frames, and more extended shots. He explained:

> To get it now, as it happens, demands the total mastery of one's tools (in this case, the Bolex): it has to register the reality to which I react and also it has to register my state of feeling (and all the memories) as I react.[16]

Film here now

By its raw, unedited nature, camera roll conveys a sense of the ever passing moment of the present, a cinematic grasping of the ephemeral. This sense of the Wordsworthian capturing of "spots of time" becomes less evident once the splicer has mended up the ragged edges of these moments. This aspect of the camera roll requires a shooting sensibility of acceptance of what happens before the lens to capture something worth seeing, even when there's nothing in particular happening at all. The poet Allen Ginsberg used the term "first thought, best thought" to describe a similar notion of the purity of unedited material with regard to writing poetry:

> I was writing a spontaneous chain poem with Chogyam [Trungpa] and he said, and we finally agreed, "First thought is best thought." That was sort of the formula: first thought, best thought. That is to say, the first thought you had on your mind, the first thought you thought before you thought, yes, you'd have a better thought, before you thought you should have a more formal thought – first thought, best thought. But the problem is, how do you get to that first thought – that's always the problem.[17]

Brian Frye's film *Lachrymae* (2000) is a camera roll, announcing itself as such through the camera flares at its beginning and end (albeit with a hidden edit or two, according to the filmmaker). Looking through the wrought-iron fence of the old marble cemetery on Second Street in New York's Lower East Side – not far from Anthology Film Archives – the film depicts the moment of dusk during a summer evening when the sun has set but the bright sky still illuminates the world. A swarm of fireflies has emerged to hover over the grass and gravestones. They appear as meandering yellow spark-like lights, tracing lines in the air and vanishing. The scene is captured in wide locked-down shots of the graveyard. A close shot of a woman's hands cupped together comes next, a faint glimmer from within her palm reveals the firefly's glow, but her curled fingers obscure our view of the lightning bug. The camera returns to shots of the cemetery, and then the film roll flares out. The shots of the hands, in particular, give a sense of the footage's unvarnished quality due to the quick jump cut from a false start while filming. This filmmaking hiccup has been left in, rather than edited out, amplifying the sense of the camera's direct record of the transient present moment.

The proportions of the event itself guide the structure of the roll of film as working within the hour in which the evening fireflies have come to congregate. Other examples of this include the train ride in Rosalind Schneider's *Irvington To New York* (1972). Although this is not an unedited camera roll, its framing of the journey's start and finish within the film's three-minute duration still makes this work a useful study for camera-roll filmmaking. To shoot such a film, attentiveness to the footage counter can aid in timing out the progress of the roll of film in relation to the time span of the moment being filmed. Ideally, its conclusion – if there is one – should coincide with the end-flares as the film rolls out. It might take a bit of experience working with the finite three-minute film roll to get accustomed to parsing out shooting time in relation to screen time, especially for those well versed in shooting hours of video footage.

Camera editing

It may be a bit of a misnomer to think of the camera-roll film as "unedited" per se. With the camera-roll film, editing takes place through the pressing and releasing of the button to "cut" the beginning and end of each shot. The camera-roll film asks the filmmaker to undo some of the traditional learning about scene coverage (master shot, over the shoulder, inserts) of the conventional filmmaking curriculum.

The common problems with filming an in-camera version of "shooting for editing" coverage are such things as a faltering start or end to shots. A person seen standing motionless for a brief second, waiting for the camera to start rolling, before suddenly coming to life with the call to "action!" is the type of thing usually excised in the editing process. Eyes glancing momentarily at the camera lens for some prompt are another such thing. The awkwardness of a hesitant camera move, a missed cue, or an unforeseen intrusion in the background of a shot is the sort of thing the multiple-take method can accommodate much better. The assurance of adequate coverage, in the form of inserts and cutaways to use just in case, is not available for post-shooting fixes. With the camera-roll film, everything counts; there are no discretionary just-in-case shots.

In this respect, the experience of shooting sequences in-camera serves as a useful lesson, even when returning later to shooting in the more conventional manner; the weakness of shooting conventional coverage is its formulaic application of master shots, two shots, and cutaways. If the premise of carefully gathered coverage is to have everything needed from

this or that angle for every possible assembly in editing, there might be every type of shot available . . . *except* for the *right shot*.

The camera-roll film can serve to hone one's concentration for getting what's really the right shot. R. H. Blythe's observation regarding the pitfalls creating the well-composed haiku can be useful in considering the cinematic skill-sharpening qualities of the camera roll. An effective haiku can be daunting because of its sparingness: "Many a haiku is a failure because, in spite of its simplicity and brevity, it is reality still clabbered up with unessential material, reality minus art. More must be taken away, less must be said."[18] The roll of film, too, has its sense of proportion – not overloaded.

Better left as it is

Every so often there are unedited rolls that become finished work; this is not because of a filmmaker shooting with the preconception of making a "camera-roll film." These are the result of seeing the footage back from the lab and not wanting to disturb its extemporaneous qualities – a sort of "if it ain't broke, don't fix it" approach to the raw footage.

Joseph Cornell and Rudy Burckhardt's *Angel* (1957), shot on an autumn day in a cemetery in Queens, is such a film. As Burckhardt described it:

> One day, it was a real magic day in November and we went out to Flushing to the cemetery and it was a warm, sunny day in November. The leaves were all on the ground and in the fountain there was orange and brown leaves floating. There were angels on the tombstones and we just used one roll of film, I think, and that became a film, I think it's called Angels or something. There was never any editing.[19]

The statue of the angel in silhouette against an intensely blue sky is a sight emblematic of the short film's palette of picturesque melancholy. There are fallen crimson leaves on the well-tended grass, close-ups of the water in the base of a fountain, reflections of the azure sky in the water, some ochre-colored leaves seen through the clear water under the surface, the whole epitomizing that ideal combination of the crisp autumn atmosphere and the otherworldly saturated colors of Kodachrome. The images feel as if they belong to another time, to the nineteenth century's fin de siècle, as if the film would be more in its element projected in a gallery of symbolist painting. Jonas Mekas, writing in *The Village Voice* in 1970, described this film as:

> An angel in the cemeteries, sweetest face, under a tree. A cloud passes over the wing of the angel. What an image. "A cloud passes, touching lightly the wing of an angel." This final image of Angel is to me one of the most beautiful metaphors cinema has produced.[20]

When Lynne Sachs made *Drawn & Quartered* (1987), she decided to cut the parts of the film she was uncomfortable with but then realized these needed to be put back. The splices in the film are not edits but the indication of her reconstituting the material back to its unedited form.

The three camera rolls, without internal cuts, contained within the seventeen-minute film *Observando El Cielo* (2007), by Jeanne Liotta, are also an example of leaving footage as

it is. The entire film is seventeen minutes long. Three 100ft rolls total about nine minutes, or slightly less, with the flares trimmed down. So roughly half of Liotta's film was edited in the camera.

Cost-effective, low-stakes experimentation

The camera-roll film can be considered for its purely pragmatic aspects: It is cheap, unencumbered with the need for other equipment beyond the camera, and doesn't require the costly steps and processes of post-production. To state the obvious, the camera-roll film is, by its very nature, a film with a shooting ratio of 1:1. The cost of a higher shooting ratio is more, but there is nowhere lower to go than 1:1. The camera roll can be a means to bypass the expense of a final print or high-end digital transfer, or at least postpone this cost until sometime later.

The advantage of the camera roll is the ability to screen a film resembling a finished work rather than calling it a "work in progress." It's splice-free and has not been sullied with the scratches and dirt typical of a film that's gone through the analog editing process. Reversal film may be shown in its raw state fresh from the camera, although care must always be observed when projecting original material. A soundtrack can be played separately from the film, if no hard sync is required, giving even more of the illusion of a "finished" work on screen.

Jem Cohen's screening at Light Industry in 2009, Curse and Blessing (Film and Filing Cabinet), was what he called: "An informal evening of mostly 16mm rarities and sketches; a few things never previously projected and at least one never previously seen, the journey more than the destination."[21] What screened there were 16mm workprints, the copies meant for editing, rather than completed answer prints. As the films were silent, the lack of a final composite print was a moot point. The workprints, being free of splices, were a perfectly acceptable means of presenting this work in this context.

Cohen's camera-roll films comprise carefully composed static shots of the city environment, homing in on such details as the movement of a banner outside of a store as it wags fitfully in the wind, oftentimes including fades in and out to move from one shot to the next. These were created using the Bolex's variable shutter. The use of fades, a technique associated with the editing process, rather than shooting, give the films all the more of a completed feel, rather than the viewing of raw material.

These economic advantages of the camera-roll film should not be seen as purely a matter of the pocketbook, set apart from the artistic considerations: A burden is lifted from the filmmaker making a one-roll film, loosening the conservatism that comes from wanting to avoid wasted money. The camera-roll film offers the possibility to be more aesthetically adventurous – to sketch, to dabble, to experiment – because there is less at risk in the event of catastrophic failure: It's not such a big deal to have a total disaster occur because of finding oneself beyond the outer boundaries of what the film can do. It is no big deal if it's just one roll of film that was risked in this.

Rose Lowder has reflected on the modest budget of her work compared to the prodigious expenses in the production of commercial cinema. Her camera-roll film, *Les Tournesols* (1982), has screened internationally on a consistent basis over many years: "Hardly any commercial films by known directors have as wide a range of audiences as *Les Tournesols*, a silly little film of a field of sunflowers! It's extraordinary, especially for something that cost almost nothing."[22]

The single-shot tableaux

The single-shot camera roll has been partly addressed in Chapter 2, regarding the passage of time and the use of a single tableau. Bruce Baillie's *Still Life* (1966) and *All My Life* (1966) use the single take to contemplate a carefully considered image, letting it soak in for the full three minutes of the camera roll. If wanting to shoot an uninterrupted three-minute film, an electric-driven camera ought to be used, rather than a spring-driven one. An Arriflex S, Beaulieu, electric Bolex (or with an added motor), or Canon Scoopic will be the right tool for the job, in this case.

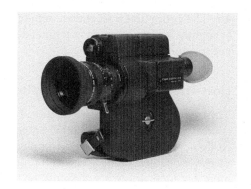

Figure 6.2 The electric motor-driven 16mm Canon Scoopic. A motorized camera is a good choice for shooting a three-minute roll as a continuous take, without needing to wind a spring-driven Bolex every 28 seconds. Camera courtesy of the Cooper Union Film Department.

Workarounds for shooting the single take camera-roll film with a Bolex

The Bolex spring will only run the camera for twenty-eight seconds before stopping. If working with the full wind, about six shots can be filmed on a 100ft roll. There are some ways to work with the Bolex and produce a continuous three-minute take: by shooting hand-cranked footage with the Bolex or using single-frame shooting and winding between clicks.

To shoot using the external crank, the spring motor is first disengaged. To crank forward, the rewind crank is turned in the opposite direction from the small arrow next to the 8-to-1 shaft. If the frames-per-second dial is set to 64fps, the tension of the camera governor is relaxed, making it easier to run from the external crank.[23] Hand-cranking the Bolex will produce an uneven pulse of exposure, with the image brightening and darkening as the crank rotates. Additionally, the camera may wobble on the tripod as it's cranked, producing the appearance of unsteady registration of the image. Shooting handheld while hand-cranking is possible, as is done in Guy Sherwin's *Hand-crank Clock* (1976), but it will tend to increase the unsteadiness of the image. Several films in Guy Sherwin's *Short Film Series* use a hand-cranked Bolex camera, including *Portrait with Parents* (1975), where the filmmaker is reflected in an oval mirror between the elder Sherwins. The mirror allows the technique to be revealed. The filmmaker is seen with camera and tripod turning the little crank at a furious pace to keep the film rolling along at a decent frame rate. *Swimming* (1977) also uses a hand-cranked camera, but with its long focal-length lens, the unsteady movement of the camera on the tripod is more pronounced.

Kevin Jerome Everson's *Undefeated* (2008) uses a single fixed composition, with the hand-cranked Bolex stopping and starting to create jump cuts and white flash frames.

Rose Lowder's previously mentioned film of a field of sunflowers, *Les Tournesols* (1982), is an example of the continuous three-minute shot produced through single-frame shooting. A gentle breeze causes the flowers to slightly sway. This movement

is transformed on screen into an agitated twitching through the film's single-frame shooting technique. A subtle racking of the lens also causes the entire image itself to vibrate. The flowers begin to take on an anthropomorphic quality through their nervous movements. According to Lowder, "*Les Tournesols* was shot frame by frame, from beginning to end in one four-hour go."[24] The pauses between single-frame exposures provide enough time to wind the camera spring, insuring it never winds down during shooting. Care should be taken not to shift the camera on the tripod while winding.

The 400ft camera roll

The ten-minute[25] camera-roll film, more often than not, is filmed with the camera fixed in place on a tripod. This is due in no small part to the additional weight of a magazine-loading camera.

J. Hoberman's *Cargo of Lure* (1974) is filmed from a boat traveling up New York waterways of an industrial rather than scenic character. The camera views the passing landscape as a riverborne dolly shot of docks and warehouses. The passing landscape is reminiscent of nineteenth-century panoramic paintings of river scenes, displayed moving slowly between a pair of reels.

Elaine Summers's *Windows in the Kitchen* (1983) is a dance film staged in a Soho loft space, large windows aligned exactingly within the film frame. Outside of the window, the facade of a cast-iron columned building across the street serves as the backdrop. The solo dancer, Matt Turney, dressed in bell-bottoms and blouse, alternates between movements and pauses, backlit, against the broad panes of glass. Clouds in the sky, outside of the frame, cause the light to transform the scene. The soot on the windows creates a hazy opaque sheen as the sunlight re-emerges. The buildings across the way are revealed as the sky becomes overcast.

Jon Behrens's *Last Moment of Existence* (2000) (mentioned previously in Chapter 2) show the implosion of the King County Domed Stadium in Seattle. The film uses the ten-minute camera roll to bait our sense of anticipation with the long wait for the film's spectacle of the stadium's explosive demolition.

Handheld exceptions to these fixed-view films include *A Trip Through the Brooks Home* (1972) by Tony Ganz and Rhody Streeter, where a ten-minute guided tour of a suburban home becomes a comedy of manners, with Mrs. Brooks repeatedly throwing shade on any innocuous comment by Mr. Brooks. Kevin Jerome Everson's *Old Cat* (2009) (described in Chapter 2) is also a handheld work shot with a full 400ft of film.

The thirty-minute camera-roll film, as seen in examples by Andy Warhol, was a more infrequent variety of a single-take experiment, due to the need for more specialized equipment; namely, the use of a 1,200ft magazine rather than the standard 400ft type.

Multiple-reel camera-roll films

Films using a series of unedited camera rolls approach this concept in different ways. Sometimes, each roll constitutes a chapter of the larger film. At other times, each roll stands on its own as a short project, coupled together with its kin as a series. The

Figure 6.3 **Top row left:** Christopher Harris's *28.IV.81 (Bedouin Spark)* (2009). Courtesy of the film-maker. **Top row right:** Rose Lowder's *Les Tournesols* (1982). Courtesy of The Film-Makers' Cooperative. **Middle row left:** Margaret Rorison's *PULL/DRIFT* (2013). Courtesy of the filmmaker. **Middle row right:** Margaret Rorison's *vindmøller* (2014). Courtesy of the film-maker. **Bottom row left:** Rice fields in Bali from Brendan and Jeremy Smyth's *Rice for Sale* (2013), Part 1: Down the Heavenly Mountain. Courtesy of the filmmakers. **Bottom row right:** Illuminated advertising filmed in single-frame tracking shots from Brendan and Jeremy Smyth's *Rice for Sale* (2013), Part 2: Toward the Demonic Sea. Courtesy of the filmmakers.

Warhol *Screen Tests* (1964–66) are more of a series of camera-roll films, while *Eat* (1963) is shot with multiple 100ft camera rolls that do not act as independent units. Marie Menken's *Eye Music in Red Major* (1961) is a film composed of two camera rolls, the first with some light editing and the second with no editing at all. Harry Smith's *Late Superimpositions* (1964) is composed of divergent camera rolls but given a unified structure through the rondo-like arrangement of the individual parts: "The trip is dark at the beginning and end, light in the middle"[26] is Smith's description for the selection of reels making up the film. Warren Sonbert's *The Bad and the Beautiful* (1967) is a series of film portraits: "10 couples, 10 camera rolls edited in the camera."[27] 1960s pop songs accompany the rolls, making use of the durational equivalency of three-minute song and three-minute camera roll. Kurt Kren's *31/75: Asyl* (1975) is three camera rolls, with some vestiges of the flares seen as a slight orange glow at the edges of the frame as one roll is spliced onto the next. While all three rolls show the same overall subject, distinct variations in the shooting of each roll give the work its three-chapter structure. Guy Sherwin's *Short Film Series* (1975–2014) is more modular, each film standing on its own, but shown in an assembled fashion, with films added to it over time. Marjorie Keller's *Superimposition (1)* (1975) was created from a series of diary-like camera rolls. Jerry Tartaglia's *See For Yourself* (1995) uses the unedited camera roll as the inherent concept of the film's insistence that we not hide our eyes and overlook the suffering and death wrought by the AIDS epidemic. The film's unedited nature is closely linked with its approach, which is to empathize with the subject's suffering seen in its raw state, rather than have the film lose some of its intimacy through editing.

The brothers Brendan and Jeremy Smyth collaborated on a multiple camera-roll movie filmed in Bali, *Rice for Sale* (2013). Its unedited approach is a seemingly sudden afterthought. The brothers describe it as an impulsive last-minute decision: "On the third day in Bali, one of us jokingly said, 'What if we made this film entirely of in-camera edits?' To which the other replied, 'Impossible!'"[28] Each roll acts as a self-contained chapter, the flares between rolls introducing a new location or subject. The filmmakers also use a particular approach for each of the sequences from one camera roll to the next. The temple mountain and rice field in the two rolls that begin the film are visual studies shot from a variety of angles; some wide and others in close-up. The perspective of a person among cohorts, rather than an arm's length viewer, is the camera's role, in a nighttime sequence where groups of workers play dominoes together. In another roll, we see a garden trellis with leafy green vines, the moving camera following the path of metal rods, shot in extreme close-up. In a carefully considered ending to the chapter, a wider view of the scene appears, just as the end-flares are about to bring things to a close: The trellis is not a trellis at all but the iron rebar sticking out from a cement foundation on a construction site. The final rolls use single-frame shooting, with and without longer time exposures, to show the urban environment of illuminated signs and billboards advertising upscale international brands, from gourmet coffee to designer clothing and jewelry.

Margaret Rorison's *PULL/DRIFT* (2013) uses three camera rolls showing the different settings of the outdoor dance performance it documents, one in black and white and two filmed in color, with the end-roll flares transitioning between one sequence and next.

The super-8 "camera roll" film

To get a little too particular about it, a super-8 camera roll film is actually not shot with a "roll" of film loaded into the camera but with a preloaded cartridge snapped into place. The nomenclature of "an unedited reel" of processed super-8 is usually used to describe the unedited 8mm film.

In some ways, the reasons for working in this manner are even more pronounced in super-8 in comparison to 16mm: The desire to project a splice-free roll of film is a greater issue with super-8, being that it is a more delicate format. Editing produces wear and tear on the film (dirt, scratches, and visible splices), which is all the more visible with the increased magnification of the small gauge. A solid, splice-free reel of super-8 can be shown with less opportunity for jumping in the projector than a roll with splices in it. Super-8 is a format no longer allowing for duplication on film, due to the discontinuation of super-8 lab stocks used for making prints. Desiring to show work on actual film (rather than a digitized version) thus requires projecting the original roll of film, rather than a copy. While super-8 can be edited, its fragility makes it more desirable to proceed from lab directly to projector because of the film being the one and only copy.

Super-8 filmmakers who have worked with unedited camera rolls include the San Francisco filmmaker Steve Polta, John Porter in Toronto, and New York-based filmmakers such as Kevin T. Allen and Matt Whitman.

Super-8 "camera roll" film festivals

This affinity between the unedited film and the particulars of the super-8 format has led to a number of festivals and screenings specifically dedicated to showing unedited film reels. In the 1990s through the 2000s, some affiliates of the multi-city film series Flicker (originating in Athens, Georgia, giving rise to other Flickers in Chapel Hill, New York, Los Angeles, and elsewhere[29]) would organize a festival of super-8 camera rolls, called Attack of the 50-Foot Reels. The premise was for filmmakers to shoot a single cartridge of super-8 film as the criteria for submission for the festival. Norwood Cheek, who ran the Flicker Film Series in Chapel Hill, North Carolina, was the organizer of the Los Angeles screenings of Attack of the 50-Foot Reels. In the case of Flicker NYC, run by David Teague, the super-8 cartridges submitted to Attack of the 50-Foot Reels would be taken over to PacLab to be processed the day of the event itself. The newly developed films would be shown for the first time ever in the evening, the audience and the filmmakers simultaneously seeing the finished results for the first time, for better or worse.

Figure 6.4 Flyer for the Flicker Film Series screening, Attack of the 50-Foot Reels. Courtesy of Norwood Cheek.

The London-based Straight8 is another camera-edited super-8 cartridge festival, still occurring as an annual event at the time of this writing. Pro8mm, the super-8 film lab in Burbank, California, encouraged submissions to its THINK FILM! Pro8mm One Roll Film Challenge with a discount on processing and digital transfers for the entrants.

16mm camera-roll screenings

Filmmaker Jim Hobbs has organized One Hundred Foot as an ongoing group screening of 16mm camera-roll projects by filmmakers in the UK and elsewhere.

In 2016, filmmakers Jennifer Reeves and Mark Street organized a screening of 16mm camera-roll films called A Roll for Peter, as a memorial project honoring Peter Hutton, initiated shortly after his death. Hutton's commitment to working with 16mm film made this a highly fitting tribute. With thirty-four filmmakers responding to the call for work, screenings of this series of eulogistic camera rolls took place at Bard College in October of 2016 and subsequently toured several cities through the university and microcinema circuits. Scenes of city, sea, and sky were the predominant elements of the filmmakers' cinematic eulogies to Hutton.

While the camera-roll film's sense of constraint is its central element, the next chapter will look at the work of those who did not simply accept the constraints handed to them but who advanced the possibilities of the camera from its fundamental aspects by working to redesign the machine itself. In some instances, the innovation was not so much a straightforward improvement in the device but the discovery of unexpected and untapped possibilities.

Notes

1 Blythe R. H., *Haiku, Volume One* (1949). Tokyo: The Hokuseido Press, 1981, pp. 6–8.
2 Cage, John, "Satie Controversy" (1950), in Richard Kostelanetz ed., *John Cage*. New York and Washington: Praeger Publishers, 1970, p. 90.
3 Koch, Stephen, *Stargazer: Andy Warhol's World and His Films*. New York and London: Marion Boyars, 1973, p. 43fn.
4 Whistler, James McNeill, *The Gentle Art of Making Enemies*. New York: G. P. Putnam's Sons, 1922, p. 5.
5 Katz, Mark, *Capturing Sound: How Technology has Changed Music*. Berkeley, Los Angeles, and London: University of California Press, 2004, pp. 31–36.
6 Green K. E., Martyn, "Storm de Hirsch Independent Filmmaker," *Super-8 Filmmaker Magazine* vol. 2 no. 1, Jan–Feb, 1974, p. 28.
7 Matthew 5:14.
8 Choreographed by Clarissa Stowell Gregory and performed by The Effervescent Collective.
9 Richter, Hans, *Hans Richter by Hans Richter*, Cleve Gray ed. New York, Chicago, and San Francisco: Holt, Rinehart and Winston, 1971, p. 50.
10 Brownlow, Kevin, *The Parade's Gone By*. Berkeley: University of California Press, 1968, p. 220.
11 *Bouquets 1–10* (1994–1995), *Bouquets 11–20* (2005–2009), *Bouquets 21–30* (2001–2005).
12 Nelson, Tara Merenda, "Scientific Creativity: The Notebooks of Rose Lowder," *Afterimage: The Journal of Media Arts and Cultural Criticism*, 2015, http://vsw.org/afterimage/2015/06/25/essay-scientific-creativity-the-notebooks-of-rose-lowder/
13 *The Film-Makers' Cooperative Catalogue No. 7*. New York: The New American Cinema Group, Inc., 1989, p. 450.
14 "No matter how awkward they may seem or how far out of proportion they may be, *never* attempt to touch up the strokes. This cannot be done in sumi e." McDowell, Jack and Takahiko Mikami, *The Art of Japanese Brush Painting*. New York: Crown Publishers, Inc., 1961, p. 74.
15 Richter, *Hans Richter by Hans Richter*, p. 50.
16 *The Film-Makers' Cooperative Catalogue No. 7*, p. 362.

17 Ginsberg, Allen, "First Thought, Best Thought" (1975), in Donald Allen ed., *Composed on the Tongue*. Bolinas, CA: Grey Fox Press, 1980, p. 117.

18 Blythe R. H., *Haiku, Volume One* (1949), pp. 315–316.

19 "An interview of Rudy Burckhardt conducted 1993 January 14, by Martica Sawin, for the Archives of American Art." https://www.aaa.si.edu/collections/interviews/oral-history-interview-rudy-burckhardt-12098#transcript.

20 Mekas, Jonas, *Movie Journal: The Rise of the New American Cinema 1959–1971*. New York: Collier Books, 1972, p. 408.

21 http://www.lightindustry.org/curseandblessing.

22 MacDonald, Scott, "Rose Lowder," in *Critical Cinema 3: Interviews with Independent Filmmakers*. Berkeley, Los Angeles, and London: University of California Press, 1998, p. 239.

23 A Bell and Howell outfitted with its own accessory crank works well for this too; in some ways, it is easier to hand-crank than the Bolex, owing to the crank being larger than the one made for the Bolex.

24 MacDonald, Scott, "Rose Lowder," p. 236.

25 More precisely, the eleven-minute roll, if not rounding off the 400ft of film to ten minutes, as is usually done.

26 *The Film-Makers' Cooperative Catalogue No. 7*. p. 450.

27 Ibid., p. 457.

28 Smyth, Brendan and Jeremy Smyth, *Rice for Sale*, DVD booklet, 2013.

29 For more on the history of the Flicker Film Series, see Roger Beebe, "Afterthoughts on an Era: Flicker Film Festival (Chapel Hill)" (2008), *INCITE: Journal of Experimental Media*, http://www.incite-online.net/beebe4.html.

7 Custom camera commandos, and the quandaries of obsolescence

This chapter covers the historic development of the camera from the use of sync sound to super-8 and filmmakers who experiment with the camera itself to produce their work.

In the early days of the motion picture, the movie camera could be a source of danger. This was not due to any hazardous qualities of the machine itself but owing to the actions of a consortium of production companies who had established the Motion Picture Patents Company. Contending for the exclusive rights to the use of threading a camera with the requisite slack, known as "the Latham loop," they consequently sought to destroy the movie camera of any independent producer. Allan Dwan, speaking to filmmaker Peter Bogdanovich, described this situation:

> These people tried to prevent us from using their loop, and without the loop you couldn't run the film through the camera . . . It was just ridiculous – like selling an automobile and not letting anybody else drive it because you have a patent on putting your foot on the pedal . . . Now to prevent us from operating, they employed roughnecks and hard-arm people and gangsters . . . They sent snipers out with long-range rifles . . . They always shot at the cameras . . . We'd always be working in hills and they'd get up in back of a tree or up on a mound above you and wait for their time. Sometimes they'd wait until a fellow was cleaning the camera – we didn't have any studio for our headquarters – and take a shot at it. Anything to destroy it.[1]

Innovations and invention thankfully no longer present such hazards, and you may thread your camera with loops with no fear of roughnecks.

The very first innovators of the motion picture – Muybridge, Marey, Edison, Le Prince, the brothers Lumière, and others – were "experimenters," so to speak, by the nature of inventing a new medium, but they were not experimentalists of the avant-garde type.

Méliès had to build his own camera because of the Lumière brothers' disinterest in selling him a *cinématographe*.[2] When the photographer Morris Engel wanted to make films in the 1940s, he too had a unique camera built for his own use. As a still photographer, Engel's camera of choice was the twin-lens Rolleiflex,[3] and the motion picture camera he had constructed would share some common features with this still camera.

Part of the impetus for creating his own camera was Engel's experience working with the photographer and filmmaker Paul Strand, who was using the compact 35mm Bell and Howell Eyemo, designed to shoot 100ft rolls of just about one minute each. But Engel felt the virtues of this nimble, highly portable camera were negated by Strand when it was

Figure 7.1 **Above:** Morris Engel's custom-made twin-lens reflex 35mm motion picture camera. Camera courtesy of Mary Engel and the Orkin/Engel Film and Photo Archive. **Below:** Morris Engel filming *Lovers and Lollipops* (1955). Courtesy of Mary Engel and the Orkin/Engel Film and Photo Archive.

attached to a heavy baseplate, and from this, onto an even heavier wooden-legged tripod.[4] It would take "an engineering and mechanical genius" named Charles Woodruff to build Morris Engel's custom movie camera: "Designed for me, it was a compact 35mm, hand held, shoulder cradled, [with] double registration pins and twin lens finder and optical system."[5]

Morris Engel's camera used an intermittent movement from a Cunningham camera installed within a 200ft magazine. The Cunningham had been a highly ergonomic combat camera designed for use during WWII. It was phased out of production because it attracted enemy fire by resembling a weapon. The 35mm magazine held the supply and take-up, one over the other, rather than the "Mickey Mouse ears" arrangement of the top-mounted camera magazine. The magazine arrangement of Engel's camera resembled the Eclair Cameflex CM3 35mm camera but with the bump of the magazine inverted, facing downward rather than upward. The interchangeable magazines met the camera at the gate, with the lens, motor, shutter, and viewfinder forming the camera's body. The most unique aspect of Engel's camera was the twin-lens viewfinding system, much like the Rolleiflex, where two matching lenses would move in tandem through the use of a gear to focus the image. One lens acted as the taking lens of the camera; the other provided the image in the viewfinder. This type of viewfinding system was used in the highly innovative Akeley Motion Picture Camera of the silent era. But Engel's viewfinder was a groundglass, allowing the camera to be held at chest level, with the operator looking down at the image rather than at eye level in front of the face. This arrangement added steadiness to the camera, as it was not balanced on the ends of bent arms but braced against the torso. Its unobtrusiveness was due to the camera's low-slung position, rather than being held aloft. The camera could be used discreetly in the street photographer's environs, as had been the case with Engel's Rollei. While it was not completely hidden, it would also not attract too much attention by its presence. "With a simple shoulder belt support, I was armed with a camera which became the heart of the esthetic and mobile approach to the film."[6]

The camera made a test run for a short documentary project before becoming the basis for *Little Fugitive* (1953), an independently produced feature film made with Ray

Ashley and Ruth Orkin. The film's storyline, about a young boy gone on the lam among the boardwalk, beach, and amusements of Coney Island, provided the opportunity to film in situations well matched to this unobtrusive camera's virtues. The Rolleiflex-inspired chest-level configuration also assisted in giving the film its sense of visual rapport with the film's child actor, placing the camera at eye level with the youngster's view of the world.

One has to wonder why this tinkering occurs. Why alter the tool? Some of these improvements came as commercial innovation and were co-opted for alternative uses, such as the use of the low-resolution toy PixelVision camera by moving image artists. Other innovations evolved in just the reverse, as experiments, becoming a commercial tool only later, as with the Whitney brothers' highly experimental apparatus employed for commissioned title sequences. The innovation of portable sync equipment for vérité documentary was used by experimental filmmakers such as Shirley Clarke, Jonas Mekas, and Robert Greaves to question the documentarian's notion of greater veracity captured by the portable camera. Some innovations revisit the arcane technology of the past, as when using old home movie cameras. In the case of the cardboard pinhole cameras of Paolo Gioli or Jérôme Schlomoff, an alternative technological history is investigated by venturing back to the rudiments of the machine and its image-producing precursor, the *camera obscura*. Still other innovations derive from intentionally misusing what was on hand to transform it from its initial purpose, as when unsplit 8mm is projected as a four-image 16mm film frame, or when Super 16 is used for creating an optical soundtrack using the filmed images.

This chapter will survey this range of alternatives and advancements beyond the basic motion picture camera of the previous chapters. It presents a history of changing technology and highlights the work of artists who have made particular use of more specialized, advanced equipment.

Home movie cameras

The appropriation of equipment designed for amateur moviemaking offers many low cost, low-tech possibilities, from Stan Brakhage's use of Regular 8mm in his *Songs* to the PixelVision works of artists such as Joe Gibbons and Cecilia Dougherty.

At the flea market, one may occasionally find old movie cameras of various kinds: little Regular 8mm cameras, super-8 cameras (that may or may not work), and 16mm home movie cameras, such as the Kodak Cine camera, resembling a brick with a lens protruding from one end of it.

A common attribute of the older 16mm home movie cameras – like the Smith and Victor, Kodak Cine Model B, and the very early single-lens version of the Bell and Howell Filmo (with black paint rather than brown) – are double-sprocketed rollers, necessitating the use of double-perforated film (or the task of filing down the second set of teeth to accommodate single-perf film). If the camera has no option for changing the frame rate, then is it likely the camera only runs at 16 or 18fps rather than

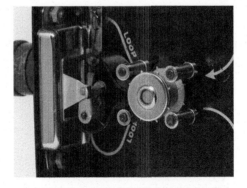

Figure 7.2 The sprocketed roller of a Keystone home movie camera from the 1920s. Note the teeth on both sides of the roller for use with double-perforated film only.

Figure 7.3 **Above:** An 8mm home movie camera manufactured by Eastman Kodak. Note the spacing of the perforations of the roll of 16mm-wide "8mm" film. **Below:** A Bell and Howell 16mm magazine camera and pre-loaded magazine.

24fps. These old cameras may likely also have weak springs, owing to their age. But an advantage of such archaic machines is the "instantly vintage" appearance of footage due to the old lenses and poor registration. There is also something to be said for cheap equipment: A filmmaker can feel more at ease in some shooting situations with a camera costing $30 to $40 rather than hundreds or thousands of dollars.

A common problem encountered by filmmakers seeking equipment at the flea market is mistaking a Regular 8mm camera for a compact-sized 16mm camera. This is because the film inside a Regular 8mm camera is 16mm wide. After processing, it will be split by the lab into two 8mm strips. One can recognize the Regular 8mm home movie camera by its smaller-sized reels, and the sprocketed rollers have twice as many teeth. It has a quarter-frame-sized gate in comparison to 16mm.

Magazine cameras

Small-sized 16mm magazine cameras are also not uncommon to run across. These would have been originally loaded with a small pre-threaded magazine holding 50ft of 16mm film. Often, the magazine is missing, making the camera little more than a hollow chamber with a motor and a lens. The magazines themselves have a complicated threading, the film wound onto a special small-sized plastic core. The magazines were designed for double-perforated film, making for another difficulty as well.

Super-8

Super-8 was introduced in 1965 for the home moviemaking market. It would eventually be overshadowed as home movies became home videos. Yet super-8 filmstock is still produced, and many super-8 cameras are still around and functional. It therefore remains a viable alternative for the motion picture experimenter wanting to work with equipment that is smaller and cheaper than 16mm. The savings generally come in the price of equipment and the filmstock itself, rather than the lab costs. It is also a format naturally disposed to provide a "home-movie" look.

The cameras themselves incorporated all of the modern amenities that came later in the evolution of the motion picture camera: a built-in zoom lens, a built-in light meter, automatic exposure control, a built-in 85 color correction filter to accommodate shooting tungsten-balanced color film in daylight, and an electric motor rather than a spring. Unlike the typically boxy Regular 8mm camera, most super-8 cameras were quite ergonomic in design, with a built-in pistol grip.

The factors for choosing one camera over another include some criteria particular to the super-8 format: Some cameras will only run at 18fps and not at 24fps. Others will have multiple speeds, including single frame. Some cameras require a separate battery for the light meter (often a small, specialized battery to be found only at a photography equipment store), and others use AA batteries to run both the camera motor and built-in meter. Some will allow for the use of manual f-stop settings, while others will only use the camera's built-in exposure meter to automatically set the aperture. Some cameras will have a macro lens and others not. Some will shoot single frame and others not, while still others will have a built-in intervalometer for time-lapse shooting. A few were designed for sound-on-film shooting with the now discontinued magnetic-stripe sound film cartridges.

It's not uncommon to find super-8 cameras with the battery terminals corroded from batteries left inside for many years, and sometimes an apparently nonfunctional camera can be coaxed back to life by scraping off the residue corrosion from the contacts in the battery compartment.

When shooting in super-8, it's not a bad idea to have spare batteries in one's camera kit. Also worth noting is an all too common super-8 vexation: the hair in the gate. The snap-in cartridges are very good at collecting hairs. An orangewood stick can be kept handy for cleaning the camera gate every time the film is loaded.

Unsplit 8mm

Regular 8mm as a format for home movies was eventually supplanted by super-8. While super-8 is still around today, Regular 8mm has long been discontinued. Its availability is contingent on finding old supplies of stock, or specialty manufacturers, or the occasional enterprising person who re-perforates 16mm with the extra sprocket holes needed for loading the film into an 8mm camera.

Because Regular 8mm begins as a roll that is 16mm wide at the time of shooting and is later split by the lab into two strands of 8mm each, you can ask the lab not to cut it down to 8mm but leave it as 16mm. When projected or digitized, this will produce four small images on the screen: two sequential frames above and below each other on either side. Since the film is flipped around to shoot the second half of the film, the images will be upside down and the motion will run backwards. Two sets of right side up images can be produced by holding the camera upside down during the second pass (however, the motion will still be running backwards in the second exposure).

Storm De Hirsch used this technique briefly in *Peyote Queen* (1965) and more extensively in her double-projection film *Third Eye Butterfly* (1968). With two reels of 16mm film projected side by side, the unsplit 8mm results in a visually impressive panorama of eight small images on screen.

San Francisco filmmaker Nathaniel Dorsky's *17 Reasons Why* (1987) uses unsplit 8mm film. The compact size of the 8mm home movie camera was, for Dorsky, a key asset: "These pocket-sized relics enabled me to walk around virtually 'unseen,' exploring and improvising with the immediacy of a more spontaneous medium."[7]

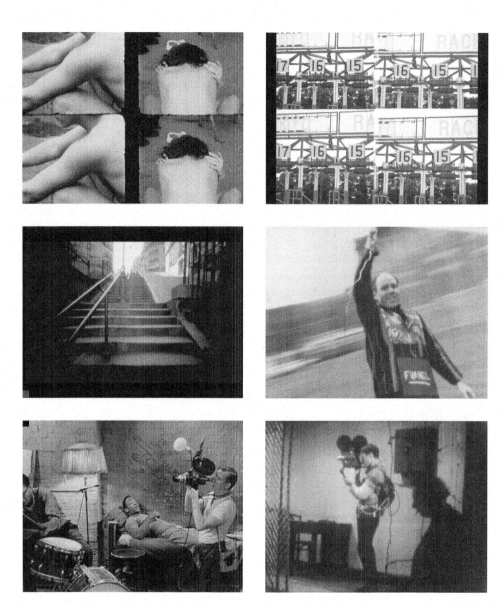

Figure 7.4 **Top row left:** Lynne Sachs's *Drawn & Quartered* (1987), filmed in unsplit Regular 8mm. Courtesy of the filmmaker. **Top row right:** Tomonari Nishikawa's *16–18–4* (2008), filmed with a novelty still camera. Courtesy of the filmmaker. **Middle row left:** Jérôme Schlomoff's *CULTURE CHANEL - The sense of places* (2014) shot with a pinhole movie camera designed and built by the filmmaker. Courtesy of the filmmaker. **Middle row right:** John Porter's *Cinefuge 5* (1981). Courtesy of the filmmaker. **Bottom row left:** Shirley Clarke's *The Connection* (1961). **Bottom row right:** Storm De Hirsch's *Jonas in the Brig* (1964). Mekas is seen using an Auricon camera, with magnetic stripe sound-on-film. Courtesy of The Film-Makers' Cooperative.

Unsplit 8mm was also used by Lynne Sachs for her short film *Drawn & Quartered* (1987). Two unclothed subjects, male and female, are seen out of doors in the setting of an urban roof garden, seated and standing in casual poses. Male and female appear juxtaposed on the two sets of images, left and right. Because unsplit 8mm projects two images at a time, it runs twice as fast as normal (which may itself be faster than normal: filmed at the standard 8mm speed of 16fps rather than 24fps). Sachs used step printing (re-photographing multiple copies of each frame, using an optical printer) in post-production to slow the frame rate back down to something resembling normal speed when projected at 24fps.

35mm still format as 35mm motion picture film

35mm motion picture cameras use four perforations per frame, while the standard 35mm still camera exposes a frame eight perforations long. A still camera can be used for shooting film that may be projected in a 35mm projector, allowing the image to flicker back and forth between the two halves of the frame. To orient the still camera to correspond to the position of the film in the 35mm motion picture camera, hold the camera on its side (in portrait orientation) with the film cartridge on top.

There are 35mm still cameras known as half-frame cameras, which, as the name would suggest, expose a four-perforation frame image, just as 35mm motion picture film. However, it should be noted, a still camera advances the film with very little regard to the need for the exact registration found with a movie camera. This type of camera will produce a jittering and quaking effect, especially if the image is static. However, if filming agitated handheld moving camerawork, the registration may not be an issue. The half-frame format will expose 72 motion picture frames from a 36-exposure still film roll: Three seconds of screen time at 24fps.

When working with still film, and not developing the film oneself, it's prudent to request the photographic developing service to not cut the film into short strips. In the case of slide film, you may request the film to be uncut and unmounted.

Figure 7.5 Novelty cameras. **Above:** The multi-lens 35mm still camera used by Tomonari Nishikawa to shoot *16–18–4* (2008). Courtesy of the filmmaker. **Below:** The Lomokino hand-crank 2-perf 35mm movie camera. Camera courtesy of Mono No Aware.

Toy cameras

Tomonari Nishikawa's short film *16–18–4* (2008) was made in 35mm with a plastic novelty still camera with sixteen lenses arranged in two rows, creating a stuttering, flickering

Figure 7.6 Paolo Gioli with one of his handmade pinhole cameras. Courtesy of the filmmaker.

version of the four-image effect, not dissimilar to unsplit Regular 8mm. The film was shot at the 2008 Japanese Derby (Tokyo Yushun). The crowd that gathered for the horserace was perhaps a grander spectacle in the film than the race itself. The subject matter of the film and its merging of still photograph and movement, according to Nishikawa's description, offer an oblique homage to Muybridge's nineteenth-century equine motion studies.

The Lomography company, makers of Diana camera-inspired plastic-bodied still photo cameras, has produced a 35mm hand-cranked movie camera using still photography 35mm cartridges, called the Lomokino. The camera's format is two perforations per image format, allowing for 144 widescreen frames on a 36-exposure roll of 35mm still camera film.

16mm film in a 35mm still camera

In *Experimental Filmmaking: Break the Machine*, Kathryn Ramey describes the process of loading 16mm film into a 35mm still camera using a bulk film loader.[8] If no bulk loader is available, then a completely darkened room can suffice for loading the film directly into the camera, sans film cartridge, first engaging the film into the camera's take-up, cutting about a two-foot length of film coming from it, and then tightly winding it up on the reel retrieved from a 35mm cartridge (or even a short piece of wooden dowel, cut to size) in the empty chamber where the loaded cartridge would be placed. The film doesn't get rewound at the end of shooting and must be unloaded in a completely dark room as well. The only advantage of this low-fi approach is in saving the step of working with a bulk loader.

Handmade pinhole cameras

Paolo Gioli works with a uniquely designed pinhole camera, where the film does not advance through the camera via an intermittent movement. A strip of 16mm film is placed in a long, thin rectangular box with a series of pinholes serving as individual lenses for each frame, each covered up and then opened, one by one, to expose the film. Simple versions are nothing but a box and a strip of film, while in more complex versions a roll of film can be loaded and advanced to the next unexposed section.

Jérôme Schlomoff has worked with 35mm pinhole motion picture cameras of his own making. He conceived of a system to advance the film accurately with the aid of a small spring mounted inside to make a "click" every perforation: Four clicks equal one frame. The body of the camera is fashioned from cardboard. A sheet of brass with the pinhole acts as the lens. An improved version of his cardboard camera used a 100ft canister, rather than the limitation of 72 motion picture frames of a 36-exposure still film roll.[9]

Brian Frye's super-8 cartridge pinhole camera – using the cartridge itself as the camera – is described by Thomas Comerford in Ramey's *Experimental Filmmaking: Break the Machine*:

> Remove the [super-8] cartridge from the packaging. Use electrical tape to fix a washer over the opening in the cartridge. Then take a little piece of tinfoil (or something similar) and poke a pinhole in it. Center the hole over the hole in the washer, and tape it down. To advance the film, melt the end of a Bic pen cap, and shove it into the take-up spindle of the cartridge. By turning clockwise (you want the film to move downward), you move the film though the camera. Be sure to employ your finger as a shutter, covering the opening while the film advances, uncovering [the] opening to make an exposure. Try to advance the film in small increments.[10]

What's called a "fender washer" tends to work well for mounting the tinfoil. The melted pen cap take-up does not work so well, coming apart from the spindle much too easily from the tension of winding. A small pair of pliers can be used as a substitute for advancing the film. The results tend to appear very jittery on screen, with the vertical position of the image having little to do with the position of the frame.

Figure 7.7 Jérôme Schlomoff's prototype for a 35mm pinhole camera, in cardboard (2001). Courtesy of the filmmaker.

Lens rigs

The optical interventions, such as those discussed in Chapter 3, may involve something as simple as holding a distorting lens in front of the camera lens. Wide-angle lenses are more challenging to use for this because of vignetting. Even when very close to the lens, it can be difficult not to see the edge of the distorting lens in the corners of the wide field of the image. Normal and telephoto lenses tend to be easier to use because of this.

Figure 7.8 Brian Frye's DIY super-8 cartridge pinhole camera.

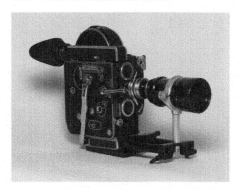

Figure 7.9 Bolex Rex5 with an anamorphic lens, mounted using accessories intended for adding a matte box/lens support/rack focus attachment to a DSLR camera.

The variety of brackets, mounts, handles and braces made for rigging DSLR cameras are also useful items for similar outfitting of the motion picture camera. Matte box brackets are a good example of this, since a Bolex matte box is not so common and can be quite expensive, yet an acceptable replacement can be fashioned from DSLR accessory parts. These items can also be used for creating mounts for fitting out an anamorphic lens in front of the camera lens or other in-front-of-the-lens optical intervention. The challenge with creating such a rig for the Bolex is that most matte box adaptors attach with a plate that makes use of the tripod screw. On the Bolex, the lens is off-center approximately 11/16ths of an inch from the tripod screw.

Modified cameras

The Krasnogorsk K–3 is often modified to mitigate some of its weaknesses: In particular, the flimsy loop formers are removed from the camera to turn it into a manual-loading camera.

Vincent Grenier modified a Pathé BTL reflex camera by attaching color filters directly onto the camera shutter to make his short film *Tremors* (1984). As he describes it:

> The Kinemacolor process was used in 1915 to obtain fairly illusionistic color from black and white films by filming and projecting them through synchronized, alternating red and green filters. The film, while already in color, takes advantage of many of the particularities of the system.[11]

The choice of the Pathé camera for this experiment was due to its particular shutter design, with two openings rather than a single one, allowing for green and red gels to expose alternating frames.

Motion control cameras

John and James Whitney's computer-controlled camera was something of a hybrid of the time-exposure camera, animation stand, and optical printer. Their innovative equipment was the inspiration for cinematographer Douglas Trumbull's slit-scan equipment created to shoot portions of the "Star Gate" sequence in Stanley Kubrick's *2001: A Space Odyssey* (1968).

Experimental animators John and James Whitney's motion control camera was designed to create a series of long exposures while pinpoint lights on the bed of an animation stand would be moved during the exposure to produce lines of light rather than dots. The concept was much like shooting with the Bolex I/T switch set to "T" when filming traffic at night, the long exposure time producing long bars of light instead of dot-like headlights. The key innovation was the exacting control of movement of the points of light being

filmed. Shooting frame by frame, the light would be brought back to its starting point and then slightly racked forward subsequent to the next exposure. This progressive shifting of position from frame to frame would produce animated movement in the resulting footage. Color gels and multiple exposures allow for complex color mixing, and slight but precisely controlled variation in the start position of geometric patterns create moving moiré effects. Multiple exposures, following the same path but spaced a few frames apart, could create an "echo" of the moving light.

Moving camera rigs

In his memoirs, the Dutch filmmaker Joris Ivens wrote about an attempted experiment in point-of-view cinematic realism:

> In my brother's medical library I found a book on optics containing the exact graph of the forward rolling curve of the eye of a walking person resulting from the combined movements up, down and forward. We attempted to reconstruct this curve with an eccentric plate placed on the axis of a small wagon equipped with four bicycle wheels.

What Ivens expected to see, from a camera mounted on this plate, was a realistic point-of-view shot from a walking perspective. It did not turn out that way. "The result on screen looked as if the shot had been taken by a drunken cameraman drifting down the street in a rowboat. The exact opposite from what we wanted."[12]

Quite a different desire to work with a custom-built camera rig inspired Michael Snow for his 190-minute landscape study, *La Région Centrale* (1971), filmed in a desolate mountainous area, Sept-Iles in Quebec, accessible only by helicopter. The origins of the project concerned Snow's interest in advancing beyond the left-right and up-down movements of the tripod he had previously worked with in *Standard Time* (1967) and *<—>* (*Back and Forth*) (1969).

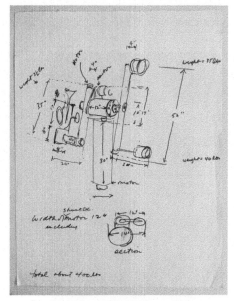

Figure 7.10 **Above:** *La Région Centrale* (Production Still) 1971. Photograph by Joyce Wieland. Courtesy of Michael Snow. **Below:** Preparatory Note for *La Région Centrale* 1970. Holograph of Michael Snow, Box 10, Folders 5 & 7, Michael Snow Fonds, E. P. Taylor Library and Archives, Art Gallery of Ontario. Courtesy of Michael Snow.

> Many marvelous cranes and dollies exist to be used in the making of movies, but in a search for some months I was unable to find an existing machine that

could do what I wanted: move the camera around a central area in such a complete way that what was holding the camera, what was moving it, was never visible, was never photographed.[13]

Snow was able to have Pierre Abbeloos, who worked for the National Film Board in Montreal, fabricate what was referred to as the camera-activating machine:

> The device that Abbeloos conceived would guide the camera along the path of a sphere, making the camera capable of passing in line across all of its surface area. The camera would stare outward, never moving inside of the sphere by radius or diameter . . . Snow would determine the camera movements by using signal tape, operated remotely, so that apart from the shadow of the apparatus, there would be no sign of a human role behind this activity.[14]

The still images shot by Joyce Wieland during the making of the film show the camera-activating machine with a 16mm Arriflex S fitted with an Angenieux zoom lens and 400ft magazine. To control the motions of the camera, Snow hid just out of sight somewhere behind the rocks and crags of the desolate environment, using the rig's control box to activate its movements. Stephen Broomer contrasts this unconventional observation of landscape by this mechanized camera rig with the anthropomorphized conception of the camera-eye: " . . . *La Région Centrale* would serve as the apogee of that strain in structural cinema that resists the mimetic relation between eye and camera so dominant in the films that came before it, in particular, those of Stan Brakhage."[15] The film conveys an erasure of the human in the bleak landscape into a vision of a celestial scale of planetary orbits and unbounded eons, yet the camera's "lens is not . . . an all-seeing godly eye, but a tool for visual construction that surveys, stamps out, pieces together and recombines the component parts of this landscape, seen in ceaselessly stable pans, into its new transcendent whole."[16]

Toronto-based super-8 filmmaker John Porter has taken advantage of the small-gauge format's lightweight equipment by spinning a small super-8 camera on the end of wires, centrifugal force keeping the camera aloft. Porter refers to these films as his *Cinefuge Series*.[17] An intriguing combination of stillness and motion is present in these films, with Porter at the center of the camera's orbit remaining fairly clear and steady in the frame, while the background is a rotating pattern of painterly motion blur.

Figure 7.11 Zoe Beloff's *Shadow Land or Light from the other Side* (2000), showing the two side-by-side images filmed using the Bolex 3-D attachment. Courtesy of the filmmaker.

Nicolas Rey's *Differently, Molussia* (*Autremont, La Molussie*) (2012) includes instances of the fixed camera abruptly spinning, the landscape on screen becoming a twirling geometric blur. A special rig held the camera in place – an SBM Bolex fitted with an electric motor. When set in motion, the camera would rapidly rotate, with the lens at the center of the axis of the spinning movement.

3-D cinematography

A curious accessory for the Bolex camera is a twin set of lenses mounted to a prism for filming 16mm 3-D. It records two side-by-side images on the film, both more tall than wide. The lenses on the device are the same distance from each other as two human eyes, creating slightly displaced images corresponding to our own 3-D vision.

The filmmaker Zoe Beloff has used this device for *Shadow Land or Light from the Other Side* (2000).

> The Stereo Bolex was a camera designed in the early 50s for people to shoot their home movies in 3-D. There was a craze – *Creature From the Black Lagoon*, you know – and the Bolex company had the idea that people would really like to shoot their home movies in 3-D . . . It's a vertical format, like portrait view . . . I thought of the Stereo Bolex as a way to bring together the Victorian interest in stereoscopes, phantoms, and illusionism. The 3-D stereo illusion is just plain trickery. We see something that isn't there, just like the sitters at a séance.[18]

The Bolex 3-D lens was designed for use with a non-reflex Bolex, rather than a reflex camera, and included an extended bracket for mounting the side finder, since the stereo lens would otherwise be in the way. In the original application of this system, a special projection lens would merge the two images, the 3-D effect created by viewing with polarized glasses. The polarizing filters only allow light to pass through the corresponding filter, creating separate images viewed by each eye.

Merging the images to create 3-D with this device no longer requires a special projection lens: Digitized black and white footage can be overlaid in the editing process, and then the color can be tweaked to add the cyan and magenta tints used for anaglyph 3-D, providing a simpler expedient than polarized 3-D. Steve Cossman, founder and director of the nonprofit cinema arts organization Mono No Aware, has found that the anaglyph 3-D system (cyan/magenta) produces more depth than polarized 3-D with the Bolex 3-D system.

Figure 7.12 **Above:** Zoe Beloff filming 3-D with Bolex camera and 3-D attachment. Courtesy of the filmmaker. **Below:** Detail of the Bolex 3-D attachment. Camera courtesy of Mono No Aware.

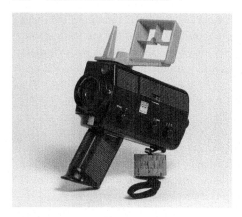

Figure 7.13 Eumig Nautica Super-8 under-water camera. Note the cork float attached to the wrist strap. Camera courtesy of Cooper Union Film Department.

Zoe Beloff has also worked in 3-D using two matched 16mm Arriflex SR II cameras for *The Ideoplastic Materializations of Eva C.* (2004), filming side by side and projecting a video transfer using synchronized laser discs. The cameras were mounted to a metal plate as close as possible to each other.

Ken Jacobs used a 3-D still camera to create still photographs in the 1970s that were subsequently combined through rapid alternation between the left and right images in the short film *Hot Dogs at the Met* (2009) and other works. The effect is something of an avant-garde version of 3-D, rather than the more straightforward binocular version, requiring no glasses and with a peculiar combination of motion and stillness present, as if the image were rotating without ever progressing beyond the starting point. The parallax effect takes place not in the eyes but in the mind of the viewer, who attempts to make visual sense of the rapidly flickering images.

Jean-Luc Godard's *Goodbye to Language* (*Adieu au Langage*) (2014) shifts the position of a pair of video cameras while shooting to create a dismantling of the illusionary depth. New York-based filmmaker Tim Geraghty has sometimes experimented with using two disparate images in his short 3-D works, letting the viewer's baffled perception attempt to sort things out. The effect sometimes has the appearance of two flat planes, at different depths from each other, within the movie screen.

Underwater cinematography

Underwater housings exist for the Bolex camera as well as various other 16mm and super-8 cameras. The housing is a blimp-like container, with a window for the lens and outer controls linking to the camera sealed inside. To keep the housing watertight, grease should be applied to the edge door before closing it up. There is even an underwater-capable super-8 camera, the Eumig Nautica (its main drawback being the inability to shoot at 24fps, rather than 18fps and single frame).

The sync sound camera

The transition from silent to sound created obstacles for the independent, owing to the complexity, expense, and the sheer bulkiness of early sync sound film equipment. The author Joe Adamson waggishly described the emergence of the "talkie" picture:

> Sound had come to motion pictures. People who tried to argue whether this was a turn for the better were drowned out by the cacophony of sputters, whines, gurgles, hisses and thumps emanating from all the better moving screens . . . Nobody in the

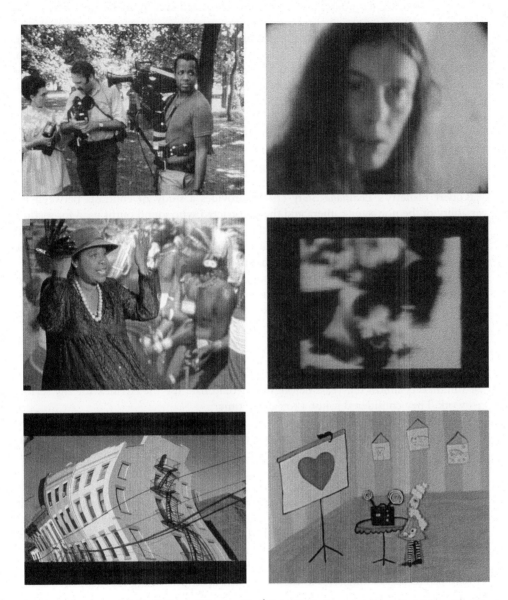

Figure 7.14 **Top row left:** William Greaves with Éclair NPR, from *Symbiopsychotaxiplasm Take One* (1968). **Top row right:** Anne Charlotte Robertson's *Five Year Diary* (1981–1997). Courtesy of Harvard Library's Film Conservation Center. **Middle row left:** Christopher Harris's *Halimuhfack* (2016). Courtesy of the filmmaker. **Middle row right:** MM Serra's *Papa's Garden* (1991), filmed with a PixelVision camera. Courtesy of The Film-Makers' Cooperative. **Bottom row left:** Jeff Scher's *Spring City* (2011). Courtesy of the filmmaker. **Bottom row right:** Helen Hill's *Madame Winger Makes a Film* (2001).

movie business knew much about sound. Nobody in the sound business knew much about movies. Everybody in both businesses resented everybody in the other.[19]

The avoidance of having microphones visible in the shot presented a unique problem. These would be hidden in flower vases and the like, now an obligatory part of the décor in scenes with dialogue. The Hollywood director Dorothy Arzner, in her early sound film *The Wild Party* (1929), freed the microphone from its concealed captivity, as her biographer, Judith Mayne, writes: " . . . [Clara] Bow was terrified of her first sound performance, and in order to make her movements on the set more natural, Arzner devised what is reputed to be the first fishpole microphone to allow flexibility of placement."[20]

As a workaround to all of these difficulties, some early independent films used post-production dubbing rather than recording live sync sound, as was the case with Morris Engel's *Little Fugitive*.

Robert Flaherty's *Louisiana Story* (1948) provides a study of contrasts between the versatility of the non-sync camera and the constricted sync sound outfit used for sections of the film. Flaherty had previously worked with the innovative 35mm motion picture camera designed by the naturalist Carl Akeley. Known as the "Akeley Pancake" because of its upright disc-shaped body, it was a hand-crank camera with a 200ft capacity and a twin-lens viewfinding system, allowing for quick set-up and focusing – essential for working out in the field. Now Flaherty came across the Arriflex II, a portable and ergonomic camera, but decidedly too noisy for sync sound shooting:

> In 1946 he saw this strange-looking camera at Irving Browning's Camera Mart. It was used as a combat camera by the German army, and he became fascinated by it, deciding it was just the camera he had been looking for all his life. It took professional filmmakers almost ten years before they would dare use the Arriflex for any serious work. They considered it just a toy at the time.[21]

The filmmaker Richard Leacock, working as Flaherty's cinematographer, would recall how the experience working with the Arriflex on this film led to his desire for an equally mobile sync sound camera:

> . . . When we were using small cameras, we had tremendous flexibility, we could do anything we wanted, and get a wonderful sense of cinema. The moment we had to shoot dialogue, lip-sync – everything had to be locked down, the whole nature of the film changed. The whole thing seemed to stop. We had heavy disk recorders, and a camera that, instead of weighing six pounds, weighed 200 pounds, a sort of monster . . . We had to impose ourselves to such an extent upon everything that happened before us, that everything sort of died.[22]

Photographer and filmmaker Fons Iannelli and the ethnographic filmmaker Jean Rouch were early innovators of sync sound filmmaking in the field. Advances in audio recording made possible with magnetic tape proved instrumental to the transformation of sync sound equipment, both in terms of portability and affordability, for the independent filmmaker. The development and use of portable sync sound equipment is most closely associated with documentary filmmakers collectively working in the cinema vérité[23] style, made possible with this equipment. These filmmakers included Richard Leacock, D. A.

Pennebaker, and the Maysles brothers, among others. Charles Reynolds, writing for *Popular Photography* magazine in 1964, described the technical innovations of the Maysles brothers' sync sound camera system:

Maysles's improvements on this camera and sound idea are three:

1. The Maysles camera balances correctly. Its weight is 30 pounds, but by positioning the magazines in the rear the camera is balanced when it rests on the shoulder and can be carried for extended periods of time – much longer than improperly balanced cameras of a fraction the weight. "Movie camera manufacturers are very concerned with camera engineering, but they are not concerned enough with human engineering," Maysles says.
2. You can see over the camera when you are not shooting. "When a regular camera is in front of you, a great part of your vision is blocked off," he says. "For me it's very important that I give all my attention to what's in front of the camera rather than on the camera itself. By positioning the viewing tube of the Angenieux zoom lens on my camera above the camera itself, the camera is always out of my field of view. In addition, all the controls are completely visible to the cameraman by simply glancing down."
3. All elements of the camera are part of the camera body. There are no battery packs hanging over the shoulder or any other accessories separate from the camera itself. Even the incident-light meter (a Spectra with pivoting light-collector) is fastened to the front of the camera.

The camera is run by synchronous motor powered by a battery pack. If such a motor were connected to a standard powerline (supplying 110-volt, 60-cycle, AC power) it would run at a standard synchronous speed. Since the batteries give only 12 to 15 volts, a transformer is used to boost the voltage to 110. An inverter changes the battery power to 60 cycles. This is accomplished by the use of a tuningfork which vibrates at 60 cycles, the signal of which is amplified and controls the motor speed. This speed control is *very* accurate (Bulova's Accutron watch works by the same principle).

The tape recorder (which is not connected to the camera in any way) also contains a 60-cycle tuning fork. It does not, however, control the speed of the recorder's motor, for, even if this were very accurate, the 1/4-in. tape could stretch, thus losing synch. Instead the signal is recorded on the edge of the tape itself, supplying a pulse which accurately controls the tape speed when rerecording is done on sprocketed 16mm magnetic tape. Thus, absolutely accurate synchronization of sound to film is obtained.[24]

Double system and single system

Recording sound simultaneously with picture may be done with a separate camera and audio recorder, or with an all-in-one camera, equipped to capture both picture and sound. The terms "double system" and "single system" refer to these methods, respectively. Each method has its advantages and drawbacks. With double system, the challenge is having

picture and sound from separate devices play together in sync. Single system will be in sync by its very nature, but its limitations include the tethering of the microphone to the camera (or the potential complications of a wireless microphone). With the single-system camera, one must always be shooting in order to record audio, while with double system, less expensive audiotape can be kept going when shooting film more sparingly.

Camera noise

Regardless of the sound-recording method, the sound of the camera itself presents a technological challenge as well. Motion picture cameras that are designed for sync sound shooting can be referred to as "self-blimped" – a term that has its origins in the large and awkward soundproof enclosures used for quieting the noisy camera, resembling a dirigible airship (with a porthole for the lens) mounted on the camera tripod. Much like an underwater housing, knobs and switches on the outside of the blimp link to the controls on the enclosed camera. Self-blimped cameras designed for quiet (though not always completely silent) operation include the Arriflex BL (standing for "blimped"), Arriflex SR, the CP-16, the Éclair NPR and ACL, and the Aaton LTR and XTR.

Noisy cameras not designed for sync shooting are referred to as MOS cameras. The term MOS is shrouded in obscurity, although a story is commonly told about the first use of "MOS." Ira Konigsberg, author of *The Complete Film Dictionary*, explains: "In the early days of sound films, technical and personnel were often foreign-born and these initials stand for 'mit out sound,' the way such an instruction might have been spoken by a German director or member of the camera crew."[25]

Optical sound

"Optical sound," the term for the audio recording method using the photosensitive motion picture film itself as the recording medium, sounds like some poetic combination of the senses, like "visual music." In point of fact, it's a literal description of the process of storing sound in the form of a reproducible image.

To create the optical soundtrack, an audio signal will activate a small shutter in front of a steady light, known as an exciter lamp. The variable light produced by the moving shutter exposes a photographic image of the waveform of the sound onto the film. Once the film is developed, a visible waveform is present on the edge of the film. An exciter lamp and a photocell on the movie projector, with the optical track passing between, reconstitute the signal into audio.

Despite its inferior quality compared to magnetic tape or digital audio, optical sound is still used in most 16mm and 35mm film projectors mostly due to compatibility, allowing for projecting older and newer film prints. A film's initial audio recording may be done on a digital recorder. But, if the film will be finished with a film print rather than a digital master, the lab will create an optical soundtrack to be used in printing.

Some cameras, like the Auricon, were designed to record the optical track directly onto the film at the time of shooting, a single-system format later supplanted by a magnetic stripe on the edge of the film. The audio quality resulting from recording directly to optical track on a single- system camera like the Auricon is a very low fidelity format. The sound films of Andy Warhol, such as *Vinyl* (1965) and *The Chelsea Girls* (1966), give an indication of the type of muffled-sounding audio produced by such a system. The exciter

lamp on the Auricon is designed to properly expose the track with 100ASA film, although a neutral density filter could provide a makeshift solution for using faster stocks.

Single system: magnetic stripe

Owing to the poor audio quality of single-system optical track recording made in the camera, filmstock with a magnetic stripe adhered to the edge was introduced for 16mm, designed especially for news cameras, like the CP-16 made by Cinema Products. A thin "balance stripe" was adhered to the sprocket edge to keep the film from warping due to the added thickness of the magnetic tape along one side.

Characteristics of the single-system sync sound camera would include a very particular "sploik" sound as the camera would go from stopped to running. A more vexing issue was the displacement of sound and picture, resulting in trailing picture or audio as the camera was started or stopped. The sound is recorded on 16mm film twenty-six frames ahead of the corresponding image in the gate.

A 50ft super-8 film cartridge was produced for shooting single system, using a camera equipped with a magnetic stripe recording head. While the standard-sized silent cartridges are still manufactured, the sound cartridge has long been discontinued. As with 16mm, the sound is offset from its corresponding frame of picture, being eighteen frames ahead in super-8.

Double-system sound: synchronizing methods

One of the earliest methods for maintaining synchronicity for double-system sound was the Vitaphone system. A large phonographic disc acted as the audio recording medium. The camera and record cutter were powered by synchronous motors, while the projector and disc player would be kept running in sync by means of gearwork between the two machines.[26]

As less cumbersome methods of working with double system emerged, the 60Hz cycle of AC power was used as a common reference between camera and audio recorder. Even if the alternating current were slightly off, the camera and recorder would still maintain sync, since both would be using the same reference. With the coming of portable reel-to-reel magnetic tape-recording machines lacking in sprocket holes to maintain sync, a system called "pilottone" was devised: a 60Hz tone recorded on the tape in addition to the audio track. Later, when playing back the tape, the speed of the machine could then be adjusted by using the pilottone as a reference.

Double system: cable sync

Battery-powered cameras and recorders presented a challenge, since the camera and recorder were no longer using the same power source and might no longer be running in perfect sync. A method known as cable sync used the camera's motor to generate a pilottone signal. A cable would run from the camera motor to a pilottone input on the audio recorder. This system, as effective as it was for maintaining sync, had the obvious drawback of the umbilical cable between cameraperson and sound recordist, the two never able to move further than the length of the cable or having to avoid getting themselves tangled up by it.

Double system: crystal sync

The camera and audio recorder were finally liberated from this tethered arrangement with the development of double-system crystal sync equipment: A quartz crystal was used to regulate the camera speed to run at exactly 24fps. Another quartz crystal for the audio recorder was used to generate a precise 60Hz pilottone reference signal.

Cameras like the Arriflex SR and Aaton are crystal sync cameras. Some older cable sync cameras can be retrofitted with an external box to regulate the motor speed, transforming it into a crystal sync camera. Before digital audio recording, the Nagra reel-to-reel audio recorder was the mainstay for sound, initially used for cable sync and later outfitted for crystal sync.

Many sync cameras, like the Arriflex SR, are designed to fit on the camera operator's shoulder. A compact coaxial magazine holds the supply and take-up side by side, the film quickly changed out by snapping a new magazine onto the camera. This specialization is in contrast to the versatility of a non-sync camera like the Bolex: The Arri SR can't shoot single frame and does not possess a variable shutter or provide backwinding capabilities. It is a camera designed to do one thing well (sync sound shooting), rather than many things.

Slates and bloopers

Double system shooting requires some method of aligning the independently recorded picture and sound. The clapstick slate is used for this purpose. A "blooper" may be used in place of a slate, activating a light filmed by the camera and recording a tone (the "bloop" of its name) simultaneously, used later to sync the footage. Timecode slates are similar to the blooper but with greater ease in identifying takes. Sometimes the sticks are clapped as a backup.

Double system without crystal sync

Digital editing has made it easier to shoot with an electric-driven camera lacking the absolute speed control of a crystal sync camera. By finding a shot with sync points to line up, it is possible to ascertain the amount of drift of camera and audio recorder (a shot slated at the head and tail is a good method for this). The audio file can then be digitally stretched or contracted to match the speed of the camera. Once this is done, then all of the audio files can be adjusted by this same percentage, as well.

Experiments with sync sound

The close association of cinema vérité and sync sound shooting would make the vérité aesthetic a logical point of departure for sync sound experiments. Shirley Clarke's *The Connection* (1961) adapts the stage production of the same name by the Living Theater. Clarke's feature stages this as the making of a documentary film of a group of addicts awaiting the arrival of the connection bringing their fix.

The film's fictitious director, Jim Dunn, and cameraman, J. J. Burden, use the small and mobile 35mm Arriflex IIC with 200ft magazine (featured more as a prop, since the film was primarily shot with a heavy blimped camera). A reel-to-reel audio recorder sits on the floor, where Dunn checks on it. Taking off the shade from a lamp, he reveals a hidden microphone. Lauren Rabinovitz describes how the film uses a simulacrum of the vérité process to question the vérité documentary's authority as cinematic truth:

While *The Connection*'s fictional director Dunn whines the cinéma vérité slogan, "I'm just trying to make an honest human document," he pans his camera, mobilizing the frame to bring some action to the sedentary situation. He wheedles, cajoles, and provokes the junkies into action in front of him . . . The irony is that there is no drama except that which Dunn invents, instigates, or shapes.[27]

Another Living Theater stage production was adapted for the screen by Jonas Mekas, as *The Brig* (1964). Mekas attended a performance of the play at the behest of David and Barbara Stone, who Mekas then conscripted to produce the project: "'I suspected it before coming,' said Barbara. 'We'll never take you to another play,' said David."[28]

Mekas used an Auricon camera equipped to record audio onto magnetic stripe 16mm film. Storm De Hirsch's short film, *Jonas in the Brig* (1964), documents his use of this heavy and cumbersome camera, mounted on a shoulder brace, to film the play. The use of this set-up was due to his goal of getting within the play, rather than film it from the audience's perspective. Mekas provided a description of his working method in the pages of *The Village Voice*:

> I had three 16 mm. Auricon cameras (single system, with sound directly on film) with ten-minute magazines. I kept changing cameras as I went along. The performance was stopped every ten minutes to change cameras, with a few seconds overlap of the action at each start. I shot the play in ten-minute takes, twelve takes in all.
>
> I remained inside the brig, among the players, constantly stepping in their way, disrupting their usual movements and *mise-en-scènes*. My intention wasn't to show the play in its entirety but to catch as much of the action as my "reporter" eyes could . . . (I had the camera, the mike, and the batteries on me, a good eighty pounds of equipment in all; the size of the stage didn't permit any other people than the cast and myself; I envied Maysles and Leacock their lightweight equipment.)[29]

While the film was primarily made with single-system sound, double system was also employed in the form of a backup track: "Two sound tracks were recorded during the shooting: one directly on film, magnetic; another separately, on a beat-up Wollensak machine."[30]

For Mekas, like Clarke, the film's production method was not just an adoption of cinema vérité but a means of questioning the form's underpinnings:

> One of the ideas that I was pursuing – or getting out of my system – was the application of the so-called cinema vérité (direct cinema) techniques to a stage event. I wanted to undermine some of the myths and mystifications of cinema vérité: What is truth in cinema? In a sense, *The Brig* became an essay in film criticism.[31]

In Jim McBride's *David Holzman's Diary* (1967), the fictive filmmaker sits before the editing bench while the Nagra III reel-to-reel recorder is seen off to the side, reels turning. He introduces the gear he is using, while illustrations from the equipment manuals accompany his anthropomorphic description of his camera and sound recorder:

> I want you to meet my friend, my eyes, my camera: Éclair NPR – Noiseless Portable Reflex camera. She weighs about eighteen pounds. I carry her on my shoulder or under my arm wherever I go. This is the Angenieux 9.5 to 95 zoom lens through which Éclair takes a picture of everything twenty-four times a second. And this is

a Nagra, a tape recorder, and this is a lavalier mic, which I use for recording inside. When I go out on my adventures, I tie all of my friends to me . . .

Holzman's dedication to his filmmaking "friends" – contrasted with unhealthy relationships to his friends of the human kind – acts as the dramatic counterpoint in McBride's film.

Symbiopsychotaxiplasm Take One (1968) by William Greaves (previously discussed in Chapter 3) takes place in Central Park with a crew of cinematographers and a sound recordist for a multi-camera shoot of the film-within-a-film called *Over the Cliff*. We sometimes see split-screen images arranged side by side – two images, and also three images – to show the footage produced by all of the cameras in a given moment, with cameras filming the filming of the film.

From a distance, we see the director, actors, and crewmembers while the voice of one of the camera operators quietly grouses into the microphone in the form of an aside:

> Camera B and C are both rolling, but, uh, there are no slates for this. Personal note from Mr Rosen to the assistant editor: The reason why all these slates are so fucked up is because they're not sure whether or not the action counts more or the slates count more, and so sometimes you get the slates and sometimes you get the action. So have fun, bubby.

The frustrated crew later questions the director about the purpose of the project, and Greaves catalogues the inventory of equipment: "There's a tripod, two still cameras, three Éclairs, there's an Arri S, we've got three Nagras. We've got an awful lot of equipment here." He turns the question back upon them: "Now, your problem is to come up with creative suggestions which will make this into a better production than we now have."

From the outset, Greaves has established his role as the director to see if actors and crew might question the authority asking them to repeatedly film the same scene over and over again. Another sync sound film seemingly premised upon a send-up of the voice of authority is the short film *Swamp* (1971), by Nancy Holt and Robert Smithson. The film uses a handheld camera walking among tall reeds into a muddy swamp. The voices of Smithson and Holt are heard discussing how to proceed through the marsh, intermingled with the sound of reeds crashing into the equipment and the occasional muffled blare of wind hitting the microphone. Holt operates the camera, and Smithson (presumably with audio recorder) instructs her:

> "Just walk straight in." "I think I am," she replies. "Straight in, to that clump. It's okay now; you're on fairly solid ground. Straight in. Just go right in." "So much of it's out of focus." "Well, just keep going in. Don't worry about the focus; just keep advancing in as much as you can."

Michael Snow chose to examine a more fundamental question of the connection of what we see and hear in the sound film medium in *"Rameau's Nephew" by Diderot (Thanx to Dennis Young) by Wilma Schoen* (1974). The film is comprised of a series of sequences drolly delving into the relationship of image and sound. Snow described the film as: "An authentic *Talking Picture*, it moves for its 'content' from the 'facts' of the simultaneities of recorded speech and image; it is built from the true units of a 'talking picture' – the syllable

and the frame."[32] Among the assortment of scenes in the film is a shot of a metal sink, hands thumping against it, demonstrating the changing pitch and timbre of the reverberant vessel as it fills with water. "The picturesque pun becomes apparent . . . the hands are *in synch* and *in sink*; this is *sink sound*."[33]

Henry Hills's *Kino Da!* (1981) uses a spring-driven Bolex camera for a short sync sound film of the poet Jack Hirschman. The poem was filmed in several takes and assembled together in editing – sometimes a single syllable is extended across several cuts. The brevity of the shots allows the inevitable slippage of sync from the Bolex's spring motor to be corrected in editing: Each shot ends before it can drift out of sync. Filming outdoors has allowed the sound of the camera to dissipate. The noisy camera is filming Hirschman at an adequate distance from the microphone so as not to be audible on the soundtrack.

Filming with magnetic stripe super-8, Joe Gibbons would oftentimes place himself before the camera, speaking to the viewer of the film, the small size of the camera lending itself to being turned around so he could film himself at work, or at home, or out in the world. Filmmaker and critic Fred Camper wrote of how Gibbons's " . . . quirky monologues seem perfectly paired to the medium's small image, dirty surface less-than-wraparound-sound. These are akin to the messages in a bottle, set adrift in the hope someone will read them, rather than authoritative declarations of the self . . . "[34]

Anne Charlotte Robertson's process of using super-8 sound film cartridges for her monumental *Diary* became hampered when Kodak eventually discontinued them in favor of continuing to make silent super-8 cartridges only:

> Right now, it's depressing. Kodak has cut out sound film. We have little caches of film hoarded away. Once that runs out we will have to hope that somebody's going to produce it, otherwise there's no sound film, there's no high speed film, so it's really closing down.[35]

Boston-based filmmaker Saul Levine's *Notes After Long Silence* (1989) makes use of the displacement of sound and picture on the strip of super-8 mag-stripe film. Whenever a cut occurs, the sound momentarily lingers on the play head of the projector, while a new image appears on the screen. Levine's film uses this to form varying juxtapositions of silent footage of a pastoral moment of a family by a lake with birds singing in the sunshine, a B. B. King solo on guitar seen on a television (the washed-out blue image due to the daylight-balanced color temperature of the TV), the pounding sounds of jackhammers on a construction site, and lovers in silent intimate embrace. The sound from one scene intrudes on the other footage through rapid cuts. These juxtapositions of sound and image evoke the feeling of being in one moment while distracted by a transitory reverie or misplaced memory. Levine, interviewed by filmmaker Donna Cameron, said of this technique: "the sound displacement in Super 8 is a very interesting thing . . . I really pushed it a lot."[36]

Christopher Harris's short film *Halimuhfack* (2016) shows a performer seated before a rear projection screen with looping footage of Masai tribespeople from an anthropology film. She is dressed in the manner of author and anthropologist Zora Neale Hurston, whose voice is heard on the soundtrack from an archival recording. We hear her speaking about African American folk songs then singing a few verses. Sound and image begin slipping quite noticeably out of sync, with Harris using a Bolex and hand-cranking it, rather

than filming with a sync sound camera. Towards the end of the film, the projected found footage is seen with exposure changes and superimpositions, created by cranking backwards and forwards. The slipping of sync that takes place throughout the film becomes Harris's analogue for the inexorable process of cultural change, adaptation, and loss particular to the African diaspora. The folk song Hurston sings is now wholly out of sync in Harris's film and no longer syncing up with how it may have been once understood, by those who first sang it, or by Hurston.

Picture as soundtrack

Canadian experimental animator Norman McLaren experimented with creating optical soundtracks by photographing shapes to create different acoustic envelopes with a modified animation camera, adapted to film in the track area of the film, rather than the picture area.[37]

The Super 16 format, its extended gate making use of the optical soundtrack area of the film, allows for using the camera to create sound from images, played back in a regu-

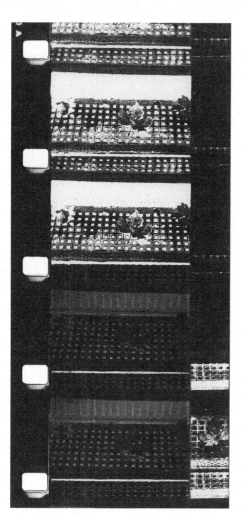

lar 16mm projector with the optical sound reader. The frameline itself will create a low rumbling square-edged waveform of 24Hz, but graphic repeating patterns are likely to generate an array of tones at various pitches; the closer the pattern is spaced, the higher the tone.

A rough gauge of the tones can be calculated by starting with the frequencies of musical notes; the note used as a reference for tuning, A_4, equals 440Hz. Its 440 cycles per second divided by twenty-four frames results in 18.33. So if roughly eighteen horizontal lines were photographed as an image and played back as the optical track, the resulting tone would be very close to the musical note A_4.

Because the optical soundtrack is twenty-six frames ahead of the corresponding frame of picture, it may be necessary to request the lab print picture and sound in two passes – one for picture and another for sound – advancing the soundtrack to put it into "projection sync" in the resulting print.

Figure 7.15 Frames from Guy Sherwin's *Musical Stairs* (1977), showing the optical soundtrack created using images from the film. Courtesy of the filmmaker and LUX.

UK filmmaker Guy Sherwin used a 16mm camera to create optical tracks in such films as *Musical Stairs* (1977), cutting between closer and wider shots of a staircase to produce lower and higher musical notes due to the distance between steps. The exposure of the image affects the volume, with bright, washed-out shots producing a soft, faint sound. The timbre changes from the elements of the composition. People walking up or down the stairs results in acoustic interference. Sherwin created the visual soundtrack from the image " . . . using a spare print of the film. It is split along its length with a Standard 8 splitter (a gadget designed for making 8mm film from 16mm)."

> The half of the film without sprocket-holes is then rolled over and re-joined with clear tape every few frames.
> This modified print now functions as an optical sound negative and is printed, with the original camera negative, to make a positive film print. By this process, picture and sound are combined on a single strip of film.[38]

An advantage of Sherwin's method of creating an optical track from motion picture images is that it uses the image from the center of the frame to generate the sound rather than the extreme edge, as is the case with Super 16.

Jim Hobbs's *Nature Morte* (2015) uses Super 16 to create an optical sound from picture, with still life arrangements of flowers in a vase filmed in lush tones of black and white and inspired by the photographs of Robert Mapplethorpe. In wider shots of the flowers, the 24Hz puttering sound of the film's framelines dominates. In closer shots, the texture of the petals creates a more diffuse purring sound. The shadow of a Venetian blind produces a more discernible pitch.

Video and film

Consideration of the differences of digital and analog oftentimes prompts the extolling of the tactile qualities of film, in contrast to digital's ungraspable chain of zeros and ones. This even goes further back, before digital, to the glosses made about analog video. At the time, it would have been grousing about videotape lacking a sense of presence in our world, owing to the absence of visible images on the surface of the tape. This distinction between the tactile and the virtual may be compared to what Walter Benjamin described as the "aura" of the original, absent from its mass-produced copies: "That which withers in the age of mechanical reproduction is the aura of the work of art."[39] His observation that: "From a photographic negative, for example, one can make any number of prints; to ask for the 'authentic' print makes no sense . . . "[40] seems even more applicable to digital's duplicating of files, which are sometimes referred to as "clones" rather than "copies" to indicate there having not been any re-encoding of the material.

Films of a hybrid nature precede digital video by many decades. Filmmakers shooting the image off of a television screen onto 16mm film are an example of this, such as Marie Menken's *Wrestling* (1964) and Stan Brakhage's *Delicacies of Molten Horror Synapse* (1991). The collaborations of Jud Yalkut and Nam June Paik produced in the 1960s are another example. The early computer animation of Stan VanDerBeek and the computer-based works of Lillian Schwartz were shot onto 16mm film as the method by which such work could be presented. Today, digital copies have been made of these, but it has not been done by going back to resuscitate the original computer programming of their creation. The 16mm film prints have been used as the masters for making the digital transfers.

Issues of film and video, digital and analog, may also be considered with regard to changes in technology, even of ecology; throwaway consumerism rapidly supplanting one generation of video equipment with another. The filmmaker Zoe Beloff has observed:

> In the early part of the twentieth century people were really interested in how things worked and how to fix them when they broke. Today, nobody cares what's inside a computer as long as it works, and when it doesn't work you throw it away and you buy another one. That's managed obsolescence. To get back to a more theoretical point of view, one of the things that I'm concerned with in my work is making a critique of the idea of progress, that because something's newer it's inherently better …My students are shooting with Bolexes that were probably made in the late 60s and have been used continuously ever since. The video cameras we have last two or three years. Anything that was manufactured in the nineties, hi-8 or whatever, is obsolete. In a couple more years we'll toss out the mini-DVs and we'll have mini-HDs. So even though video cameras cost less to buy than 16mm cameras, they last a tiny fraction of the time. So is it really cheaper?[41]

Since 2006, when Beloff's interview took place, mini-DV has been fully eclipsed by High Definition video. Now HD (1920x1080 pixels) is being supplanted by 4K video (3840x2160). 6K (6144x3160) and 8K (7680×4320) may follow sooner rather than later. The standard 16mm format has changed very little since 1923, by comparison (other than the adoption of 24fps with the coming of sound at the end of the 1920s).

Analog video: NTSC and PAL

Standard Definition NTSC video expresses as much (if not more?) of a nostalgic visual timbre than analog film: the rippling rainbow-hued helical-scan tracking errors, the transient monochrome horizontal lines of tape dropout, the wobbling light-smear deterioration of bright or dark objects from re-dubbing. Alison O'Daniel's *The Tuba Thieves: The Deaf Club* (2014)[42] recreates a punk concert in late 70s at the San Francisco Deaf Club, shot partly on High Definition video, 16mm, and also footage shot in analog video with a VHS camcorder. The camcorder footage, according to O'Daniel, had enough of an uncanny stamp of its era to fool viewers into thinking it was archival footage intercut into the sequence she had recreated.

Standard Definition video, usually referred to as NTSC, for National Television Standards Committee (although the joke is that it actually stood for "Never Twice the Same Color"), has a 4:3 aspect ratio and 486 scan lines per frame. The frame rate is 29.97 frames per second, just a fraction of a second slower than real time. The frames do not actually appear wholly at once like the opening of a projector shutter. These are composed by a small electron beam moving back and forth across the inside surface of the cathode ray tube. Each frame is divided into two fields: one of odd lines and one of even lines, the beam making two interlaced transits across the tube for every frame of video. The term for these two fields making one complete frame is "interlaced" video, compared to "progressive" formats, with each frame composed of individual images, sans fields.

The reason for video's 29.97 frame rate, rather than 30fps, goes back to the introduction of color to the previously existing black and white video signal, causing it to slow down but not by enough to make all the existing black and white televisions of the time suddenly become obsolescent. Building upon existing technology is also the reason for

NTSC having been established originally at 30fps, since the sixty cycles of alternating current was used as a reference.

PAL (Phase Alternating Line) is the analog video system used in the UK and most of the rest of Europe, and other parts of the world, also with a 4:3 aspect ratio but a slightly higher number of scan lines, 576 scan lines per frame, and a frame rate of 25fps, with fifty interlaced fields per second.

PixelVision (PXL-2000)

The allure of the PixelVision camera is one of going backwards rather than forwards. While most of us are busy chasing after the ever-increasing resolving power of High Definition video, some artists have turned to the most low-fi format easily available. The Fisher Price PXL-2000, appearing in the late 1980s, was a children's toy video camera, shooting contrasty, black and white images in its own low-resolution format. The image is 120 x 90 pixels with a frame rate of 15fps, recording onto a cassette tape inside the camera. As a toy, it was not much of a success, to put it mildly, but developed a small following of filmmakers and video artists intrigued by its rudimentary, low-fi qualities.

PixelVision experimenters sometimes bypass the camera's cassette tape recording system by connecting it to an external video recorder, the major difference between the two methods being the issue of image degradation from the cassette's recording system itself. The flaws of the cassette can be something of an enhancement of the low-fi qualities of the format. When the cassette is stopped and started, a dramatic ramping tone is produced on the audio, as heard during the cuts in Sadie Benning's *Living Inside* (1989).

The work of PixelVision filmmakers includes the early diary films of Sadie Benning, intermixing panning shots of handwritten text, shots turning the camera around at herself to reveal an eye or an ear while speaking in confiding tones to the viewer, shots composed with toys, magazines, and images filmed off of a television screen. MM Serra's *Stasis Series I & II I Still Life; II. Papa's Garden* (1991) are two PixelVision works, the first showing the interference patterns created by repeatedly restarting the camera with the batteries nearly fully drained and the later composed of close-ups of the titular garden, the lush greenery of growing plants rendered gray and arid like some scene from the surface of the moon. In Joe Gibbons's *Elegy* (1991), the filmmaker takes a dog, Woody, for a walk through a graveyard and uses the occasion to explain death and mortality to his contently oblivious panting companion. Michael Almereyda's *Another Girl Another Planet* (1992) and Peggy Ahwesh's *Strange Weather* (1993) work with a more preconceived narrative form in this low-fi format. Cecilia Dougherty and Leslie Singer's *Joe-Joe* (1993) featured the directors in the role of Joe Orton and Joe Orton, the gay British playwright reimagined as a lesbian duo in matching leather biker caps, engaging in scenes of witty banter with the two halves of herself. The PixelVision camera, lightweight and plastic, moves with exuberant freedom in constant handheld arcs, swoops, pans, and tilts, nearly

Figure 7.16 PixelVision PXL-2000 camera. Camera courtesy of MM Serra.

always close to the subject, the lens distort-
ing what it sees due to its proximity to the
faces and objects it inspects.

Analogues to analog

Video and film have had some curious
points of intersection, technical and aes-
thetic. For instance, many contemporary
digital video cameras seek to emulate the
"film look," such as the option to shoot
at 24fps rather than the long-established
video frame rate of 29.97fps. In pursuit of
giving a filmic feel to the image on screen,
digital mavens put old glass onto new

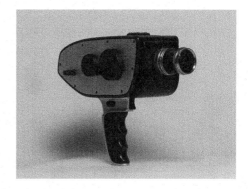

Figure 7.17 The Digital Bolex, with a 10mm
Switar lens. Camera courtesy of
Michael Stewart.

cameras. Old lenses are now becoming more expensive than they were a few years ago.
As a consequence of this, there are a plethora of analog cameras, sans lenses, for sale
online, to the frustration of someone trying to put together a complete kit.

The Digital Bolex may sound like a contradiction in terms, but launched as a Kick-
starter project in 2012, the camera was designed to shoot HD digital video and, like its
analog namesake, use c-mount lenses such as the esteemed Switar. The ergonomics of use
(in contrast to the awkwardness of a DSLR used for shooting digital video) was another
important aspect of its design, according to its makers: " . . . the camera body is designed
to fit comfortably in your hands – emulating the feel of a traditional 16mm film camera,
while still offering all of the shooting positions and mounting options of a professional
digital cinema camera."[43] Production of this camera ended in 2016.

There are some ways in which digital video has assisted, rather than hindered, the
resurgence of analog media. A case in point is analog super-8 film. In its own day, super-8
presented several challenges in presentation due to the very poor quality of transfers to
analog video. Companies offering to transfer your 8mm home movies to VHS sometimes
used little more than a projector and tabletop rear screen setup for this. The flaws of VHS
as a format only compounded the quality of the mediocre transfer. But in recent years,
affordable access to excellent quality digital transfers from super-8 has made this "dead"
format relevant again. A well-produced digital scan from super-8 maintains much of the
original film's clarity and vividness. It is hard to imagine the current super-8 revival hap-
pening without this symbiosis between analog and digital.

Super 16 has followed a similar path as well. The format was initially devised to be opti-
cally blown up to 35mm, but its widescreen aspect ratio of 1:1.66 fits nicely (although not
precisely) into the 16:9 format of HD video.

Digital cameras, too, have characteristics and quirks apt for innovative aesthetic hijack-
ing. Jeff Scher's short film *Spring City* (2011) was, according to the filmmaker's description
of the work,

> . . . photographed entirely by exploiting a neat quirk of the camera on my two-
> year-old iPhone. Shaking the phone vigorously while taking pictures in bright
> light will produce wonderfully rubbery, fun-house-mirror effects. Turning these

still images into a movie required taking over 4,000 of them, wiggling the camera each time.[44]

Filming in this strange manner out in the streets of New York, Scher would discover: "Not a single person asked what I was doing."[45]

Helen Hill's credo of DIY analog filmmaking, *Madame Winger Makes a Film: A Survival Guide for the 21st Century* (2001), emphasizes the value of sincerity and working with whatever modest means are available to make a truly meaningful work. The tools themselves only matter as far as how you use them:

> Please remember, that it's a good idea behind the film, and not fancy technology or big budget that makes a great film. In this century of changing digital technology, you may want to hide out in your own homemade film lab bomb shelter, or you might take the barest of materials into your kitchen and make a lovely little flick about something you love. Filmmaking is fun, so get going!

Notes

1 Bogdanovich, Peter, *Who the Devil Made It: Conversations with Robert Aldrich, George Cukor, Allan Dwan, Howard Hawks, Alfred Hitchcock, Chuck Jones, Fritz Lang, Joseph H. Lewis, Sidney Lumet, Leo McCarey, Otto Preminger, Don Siegel, Josef von Sternberg, Frank Tashlin, Edgar G. Ulmer, Raoul Walsh*. New York: Alfred A. Knopf, 1997, p. 55.

2 Frazer, John, *Artificially Arranged Scenes: The Films of Georges Méliès*. Boston: G.K. Hall & Co., 1979, p. 34.

3 Cornic, Stefan, *Morris Engel and Ruth Orkin: Outside: From Street Photography to Filmmaking*. Editions Carlotta Films, 2015, p. 27.

4 Conversation between Morris Engel and the author in the mid 1990s.

5 Engel, Morris, "Little Fugitive, A Biography of a Motion Picture" (unpublished ms.), p. 2.

6 Ibid., p. 3.

7 *Canyon Cinema Film / Video Catalog*. San Francisco: Canyon Cinema, 2000, p. 152.

8 Ramey, Kathryn, *Experimental Filmmaking: Break the Machine*. Burlington, MA: Focal Press, 2016, p. 341.

9 http://schlomoff.hautetfort.com/archive/2006/04/14/histoire-de-la-camera-stenope-35mm-en-carton.html.

10 Comerford, Thomas, "Pinhole Notes" (2002) in Kathryn Ramey, *Experimental Filmmaking: Break the Machine*. Burlington, MA: Focal Press, 2016, pp. 309–310.

11 *The Film-Makers' Cooperative Catalogue No. 7*. New York: The New American Cinema Group, Inc., 1989, p. 219.

12 Ivens, Joris, *The Camera and I*. New York: International Publishers, 1962, p. 42.

13 Snow, Michael, *Michael Snow – Sequences – A History of His Art*, Gloria Moure ed. Barcelona: Ediciones Poligrafa, 2015, p. 136.

14 Broomer, Stephen, *Codes for North, Foundations of the Canadian Avant-Garde Film*. Toronto: Canadian Filmmakers Distribution Centre, 2017, p. 235.

15 Ibid., p. 235.

16 Ibid., p. 248.

17 MacDonald, Scott, *A Critical Cinema 4*. Berkley, Los Angeles, and London: University of California Press, 2005, p. 320.

18 Hendershot, Heather, "Of Ghosts and Machines: An Interview with Zoe Beloff," *Cinema Journal* vol. 45 no. 3, Spring, 2006, p. 134.

19 Adamson, Joe, *Groucho, Harpo, Chico, and Sometimes Zeppo*. New York: A Touchstone Book, Simon and Schuster, 1973, pp. 77–78.

20 Mayne, Judith, *Directed by Dorothy Arzner*. Bloomington and Indianapolis: Indiana University Press, 1994, p. 48.

21 Eagle, Arnold, "Looking Back . . . at 'The Pirogue Maker', 'Louisiana Story', and the Flaherty Way," *Film Library Quarterly* vol. 9 no. 1, 1976.

22 "The Frontiers of Realist Cinema: The Work of Ricky Leacock" (From an Interview conducted by Gideon Bachmann). *Film Culture* No. 22–23, Summer, 1961, pp. 13–14.

23 Sometimes this movement is referred to as "direct cinema" to distinguish these American-produced films from the work of French cinema vérité filmmakers such as Jean Rouch.

24 Reynolds, Charles, "Focus on Al Maysles" (1964), in Lewis Jacobs ed., *The Documentary Tradition*, 2nd ed. New York: W. W. Norton & Company Inc., 1979, pp. 403–404.

25 Konigsberg, Ira, *The Complete Film Dictionary*. New York and Scarborough, Ontario: The New American Library, 1987, p. 217. The less colorful (but perhaps more reasonable) explanation would have the term refer to "Minus Optical Sound" or "Motor Only Sync."

26 Kellogg, Edward W., "History of Sound Motion Pictures," in Raymond Fielding ed., *A Technological History of Motion Pictures and Television*. Berkley, Los Angeles, and London: University of California Press, 1967, p. 180.

27 Rabinovitz, Lauren, *Points of Resistance: Women, Power & Politics in the New York Avant-garde Cinema, 1943–71*. Urbana and Chicago: University of Illinois Press, 1991, pp. 115–116.

28 The Brig: Mekas, Jonas, "Shooting *The Brig*," in *Movie Journal: The Rise of the New American Cinema 1959–1971*. New York: Collier Books, 1972, p. 191.

29 Ibid., pp. 191–192.

30 Ibid., p. 193.

31 Ibid., p. 192.

32 *The Film-Makers' Cooperative Catalogue No. 7*, p. 455.

33 Chodorov, Pip, in Ivora Cusack and Stéfani de Loppinot's *"Rameau's Nephew" by Diderot (Thanx to Dennis Young) by Wilma Schoen*, Ivora Cusack, Andrea Rossi, Eric Witt, and Vincent Young trans. Paris: Exploding and Re:Voir, 2002, p. 45.

34 Camper, Fred, "The Qualities of Eight," in Albert Kilchesty ed., *Big As Life, An American History of 8mm Films*. Museum of Modern Art/San Francisco Cinematheque, 1998, p. 29.

35 Cameron, Donna, "Pieces of Eight: Interviews with 8mm filmmakers," in Albert Kilchesty ed., *Big As Life, An American History of 8mm Films*. Museum of Modern Art/San Francisco Cinematheque, 1998, p. 67.

36 Ibid., p. 62.

37 Russett, Robert and Cecile Starr, *Experimental Animation*. New York: Van Nostrand Reinhold Company, 1976, pp. 166–169.

38 Sherwin, Guy, *Optical Sound Films 1971–2007: Guy Sherwin*. London: LUX, 2007, p. 46.

39 Benjamin, Walter, "The Work of Art in the Age of Mechanical Reproduction," in Hannah Arendt ed., *Illuminations*, Harry Zohn trans. New York: Schocken Books, 1969, p. 221.

40 Ibid., p. 224.

41 Hendershot, "Of Ghosts and Machines: An Interview with Zoe Beloff," pp. 137–138.

42 Full disclosure: I make an appearance in this project, in the role of Bruce Conner.

43 https://www.digitalbolex.com/about-the-d16/.

44 https://opinionator.blogs.nytimes.com/2011/04/22/spring-city/.

45 Ibid.

8 Camera as diary, the film portrait, and the remembrance of filmed past

This chapter covers filmmakers borrowing from the modes of diary, home movie, and portrait and how footage takes on new meanings as it passes through time.

Jonas Mekas's *As I Was Moving Ahead Occasionally I Saw Brief Glimpses of Beauty* (2000) is a film with a rather long title. This is appropriate enough, since the film is long as well. Made up of twelve sections, the film is nearly five hours in total. Its subject is what Mekas shot as part of his movie diaries over the years, culling together material and assembling it after some time has passed. He confides to us on the film's soundtrack:

> My dear viewers, I guess you have come to another realization by now, and that is that I am not really a filmmaker. I do not make films – I just film. I'm most obsessed with filming, I'm really a filmer, and it's me and my Bolex. I go through this life with my Bolex, and I have to film what I see, what is happening right there. What an ecstasy just to film! Why do I have to make films when I can just film? When I can just film whatever is happening there in front of me.

Mekas's identification with himself as "filmer" rather than "filmmaker" addresses the basis of the cinematic diary: The process of filming superseding the need for the material to have a purpose, to become a product, contrived at the outset before shooting begins. It also aligns the term with other forms of "-er" among the arts, such as photographer, painter, dancer, writer.

He had grown up in a farming village in Lithuania and took an interest in writing poetry as a young man. He and his brother, Adolfas, worked as forced laborers in a factory in Germany during the war. They arrived in New York in 1949 as displaced persons and were soon taking an interest in the film scene around New York. This was at the time when Morris Engel, Shirley Clarke, and John Cassavetes were working to produce independent feature films. The brothers founded *Film Culture* magazine. Inspired by Cassavetes's *Shadows* (1959), and other films of what was then called the New American Cinema, Jonas made an independent feature, *Guns of the Trees* (1961). Early on, Mekas disparaged the experimental film scene in the U.S.[1] But then, after what Mekas would describe as a St. Augustine-like conversion,[2] he would go on to become a fierce advocate of experimental and underground cinema. In 1958, he began writing a weekly column in *The Village Voice*, championing the work of numerous experimental filmmakers of the 1960s. He arranged screenings at the Film-Makers' Cinematheque. He had a hand in the founding of The Film-Makers' Cooperative and Film-Makers' Distribution Center, and in

1970, he established Anthology Film Archives, first at the Public Theater. The organization later acquired and renovated its own building – what had been a disused city courthouse – on Second Avenue and Second Street.

Mekas's diary films were created slowly over time, shooting here and there. Only after several years did he produce finished work from the material he had been shooting, beginning with *Diaries, Notes, and Sketches, also known as Walden* (1969).

David E. James has made the distinction between the "film diary" – the act of filming images from daily life – and the "diary film" – the shaping of this material from the raw film diary into an autobiographical work.[3] The term film diary, or movie diary, or diary film oftentimes has more to do with the sensibility of filming a cinematic record of those seemingly insignificant moments of daily life: "I have been walking around with my Bolex and reacting to the immediate reality: situations, friends, New York, seasons of the year."[4] It may be occasional, like the travel diary, rather than requiring a strictly quotidian approach.

Describing his diary-keeping process, Mekas contrasted the film diary with its written counterpart:

> When one writes diaries, it's a retrospective process: you sit down, you look back at your day, and you write it all down. To keep a film (camera) diary, is to react (with your camera) immediately, now, this instant: either you get it now, or you don't get it at all. To go back and shoot it later, it would mean restaging, be it events or feelings.[5]

While the film diary is constrained by what it captures in the contemporaneous moment of shooting, there are ways filmmakers have gotten to the unfilmed subject matter obliquely, to work with "a retrospective process," so to speak, through contrast of voiceover and image, by way of example.

What is it to keep a film diary? The occasions one may choose to film may be " . . . nothing spectacular, all very insignificant, unimportant – misc. celebrations of life that has gone, by now, and remains only as recorded in these personal, brief sketches."[6] David E. James describes this in connection with the fleeting shots of Mekas's shooting style:

> The short bursts of photography and especially the single-framing by which Mekas takes note(s) of the loveliness of daily life characteristically involve swift modulations of focus and exposure that transform the color and contours of a natural object or scene – painting with the sun, precisely. The constantly voyaging camera creates a continuous stream of visual aperçus, alighting on one epiphany after another – a face, a cup of coffee, a cactus, a foot, a dog scratching itself, another face, a movie camera.[7]

One may ask of the process how much of a film diary is truly spontaneous, since, realistically, the person filming had to purchase the raw stock in advance and decide on this occasion (and not that other occasion) to bring a camera loaded with film. There are a number of other questions to ask oneself about the process of keeping a film diary. Should the act of filming preference certain occasions of celebration or spectacle, a performance, a wedding, reuniting with visiting friends? Something more humble? Like the light in the morning or wintertime snow.

To shoot or not? The camera might be hefted along but nothing inspires getting it out and shooting at one time or another. How does one play around the ellipses of reloading the camera, creating a gap in what may be recorded, or if using the Bolex camera, the 28-second stanza limiting the shot length before the spring must be wound again. The

diarist must make constant decisions as to how to parse out small bits of time. Is a particular moment worth using a full 28-second shot, or does it just merit a glimpse? An entire roll or multiple rolls? Film is finite. Filming a journey, viewed out the window of a train, may use up all the raw stock so too little is left for the arrival at the destination. Another consideration for the diarist: Should the film diary be just a visual record of things or should sound also be recorded?

Perhaps the most fundamental question about the film diary is to what end are you filming: Is it to keep in practice with filming? Is it eventually meant to be seen in the form of a project, or just be filmed for its own sake, regardless of being seen by anyone, much as with the written diary kept hidden away in a drawer? Is it to be shown in unedited form or crafted and shaped from film diary into diary film? If the goal is to collect footage for eventually making a diary film, in what ways does this bear influence on the diaristic aspect, much as the supposedly personal diaries of writers may read as if composed with an eye to eventual publication? Diary filming for the sake of making a diary film may be considered as a shooting sensibility applied to a definite project, rather than the diary-like amassing of footage for its own sake. The film shot in a diary-like manner borders on the observational documentary intertwined with the experimenter's approach to the camera. The writer Michael Renov compares the film diary sensibility to that of the essay:

> The essay form, notable for its tendency toward complication (digression, fragmentation, repetition, and dispersion) rather than composition, has, in its four-hundred-year history, continued to resist the efforts of literary taxonomists, confounding the laws of genre and classification, challenging the very notion of text and textual economy.[8]

These questions will often lead to different answers in the work of differing diary filmers. The diary is a work of personal cinema, and individual approaches to shooting enhance this personal quality in the way that no two individuals are completely alike.

Gordon Ball's *Farm Diary* (1970) documents life at a countercultural rural refuge. The poet Allen Ginsberg lists the activities of daily life taking place before the lens:

> Cleaning the well, reading the paper, chanting Prajna Paramita Sutra, tilling the earth, sipping coffee, picnicking, the sun setting, the sun rising, mist settling, motoring through the countryside, building the woodshed, digging for the hidden well, the morning walk, bathing, horseshoeing, caressing the cow, cutting wood, the annual parade, the sun yellowing leaves, the leaves wrinkling, the leaves fallen and blown, the snow, sledding, bearing water through the snow, 17 below, the blizzard.[9]

Vivian Ostrovsky's short film, simply called *Movie* (1982), uses the diary form to stitch together disparate fragmentary moments: a view from a car of streetlights at night; underlit scenes at a discotheque with the movements of figures in shadow; a sunset; a view of palm trees in the median separating a broad avenue viewed from above (perhaps from a hotel balcony); a classical concert with orchestra in evening clothes, the camera switching on and off to produce jump cuts of a singer entering the stage and later bowing to the audience: a humorous ellipsis, with the performance itself skipped over.

The diary film's personal sensibility may not be limited to the filming itself. The filmmaker Yasunori Yamamoto, with several hundred reels of super-8 film in his diary, has recorded scenes of his life in New York and Japan. Yamamoto's diary film as a personal undertaking – filmed as a work of the private sphere rather than the public one – is not

just a matter of its production but also its presentation. Yamamoto would show reels from his super-8 diary along with the work of other artists invited to salon-like gatherings at his New York apartment in the 1990s. The setting of the screening, in a personal space rather than a public cinema, dovetails with the nature of diary keeping.

Bradley Eros has shot some 300 reels of super-8 diary footage, collected in true diary-like fashion, but like the written diary put away in the drawer, it remains unseen.

Travel diaries

There is a moment in Jim Jarmusch's feature film *Mystery Train* (1989) when the Japanese couple are together in their Memphis hotel room. The brooding ducktail-coiffed man goes about with a still camera inspecting every detail:

> "Jun, why do you only take pictures of the rooms we stay in and never what we see outside, while we travel?"
> "Those other things are in my memory. The hotel rooms and the airports are the things I'll forget."

The flâneurs of filmmaking, such as Rudy Burckhardt, have used the camera for creating travel diary films: *Haiti* (1938), *Montgomery, Alabama* (1941), and *Saroche* (1975) record more of the experiences of a traveler observing the local character of a place. The Peruvian market in *Saroche* seems more of interest than Machu Picchu. This is in contrast to the tourist's home movie travel film, with views of the guidebook's obligatory destinations. Jonas Mekas's *Reminiscences of a Journey to Lithuania* (1972) uses the travel diary as a means to seek out his past and affirm his new life, shooting film in the process of this evocative journey.

Howard Guttenplan, who helmed the Millennium Film Workshop for many years, referred to his super-8 and 16mm works as cinematic diary films. Guttenplan's diary films often took the form of travel shooting when he was able to gain a temporary reprieve from his work as an arts administrator and film programmer. Brief shots – sometimes no more than a fraction of a second – come one after another in *European Diary* (1978): a woman's face in profile sitting at an outdoor café; the light near dusk illuminating the street; a wall painted red, framed so as to fill the screen with its color as an unbroken field of red and the faintly discernible texture of the underlying brickwork. Guttenplan referred to his process of filming as "shooting in stride," which Alister Sanderson described, in the pages of the *Millennium Film Journal*, as working " . . . neither as a film-maker nor as a movie-making tourist, but as a traveler who happened to possess a camera."[10]

Home movies

The experimental filmmakers' film diary shares kinship with the home movie. The home movie may be more discerning than the diary in its selection of moments from everyday life: babies born and celebrating birthdays, childhood and more birthdays, distant relatives gathered together, holiday scenes, family vacations. Yet the diary filmer, often as not, waits for no such special occasion to pull out the camera.

Patricia Zimmerman, writing about non-professional filmmaking, points to the correspondences of amateur and avant-garde:

> Since the 1950s, with filmmakers such as Stan Brakhage and Jonas Mekas, the American avant-garde has appropriated home-movie style as a formal manifestation of a

spontaneous, untampered form of filmmaking . . . It does not conform to prescriptive formats: subjects interact with the camera as friends and openly pose, the camera firehoses, and scenes from daily life unroll unedited, or in no particular narrative sequence.[11]

Stan Brakhage highlights the relation between his artistic output and the private world of the family in many of his works. A short film is even titled *An Avant-Garde Home Movie* (1961).

For the cinematic diarist, the home movie is held in esteem for its artless, folksy qualities. But the home movie does possess its own recurrent aesthetic conceits: the posed shot with the subject standing uncomfortably in the frame, much as one would for a still photograph, and seeming to wonder if it is better to stand still, or speak, or do some droll, gesturing action as the movie camera rolls.

> Other characteristics typical of the home movie include flash frames, over- and underexposure, swish pans, variable focus, lack of establishing shots, jump cuts, hand-held cameras, abrupt changes in time and place, inconsistent characters and no apparent character development, unusual camera angles and movements, and a minimal narrative line.[12]

Family Album (1986) by Alan Berliner was not shot by the filmmaker, but it is a lofty homage to home movie making. Berliner utilizes the artless domestic charm of amateur footage and home audio recordings as the film's building blocks. Deanna Morse's short film *Camera People* (1984) also pays homage to the home movie as found footage, egalitarian in its celebratory view of the human subject. The film reprints scenes of home movies, the diverse families linked by all of those commonly filmed home movie tropes: picnics, school functions, birthdays, moments of goofing off in front of the camera. Acknowledging the camera throughout the film, faces smile at the lens, sometimes people wave, stick out their tongues, give the piece sign, or flip the bird.

A home movie of a different nature is seen in *How Strong The Children* (1998) by filmmaker Rohesia Hamilton Metcalfe, with video footage of the temper tantrums and screaming usually cut from the home movie's typical depiction of a family of smiling faces and celebratory moments.

Takahiko Iimura's silent short film, *Taka and Ako* (1966), shot in black and white and printed in a ruddy-brown sepia tone, may be regarded as a homage to the unassuming virtues of the snapshot photograph. Smiling faces turn to the lens and awkward expressions are captured by the happenstance of the less than decisive moment of these informal photographs. The film is a dual portrait of Takahiko and Akiko Iimura, moving briskly through a collection of photographs, snapshots, and photographic contact sheets. The photographs are sometimes shown as stills in quickly cut sequences and at other times with a moving camera panning across the multiple frames of contact sheets.

In his essay on the attitudes towards the professional moviemaker, the artist, and the recreational filmmaker, "In Defense of Amateur,"[13] Stan Brakhage reminds the reader that the root of the word "amateur" means a lover of something, as in "amour". The validation (and valorization) of the amateur over its more negative connotations of dilettante or tyro has its parallels in the charms of the folk artist, as with the acclaim of the self-taught painter Henri Rousseau, or even those further outside of the mainstream, such as the janitor Henry Darger, whose extensive adventures of the Vivian Girls were only discovered posthumously.

George and Mike Kuchar came to filmmaking as teenagers in the Bronx through the amateur route rather than by way of formal training: "For their 12th birthday they were given an 8mm DeJur movie camera."[14] Their first screenings took place at the amateur-oriented 8mm Motion Picture Club. As George Kuchar described it to the author Jack Stevenson: "'It was run by fuddy-duddies . . . Everybody got dressed up and they showed their vacation footage . . . the old ladies would get offended at my movies because they were "irrelevant" I guess.'"[15] But their work would be embraced by the avant-garde of New York's downtown scene, delighted by its ingenuous genius. George Kuchar would adopt the diary form for his video works, which saw him joking around with friends and other filmmakers, observing the behavior of cats, corresponding with the author of books on UFOs, and traveling to Oklahoma to satiate his interest in tornadoes. The Kuchar brothers' background as amateurs served their careers as artists. They were unafraid to lampoon the conventions of cinema or to find inspiration from the dregs of potboiler Hollywood in their largely self-taught production process.

But a conundrum remains to be untangled. If the attributes of haphazard or unprofessional shooting are an avenue for broadening the palette of cinematic technique, how can it really be called a "technique" at all, rather than the lack of it? How is "artful artlessness" not a self-negating concept? The use of home movie's crude and simple filmmaking affectations by avant-garde artists as a naïve-tinged form of aesthetic refinement has its analogue in wabi-sabi – the extolling of that which is rustic, simple, with a patina of wear – such as that described by Okakura Kakuzo in *The Book of Tea*:

> The tea-room is unimpressive in appearance . . . the materials used in its construction are intended to give the suggestion of refined poverty. Yet we must remember that all this is the result of profound artistic forethought, and that the details have been worked out with care perhaps even greater than that expended on the building of the richest places and temples. . . . The selection of its materials, as well as its workmanship, requires immense care and precision.[16]

Just as wabi-sabi is not the undiscerning adoption of the rustic but, in its precise selection of materials, a transformation of the simple and rustic into an aestheticized form of the highest refinement, so too the "artless" home movie can serve as inspiration for the experimenter.

There is a sense of the unvarnished present in this imperfect record of seemingly off-handedly shot footage, the flaws acting as part of the photochemical verisimilitude, awkwardly forthright, even if not completely truthful. Mekas found that in his own diary footage something of its essence was lost to too much improvement after the fact:

> Before 1960 I tried to edit the material from 1949 to 1955. But I practically destroyed it by tampering with it too much. Later, in 1960 or 1961, I spent a lot time putting it *back* to the way it was originally.[17]

A paradoxical aspect of these avant-garde evocations of the amateur's lack of professional polish is the amateur's striving to rid these supposed defects from his or her movies. Exhortations to make more professional-looking home movies are the crux of production guidebooks for the amateur moviemaker. As Brakhage observes, the overly self-conscious amateur will:

... imitate the trappings of commercial cinema (usually with no success whatsoever, as he [or she] will attempt the grandiose of visual and audio with penny-whistle means) ... we all do really know him, this would-be professional, who does in his imitation of "productions" give us a very real symbol of the limitations of commercial cinema without any of the accomplishment thereof ...[18]

Visual diaries and verbal camera confessions

With the non-sync Bolex, the film diarist is recording the sights of daily experiences, with or without subsequent verbal commentary or titles. Sync sound diary films appear with the availability of portable sound film equipment, shot in 16mm or super-8. In some cases, the sync sound diary film may share the temporal vantage of the written diary, with the filmmaker describing events to the viewer through a confessional monologue, delivered to the camera after the fact, rather than captured in the moment.

Jim McBride's fictional *David Holzman's Diary* (1967) epitomizes the type of diary movie framed around the sync sound monologue. The fictional protagonist engages in one-sided conversations with the camera while sitting at his editing bench. Holzman films his friend Pepe, who expresses his doubts about the diary film endeavor:

> The problem is, you want to make a movie out of your life, alright. So you want to be in it, and you want Penny to be in it, and me to be in it, and your apartment, my apartment. But I am an interesting character to watch, but you're not an interesting character, and Penny is certainly not an interesting character at all.

Joel DeMott's *Demon Lover Diary* (1980) has some sporadic narration, but often the camera just films and DeMott engages with her subjects in the moment of shooting. The film shows the making of a low-budget horror film from behind the scenes, DeMott accompanying her boyfriend, Jeff Kreines, out to Michigan where he will be the movie's cinematographer. Filmed with a 10mm Switar lens on a CP-16, with camera in one hand and microphone in the other, DeMott's film progressively documents the horror movie production's growing shambles. DeMott's voiceover sometimes interjects to provide context and commentary. *The Demon Lover* directors, Donald G. Jackson and Jerry Younkins, express a constant apprehension regarding the striving for professionalism of the slipshod shoestring production. They speak to a reporter about their ambitions for the project:

> "We think we're going to come up with the best low budget horror movie ever made ... We know it's worth spending two years to do a masterpiece, and that's what we're trying to do – all of our heart, mind, body, and soul, we're trying to create a masterpiece."

A moment later, the two-year time frame seems not to matter:

> "We're filming for 14 days – principal photography will be completed in 14 days ... 'cause we want to prove to people not only can we make good movies, and better than anybody else, we want to show them we can do it fast. I think it's really important not only to be good but to be fast."

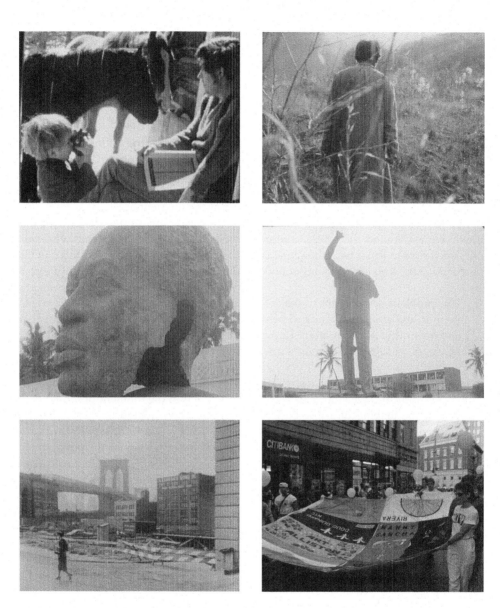

Figure 8.1 **Top row left:** A visit to the Brakhage family in Jonas Mekas's *Diaries, Notes, and Sketches, also known as Walden* (1969). **Top row right:** Bruce Baillie's *Mr Hayashi* (1961). Courtesy of The Film-Makers' Cooperative. **Middle row:** Two images from Ephraim Asili's *American Hunger* (2013). **Bottom row left:** Rudy Burckhardt's *Under The Brooklyn Bridge* (1953). © 2019 Estate of Rudy Burckhardt/Artists Rights Society (ARS), New York. **Bottom row right:** Jim Hubbard's *Elegy in the Streets* (1989). Courtesy of the filmmaker.

Jerry then adds, regarding this masterpiece:

"This stuff is junk, and we know it. But you gotta start someplace. And you gotta make money with your first product. 'Cause film is unlike any other media; it's so expensive it's unbelievable to participate in it. We've got to show a profit on our first film in order to continue, and we're going to continue."

Don intercedes: "When he says 'it's junk' he means it's designed as pure entertainment."

Not all autobiographical cinema uses the camera as a diary-keeping apparatus; James Broughton's *Testament* (1974) is autobiographical while being hardly a diary film, in that it is wholly scripted and directed rather than shot in an extemporaneous manner.

An autobiographical cinematic essay sharing more in common with the visual sensibility of the cinematic diary is *The Male GaYze* (1990) by Jack Waters. Its merging of these modes of filmmaking is central to the film. Waters juxtaposes his voice on soundtrack recalling the experiences of being a gay, black dancer and choreographer visiting a dance festival in Europe, and images in the United States: The filmmaker looking out of a window in the city and pastoral scenes with children, friends in a swimming pool, and grazing horses, while visiting the countryside. The sound and image seem to exist in different spheres of time: the present of the footage and past of the voiceover, as if the filmmaker is telling the story of his misadventures in Europe there in the present day setting of the images.

Waters's film is instructive in solving the diary film's dilemma of temporality: the written diary is freely created as a retrospective process, whereas the film diary is confined to the present moment when the camera is loaded and ready to shoot. Yet time may be bifurcated, as Waters does: the visual diary footage merged with the soundtrack's verbal recollections of the past.

In Jonas Mekas's diary films, scenes of snow and snowstorms become a visual surrogate for the Lithuania of his childhood, a way to enter into the past through the material available in the present. He explains this on the soundtrack of *As I Was Moving Ahead Occasionally I Saw Brief Glimpses of Beauty*:

> I may not even be filming the real life; I may just be filming my memories. I don't care. I just have to film, like I have to film snow. I have to film snow. How much snow – how much snow there is in New York? But you will see a lot of snow in my films. Snow is like mud of Lourdes. Why do they always when they paint paradise show it just full of exotic trees? No! Paradise – my paradise – was full of snow. My paradise was full of snow, I tell you, paradise was full of snow, white snow, and I used to roll in it, and I was so free and happy. I was in paradise, I knew – I know! – I was. When I was a child I was in paradise, I know.

Single-system super-8 cameras, using film with a magnetic stripe to shoot sync sound, have been the basis of diary films with the filmmaker speaking in confidence to the camera, as Joe Gibbons does in *Living in the World* (1985) and *Confessions of a Sociopath* (2002). For Gibbons, the diary film does not place him in the passive role of observer, but life itself becomes invented and performed for the camera: "'My films allow me a unique moral license,' says Gibbons. 'I can stomp on flowers, spy on people, break things, perform the most reckless deeds – all in the name of *the film that must be made*.'"[19]

Massachusetts filmmaker Anne Charlotte Robertson's super-8 film diary, begun in 1981, comprised eighty-three reels of film by the time of her death in 2012. Her *Diary* contained both introspective, sometimes morose, subject matter, in addition to lighter moments of cinematic reverie, including " . . . struggles with bipolar syndrome, weight, vegetarianism, and a range of other personal issues, as well as the pleasures of garden-ing, extended family, and daily life."[20] Using super-8 cartridges with a magnetic stripe, she sometimes would speak aloud as an impromptu narration delivered from behind the camera while shooting. But when screening reels from her *Diary*, she would add further verbal commentary with a live microphone, the two competing voices speaking over each other, making different points, or delving into different subjects as a tangle of interspliced words from past and present, creating the impression of a melancholy-hued cut-up poem. She summed up her aesthetic sensibility: "I tend to crowd a lot of things in my garden, I crowd a lot of things in my films – in a diary, that's the most realistic attitude to take. Crowd everything in. In a sort of free-form style. Like the less you edit the more it says."[21]

Sadie Benning's PixelVision diary films make use of the medium's sync sound format, in addition to her confidentially imparted commentary fragments of music playing in the background or the sound of the television intruding. Benning would also employ handwritten text, as if passages from a written diary were being filmed in these moments within her work.

Cinematic songs, sketches, notes, and letters

The film diary's relationship to the written diary – the transplantation of written model into visual image-making – has its parallel in many instances of borrowings from one creative paradigm to another. The critic James Huneker's essay "Painted Music" surveys a number of these artistic incursions.[22] There is Bedřich Smetana's autobiographical string quartet, with its contrasting episodes of despair, youthful exuberance, and romantic ardor, and the high-pitched sound of his tinnitus replicated on the violin, entitled *From My Life* (*Z mého života*); the painted Nocturnes and Symphonies of James McNeill Whistler; and Franz Liszt's symphonic "poems." Cinema has the "city symphony" as a genre crowded with examples of this musical form transposed into moving images. Brakhage's 8mm films are a series of visual *Songs*. Marie Menken made cinematic bagatelles, and eye music.

Menken's work was called "poetry" by Jonas Mekas,[23] while Melissa Ragona argues that it has more in common with fine arts and painting.[24] Menken herself suggested this in an interview about her filmmaking process: "I just liked the twitters of the machine, and since it was an extension of painting for me, I tried it and love it."[25]

Marjorie Keller – whose own work included many films of a diary-like nature – has highlighted Menken's sketching and jotting with the camera:

> Her films resonate far beyond their quiet surfaces. *Notebook* stands as a portal, opening up filmic spaces on their own terms. In the film, she presents details of daily life as the jottings in a moving sketchbook, fragments of observation and cinematic creation – little mysteries. The titles of her films provide some clues – *Glimpse of the Garden*, *Arabesque for Kenneth Anger*, and *Notebook* itself all indicate a fleeting look, gesture, jotting.[26]

Saul Levine has used the term "notes" to describe many of his films, including *Note to Pati* (1969), *Note to Colleen* (1974), *Notes of an Early Fall* (1976), *Rambling Notes* (1976),

New Left Note (1982), *Note to Poli* (1982), *Notes After Long Silence* (1989), and *Whole Note* (2000). He doesn't limit the term "notes" to just jottings to oneself but also to the note as a form of letter to another person and even the term's reference to musical notes.

David Brooks's *Letter To D. H. In Paris* (1967) is comprised of "stoned friends/music more music/fields/movement/play/spontaneity . . . "[27] as a filmic epistle. Another film in the form of a letter was the result of a roll of 16mm film mailed back and forth between Brooklyn, New York, and Boulder, Colorado, by the author of this book and filmmaker Nicole Koschmann, producing *Boulder-Brooklyn, a correspondence film* (2001). Images were superimposed from the two locations on the same roll in exquisite corpse fashion: Neither of us knew what images the other had shot, so we had to work by means of anticipation in deciding what to shoot to act as a visual complement to what the other person might conceivably expose onto the film.

The film portrait

The filmic diary is often a form of self-portrait even when the filmmaker remains hidden behind the camera. We see through the eyes of the filmmaker – we see the world in the particular ways she or he sees it. Film portraits may say as much about the portraitist as the one portrayed: Warhol's silently unreeling *Screen Tests* exhibit the odd combination of aloofness and audacity of the artist. Marie Menken's *Andy Warhol* (1965), shot primarily in single frame, is a portrait of the artist at work on his 1964 Flower series, while also representative of the Menken flair for time-lapse shooting. Sometimes, as in the case of filmmakers making films for other filmmakers, the portrait is a nod to the filmmaking style of the one portrayed, as with *A Valentine for Marie* (1965) made by John Hawkins and Willard Maas for Marie Menken, using the cut-out animation inspired by her own experiments in *Notebook* (1962) and *Dwightiana* (1959).

In the case of many of the Mekas diary films, the principal subjects of the work are the community of people surrounding the person filming – friends, family, strangers – a self-portrait formed not just by the camera's lone viewpoint but also by those the filmmaker has chosen as cohorts: Adolfas Mekas and Pola Chapelle, Hollis Melton, Tony and Beverly Conrad, Ken and Flo Jacobs, David and Barbara Stone, John Lennon and Yoko Ono, George Maciunas, Nam June Paik, Barbara Rubin, brief encounters with Andy Warhol or Allen Ginsberg, and visits to Hans Richter.

Bruce Baillie has used the camera for short visual portraits: *Mr Hayashi* (1961) and *Tung* (1966). Standish Lawder visited Hans Richter at his Connecticut farm and filmed *Sunday In Southbury* (1972) concurrent with Jonas Mekas filming there with his Bolex. Guy Sherwin's *Portrait with Parents* (1975) "is a single three-minute take of Sherwin's parents standing in front of a mantelpiece, flanking an oval mirror which reflects the filmmaker. The camera is hand-cranked, which gives a shuddering jerky quality to the images of the couple smiling at and talking to the camera and filmmaker and, by extension, the spectator."[28] Sherwin's inclusion of the reflection in the mirror of the portrait-maker, resembling a similar arrangement in painted portraiture – Jan van Eyck's The Arnolfini Portrait – is seemingly an invitation for the viewer to ponder the transposition of portraiture from canvas to movie screen. Jeff Scher's *Warren* (1995) turns the camera on filmmaker Warren Sonbert, whose slightly uncomfortable facial expressions show him reluctantly acquiescing to being filmed. Marie Losier's *Snowbeard* (2009) uses a 100ft camera roll for an unedited film of Mike Kuchar. The portrait films of Gérard Courant have been produced over decades and number in the hundreds.

Andrew Lampert's super-8 *#6 Okkyung* (2004) seems paradoxical in its cinematic premise: a silent film portrait of the musician Okkyung Lee. The subject of the short super-8 film is seen backlit producing unheard sound while playing the cello. The silent film becomes a visual study of movement of arms and body with cello and bow. The intensity and concentration of her playing becomes the object of interest. Watching it, the viewer mentally attempts to imagine the absent sounds based on the gestures; the hand on the fingerboard and the bow on the strings.

Portland filmmaker Vanessa Renwick makes an inanimate object the star of her film *Portrait 2: Trojan* (2007), depicting the last days of a decommissioned power plant. A hulking presence in the bucolic countryside, it seems like some menacing alien machine, like that of the 1950s sci-fi movie *Kronos* (1957).

The film portrait might not even require seeing the subject of the portrait on screen. It may instead provide inferences about the subject through possessions, furnishings, and environment. Stan Brakhage has described how Marie Menken's *Glimpse of the Garden* (1957) is a portrait of an unseen gardener, by way of the camera's observation of the garden itself: "Marie made portraits of her subjects by photographing the thing that these people would love, or did love . . ."[29] Brakhage contrasts this oblique form of film portrait with the more traditional idea of portraiture, wherein the camera is pointed directly at the portrait sitter:

> Her "Dwightiana," "Arabesque for Kenneth Anger," and "Bagatelle for Willard Maas" arrived at that very instant when the only concept of portraiture there then was in film – and still is, too much – was in terms of "taking a picture"; which is to say with very little giving into it, certainly not the sort of investment that had made oil portraiture great. There had also always been the sense that a portrait had to demonstrate the distinguishing features of a face, but this could not be the business of film as it could be with oil painting. Marie solved that dilemma.[30]

Su Friedrich approaches the indirect form of portrait-filmmaking in *Rules of the Road* (1993), a film that, at first, appears to be a portrait film of a station wagon. Friedrich's 16mm camera gathers images out on the streets of Brooklyn and Manhattan, seeking out station wagons parked and passing by. The view from a car interior appears, showing the passing landscape along the Belt Parkway then scenes from inside the car of the landscape further outside of the city. Friedrich speaks, unseen, on the film's soundtrack, discussing how her partner, a painter, decided she needed a car and how the two of them shared ownership of the resultant station wagon. Friedrich at first regarded this as an indulgence for someone living in New York City but grew quite accustomed to its convenience. What emerges through the film is a growing gleaning of the car acting as the film's proxy for the person, to create a film portrait of Friedrich's relationship and break-up with her long-term girlfriend. The unseen partner is identified as an unnamed "she" in the film's voiceover. The station wagon becomes the setting for moments of being alone together in public, with the bubble of semi-privacy as a place to argue, to confide.

Jon Beacham's *Film for Violet* (2017) is, like Menken's *Glimpse of the Garden*, a portrait through the environment surrounding the unseen subject. As Beacham describes it, it is: "A portrait of my grandmother Violet's house and Lake Erie. Shot in Euclid, Ohio, slowly over the course of three years. Golden light and the calm of the lake. A film about an interior."

Diary as archive

The filmmaker Ephraim Asili has made a series of films addressing the African diaspora through the visual relationships from one location to another. *Forged Ways* (2011) and *American Hunger* (2013) include scenes taking place in New York, New Jersey, and Philadelphia, intercut with footage shot while traveling in Ghana and Ethiopia. At times, the sequences are contrasts, as when a man walks alone on a winter day through a deserted industrial section of the city counterpointed with images filmed in Ethiopia. But more often, some editorial linkage bridges sequences: Ghanaian children playing on the sandy shore, viewed from above, seen through the gun ports of a colonial-era fort, and a couple strolling on a beach in the United States, a seeming echo or visual alliteration between one location and the other. A man in Africa plays records on a portable player, the soundtrack of African pop music bleeding over onto scenes of the couple on the beach, now listening to the same music on a radio. At times, a shot might cause a moment of puzzlement: Where is it? Scenes of women in African dress, in one instance, turn out to be a street festival held in Philadelphia. Only when a wider shot includes a telltale street sign do we place the camera back in the United States.

The bright sky washes out images in black and white. A headless statue resolutely stands with an arm raised in the air, with the disembodied head displayed alongside in the sunlit plaza. A voice on the soundtrack is heard delivering a political speech. The sequence is one of temporal juxtaposition, the gray-toned footage suggesting archival images rather than the present day. Asili has described[31] how people would ask him where he found this "old footage" that he had shot himself using black and white 16mm film. The intent had been to create something to use in place of found footage. Rather than be pestered with the rights and permissions sometimes encountered with found footage filmmaking, Asili used the 16mm camera to create his own archive of material. He compared this to what Jonas Mekas has done in shooting his film diary, which is to create a personal archive from which images could be retrieved and utilized later. Even the semi-narrative scenes in these films were part of an abandoned narrative film, now absorbed into the projects as a counterpoint to the travel diary footage, akin to using this too as a form of found footage.

Jeff Preiss transformed a seventeen-year 16mm film diary into his film *STOP* (1995–2012). It includes views of his downtown New York neighborhood; the vista of cotton-like clouds from an airplane window; planes overhead seen from the ground; viewing the passing landscape from trains while traveling to cities in Europe and Asia; the events of 9/11 witnessed from Tribeca, just north of the World Trade Center; gallery exhibits and film screenings; and the filmmaker's child awakening to the experience of gender identity. The film moves abruptly from scene to scene, with sequences arranged chronologically, the camera roll numbers created while transferring the footage serving to index the fragments of passing time. Shot without audio, using a Bolex camera, the film's sound was added after the fact to simulate the aural environments corresponding to the footage. The sound changes abruptly with the starting and stopping of the camera, in simulation of the use of single-system sound. The brevity of each shot, lasting usually no more than two seconds, enhances the sense of time's constant disappearance from our grasp. As the rolls of film and the years pass by, changes take place in the shooting: Traveling to Berlin, a circular matte is used in front of the camera lens, recurring later, and then put aside. In the later rolls, Preiss films a curious variation on the panning shot. The camera pans first right or left then doubles back the way it came. This happens a few more times, the camera

scanning or searching, rather than using the pan to arrive at some visual resolution at the end of the shot.

David E. James has charted the passage of time from Mekas's collection of film diary material from shooting to its long hibernation, curled up on a reel, to its exhumation into the diary film.[32] As wine ages in the bottle, the reel of film within the can undergoes an unseen transformation as ephemeral time congeals into a solid stable entity. Images and time: footage takes on new meaning, a view of the past. As Susan Sontag expressed it, writing about photography: "A photograph of 1900 that was affecting then because of its subject would, today, be more likely to move us because it is a photograph taken in 1900."[33] The camera doesn't merely film the present moment but is a machine for capturing images of those who will perish, the image in the emulsion of film like a tender token to prompt one's fading memory. The motion picture turns the dead into phantom automata whose gearwork action is only capable of repeating the same movements with each viewing of the film strip. Time, preserved on film, moves from present to the past, wound upon the reel.

Footage takes on a patina of its own time through the medium's palette: the silvery black and white or the lushness of Kodachrome giving a strange and false impression of the past having such tonalities. A photograph from a century ago updated to the contemporary world through digital colorization has an appearance of something fake and recreated rather than feel of its own time. But the world had been in color then, had it not? Worse still is when old movie footage is viewed with that detestable thing on consumer High Definition televisions called "motion smoothing." Filmic memory: it is thus clouded as well by the medium.

Rudy Burckhardt's films from the 1940s, 50s, and 60s show a city no longer extant. Working-class neighborhoods are today filled instead with chi-chi boutiques and pricey eateries. The factories of DUMBO in *Under The Brooklyn Bridge* (1953) have now been transformed into a trendy tourist destination. The infamously seedy Times Square area of *Square Times* (1967) and *Sodom and Gomorrah, New York 10036* (1975) has been bowdlerized and remade into a glorified shopping mall. The East Village of *Eastside Summer* (1953) has also transformed from lively unassuming neighborhoods of immigrants from Eastern and Southern Europe, the Caribbean, and Latin America into another upscale hipster hangout. Jonas Mekas's footage of Williamsburg in the 1950s or Ken Jacobs's *Orchard Street* (1955) also transform the movie screen into a window looking into an irretrievable past, moving further away with each passing moment.

Irish filmmaker Moira Tierney's *Ride City* (1999) uses super-8 film presented as a double-screen film with images side by side. The work records images of Smithfield Market, the open-air horse market taking place on the streets of Dublin, and seems like a glimpse of some moment from another century transported to today: teenagers ride young colts along the cobblestone streets and men fit horseshoes to hooves, heating the iron shoes on braziers to adjust them to size with hammer blows.

The poet and filmmaker Stephanie Gray, also working in super-8, has filmed the boarded- up storefronts of downtown Buffalo, New York. A handheld camera makes hesitant movements across facades of decaying buildings, observing the patina of the weathered surfaces and old signs: "Meats and Poultry," "Optometrist," "Furrier," in vintage typeface and flaking paint. In the midst of glinting sunlight from some reflective surface – its intense brightness splaying across the surface of the film's emulsion – the camera frames a goddess-like statue of a woman on top of a building, the images of a pagan deity, reduced to the role of architectural decoration, disinvested of the devotions of some lost, forgotten

golden age. Hints of urban renewal come in the form of fancy new streetlights added to the city's downtown shopping district, while the buildings themselves continue to display "For Rent" signs. The closing day of a neighborhood bakery is the subject of another of Gray's films, *More Bread (Forever)* (2004).

Stan Brakhage finds the desire to fight against oblivion through this cinematic transubstantiation in even the most innocuous of home movies:

> When an amateur photographs scenes of a trip he's taking, a party, or other special occasion, and especially when he's photographing his children, he's primarily seeking a *hold on time* and, as such, is ultimately attempting to defeat death. The entire act of motion picture making, thus, can be considered as an *exteriorization* of the process of memory.[34]

Or, as Susan Sontag observes: "All photographs are *memento mori*."[35]

Jim Hubbard's *Two Marches* (1991) and *Elegy in the Streets* (1989) are filmed in the diary-like manner of personal filmmaking. *Two Marches* is comprised of footage from the National March on Washington for Lesbian and Gay Rights in Washington DC, taking place before and during the AIDS crisis. *Elegy in the Streets* compiles scenes of ACT-UP protests, the Gay Pride March in New York City, the AIDS Quilt, and the death from AIDS of filmmaker Roger Jacoby. The camera witnesses the political activism and protest with Hubbard as participant rather than onlooker. The camera is not filming the crowds from without but from a viewpoint within the protest.

Jerry Tartaglia's *See For Yourself* (1995) is, as noted in Chapter 3, an experimental film about the AIDS crisis. Silent footage documents an emaciated man in a hospital, in his home, and in a state of postmortem composure laid within an open casket. In the film's coda, the subject shifts to an in-camera superimposition of red flowers over sheet music from Giuseppe Verdi's *La Traviata*, from the scene where Alfredo is reunited with Violetta as she is dying of consumption. The film's use of raw footage and end-flares reinforces the title's directive: to witness and confront the reality of an epidemic, the camera's unwillingness to look away an act of resistance against the stigma and fear surrounding HIV.

When Mekas stopped using his 16mm Bolex, he turned to shooting with a consumer video camcorder and continued to work with this Standard Definition camera even as High Definition became the ubiquitous digital format. The format was less important than the diary-keeping process. Diary filming may be more about the act of using the camera rather than the objective of making a "movie" in the more conventional sense. Early in his career, he had directed the feature-length films *Guns of the Trees* (1961) and *The Brig* (1964), but when he began keeping his film diary, this form of filming seemed to be of a different nature from those projects; more of a side endeavor to everything else he was doing:

> . . . I got so entangled with the independently made film that I didn't have any time left for myself, for my own film-making – between Film-Makers' Cooperative, Film-Makers' Cinematheque, *Film Culture* magazine, and now Anthology Film Archives. I mean, I didn't have any long stretches of time to prepare a script, then to take months to shoot, then to edit, etc. I had only bits of time, which allowed me to shoot only bits of film. All my personal work became like notes. I thought I should do whatever I can today, because if I don't, I may not find any other free time for weeks. If I can film ten seconds – I film ten seconds. I take what I can, from desperation. But

for a long time, I didn't look at the footage I was collecting that way. I thought what I was actually doing was practicing. I was preparing myself, or trying to keep in touch with my camera, so that when the day would come when I'll have time, then I would make the "real" film.[36]

The film diary provides this lesson: It asks of you not to wait around – perhaps indefinitely – to make the "real" film once you have all of the professional equipment, the feature film-sized budget, the producer, cast and crew, and all the other elements of the conventional movie-making juggernaut of resources and personnel. The artists we have surveyed in this book have often turned to the camera as a means of stripping away all of this to get to the film itself, be it for budgetary reasons or some less pragmatic reason involving the relationship between filmmaker and creative process. In the case of the camera-roll film, the entire editing suite is bypassed and the film proceeds to the screen. These filmmakers have created enduring works using the camera as a tool for innovation and experimentation. This approach can place the tools of production more easily within reach than it may seem, allowing you to work frugally in one of the most expensive art forms there is (although architecture is probably up there too). So too the chain of change, comprised of an ever accelerating obsolescence, can be severed: A super-8 camera several decades old, and no longer manufactured, can be loaded up with freshly produced film, and you can go out and shoot with it today. It can also be the starting point for taking things further: The economizing of shooting 16mm camera rolls may lead to hand-processing and darkroom experiments. Footage from a film diary could be edited into a diary film. A lasting body of work can be created not through the hubris of being the "director," ordering your crew about like Ozymandias commanding his colossal works be built, but by fashioning it through your own hand, laying it brick by brick: "If I can film ten seconds – I film ten seconds."

Notes

1 Mekas, Jonas, "The Experimental Film in America" (1955), in P. Adams Sitney ed., *Film Culture Reader*. New York: Praeger Publishers, 1970, pp. 21–26.
2 Ibid., p. 26.
3 James, David E., "Film Diary/Diary Film," in David James ed., *To Free the Cinema: Jonas Mekas and the New York Underground*. Princeton, NJ: Princeton University Press, 1992, pp. 145–179.
4 *The Film-Makers' Cooperative Catalogue No. 7*. New York: The New American Cinema Group Inc., 1989, p. 362.
5 Ibid., p. 362. Parentheses in the original.
6 Ibid., p. 367.
7 James, "Film Diary/Diary Film," p. 157.
8 Renov, Michael, "Lost, Lost, Lost: Mekas as Essayist," in David James ed., *To Free the Cinema: Jonas Mekas and the New York Underground*. Princeton, NJ: Princeton University Press, 1992, p. 215.
9 *The Film-Makers' Cooperative Catalogue No. 7*, p. 19.
10 Sanderson, Alister, "The Diary Cinema of Howard Guttenplan," *Millennium Film Journal* vol. 1, Winter 1977–78, p. 107.
11 Zimmerman, Patricia R., *Reel Families: A Social History of Amateur Film*. Bloomington and Indianapolis: Indiana University Press, 1995, p. 146.
12 Ruoff, Jeffrey K., "Home Movies of the Avant-Garde," in David James ed., *To Free the Cinema: Jonas Mekas and the New York Underground*. Princeton, NJ: Princeton University Press, 1992, p. 297.
13 Brakhage, Stan, "In Defense of Amateur," in Bruce R. McPherson ed., *Essential Brakhage: Selected Writings on Filmmaking*. Kingston, NY: Documentext, 2001, pp. 142–150.
14 Stevenson, Jack, *Desperate Visions 1: Camp America*. London: Creation Books, 1996, p. 164

15 Ibid., p. 166.

16 Kakuzo, Okakura, *The Book of Tea* (1906). Tokyo: Tuttle Publishing, 1956, pp. 56–57.

17 MacDonald, Scott, "Jonas Mekas," *Critical Cinema 2*. Berkeley and Los Angeles: University of California Press, 1992, p. 91.

18 Brakhage, "In Defense of Amateur," p. 143.

19 Rumsey, Spencer, "Profiles: The Avant-Garde World of Filmmakers Joe Gibbons and Gene Barresi," *Super-8 Filmmaker Magazine* vol. 7 no. 6, Nov 1978, p. 60.

20 Petrolle, Jean and Virginia Wright Wexman ed., *Women and Experimental Filmmaking*. Urbana and Chicago: University of Illinois Press, 2005, p. 206.

21 Cameron, Donna, "Pieces of Eight: Interviews with 8mm filmmakers," in Albert Kilchesty ed., *Big As Life, An American History of 8mm Films*. Museum of Modern Art/San Francisco Cinematheque, 1998, p. 66.

22 Huneker, James, "Painted Music," *Bedouins*. New York: Charles Scribner's Sons, 1920, pp. 81–93.

23 Mekas, Jonas, "Praise to Marie Menken, the Film Poet" (1962), in *Movie Journal: The Rise of the New American Cinema 1959–1971*. New York: Collier Books, 1972, pp. 46–48.

24 Ragona, Melissa, "Swing and Sway: Marie Menken's Filmic Events," in Robin Blaetz ed., *Women's Experimental Cinema: Critical Frameworks*. Durham, NC, and London: Duke University Press, 2007, pp. 20–44.

25 Mandell, Leslie (assisted by Paul Sitney), "Interview with Marie Menken," *Wagner Literary Magazine* no. 4. Gerard Malanga and Paul Katz ed. Staten Island, NY: Wagner College, 1963–64, p. 48.

26 Keller, Marjorie, "The Apron Strings of Jonas Mekas," in David James ed., *To Free the Cinema: Jonas Mekas and the New York Underground*. Princeton, NJ: Princeton University Press, 1992, p. 86.

27 *The Film-Makers' Cooperative Catalogue No. 7*, p. 79.

28 Ibid., p. 444.

29 Brakhage, Stan, *Film at Wit's End*. Kingston, NY: McPherson and Company, 1989, p. 44.

30 Ibid., p. 44.

31 Ephraim Asili speaking about his work at a screening at The New School in 2017.

32 James, "Film Diary/Diary Film," p. 166.

33 Sontag, Susan, "Photography," *New York Review of Books Anthology*. New York: New York Review of Books, 1993, p. 109 (NYRB October 18 1973).

34 Brakhage, "In Defense of Amateur," p. 149.

35 Sontag, "Photography," p. 105.

36 Mekas, Jonas, "The Diary Film," in P. Adams Sitney ed., *The Avant-Garde Film: A Reader of Theory and Criticism*. New York: Praeger Publishers, 1970, p. 190.

Index